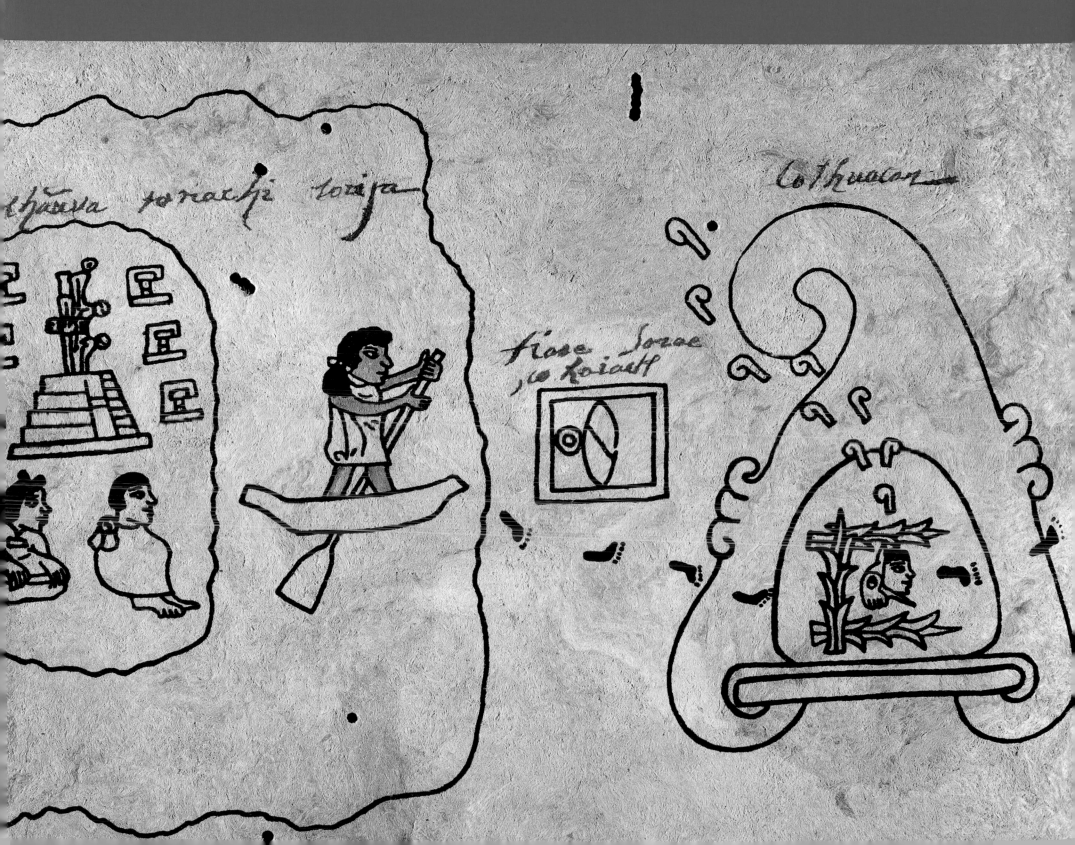

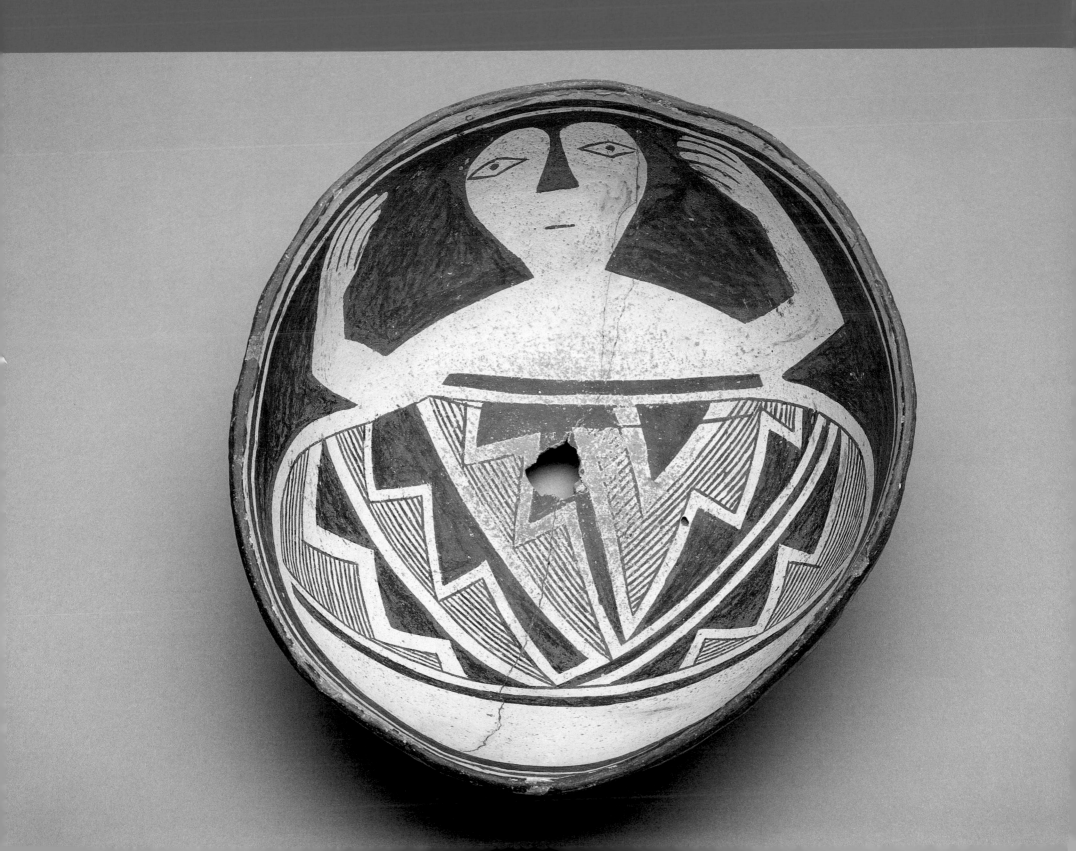

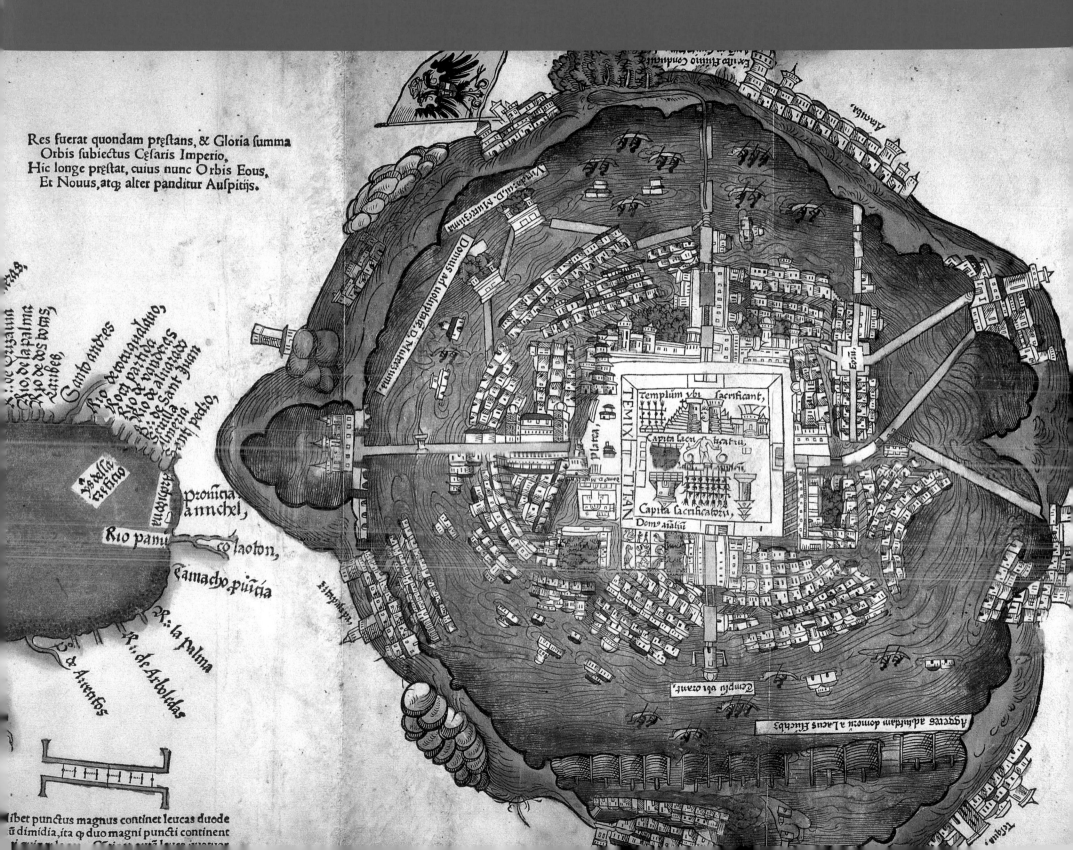

Res fuerat quondam prestans, & Gloria summa
Orbis subiectus Cesaris Imperio,
Hic longe prestat, cuius nunc Orbis Eous,
Et Nouus, atq; alter panditur Auspitijs.

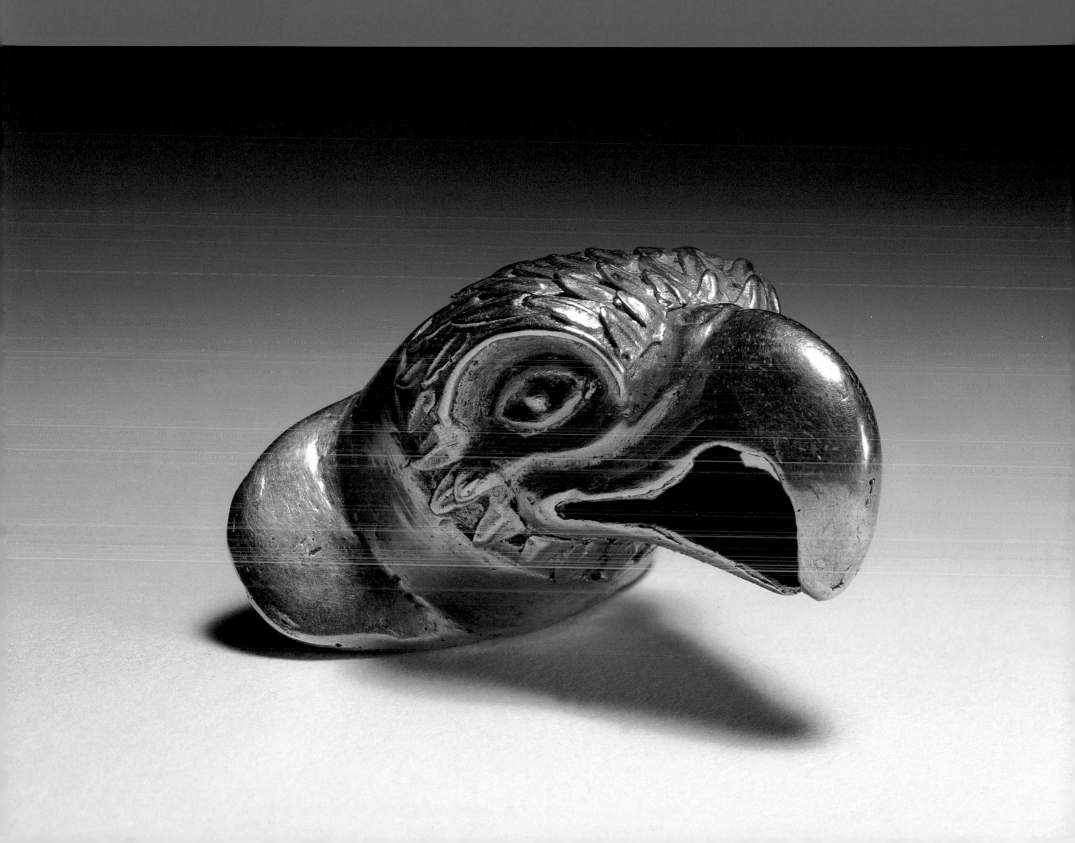

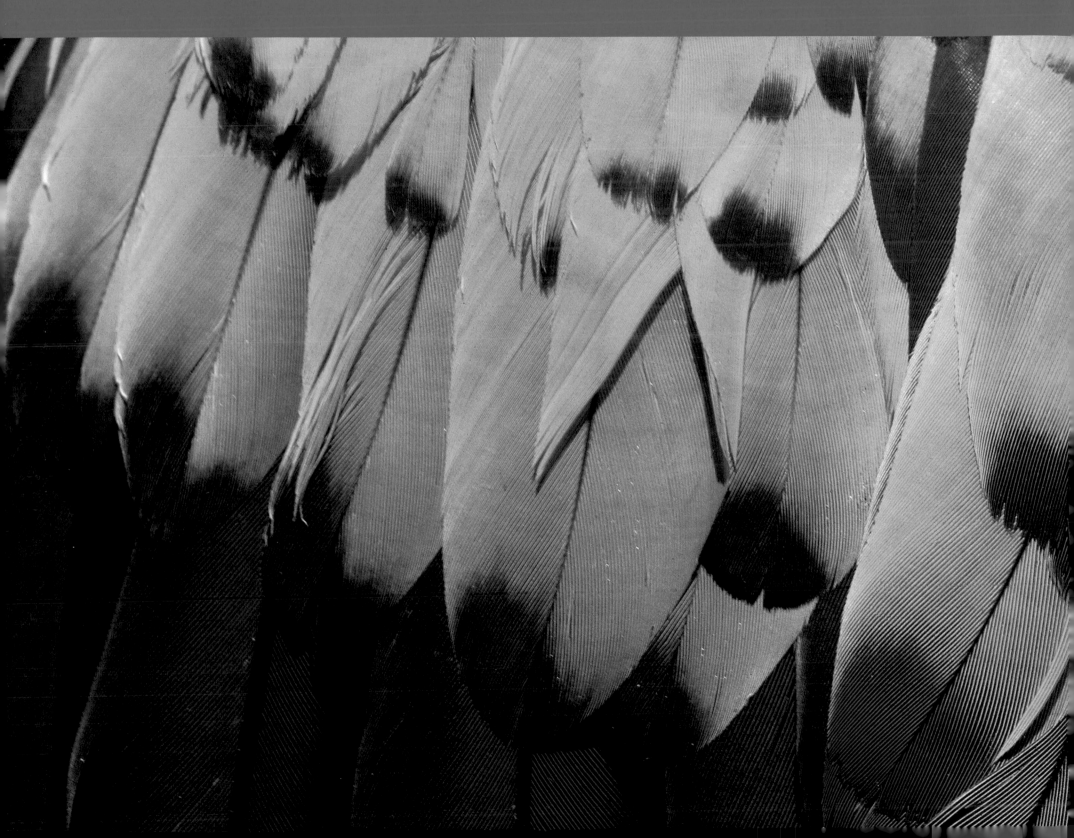

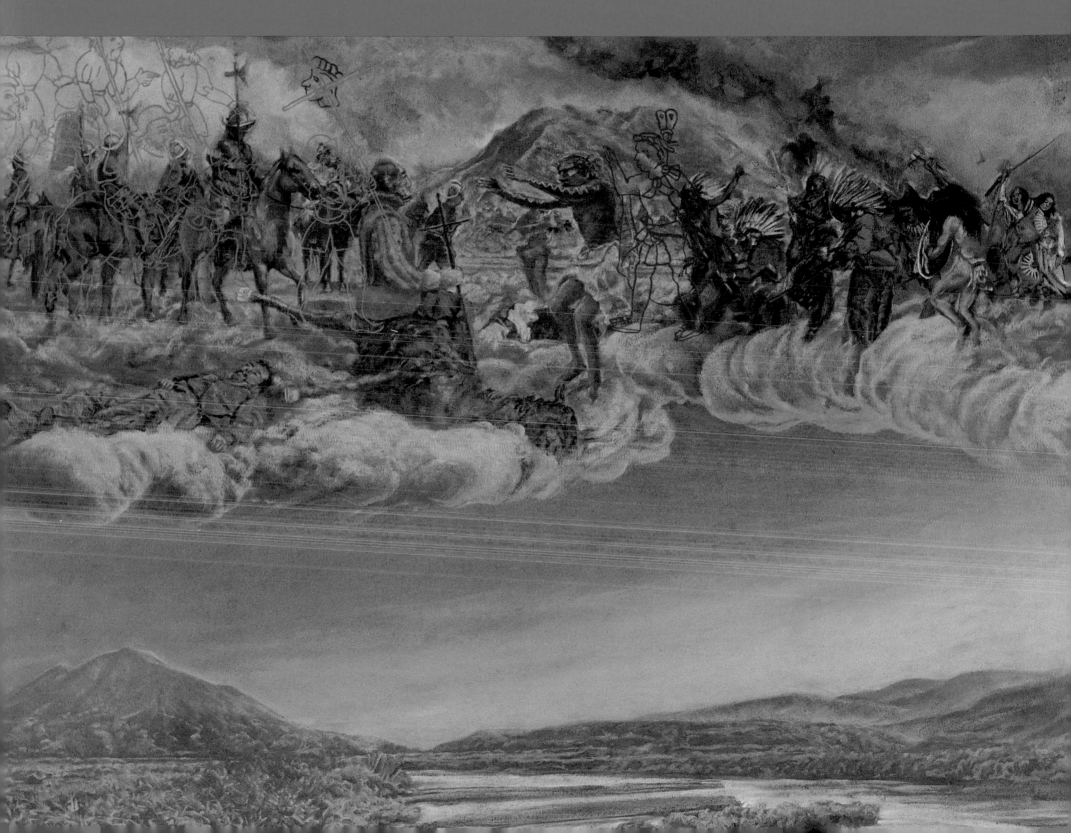

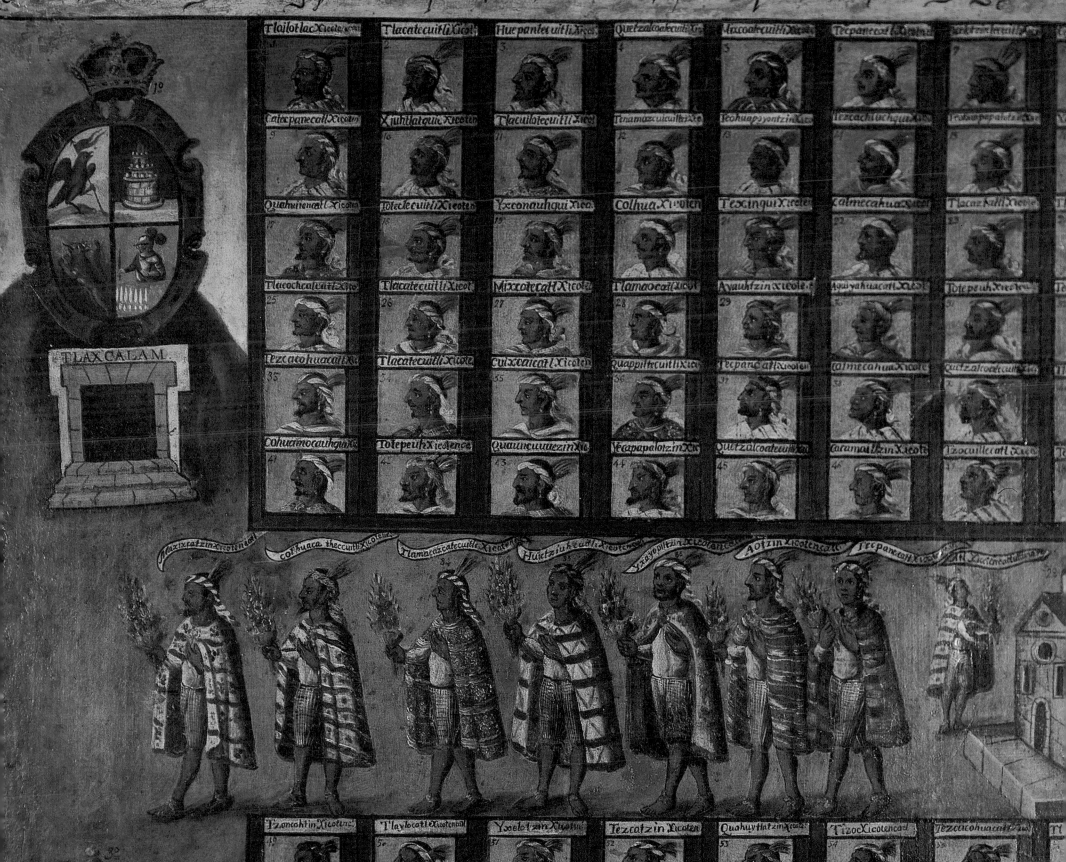

THE ROAD TO
AZTLAN
ART FROM
A MYTHIC HOMELAND

VIRGINIA M. FIELDS
VICTOR ZAMUDIO-TAYLOR

With contributions by

Michele Beltrán
J. J. Brody
Enrique Chagoya
Constance Cortez
James D. Farmer
Acelia García de Weigand
Ramón A. Gutiérrez
Stephen H. Lekson
Miguel León-Portilla
Danna A. Levin Rojo
Elin Luque
Amalia Mesa-Bains

John M. D. Pohl
Carroll L. Riley
Polly Schaafsma
Rina Swentzell
Karl Taube
Victoria D. Vargas
Laurie D. Webster
Phil C. Weigand
Anne I. Woosley

LOS ANGELES COUNTY MUSEUM OF ART

This book was published in conjunction with the exhibition *The Road to Aztlan: Art from a Mythic Homeland*. The exhibition was organized by the Los Angeles County Museum of Art. It was made possible by a generous grant from AT&T. It was supported in part by grants from the Rockefeller Foundation and the National Endowment for the Humanities, dedicated to expanding American understanding of history and culture. Additional support was provided by the Ethnic Arts Council of Los Angeles.

The Los Angeles presentation was made possible by KMEX-TV/Univision.

In-kind support for the exhibition was provided by FrameStore.

Publication of the catalogue was supported in part by a grant from the U.S.–Mexico Fund for Culture, a program created and funded by Mexico's National Fund for Culture and the Arts (FONCA), The Rockefeller Foundation, and Bancomer Cultural Foundation.

Exhibition Itinerary

Published by the Los Angeles County Museum of Art, 5905 Wilshire Boulevard, Los Angeles, CA 90036.

Distributed by the University of New Mexico Press, 1720 Lomas Boulevard, N.E., Albuquerque, NM 87131-1591, 1-800-249-7737, www.unmpress.com.

Library of Congress Cataloging-in-Publication Data

Fields, Virginia, 1952–
The road to Aztlan : art from a mythic homeland / Virginia Fields, Victor Zamudio-Taylor; with contributions by Michele Beltrán ... [et al.]. —1st ed.
 p. cm.
An accompaniment to an exhibition at the Los Angeles County Museum of Art.
 Includes bibliographical references and index.
 ISBN 0-8263-2426-6 (Univ. of N.M. Press : cloth : alk. paper) – ISBN 0-8263-2427-4 (Univ. of N.M. Press pbk. : alk. paper)
 1. Aztlan—Exhibitions. 2. Indians of Mexico—Commerce—Exhibitions. 3. Indians of Mexico—Migrations—Exhibitions. 4. Indians of Mexico—History—Sources—Exhibitions. 5. Indians of North America—Commerce— Southwest, New—Exhibitions. 6. Indians of North America—Southwest, New—Migrations—Exhibitions. 7. Indians of North America—Southwest, New—History—Exhibitions. 8. Los Angeles County Museum of Art—Exhibitions. I. Zamudio-Taylor, Víctor. II. Los Angeles County Museum of Art. III. Title.

F1219.3.C6F54 2001
979'.0074'79493—dc21

2001000245

Director of Publications: Garrett White
Editor: Karen Jacobson
Designer: Amy McFarland
Production Coordinator: Karen Knapp
Supervising Photographer: Peter Brenner
Rights and Reproductions Coordinator: Cheryle T. Robertson

Printed in Germany by Cantz

COVER PHOTOGRAPH:
Alison Wright, *Rainbows over the Javan River, Peru,* c. 1980s–1990s.

PAGES 1–8: Text: Knab 1994, 85–86. Images: Facsimile of the Codex Boturini (*Tira de la peregrinación*), first half of the 16th century, detail of fol. 1 (detail of cat. no. 158); *Bowl Depicting Man and Bowl,* c. 1000–1150 (cat. no. 78); map of Mexico-Tenochtitlan attributed to Hernán Cortés, 1524 (detail of fig. 204), *San Hipólito,* 18th century (detail of cat. no. 204); *Labret in the Form of an Eagle Head,* c. 1200–1500 (cat. no. 171); photograph courtesy of Fomento Cultural Banamex, A.C.; John Valadez, *The Border* (panel 2), 1991–93 (detail of cat. no. 222); attributed to Conde Sifuentes, *Nobleza tlaxcalteca en la época de la conquista,* 18th century (detail of cat. no. 207).

PAGE 10: Carlos Almaraz, *Two of a Kind,* 1986 (detail of cat. no. 246).

PAGES 78–85: Text: León-Portilla 1969, 80 (page 80); León-Portilla 1969, 94 (page 83). Images: Lucy M. Lewis, *Black-on-White Jar,* 1972 (detail of cat. no. 215); *Bowl with Spiral Design,* 13th century (detail of cat. no. 108); *Necklace,* 14th–15th century (cat. no. 164); *Mosaic Ornament,* A.D. 900–1519 (cat. no. 176); Michel Zabé, Untitled, n.d.; *Coyolxauhqui Mask,* c. 1500 (cat. no. 166); Michel Zabé, Untitled, n.d.; *Mask,* 15th–16th century (detail of cat. no. 173).

PAGES 230–35: Text: León-Portilla 1992, 144 (page 234). Images: *Presentes de los Indios de Moctezuma a Hernán Cortés en San Juan de Ulua,* 18th century (detail of cat. no. 183); *Serape,* 19th century (detail of cat. no. 199); *Chalice,* c. 1575–78 (details of cat. no. 186); *Gourd with Lid,* early 20th century (cat. no. 233); *Eight Stone Figures,* c. 1000–1100 (cat. no. 80).

PAGES 300–309: Text: Alurista 1971, no. 1 (page 302); León-Portilla 1969, 87 (page 306). Images: Roberto Juarez, *Calamus Border,* 1995 (detail of cat. no. 247); Rubén Ortiz Torres and Jesse Lerner, *Frontierland/Fronterilandia,* 1995 (video still from cat. no. 237); Carmen Lomas Garza, *El Milagro* (The miracle), 1987 (see fig. 253); Louie "the Foot" González, *Announcement Poster for a UFW Benefit and Dance,* 1976 (detail of cat. no. 211); anonymous, Mexico, *Ex-voto of Felipe Sánchez,* 1943 (see fig. 249) *Río Abajo San José,* 19th century (cat. no. 198); *San Juan Nepomuceno,* New Mexico, paint on hide, 72 x 45 in. (182.9 x 114.3 cm), Museum of International Folk Art, Museum of New Mexico (A.5.52.12); detail of *Mapa de Cuauhtinchan 2* (see fig. 58); anonymous, Mexico, *Ex-voto of José Luis Palafox,* 1967 (see fig. 248); Josefus de Ribera y Argomanis, *Verdadero retrato de Santa María Virgen de Guadalupe, patrona principal de la Nueva España jurada en México,* 1778 (detail of cat. no. 205); David Avalos, *Hubcap Milagro #4,* 1986 (cat. no. 225).

CONTENTS

PART I
HERE BEGINS THE ROAD

12

PART II

**ANCIENT ROADS,
NEW JOURNEYS**

PART III

**THE LANDSCAPE
OF AZTLAN**

13

In our fast-paced contemporary society, it is not always apparent that California and the southwestern United States have ancient histories that impact our lives. The exhibition *The Road to Aztlan: Art from a Mythic Homeland* reminds us that for at least two millennia the peoples of this region have concerned themselves with questions that are relevant today: What are the roles of place and origin in a meaningful sense of belonging? How is the individual connected to the group and to nature? *The Road to Aztlan* investigates these questions within the framework of the relationships of California and the Southwest to the peoples of Mexico. The exhibition explores the vital communication between these regions, in which myths, ideas, and precious objects traveled back and forth over centuries, unifying these lands long before they were separated by an international border. Through the works of art and other objects produced in this area, it is possible to trace continuities and transformations in the beliefs and practices of these populations over time. We are especially pleased to be able to present objects that have never been seen in the United States, or that are being shown for the first time in this innovative context.

As a major undertaking for the museum, *The Road to Aztlan* constitutes an important component of the programming of the Center for Latin American Art at the Los Angeles County Museum of Art (LACMA). The center reflects LACMA's commitment to the collection, conservation, exhibition, and interpretation of Latin American art from pre-Columbian times to the present and to the translation of these objects into meaningful viewing experiences for our audiences.

The Road to Aztlan is the product of five years of research and planning by Virginia M. Fields, the museum's curator of pre-Columbian art, and Victor Zamudio-Taylor, an independent curator and adviser to the Televisa Cultural Foundation. Their quest for Aztlan has resulted in this engaging exhibition. Aztlan as a myth or an allegory concerning a place of origin pertains to the many cultures that define Los Angeles as a vibrant urban center. The exhibition thus reflects and elaborates important issues of diversity and cultural complexity found in our community.

We are thankful for the magnanimous support of the exhibition sponsors, whose assistance made the vision of the curatorial team a reality. We would like to thank AT&T, our national sponsor, which provided a generous grant. The LACMA presentation was also made possible by KMEX-TV/Univision. The exhibition was funded in part by grants from the Rockefeller Foundation and the National Endowment for the Humanities. The catalogue received support from the U.S.–Mexico Fund for Culture. The Ethnic Arts Council of Los Angeles provided key support at the inception of the project.

We would like to express our gratitude to Elizabeth Ferrer, director of the Austin Museum of Art; Sue Graze, director of the Texas Fine Arts Association; and James Moore, director of the Albuquerque Museum, for their enthusiasm for the project, which led them to bring *The Road to Aztlan* to their respective institutions in the heart of Aztlan. Finally, we are grateful to the many institutions and individuals who so generously lent their works of art and artifacts to the exhibition.

ANDREA L. RICH
President and Director
Los Angeles County Museum of Art

On the threshold of the twenty-first century, the intensive search for the original land of the ancient Mexicans continues. As we enter a millennium in which we will experience new forms of civilization, it seems appropriate to embark upon a journey to uncover the face of an ancient culture, one that came before the Aztec "Society of Eagles and Society of Jaguars" referred to in Nahuatl poetry. Even in our changing world, there continues to be great interest in and respect for origins, for that which is ours and which identifies us far beyond our borders.

The exhibition *The Road to Aztlan: Art from a Mythic Homeland* evokes, through 250 works of art, that territory of origin, that place of whiteness, that first homeland where there was an abundance of herons, which was the starting point for the narrative of the Codex Boturini (*Tira de la peregrinación*), a sixteenth-century document that illustrates the departure from Aztlan and the journey undertaken by the Aztecs in search of the promised land.

It seems fitting that it is precisely in this year, 2001, which the United Nations has designated as the occasion for a "Dialogue between Nations," that this event takes place, this fortunate dialogue between two nations joined by their cultures: the United States and Mexico. This century is witnessing the emergence of a new Mexico, a more democratic and pluralistic Mexico, a Mexico that is moving toward better times but that invariably honors its origins, its history, and its national identity. In collaboration with the Los Angeles County Museum of Art and through the Instituto Nacional de Antropología e Historia, the Consejo Nacional para la Cultura y las Artes has lent thirty significant pieces from six Mexican museums which illustrate the cosmological concepts of the original Mexicas who participated in the historic pilgrimage that ended in Tenochtitlan. This exhibition—in which historians, chroniclers, archaeologists, artists, and citizens of two nations have participated—offers a profound collective reflection on our origins.

Beyond controversy and beyond questions about the historical veracity of the myth, the pristine land of Aztlan persists in time and in the hearts of men and women, in the living memory of a common past, creating the possibility for a dialogue such as the one that links citizens of both the United States and Mexico today.

Sari Bermúdez
President
Consejo Nacional para la Cultura y las Artes
CONACULTA · INAH ✿

15

AT&T SPONSOR'S STATEMENT

Rupert García
MAGUEY DE LA VIDA, 1973
(Cat. no. 210)

For AT&T, communications isn't just our business; it's also our pleasure. Since the 1940s, AT&T has supported artistic expression and has helped bring a diverse array of contemporary artists to a wider public.

We are particularly pleased to be a sponsor of *The Road to Aztlan: Art from a Mythic Homeland,* originating at the Los Angeles County Museum of Art. The diverse visions of the artists represented in this exhibition will deepen our understanding and expand our thoughts.

In supporting *The Road to Aztlan,* AT&T is privileged to celebrate the visionaries of ancient, historic, and contemporary art who have spoken to us across the boundaries of time and culture. We congratulate the Los Angeles County Museum of Art on this historic undertaking.

C. MICHAEL ARMSTRONG
Chief Executive Officer

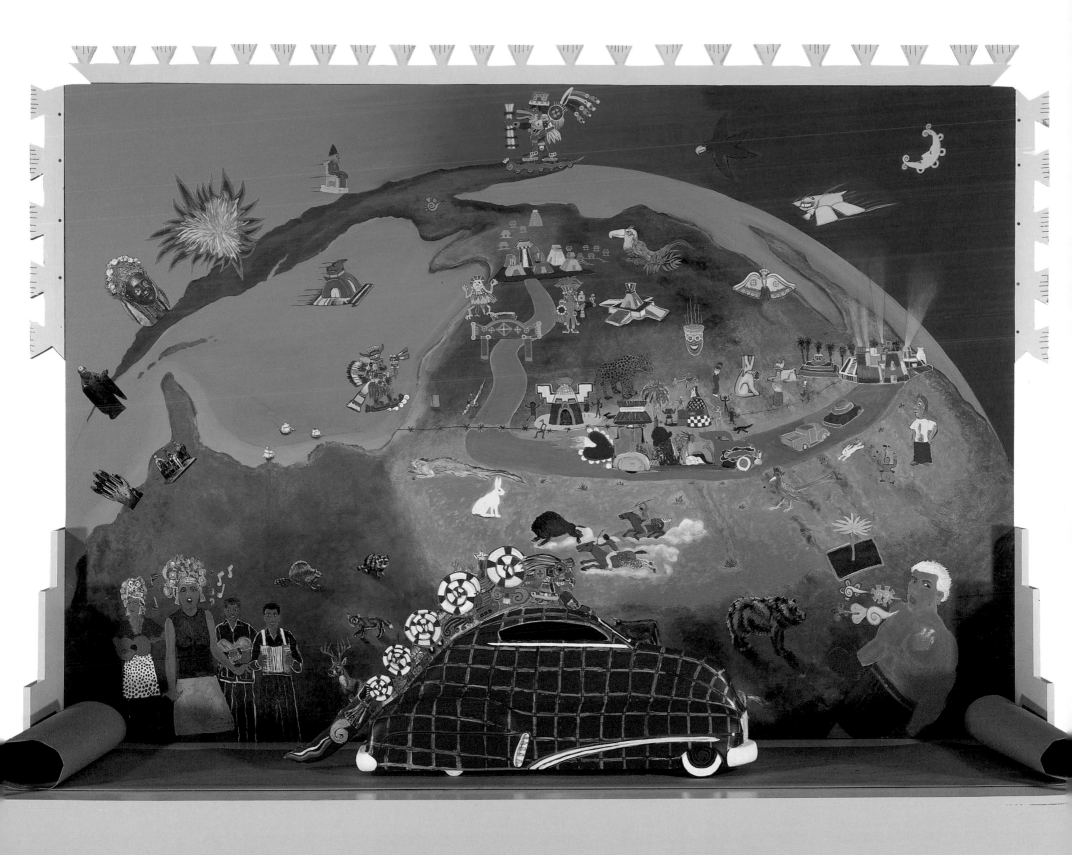

Gilbert (Magu) Sánchez Luján
Trailing los Antepasados,
2000
(Cat. no. 250)

KMEX-TV, Channel 34 and Univision are proud to partner with the Los Angeles County Museum of Art (LACMA) and be a part of *The Road to Aztlan: Art from a Mythic Homeland* during its inaugural presentation in Los Angeles from May 13 through August 26, 2001. We are pleased to share this landmark exhibition with the community we serve, especially since this is the first time that an exhibition of this caliber and magnitude about Aztlan has been presented to the public outside of Mexico.

We celebrate this important historical journey through time that honors the history, tradition, and cultures of Mexico and the American Southwest. *The Road to Aztlan* reveals the profound nature of the interactions and exchanges that occurred between these two regions, emphasizing deeply rooted shared aspects of cultural practices and cosmology over time and distance. The emotion, pride, and spirit of the mystique surrounding the legendary land of Aztlan continues to thrive in Los Angeles today. Regardless of the viewer's language and culture, the impressive exhibition and catalogue will provide a detailed background against which we can all truly appreciate the influence of ancient traditions on modern society and culture.

At KMEX-TV/Univision, it is our sincere hope that our support of this significant exhibition organized by LACMA will encourage all families to learn more about Aztlan, its people, and their accomplishments, as well as provide the yearning to discover more about our continent's beginnings and rich history.

Enjoy the exhibition.

univision
Los Angeles

AZTLAN

FROM MYTH TO REALITY

MIGUEL LEÓN-PORTILLA

Translated from the Spanish by Rose Vekony

Many ancient accounts in Nahuatl speak of Aztlan, the "place of the herons," and Chicomoztoc, the "place of the seven caves," as the homeland and place of origin of the Mexicas, or Aztecs, which these legendary records situate in the north. Let us hear their ancient words:

Nican ompehua in ohtli [Here begins the road].[1]

So states the *Historia tolteca-chichimeca*, which, in discussing Chicomoztoc, also names Aztatlan, or Aztlan, as the point of departure. The same is said in the *Anales de Tlatelolco* and other texts:

Inic hualquixohuac Teocolhuacan Aztlan ca tel mochi nican mottaz [Thus they went from ancient Colhuacan, from Aztlan, all this will be seen here].[2]

Furthermore, the Nahua believed that Aztlan-Chicomoztoc had not disappeared. In the mid-fifteenth century Moctezuma Ilhuicamina's adviser Tlacaelel urged him to send an expedition to that place. According to the chronicler Diego Durán, who drew on ancient testimonies, Moctezuma's ambassadors arrived in Aztlan. There they met with a goddess, the mother of the powerful Huitzilopochtli. Upon their return they told Moctezuma Ilhuicamina: "We have carried out your order, and your word has been fulfilled, for we have found out what you wished to know, and we have seen that land of Aztlan and

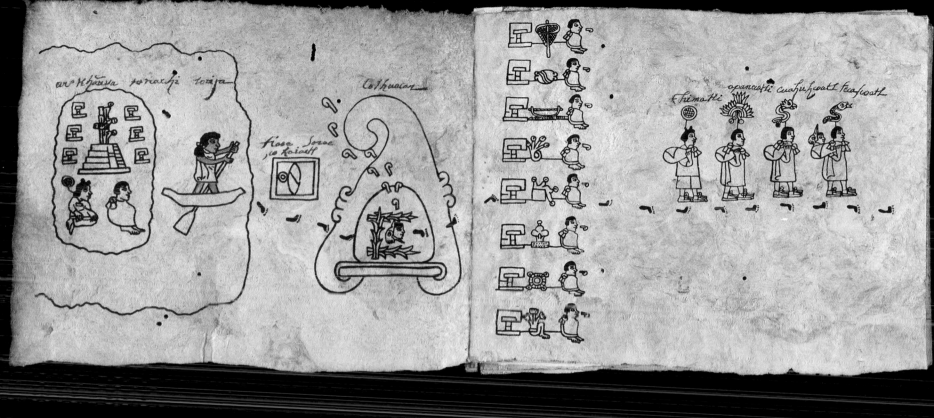

FIGURE 1

Facsimile (1991) of the
CODEX BOTTURINI
(*Tira de la peregrinación*)

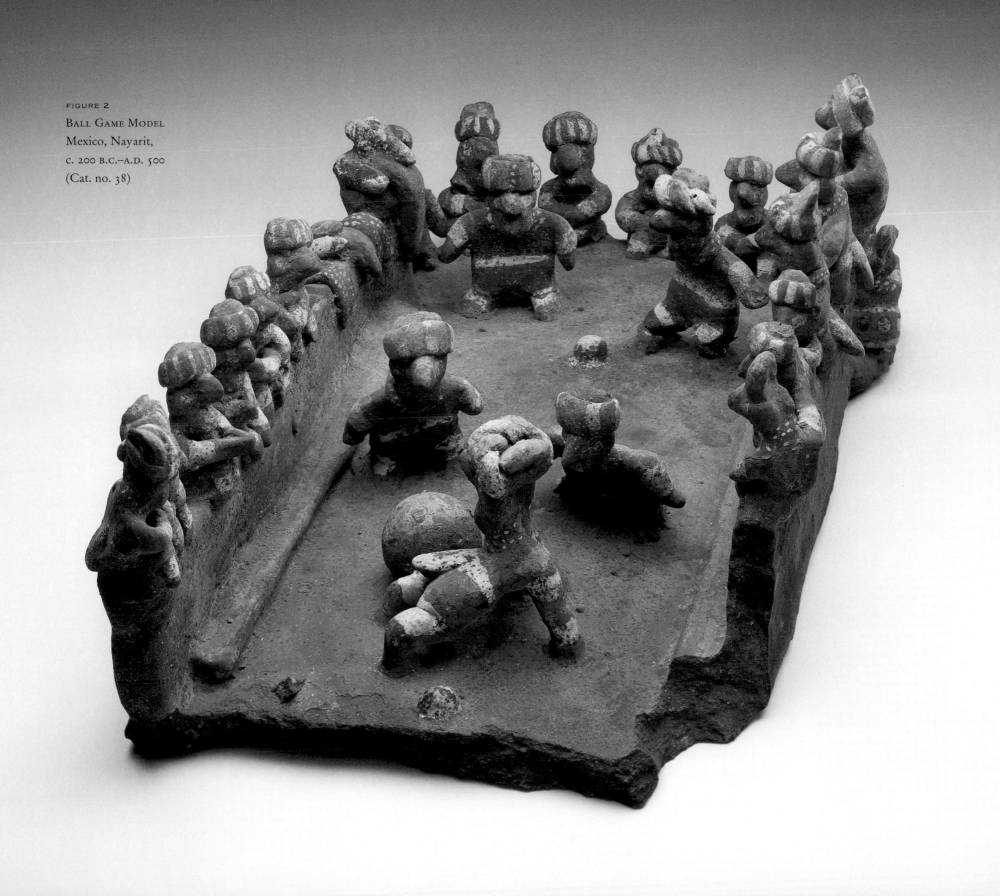

of Colhuacan, where our fathers and grandfathers lived, and we have brought back from those lands things that grow there."[3]

This was a journey to Aztlan, realized in myth by the descendants of those who long before had left that place. It was not a land inhabited by primitive peoples. Moctezuma's envoys proved as much, presenting him with "row upon row of fresh corn cobs and seeds and roses, and all the different things that grow in that land, and tomatoes, chilies, and blankets of fiber that those people produced and loincloths."[4]

In these passages we have heard the discourse of myth: departure and return, the constant evocation of Aztlan—the land of herons, of the seven caves—and also Colhuacan, the curved hill. Now let us hear that other discourse, that of the archaeologists and ethnologists, beginning with the pioneering works in northwestern Mexico by Carl Lumholtz between 1894 and 1897, followed by those of Manuel Gamio in 1908–9, and augmented in the U.S. Southwest by numerous researchers, among them Emil W. Haury, Carl Sauer, J. Charles Kelley, and Charles C. DiPeso.

All these researchers concur that there is much to investigate on the subject of that north, or rather northwest, which the discourse of myth designates as the point of departure for the Mexicas and other Nahuatl-speaking peoples. But they all concur on another important point as well. They assert that, from the time of Teotihuacan (from the third to the eighth century A.D.) and even before, beyond the vast cultural region of Mesoamerica, situated in the center and south of Mexico, many inhabitants of those northern lands participated in the cultural achievements of the Mesoamericans.

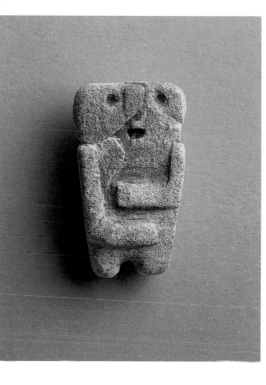

23

FIGURE 4
JAR WITH TEXTILE DESIGN
New Mexico, Anasazi
(Tularosa Black-on-White),
c. 1100–1250
(Cat. no. 122)

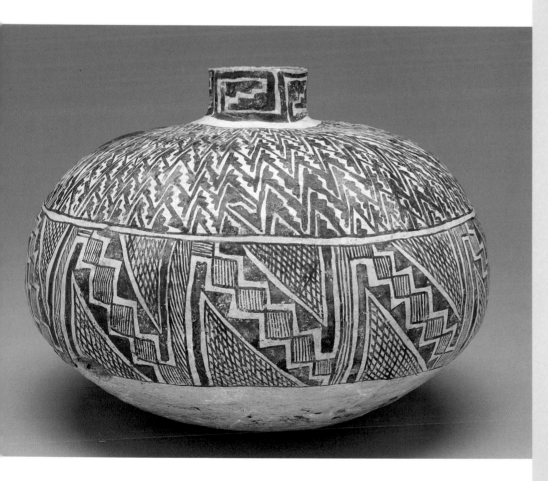

This claim is based on archaeological and ethnological evidence. Some centuries before the Christian era, the cultivation of maize had penetrated beyond Mesoamerica, into the north of Mexico and what is presently New Mexico, Arizona, and California. In these areas researchers have also found ceramics and small sculptures carved in stone dating from before the first millennium A.D. The cultivation of cotton was another development assimilated from Mesoamerica at an early date. The Hohokam and Anasazi people in Arizona and the Zuni, Hopi, and other Pueblo Indians had early town planning and ball courts going back to about A.D. 800. A notable archaeological find in the Hohokam area was a sculpture akin to the reclining chacmool figures found atop temples in Mesoamerica. The people who lived in that region spun and made textiles, as well as feather attire. The great wealth of polychrome ceramic pieces found in sites such as Casas Grandes in Chihuahua and many other places in the north attests to the level of refinement attained by the inhabitants of the mythical Aztlan. Many small copper bells from the second millennium A.D. have likewise appeared in places that are now part of the southwestern United States and northwestern Mexico. All of these findings prove the existence of trade between these areas and Mesoamerica.

For their part, ethnologists have found a clear relation between northern and Mesoamerican deities, such as the katsinas and the effigy of Tlaloc, the horned and feathered serpent and Quetzalcoatl. The idea of cosmic quadrants associated with different colors is also common to both regions, as are numerous rituals, including dances and other ceremonies. Linguistic findings are compelling as well. Glottochronology shows

that the Uto-Aztecan family began to splinter off and disperse in the third millennium A.D. in an area not far from the present-day border between Arizona and Sonora. Many of the groups that spoke Uto-Aztecan languages stayed in the American Southwest, while others penetrated into northwestern and even central Mexico. The former included the Luiseño, Cupeño, Mono, and others in California; the Hopi and Papago in Arizona; and other groups in New Mexico as well as northwestern Mexico, among them the Opata, Yaqui, Tarahumara, Tepehuan, Cora, and Huichol. The Nahua settled in various places—from the south of Durango, Zacatecas, and Sinaloa to the center of Mesoamerica and other regions of the south. And we should not forget that there were speakers of non–Uto-Aztecan languages, such as those of the Athabascan family (Navajo and Apache) and the Hokan family (Cocopa, Seri, and the various branches of the Pai).

Linguistics thus offers another proof of the interrelation among Uto-Aztecan speakers, from the mythical Aztlan to central Mexico. The trade routes of the *pochteca*, or merchants, contributed to the cultural expansion into northern lands. The road to Aztlan had already been traveled and would continue to be for centuries, even up to the present day, in both directions.

TWO VALUABLE ACCOUNTS

As we have seen, the researchers' discourse has shed light on the discourse of myth. That being so, it is odd that, even among some of those researchers, the goal of identifying the precise geographic

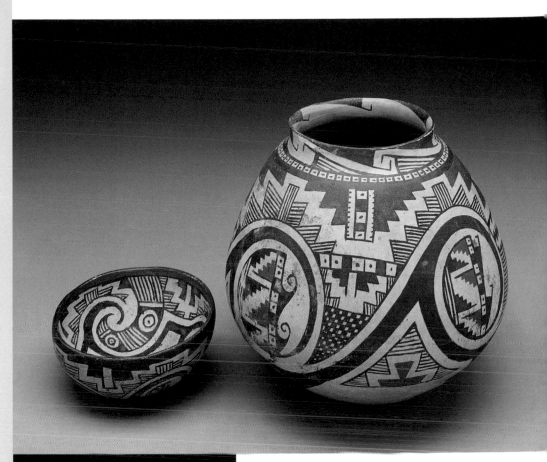

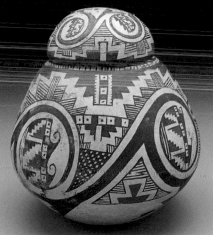

FIGURE 5
LIDDED JAR
Mexico, Chihuahua,
Casas Grandes,
c. 1280–1450
(Cat. no. 124)

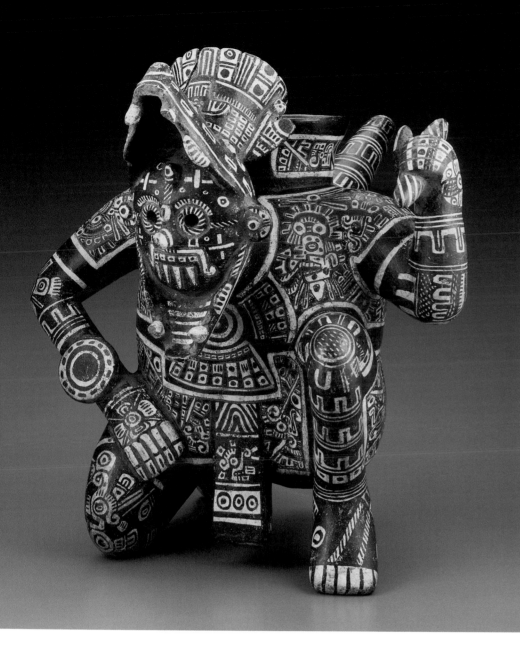

location of Aztlan-Chicomoztoc persists. Some tend to situate it on the lake of Mexcaltitlan, in Nayarit; others believe that it was in Guanajuato or in La Quemada and Chalchihuites in Zacatecas.

But others have more wisely chosen to situate the discourse of myth in that region which some call the great American Southwest and others the great Mexican Northwest. Two chroniclers of Nahua descent, one from the end of the sixteenth century and the other from the beginning of the seventeenth, spoke of this. Fernando Alvarado Tezozomoc (c. 1530–1610), the grandson of Cuitlahuac (who was Moctezuma's successor) and the author of the *Cronica mexicayotl*, wrote in Nahuatl about the arrival of the Mexicas at the place that would become Mexico-Tenochtitlan: "The Mexicas there were in a great *altepetl* ('water' + 'mountain'), or town. There Aztlan, Chicomoztoc, the Land of Herons, that of the Seven Caves, was to be found, perhaps very close by, right near the great shores, the great

FIGURE 6
RAIN GOD VESSEL
Mexico, Colima, El Chanal,
12th–15th century
(Cat. no. 11)

FIGURE 7
COPPER BELLS
Mexico, Chihuahua, Casas
Grandes, 13th–14th century
Copper
Left: 1 3/16 x 3/4 in. (3 x 2 cm);
right: 1 5/16 x 1 1/16 in.
(3.3 x 2.7 cm)
CNCA-INAH Museo Nacional de
Antropología, Mexico City,
(a, 12-1-975; b, 12-1-977)

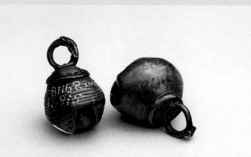

riverbanks that the Spanish now call Yancuic Mexihco, New Mexico. . . . In the year 12 Reed (1057) the old Mexica-Chichimecas thus went from Aztlan Chicomoztoc. . . . Thus they are coming, making their way here on foot."[5]

That great land, which many Spaniards had already reached, according to the reports of Fray Marcos de Niza, was named New Mexico by Juan de Oñate precisely because he thought it rivaled Mexico in wealth. The other chronicler, a descendant of the poet-king Nezahual-coyotl, Fernando de Alva Ixtlilxochitl (c. 1578–1650), offered the following testimony in his *História de la nación chichimeca* regarding the origin of the Tezcocanos: "It was already 1011 in the year of Our Lord when the Aculhuas arrived. . . . And, according to their histories, it seems they came from the other side of that mediterranean [i.e., interior] sea that they called Bermejo, along which the Californias are located."[6]

Without knowing it, in linking their ancestors with New Mexico and California, Alvarado Tezozomoc and Alva Ixtlilxochitl wrote out a birth certificate that would have lasting authority—this in spite of subsequent developments, such as the international border that would separate New Mexico and California from Mexico in 1848. Nor did these writers suspect that the intercultural relation between these northern lands and central Mexico was really much older, going back to the spread of agriculture from Mesoamerica to the north in the first millennium B.C.

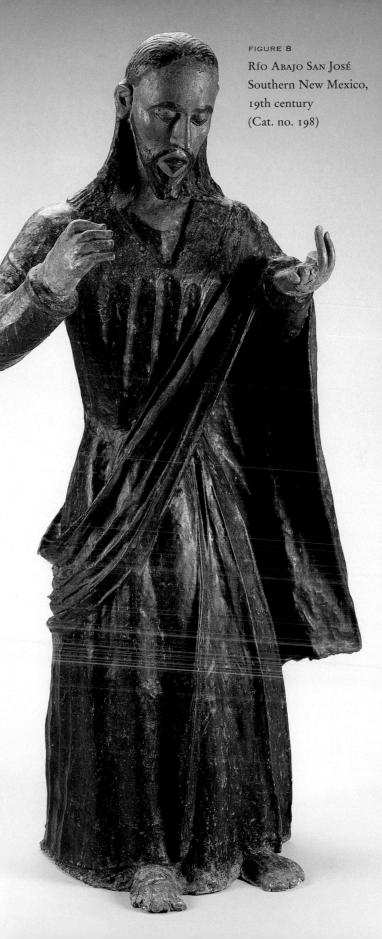

FIGURE 8
Río Abajo San José
Southern New Mexico,
19th century
(Cat. no. 198)

FIGURE 9
SERAPE
Mexico, Saltillo, 19th century
(Cat. no. 199)

Nahuas and Spaniards Penetrate into Aztlan

The story of this return to Aztlan contains some fascinating episodes. We begin with the travels of Álvar Núñez Cabeza de Vaca, in the company of Esteban, a black man, in 1528–30, after the other Spaniards under the command of Pánfilo de Narváez had perished in Florida. The news that Cabeza de Vaca brought to the capital of New Spain spurred the Spanish viceroy, Antonio de Mendoza, to send an expedition headed by Fray Marcos de Niza, accompanied by Esteban, another friar, and a group of Indians. The expedition departed from Culiacán, in Sinaloa, and after crossing Sonora, it entered the territories of Arizona and New Mexico. There the travelers heard of the cities called Cíbola and Quivira, and others as well. Later, in his account, Fray Marcos would write that "Cíbola is greater than Mexico City."

The road to Aztlan, newly reopened, prefigured the attraction that this northwest was to exert for all time. Other expeditions would follow Fray Marcos's, and each revealed the immensity of the north. Among these were the explorations of the area now called Baja California dispatched by Hernán Cortés in 1531; his stay there in 1535; and Francisco de Ulloa's subsequent navigation to the mouth of the Colorado River. Other journeys, this time at the order of Viceroy Mendoza, included that of Hernando de Alarcón, by sea, to the confluence of the Colorado and Gila Rivers, and that of Francisco Vásquez de Coronado, by land, to points beyond those explored by Fray Marcos de Niza. In their amazement, the Nahua and others who participated in these expeditions gave new life to the road to Aztlan.

Next came settlements, some temporary and others permanent, although at times interrupted by Indian rebellions. California was explored by Juan Rodríguez Cabrillo in 1542. The conquest of New Mexico, which at that time comprised Arizona and other regions, was carried out by Juan de Oñate. And although many years later, in 1680, the great uprising of the Pueblo Indians would take place there, the return of the Nahua as allies of the Spanish signaled the revival of the road to Aztlan. The fate of that great region would be reunited with that of Mesoamerica, in which a Spanish influence was now beginning to spread.

The Hispanic-Mesoamerican penetration into the north has left indelible marks. Among these, as symbol and reality, are the numerous Spanish place-names and some Nahuatl ones as well. Many of them are related to the missions, whose edifices stand proudly to this day—with their beautiful architecture, altarpieces, and paintings—as an important part of the cultural heritage of the Southwest. California has numerous missions, from San Diego to San Francisco Solano, as well as the secular Pueblo de Los Angeles. Likewise, Missions Tumacacori and San Xavier del Bac still stand in Arizona, as do the string of missions along the Rio Grande in New Mexico. Farther away, two large states boast Spanish names: Nevada and Colorado. Named, respectively, after a mountain range and a river, they, like many other geographic formations, keep that other time-honored presence alive. As for Nahuatl, one example comes to mind: Analco, meaning "on the other side of the water or of the river," is the name given to an old quarter of Santa Fe, New Mexico. The descendants of the thousands of settlers from Mexico

are, of course, another enduring reminder of the Hispanic-Mesoamerican presence of the colonial period.

TWO CENTURIES OF CROSSINGS

When Mexico attained independence in 1821, the territories that had been part of New Spain, including its great northwest, fell under Mexican jurisdiction. In 1819 the Transcontinental Treaty (or Adams-Onís Treaty) between Spain and the United States had established an international border. Thus the area that today makes up California, Arizona, New Mexico, Utah, Texas, Nevada, and part of Colorado and Wyoming belonged to Mexico.

Very early on, the United States made clear its intention of annexing what is today the Southwest, first sending settlers to Texas and later making offers to buy land. We need not recount here how this goal was realized; suffice it to say that it was through a war of conquest in 1847 and 1848. At that time one might well have imagined that that enormous expanse of land—more than five hundred thousand square miles—would little by little lose its cultural identity, that of ancient Aztlan, filtered through the Hispanic and Mesoamerican past.

But what one might have imagined did not come to pass. The Americans who rushed in and turned places like Los Angeles and San Francisco into two great metropolises did not change the place-names, although of course they imposed the English language. They had violent confrontations with ancient Indian groups, especially the Navajo and the Apache. The people of Hispano-Mexican origin were often

FIGURE 10
Carlos Almaraz
TWO OF A KIND, 1986
(Cat. no. 246)

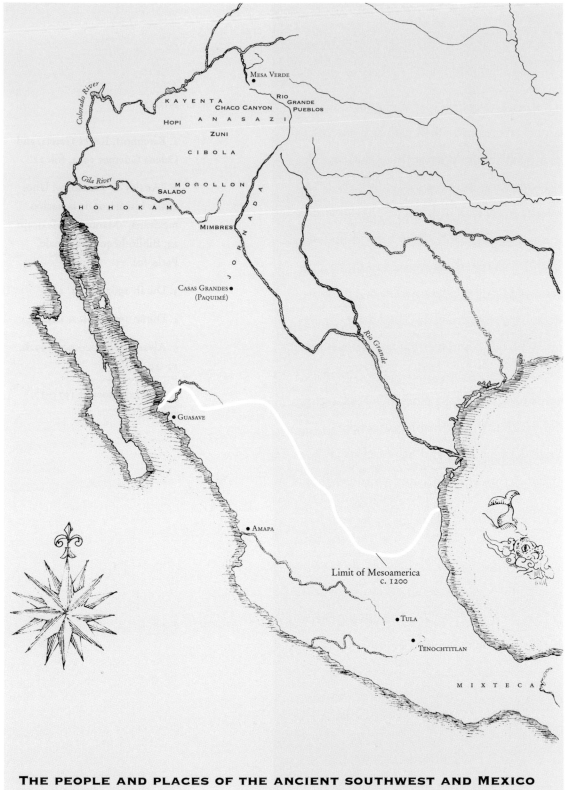

**THE PEOPLE AND PLACES OF THE ANCIENT SOUTHWEST AND MEXICO
(A.D. 1000–1521)**

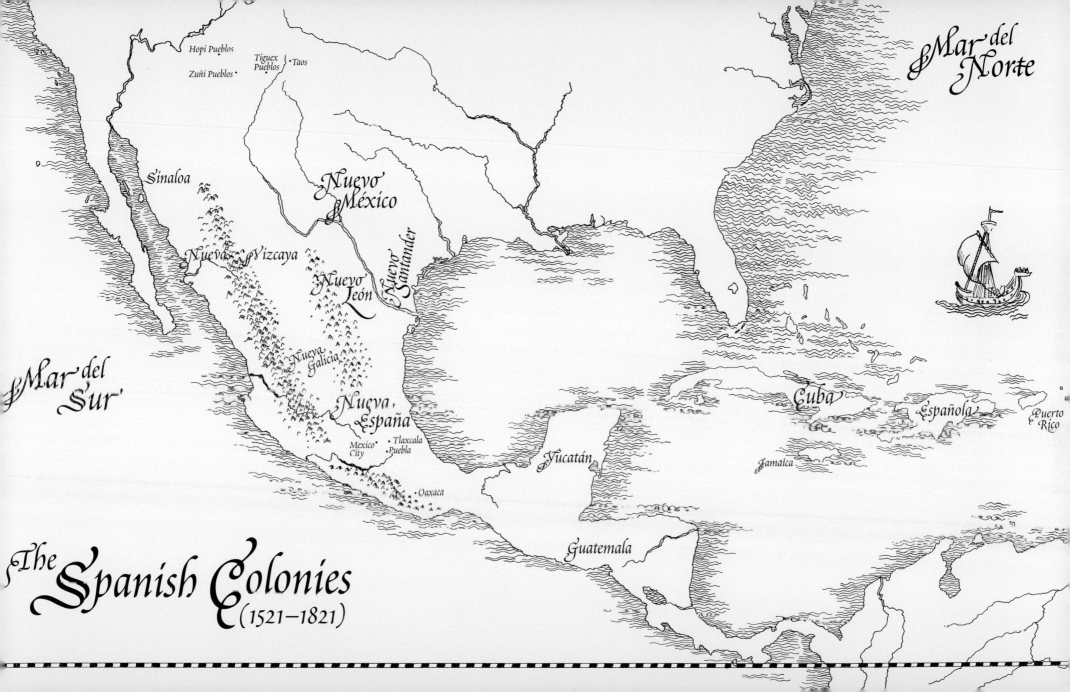

Hopi Pueblos

Zuñi Pueblos

Tiguex Pueblos · Taos

Mar del Norte

Sinaloa

Nuevo México

Nueva Vizcaya

Nuevo León

Nuevo Santander

Nueva Galicia

Mar del Sur

Nueva España

Mexico City · Tlaxcala · Puebla

Oaxaca

Yucatán

Guatemala

Cuba

Jamaica

Española

Puerto Rico

The Spanish Colonies (1521–1821)

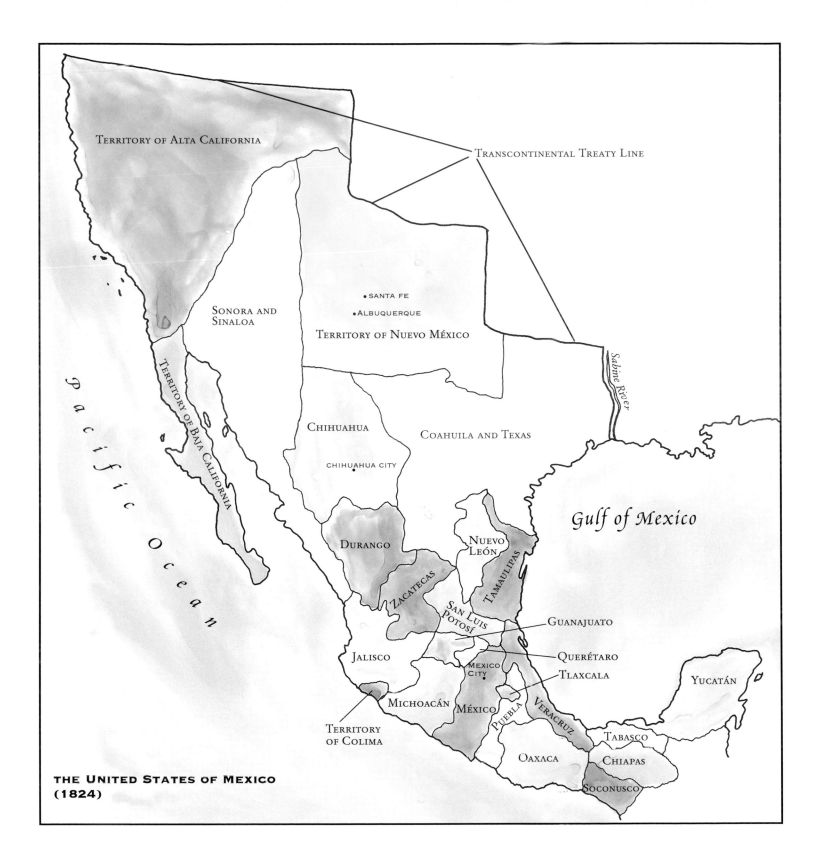

THE **UNITED STATES** OF **MEXICO**
(1824)

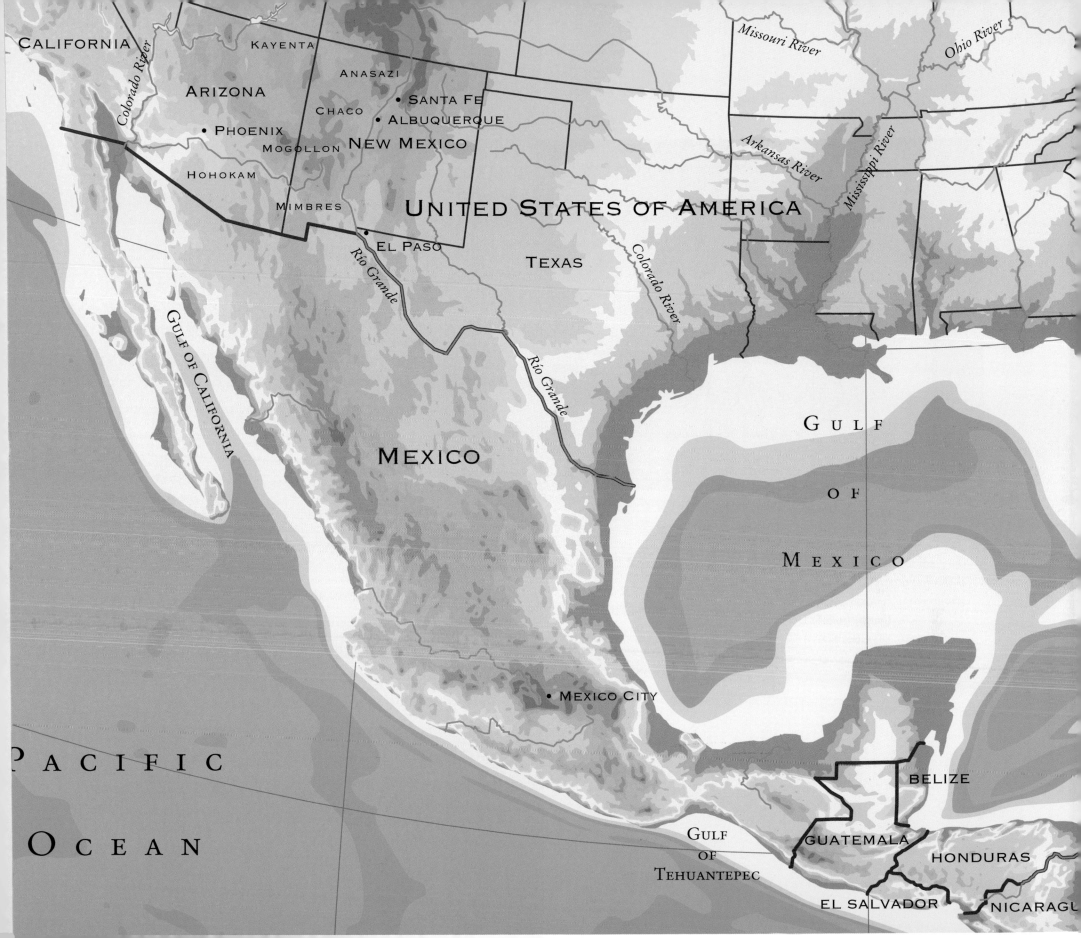

delineates how the concept of Aztlan has evolved over the past five hundred years, changing to reflect the different cultural contexts of its use.

Taking the quest for Aztlan into the realm of scholarly inquiry, *The Road to Aztlan: Art from a Mythic Homeland* explores the art derived from and created about the legendary area that encompasses the American Southwest and portions of Mexico. The exhibition covers a span of more than two thousand years, beginning with a time long before this region was divided by an international border and continuing up to the present day. Designed to present a historical overview of the relationships between the American Southwest and Mexico, it is divided into three chronological periods: the pre-Columbian era (third century B.C.–1521), the colonial period (1521–1848), and contemporary times (1848–2000).

Central to the conception of the exhibition is the notion of Aztlan as a metaphoric center place, reflecting a sacred geography and a social imaginary that incorporates economics, religion, history, and art. Aztlan, as a geographic location and as an allegorical construct, represents a place of origin, a point of emergence from the past, and a focus of longing.[4] In regard to the centrality of place, Mary Helms has noted that cosmological centers define social identity through references to distance and precious objects.[5] The center is viewed as the navel of the world, the location of the *axis mundi*, which is a means of passage from one cosmic region to another.

In the origin legends of peoples throughout the Southwest and Mexico, populations emerged from an earlier world and moved over the landscape on a mythic scale. The landscape was defined by boundaries in the four (or six) directions, but the concept of the center place also travels with individuals and communities in songs, myths, and art (see fig. 12). Myths and songs relate a sacred history concerning a primordial event that took place at the beginning of time, and this cosmology is often recapitulated in sacred art and architecture. In the view of many Pueblo groups, their communities are located at a metaphorical center space (or earth center), which was sought and ultimately located by their ancestors after many difficult migrations.[6] Writing in this volume, Rina Swentzell describes the continued significance of the center in Pueblo cosmology, evoking the spiritual and physical landscape of her community.

The theme of Aztlan also provides an ideal opportunity to investigate the relationship between myth and history as expressed in the art and material culture of the various peoples of the Southwest and Mexico over time, as well as the continuity and evolution of cultural practices throughout the pre-Columbian, colonial, and contemporary eras. The exhibition considers aspects of tradition and innovation within cultures as people sought to maintain, negotiate, and redefine cultural identity in the face of social disruption and change.

In the current literature on Aztlan, Chicano/a scholars and artists have highlighted how the concept of Aztlan expanded to encompass multiple centers with Mexican and Chicano/a migration and diaspora in North America. Aztlan has become deterritorialized, reconfiguring

FIGURE 12
BOWL WITH FOUR-PART DESIGN
New Mexico, Mimbres, Swarts
Ruin, c. A.D. 1000–1150
(Cat. no. 90)

42

FIGURE 13
RATTLESNAKE TAIL WITH
MAIZE EARS
Mexico, Aztec, c. 1325–1521
(Cat. no. 1)

the experience of Chicanos/as by providing them with a profound sense of place while still embodying the longing for origins. As Chon Noriega has noted, Aztlan now refers not to a precise geographic area, but to all those places where there is a strong Mexican and Chicano/a cultural presence.[7]

CONNECTIONS BETWEEN THE AMERICAN SOUTHWEST AND MEXICO IN PRE-COLUMBIAN TIMES

Archaeological investigations suggest that interactions between the Southwest and Mexico may date to as early as 1500–1000 B.C., when knowledge of maize agriculture spread north from Mexico.[8] Maize (*Zea mays*) has been the most important food crop of Mexico since the onset of the Formative period (c. 1800 B.C.), and representations of maize extend from that time through the iconography of the Post-classic period (A.D. 900–1521; see fig. 13). According to both ancient and contemporary Maya mythology, the present race of humans was created from maize and penitential blood. The Maya, like the Hopi, believe that humans share common characteristics and critical stages in their life cycles.[9] The impact of maize agriculture on Southwestern and Meso-american societies is represented not only in their transformed economies but also in the accompanying ritual activity relating to planting and harvesting.

Aztlan as a place of exchange is marked by other shared concepts, such as color-directional symbolism, twin culture heroes (see figs. 14, 15), a feathered or horned serpent (see fig. 16), and various versions of

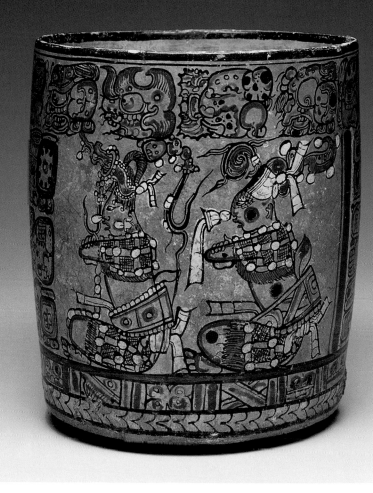

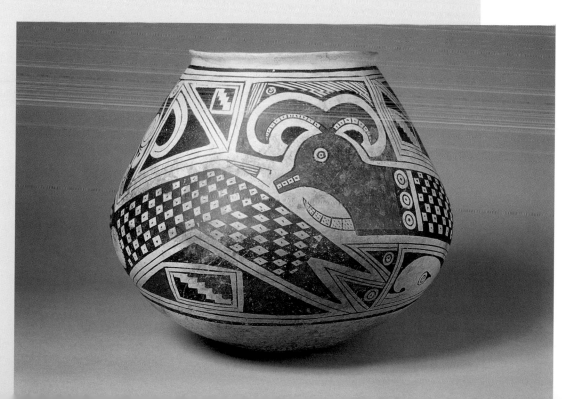

FIGURE 14 (TOP LEFT)
BOWL WITH TWIN FIGURES
AND A FISH
New Mexico, Mimbres,
c. A.D. 1000–1150
(Cat. no. 40)

FIGURE 15 (TOP RIGHT)
DRINKING VESSEL DEPICTING
HERO TWINS
Mexico, Maya, Central
Campeche,
c. A.D. 593–830
(Cat. no. 39)

FIGURE 16 (LEFT)
JAR WITH HORNED SERPENT
Mexico, Chihuahua, Casas
Grandes, c. 1280–1450
Ceramic with pigment
Height: 7 in. (17.8 cm);
diam: 6 in. (15.2 cm)
National Museum of the
American Indian (11/9739)

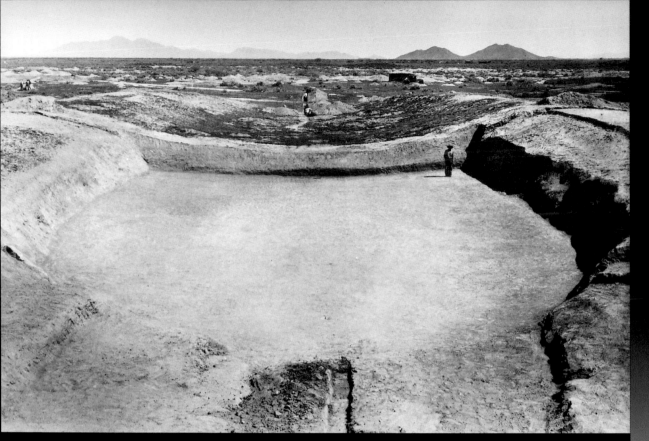

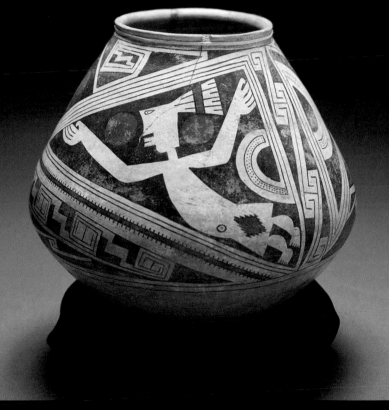

FIGURE 17

The excavated west half of
Ballcourt 1, Snaketown
Arizona State Museum,
University of Arizona

FIGURE 18

JAR WITH BALLPLAYERS
Mexico, Chihuahua, Casas
Grandes, c. 1280–1450
Ceramic with pigment
Height: 8 in. (20.3 cm);
diam: 7½ in. (19 cm)
Department of Anthropology,
Smithsonian Institution
(A323868-0)

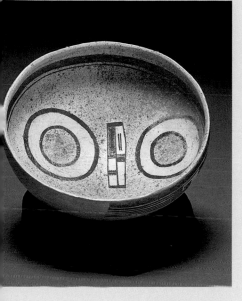

a ball game played on specially constructed courts (figs. 17, 18). An intriguing reference to the central Mexican goggle-eyed storm god, associated with fertility and rain ceremonies, appears on a Sikyatki bowl (fig. 19). In his essay in this volume, James Farmer points to the antiquity of the representations of goggle-eyed figures and celestial serpents in the rock art of the American Southwest, suggesting the possibility that these iconographic traditions may have moved from north to south. The plumed serpent/rain deity is depicted on a number of vessels, including a central Mexican example from Teotihuacan (fig. 129), a northern Mexican example from Casas Grandes (fig. 16), and an example from Michoacán (fig. 20). Polly Schaafsma, writing in this volume, discusses the various permutations of feathered and horned serpent images in Mesoamerica and the Southwest and the cultural metaphors that they embody.

The circulation of goods and ideas initiated a new kind of connectivity, which may be viewed as a symbolic discourse occurring among networks of cosmological centers.[10] Distant centers, perceived as places of origin, may have been regarded as sources of esoteric knowledge.[11] As Ben Nelson has suggested, esoteric knowledge is given expression through material objects and the networks formed to create and transmit such objects. These technically and aesthetically sophisticated objects

FIGURE 19
BOWL WITH GOGGLE-EYED DESIGN
Arizona, Hopi, 14th century
Ceramic with pigment
Height: 4½ in. (11.4 cm);
diam: 8½ in. (21.6 cm)
Department of Anthropology, Smithsonian Institution
(A155503-0)

FIGURE 20
JAR WITH SERPENTS
Mexico, Michoacán, Jiquilpan, c. A.D. 400–600
(Cat. no. 13)

45

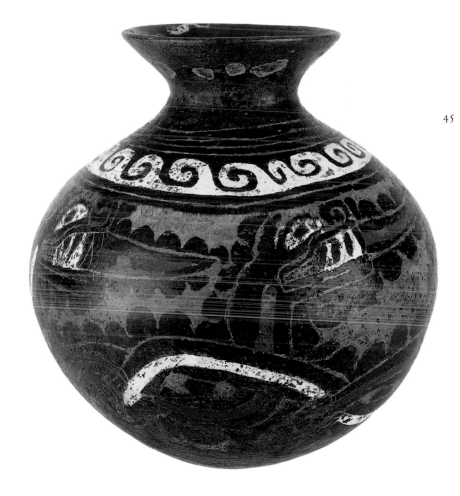

FIGURE 21

Bird-Shaped Pendant
Arizona, Hohokam, 10th–13th
century(?) A.D.
(Cat. no. 67)

FIGURE 22

Anthropomorphic
Knife Handle
Mexico, Aztec,
15th–16th century
(Cat. no. 24)

FIGURE 23 (OPPOSITE PAGE)
Pueblo Bonito, Chaco Canyon,
New Mexico

46

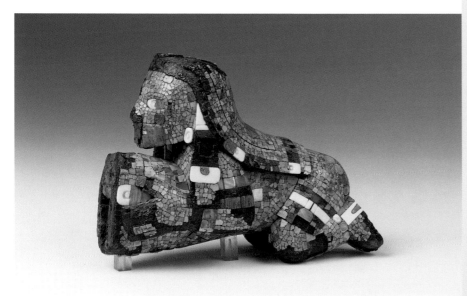

are imbued with meaning through references to the distant, the ancient, and the enduring. In Nelson's model, social linkages between cosmological centers established lines of artistic communication, combining in patterns that represent archaeological horizons and traditions.[12] The exhibition highlights the regional centers where the evidence of cultural exchange is most visible, placing these cultures within their chronological and geographic contexts and examining how they defined themselves as sacred centers. This section of the exhibition focuses on the Hohokam of southern Arizona; the Mimbres of southern New Mexico; the Ancestral Pueblo peoples of the Four Corners area (see fig. 23); the polity of Casas Grandes (Paquimé) in Chihuahua, a broad region of West Mexico (which may have constituted the route of exchange between the Southwest and Mexico); and the Postclassic world of Tula, Tenochtitlan, and Oaxaca. Stephen Lekson's essay in this volume describes the dynamics of the polities of Chaco Canyon, Aztec Ruins, and Paquimé, linking their histories to a physical and symbolic landscape.

Symbolic communication at a local level required durable and striking objects that affirmed principles of cosmological and political order by making reference to origins.[13] For example, turquoise was used as adornment in both the Southwest (see fig. 21) and Mesoamerica and may well have supplanted jade as the precious stone of choice in Postclassic Mexican societies, as illustrated by a fifteenth- to sixteenth-century knife handle (fig. 22). Objects of copper, fabricated in West Mexico and traded into the Southwest and northern Mexico, are

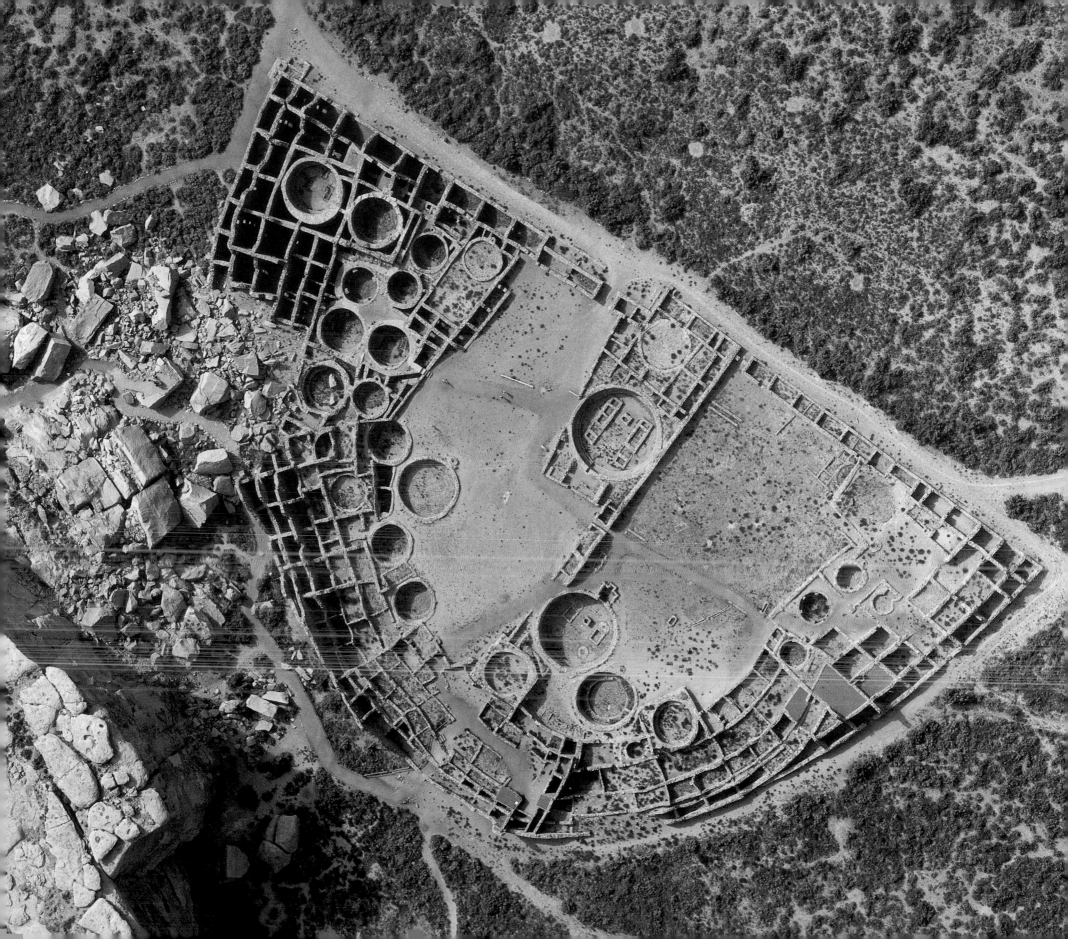

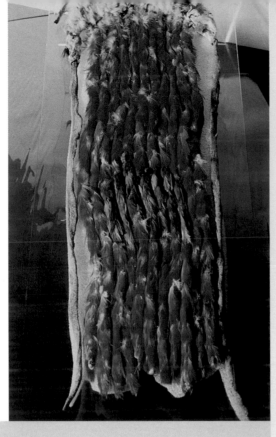

FIGURE 24
Squirrel Pelt with
Macaw Feathers
Utah, Ancestral Pueblo,
10th century
Edge of Cedars State Park

FIGURE 25
Bowl with Mythical Being
and Parrots
New Mexico, Mimbres,
McSherry Ruin,
c. A.D. 1000–1150
(Cat. no. 29)

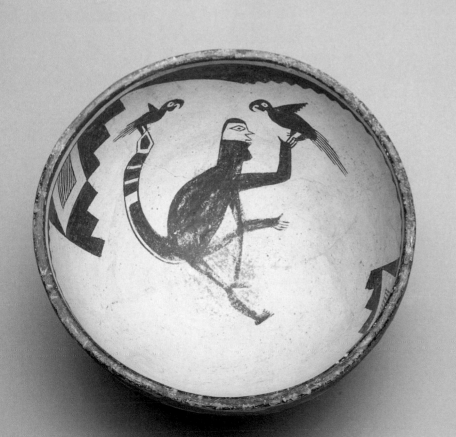

represented primarily by bells, such as a turtle crotal from Paquimé (fig. 197). In her essay in this volume, Victoria Vargas presents the results of her investigations into the exchange, symbolism, and social uses of copper bells in the Southwest and northwestern Mexico, arguing that, rather than being local products, as earlier scholars believed, the bells were conveyed into these areas from West Mexico.

Macaws from highland Mexico and their feathers were also greatly prized in Southwestern societies (see fig. 24), where depictions are found painted on kiva walls and modeled in ceramic (see fig. 25). Feathers were prized by Mexican societies as well, as the few surviving feather objects found in Mexican and European museum collections attest (see figs. 26, 27). Although the mechanism of exchange is a matter of some debate, goods and ideas clearly moved among the populations of Meso-america and the Southwest. In his essay in this volume, John M. D. Pohl describes exchange within the context of complex cultural inter-action, involving not only the movement of precious and rare goods but also the transmission of the ritual information in which the materi-als are embedded. Phil Weigand and Acelia García de Weigand's essay examines the connections between the American Southwest and Meso-america as manifested by the procurement of rare resources, especially turquoise, and long-distance trade.

Technological innovations and other traits were not transmitted simply from south to north, as Emanuel Breitburg has pointed out.[14] His analysis demonstrates the probability that turkeys, cultivated for their feathers and meat, were originally domesticated in their native habitat by Anasazi and Mogollon groups and introduced into Mesoamerica

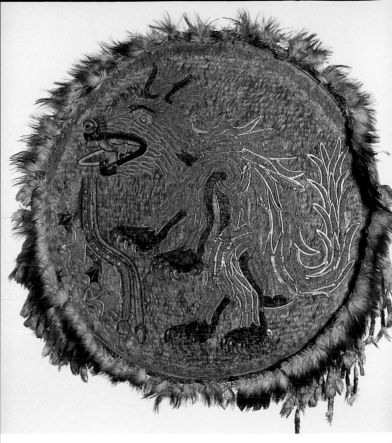

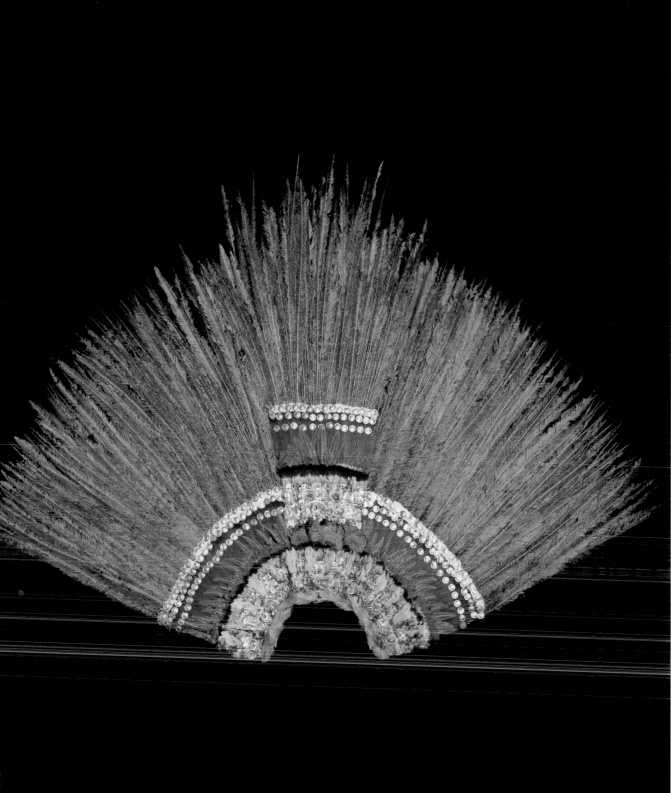

49

FIGURE 28

EFFIGY VESSEL WITH MODELED
TURKEY HEAD
Mexico, Hidalgo,
10th–13th century A.D.
(Cat. no. 42)

FIGURE 29

BOWL WITH TURKEY DESIGN
New Mexico, Mimbres,
c. A.D. 1000–1150
(Cat. no. 43)

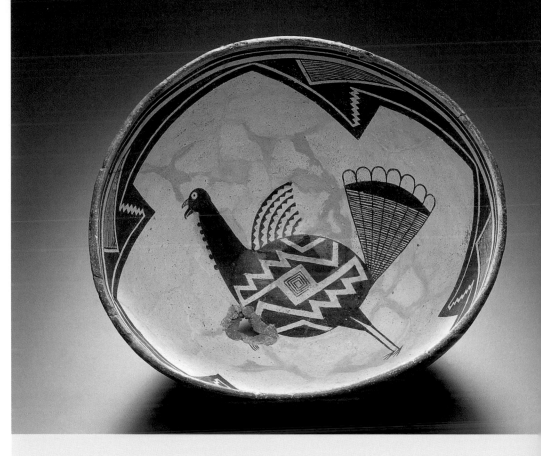

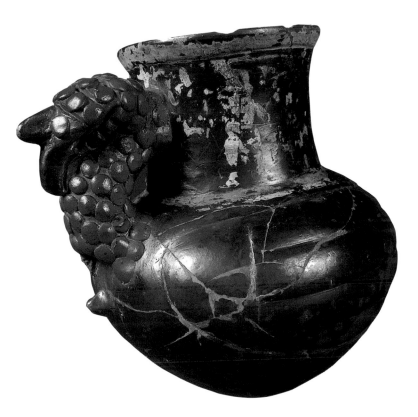

via Casas Grandes (see figs. 28, 29). Likewise, studies reveal that the bow and arrow in use in the northern Southwest did not reach central Mexico until around A.D. 900.

Cultural influence did often travel from Mexico to the Southwest, however. Evidence suggests that the katsina religion spread north from western and northern Mexico through the Mogollon region, for example, serving as a unifying mechanism for the newly created Pueblo world.[15] J. J. Brody, writing in this volume, examines the role of rock art and pottery painting as cultural expressions that represent aspects of the metaphorical world of the Pueblos, providing further unifying mechanisms.

The Arrival of the Spaniards

After two years of raids, battles, and sieges, Hernán Cortés and his
forces defeated the Aztec empire of central Mexico in August 1521.
The conquistadores proceeded to establish a colony they called Nueva
España, or New Spain, encompassing an enormous geographic area
(see fig. 209). Stimulated by the victorious Reconquista (1492), in which
the Moors were expelled from the Iberian Peninsula after a presence of
more than seven hundred years, and the forced conversion to Christianity
of Moslems and Jews who did not choose exile, the Spaniards in the
Americas were driven by an imperial hunger for territories, and the
wealth they might contain, and a corresponding desire to convert native
peoples to Catholicism. Once they had established a foothold in New
Spain, the Spaniards turned their attention to the north.

The legendary aspect of the Southwest took on new meaning in
the sixteenth century, beginning in 1539 with the expedition of Fray
Marcos de Niza, whose guide was a freed African slave named Esteban
de Dorantes. Serving as a precursor to the 1540 expedition of Francisco
Vásquez de Coronado, Fray Marcos de Niza's explorations were spurred
on by reports made a few years earlier by Álvar Núñez Cabeza de
Vaca.[16] Fray Marcos de Niza reported the discovery of a golden city
named Cíbola, one of seven cities that were in actuality Zuni pueblos.
As the legend grew, a Southwestern indigenous conception of a local
homeland was joined to the Spanish image, in turn informed by
European medieval travel literature and myths, to form the broader
regional myth of the seven cities of Cíbola. In his essay in this volume,

Carroll L. Riley relates the history of Spanish explorations in northern Mexico and the Southwest, describing the expectations and motivations that drove the Spaniards to the north.

The arrival of the Spaniards in the sixteenth century had an immediate impact on the indigenous populations of the Pueblo region along the banks of the Rio Grande, whose social and political systems, while remaining recognizably Puebloan, were modified by European contact. In contrast, the Western Pueblos not only resisted the Spanish more persistently, but the ecological niches they occupied were also less productive and thus less attractive to the conquistadores. Moreover, their pueblos were constructed on remote geologic formations and were thus more defensible. The Spanish built their towns among the Eastern Pueblos, where there were more abundant natural resources.

Subsequent Spanish religious and political imperialism, combined with the devastating effects of introduced diseases, dramatically impacted indigenous populations. Resistance on the part of native peoples to Spanish institutions, however, led to a series of rebellions throughout the region, culminating in the Pueblo Revolt in New Mexico in 1680, when the Spanish were forced to abandon their settlements along the Rio Grande. During the reconquest of New Mexico in the 1690s, only the Hopi remained independent, due to their location far from the Rio Grande settlements. A rare map of New Mexico painted on canvas depicts the wars of conquest and the heroic native resistance to the Spaniards (fig. 209).

Despite disruptions, native traditions persisted to varying degrees throughout Mexico and the Southwest. Material and spiritual culture during this period reflects a dynamic relationship of interaction and adjustment, convergence and negotiation, as well as translational strategies. The objects in the exhibition demonstrate that, despite the wholesale destruction of native monuments in the major centers and the suppression of many local traditions, especially religious practices, artistic production of many forms continued into the colonial period. Traditional themes and forms existed alongside new ones, and the native arts evolved in a creative and original way in response to the influx of European artistic precepts, techniques, and worldviews.

Native artistic expressions of the early colonial period—particularly codices, maps (see fig. 210), feather-mosaic paintings and objects (see figs. 33–36), and paintings on hide (see figs. 30, 31), all based on pre-contact forms and media—may be interpreted as cultural indices of the clash, juxtaposition, and hybridization of native and European worldviews. Intermingled visual languages, along with the coexistence of styles, represent epistemologically, and in terms of the social imaginary, the negotiation and translation of different histories and universes.[17] There are numerous objects, texts, and monuments in which

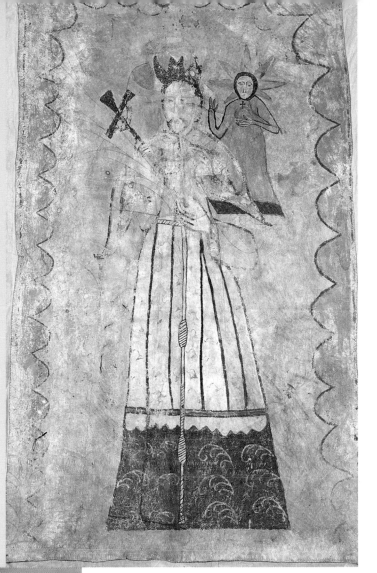

53

FIGURE 30
SHIELD
New Mexico, Tesuque Pueblo, c. 1850
(Cat. no. 203)

FIGURE 31
SAN JUAN NEPOMUCENO
New Mexico, 18th century
Painting on hide over earlier painting of Saint Anthony
72 x 45 in. (182.9 x 114.3 cm)
Museum of International Folk Art, Museum of New Mexico
(A.5.52.12)

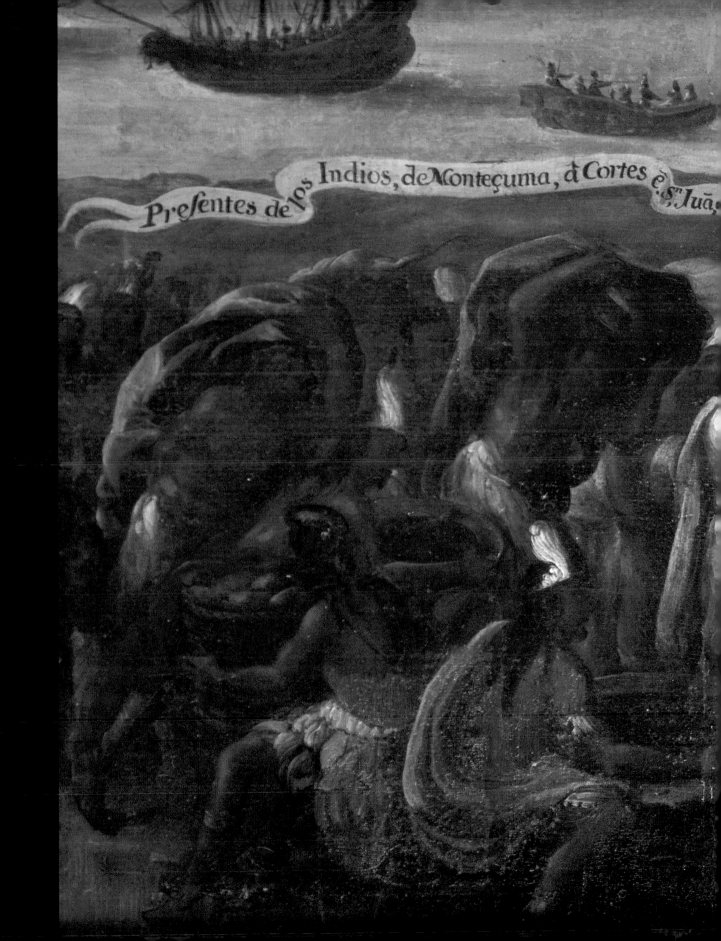

FIGURE 32

Anonymous, 18th century
PRESENTES DE LOS INDIOS DE
MOCTEZUMA A HERNÁN CORTÉS
EN SAN JUAN DE ULUA
(Cat. no. 183)

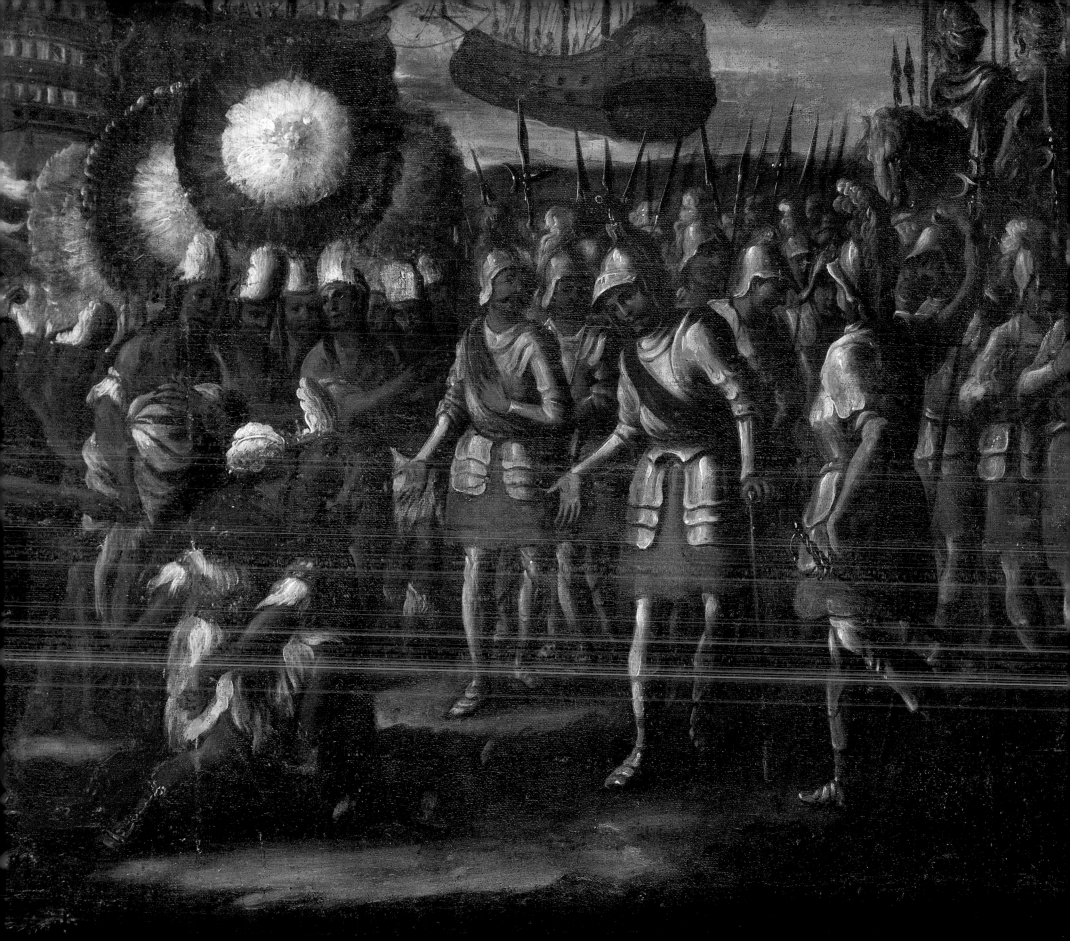

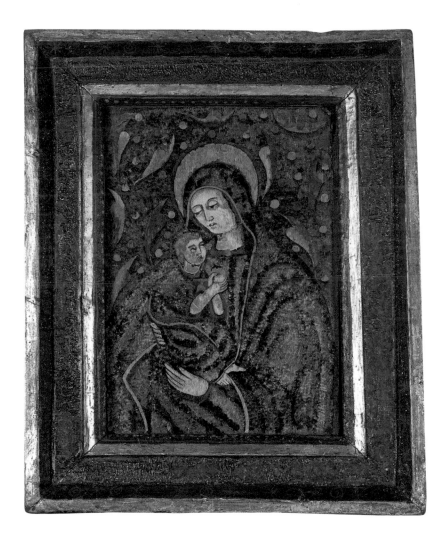

FIGURE 33

Madonna and Child

Mexico, Michoacán, c. 1550–75

(Cat. no. 184)

FIGURE 34

San José

Mexico, 16th century

(Cat. no. 185)

glyphs coexist alongside roman characters or in which the flat pre-Columbian figurative style is used to render native references and one-point perspective is used to represent the Spaniards and their world. In other cases, the native compositional style and ordering of pictorial planes and nonlinear narratives are used to depict European themes, as in the sixteenth-century *Lienzo de Tlaxcala*. Regarding religious art, the imposition of the European canon and formal devices does not necessarily signify assimilation on the part of native artists but rather calls attention to their virtuosity in using different techniques to render the strange symbols and narratives associated with Christian history and iconography.

Feathers—which were associated with the Aztec deities Huitzilopochtli and Quetzalcoatl and thus had a complex symbolic value—are an indexical example of the use of preconquest materials during the colonial period. Objects made with feathers were employed by the Mexica in religious, political, and military rituals. Only high nobles, priests, and warriors were permitted to use and wear rare feathers. In the years following the wars of conquest, schools were established for the native nobility at which indigenous featherwork techniques were taught alongside more traditional academic subjects. Native artists produced a variety of objects, including feather-mosaic paintings (*emplumados*; see figs. 33, 34), objects for the Mass (see figs. 35, 36), and ecclesiastical attire with feather appliqué. In addition to being used in Catholic ritual on important occasions, these objects were presented as gifts to high-ranking figures.

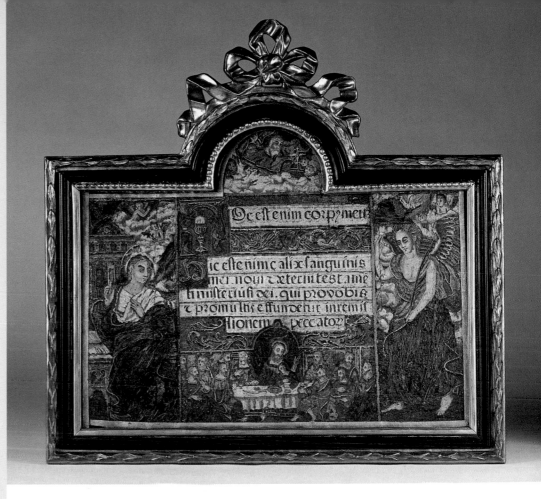

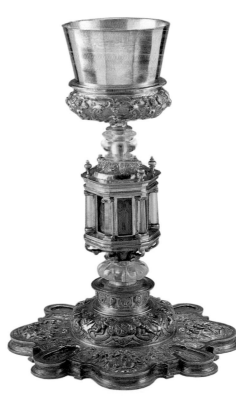

FIGURE 35
PRAYER TABLET
Mexico, Michoacán, Pátzcuaro,
c. 1550–80
(Cat. no. 187)

FIGURE 36
CHALICE
Mexico, Mexico City,
c. 1575–78
(Cat. no. 186)

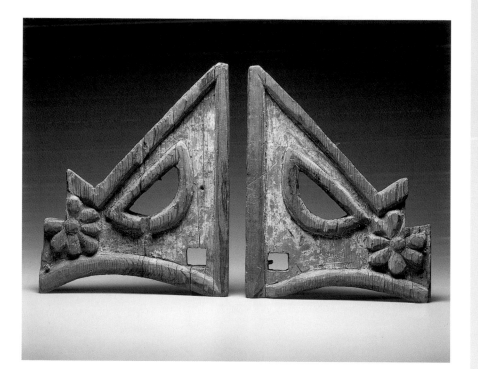

58

FIGURE 37
CARVED BRACKETS
New Mexico, Zuni Pueblo,
1775–76
(Cat. no. 181)

For the Europeans, objects made with feather mosaic and appliqué became prestige items, just as they had been for the Mexica, as well as having an exotic value. The bundles of rare feathers that the Mexica collected as a form of tribute to their rulers can be interpreted as a sign of imperial domination, and in a similar fashion, featherwork objects became linked to European dominance of the New World as examples of the quest for exotica. Many of the few extant feather-mosaic paintings, which have diverse stylistic and formal characteristics, made their way into European *Wunderkammern*, or cabinets of curiosities.[18]

In the exhibition, objects from New Spain and New Mexico are juxtaposed, highlighting differences in style and technique. Similarities in materials and forms are, however, also evident. For example, the different schools of painting on wood in New Spain and New Mexico are contrasted, while commonalities are revealed in such objects as the figure of the Holy Child of Atocha (fig. 241), a focus of devotion along the route through Zacatecas that linked the two areas. The figure of the saint was made in New Spain, while the chair on which he sits was made in the town of Taos, New Mexico. While imposed practices are reflected in such objects as the carved brackets from the Church of Our Lady of Guadalupe at Zuni Pueblo (fig. 37), other cultural traditions were preserved, as seen in the Zuni ceremonial bowl (fig. 38). Issues of cultural adjustment and exchange are illustrated by continuities that reflect the ability of native peoples to preserve and negotiate cultural identity despite dislocation and the disruption of their way of life.

The same cultural groups that were united in the pre-Hispanic period by other shared categories were now linked by colonialism and the fashioning of new cultural identities. Power and status were based on the social construction of race, as European and native peoples mixed biologically. Ramón Gutiérrez, in his essay in this volume, explores the nature and history of *mestizaje* (miscegenation) in the Americas. Colonial society in New Spain and New Mexico was stratified into an elaborate system of castes that ranked the offspring of interethnic unions. One's caste determined not only one's rights and privileges but also one's job and even one's attire. In the eighteenth century this key aspect of colonial society was documented in the artistic record in the form of *pinturas de castas* (caste paintings), a pictorial genre unique to Mexico, which later spread to the viceroyalty of Peru (see fig. 236).

Contemporaneous with the *casta* paintings and their concern with the taxonomy of race were paintings that depicted the lineage of Tlaxcalan and Mexica nobles. Prior to this, in the sixteenth and seventeenth centuries, genealogy and its pictorial and written expressions triggered a variety of codices and texts that argued claims to land and water rights as well as labor tribute and privileges on the basis of lineage. Equally important is the historiography of key mestizo chroniclers who used pre-Columbian sources to establish a version of history informed by indigenous narratives and to assert their own social position, based on lineage. Emblematic of this discourse is the work of Fernando de Alva Ixtlilxochitl and Fernando Alvarado Tezozomoc, scholars and collectors of pre-Columbian materials who descended

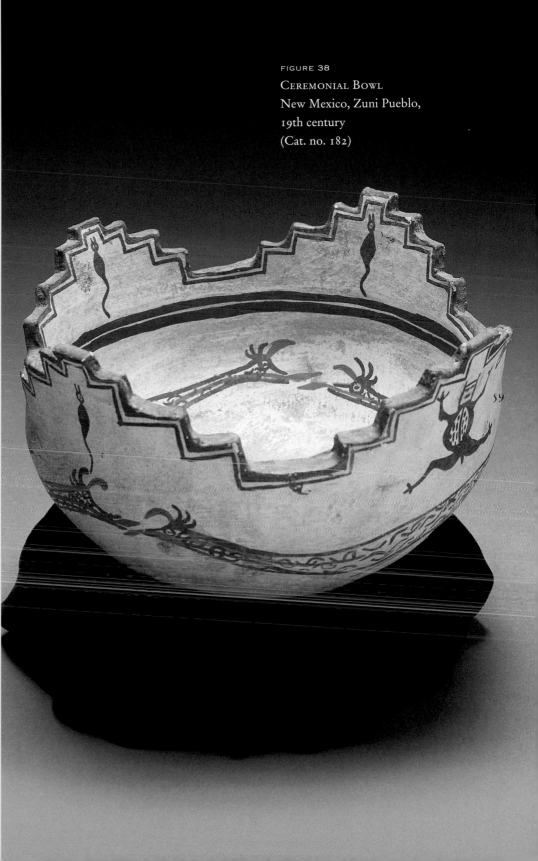

FIGURE 38
CEREMONIAL BOWL
New Mexico, Zuni Pueblo,
19th century
(Cat. no. 182)

59

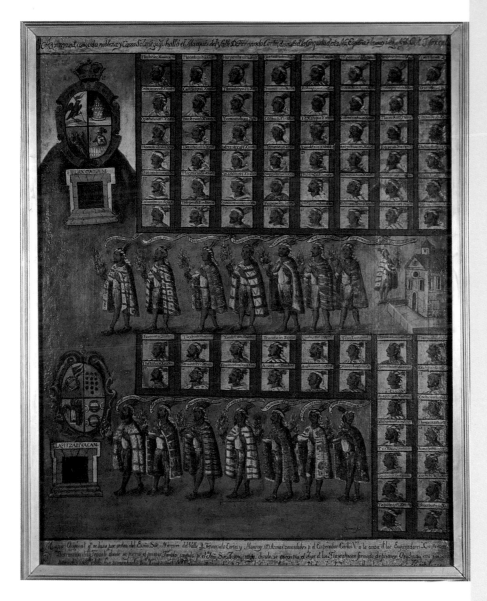

FIGURE 39

Attributed to Conde Sifuentes
(Mexico, 18th century)
NOBLEZA TLAXCALTECA EN LA
ÉPOCA DE LA CONQUISTA
(Cat. no. 207)

from noble indigenous families who had intermarried with the Spaniards.[19] A painting executed in a flat codex style (fig. 39) depicts the lineage of the Tlaxcalan nobility at the time of the conquest.

The concern with pre-Columbian noble lineage and the appearance in the seventeenth and eighteenth centuries of paintings that depict historical events relating to the conquest have recently been interpreted as articulating New Spanish concerns with a Creole identity.[20] Leading intellectual figures in viceregal Mexico, such as Sor Juana Inés de la Cruz (1651–95) and Carlos de Sigüenza y Góngora (1645–1700), articulated in their oeuvre a nascent national identity. Key in this regard are two religious works in the exhibition associated with Mexican nationhood. One painting depicts the Virgin of Guadalupe above the symbols associated with the founding of Tenochtitlan (fig. 40). She is flanked by the allegorical figure of a noble preconquest Indian and Juan Diego, the Indian who experienced the miracle of her apparition. The painting represents a departure from the vast corpus of works that depict the Virgin over the hill of Tepeyac. Equally important is a painting representing San Hipólito (fig. 211), the saint who became the patron of Mexico City because the Aztec empire was defeated on his feast day. In this rare work, San Hipólito is depicted flying on an eagle over the founding symbols of the Mexica capital.

In both Mexico and the Southwest, the response to the Spanish presence was also expressed by textiles and *retablos*, or devotional paintings on wood, such as a work showing Santa Bárbara wearing a feather headdress (fig. 41). These small-scale paintings usually depict patron saints and were often the focus of personal devotion and the

Figure 40
Josefus de Ribera y Argomanis
Verdadero retrato de Santa
María Virgen de Guadalupe,
patrona principal de la
Nueva España jurada en
México, 1778
(Cat. no. 205)

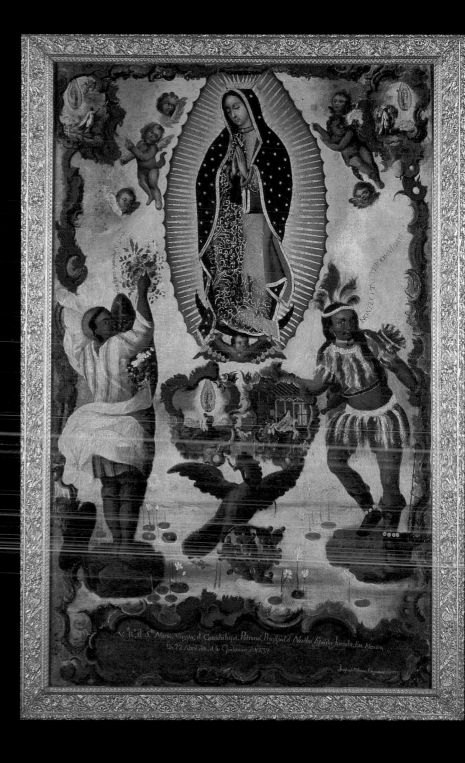

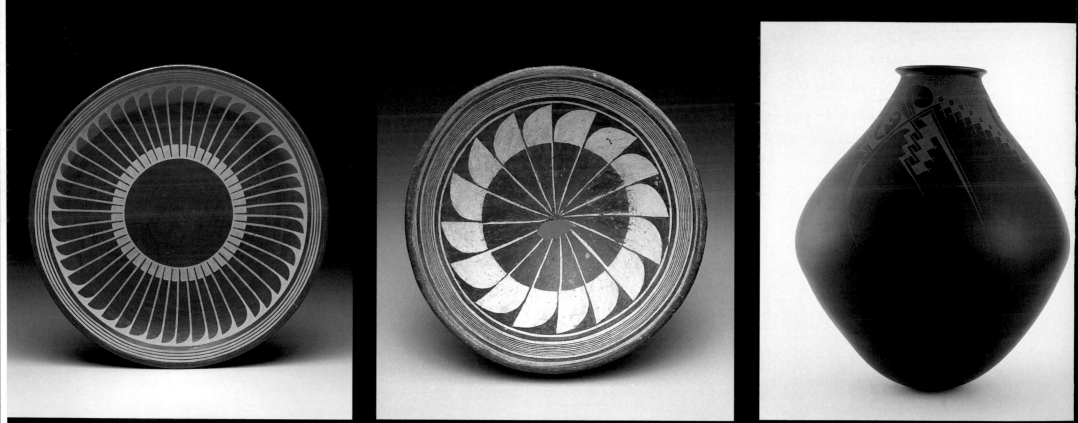

political activists, cultural workers, and artists in the 1960s—provided that ethos and foundation.

Aztlan—as symbol, as allegory, and as real and invented tradition—served as a cultural and spiritual framework that gave Chicanos/as a sense of belonging and a link to a rich and extensive history. The mythic geography of the Southwest was identified with the historical geography of the Chicano/a community. Some activists even contended that it was their ancestors who accompanied Coronado on his initial explorations, achieving the original colonization of today's Southwest. In developing their concept of Aztlan, Chicanos/as not only referred to the historical fact of New Spain's expansion northward but also suggested that it was precisely in these northern regions that the Aztecs' mythic homeland was located. In this manner the Chicano community created a symbolic origin for itself and a framework for its contemporary articulation.

The notion of such an ancestral homeland, understood within diverse political frameworks, has been a central concern of Armando Rascón, a cross-media conceptual artist. In projects such as the various versions of *Occupied Aztlán* (1994), his curatorial work in the video program *Xicano Ricorso* (1994), and his key installation *Artifact with Three Declarations of Independence* (1991; fig. 272), which re-presents foundational Chicano/a documents, Rascón deals with history as lived experience, exploring the potentially liberating effects of historical consciousness.

David Avalos, a member of the same artistic generation as Rascón, deals with contested sites, social issues, and vernacular culture. His sculptural works employ an array of materials, references, and forms

FIGURE 46
David Avalos
HUBCAP MILAGRO #4, 1986
(Cat. no. 225)

drawn from Chicano/a and borderlands cultures. *Hubcap Milagro #4* (1986; fig. 46) brings together the aesthetic of *rasquachismo* (an approach that transforms the practices of "making do" that are characteristic of Chicano/a culture into strategies of parody and pastiche), car culture, and such traditional devotional expressions as the ex-voto and the *milagro* (a token signifying that a miracle has occurred).

The artist, educator, and advocate Amalia Mesa-Bains conceives of Aztlan fundamentally as a spiritual geography that actively configures Chicano/a life: personal, political, social, and cultural (see her essay in this volume). Aztlan, as a spiritual ground and impulse, has been key in the construction of Chicano/a identity through its connection to ritual and ceremony and their role in preserving memory and tradition. Cultural expressions such as home altars and *ofrendas* constitute alternate chronicles of everyday life, and they have inspired successive generations of artists thematically and formally.

The centrality of land and a sense of place is articulated in the use of landscape as a genre to reference a multiplicity of issues. In the abstract paintings of Roberto Juarez (figs. 47, 48), landscape appears as

a motif that evokes lyrical and poetic views of the self and culture. By contrast, landscape is rendered as a psychologically charged, mythical social space in the oeuvre of Carlos Almaraz (see fig. 10), which articulates a postmodern urban Chicano/a experience. In Mesa-Bains's sculptures and installations, which engage with the domestic and feminine universes, landscape is a means to explore memory and its dynamic relationship to nature (see fig. 49).

Chicanos/as turned to pre-Hispanic myths and symbols as a source of spiritual inspiration in their struggle for self-determination, as seen in *The Nepantla Triptych* by Yreina Cervántez (figs. 274–76). As

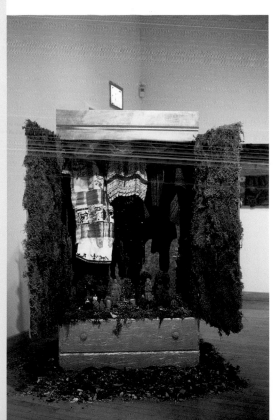

FIGURE 47 (TOP LEFT)
Roberto Juarez
CALAMUS BORDER, 1995
(Cat. no. 247)

FIGURE 48 (TOP RIGHT)
Roberto Juarez
THOREAU BORDER, 1995
(Cat. no. 248)

FIGURE 49
Amalia Mesa-Bains
THE "CASTAS" CLOSET, 1995
(detail)
Mixed-media installation at the
Bronx Museum of the Arts

Constance Cortez notes in her essay in this volume, the artist, who portrays herself in the guise of the Aztec goddess Coyolxauhqui, examines her indigenous roots, spirituality, and the ideological and artistic perspectives that have been imposed on her by the dominant culture. Issues of identity and self-representation are engaged in a more ironic fashion in the work of James Luna, whose photographic triptych *Half Indian, Half Mexican* (1991; fig. 277) both plays with and challenges stereotypical associations between physical appearance and ethnic makeup. Luna's concern with racial categories echoes the taxonomic obsession of the eighteenth-century *casta* paintings. Cortez offers the Aztec concept of *nepantla*, defined as a site of transformation, as a model for accommodating the present-day realities of intracultural diversity and social change.

Contemporary Mexican artists, looking at the pre-Columbian and colonial past, have tried to make sense of how Mexican national identity was formed and how it relates to present-day society. Mexican and Chicano/a artists have viewed pre-Columbian art and culture differently. Mexican artists tend to be more ironic and less direct than their Chicano/a contemporaries in their engagement with these themes, establishing a more complex relationship to pre-Columbian canons. The Chicano/a engagement with the pre-Columbian past, by contrast, reflects a grass-roots origin and is community-oriented. For Chicano/a artists, the concept of Aztlan has served as a means of asserting identity and claiming a history, whereas for Mexican artists, consideration of the pre-Columbian past has prompted a more philosophical investigation of

the construction of identity over time and its deployment in national narratives.

In the early twentieth century the ideology of the Mexican Revolution (1910–20) and its aftermath—expressed in the work of artists of the Mexican School such as José Clemente Orozco, Diego Rivera, and David Alfaro Siqueiros—sought to come to terms with the past and indigenous cultures. Pre-Columbian forms, techniques, colors, and themes were employed as a means of asserting a national identity not linked to European models. As the discourse on national identity became associated with the state, however, the project was critiqued for its hegemonic outlook as well as its heroic stance. In the 1980s, a period of social and economic crisis in Mexico, artists such as Julio Galán, Javier de la Garza, Dulce María Núñez, and Nahum Zenil began to engage the Mexican past, from pre-Columbian times to the contemporary era, in a much more personal and ironic fashion. Especially noteworthy is the revival of colonial forms and subject matter (long taboo in twentieth-century Mexican art), combined with references to popular culture and kitsch, in the work of these artists.

This "postmodern" approach to the past and to questions of personal and cultural identity was anticipated by Frida Kahlo in the 1930s and 1940s, which is why she is the only artist of the Mexican School represented in this exhibition. Kahlo's small-scale works on metal and wood allude to the tradition of colonial votive painting but express autobiographical themes, juxtaposed to or fused with references to popular culture (see fig. 50).

FRIDA KAHLO

Inspired by Kahlo's treatment of the personal as a cultural configuration in which individual and national identity are interrelated in a dynamic and unexpected manner, Dulce María Núñez has combined key images and icons that have fashioned Mexican cultural identity over time (see fig. 51). These concerns are also present in the work of Santa C. Barraza, an artist from southern Texas, where the Mexican tradition of votive painting (ex-votos and *retablos*) has persisted. Barraza has depicted key Mexican cultural figures, employing a narrative form and an intimate symbolism focusing on land, homeland, and the cycles of life (see fig. 262). (Popular manifestations of the Mexican ex-voto tradition are discussed by Michele Beltrán and Elin Luque in their essay in this volume.)

Javier de la Garza, addressing issues such as the return to painting and its relationship to photography and mass media, executed an important corpus of portraits of indigenous peoples and works incorporating pre-Columbian references. While a large part of de la Garza's oeuvre is informed by mass-media imagery—including classic Mexican cinema, advertising, and homoerotic print culture—works such as *Mexica sobre fondo rojo* (1992; fig. 52) are based on archaeological objects and reiterate key aspects of Aztec aesthetic canons. In the work of Enrique Chagoya, a Mexican-born artist who has long worked in the United States, references to pre-Columbian culture are combined with comic book imagery, creating ironic and often humorous juxtapositions (see figs. 215, 278).

The sculptures of Thomas Glassford, Silvia Gruner, and Gabriel Orozco are conceptual works that reflect on the pre-Columbian past

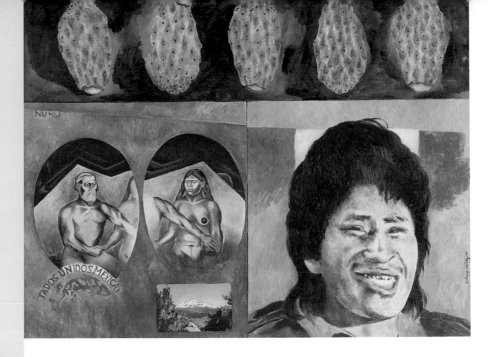

FIGURE 51 (TOP)
Dulce María Núñez
FILIACÍON, 1987
(Cat. no. 227)

FIGURE 52 (BOTTOM)
Javier de la Garza
MEXICA SOBRE FONDO ROJO,
1992
(Cat. no. 236)

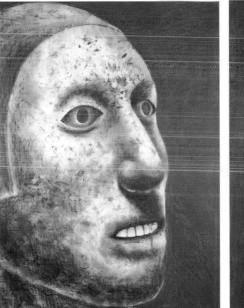
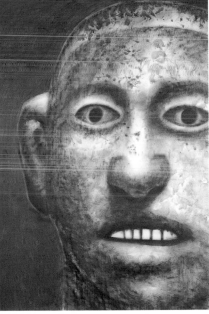

FIGURE 53
Gabriel Orozco
LINEA PERDIDA, 1993–96
(Cat. no. 242)

72

but allude to history in a roundabout way. In their works the object is not static but is placed in a performative or ritual context. Through conceptual and process-based operations, these artists reactivate key features of cultural history, at times casting them in a personal register.

Gabriel Orozco has an ongoing interest in pre-Columbian cultures and their significance in modernity and postmodernity. A recent project at the Philadelphia Museum of Art was based on the museum's collection of pre-Columbian sculpture, which was formed by Louise and Walter Arensberg.[22] In a variety of photographs, sculptures, and process-based actions, Orozco has linked the ancient Mesoamerican ball game with contemporary sports, in particular soccer.[23] In a series of interrelated sculptures, he has worked with industrial materials and discards, alluding to the "making do" strategies of recycling and invention characteristic of developing countries. *Linea perdida* (1993–96; fig. 53) refers to ritual, skill, and chance, raising key aesthetic and cultural issues.

Silvia Gruner has also had a long-standing interest in pre-Columbian cultures. Working in a more personal manner, she has produced a diverse corpus of works dealing with culture, nature, and the body, which engage the past in a contemporary manner. In video works such as *In situ* (1995), pottery and sculptural shards are remodeled into tiny figures that she plays with and transforms in her mouth. The necklace—as an object, metaphor, and allegory—has been key for Gruner, allowing her to deal with formal, cultural, and personal issues that occupy, in the artist's words, "a realm where the physical and the spiritual are constantly negotiated."[24] Many of Gruner's necklaces are sited in or intervene in diverse cultural contexts, eliciting an array of

FIGURE 54
Silvia Gruner
500 KILOS DE IMPOTENCIA
(O POSIBILIDAD), 1997
(Cat. no. 240)

73

crisscrossing transhistorical references. The artist "activated" her monumental volcanic rock sculpture *500 kilos de impotencia (o posibilidad)* (1997; fig. 54) by submerging it in San Diego Bay, underlining once more her interest in ritual as well as nature/culture relations.

Thomas Glassford—who grew up in a bilingual household in Laredo, Texas, and is currently based in Mexico City—has a personal history that is emblematic of borderlands culture and the dynamic movement of peoples in this region across time. Ethnobotanists have traced patterns of migration through the diverse species of gourds that grow along the roads that link Mexico with the U.S. Southwest. Utilizing the gourd as an object, reference, and index of culture, Glassford creates sculptures that allude to issues pertinent to migration, ecology, and the dynamic use of and intervention in social space (see fig. 55). Informed by high modernism and popular humor (in the

FIGURE 55
Thomas Glassford
INVITATION TO PORTAGE 2, 1992
(Cat. no. 243)

74

Mexican vernacular, *guaje*, the Spanish word for gourd, is a derogatory term suggesting stupidity), Glassford's use of the gourd also addresses issues of sexuality and the centrality of the body and ritual in contemporary culture.

Teresa Serrano, one of the few artists based in Mexico whose work elicits comparisons to that of Louise Bourgeois and Eva Hesse, is concerned with the pre-Columbian past and its significance for contemporary culture, using it to address issues of tradition and innovation as well as gender. Her sculpture *River* (1996; fig. 56) was first presented in Tepoztlán, Mexico, in 1996. Tepoztlán, which is about seventy-five miles south of Mexico City, was the site of one of the most heroic battles in the wars of conquest; it was set ablaze when its inhabitants refused to surrender to the Spaniards. The town contains the ruins of a pre-Columbian pyramid, commonly referred to as the House of Tepozteco, which is said to be the birthplace of Quetzalcoatl. Employing hand-stitched textiles and a metal armature, the sculpture casts ancient forms into a new language. Serrano's reductive formal language and choice of materials underline, in a poetic and abstract manner, the complexity of engendered sociocultural expressions.[25]

The concern with place and the dynamic engagement with the past that are evident in the works of contemporary Mexican and Chicano/a artists resonate throughout *The Road to Aztlan*. The exhibition brings together objects and artistic expressions from a region that has been characterized by both a shifting cultural and political landscape and a remarkable persistence of traditions, symbols, and beliefs. Many of the

works discussed here embody narratives of dislocation, translation, and negotiation, reflecting the exchange, sharing, and imposition of cultural values.

In terms of museum practices, the exhibition breaks new ground in looking at the southwestern United States and northern Mexico not as two culturally distinct regions, but as a heterogeneous yet unified cultural area in which deep-rooted regional traditions are linked by common belief systems. In emphasizing the persistence and renewal of these traditions over time, *The Road to Aztlan* also calls into question the view, put forth in both scholarly and popular accounts, that the arrival of Europeans in the Americas put an end to the evolution of indigenous beliefs and practices. We do not wish to minimize the devastation and loss that resulted from colonialism and its aftermath. Indeed, who can forget the lament of the Mexica, responding to the destruction wrought by the Spaniards: "We have pounded our hands in despair against the adobe walls, for our inheritance was only a net of holes."[26] Yet we believe that an emphasis on concepts such as "spiritual conquest" and "cultural assimilation" makes it difficult to grasp the multiform expressions that articulate positions of criticality and resistance, as well as the mutual exchange of cultural influence between the colonizers and the colonized.

One thing that clearly emerges from an examination of the history of this region over two millennia is the importance of cultural identity—conceived not as a static construct, but as a flexible and dynamic one—at times when traditional ways of being and thinking are threatened. While we have underlined how the concept of Aztlan

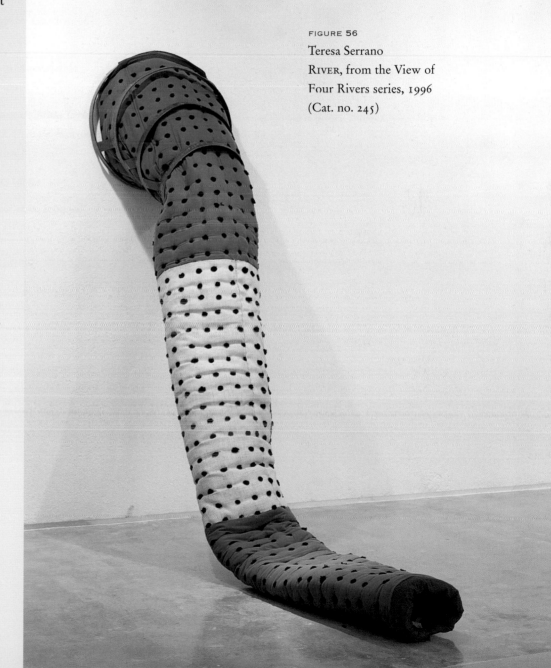

FIGURE 56
Teresa Serrano
RIVER, from the View of
Four Rivers series, 1996
(Cat. no. 245)

I am come, oh my friends,

with necklaces I entwine you,

with feathers of the macaw I adorn you,

a precious bird, I dress with feathers,

I paint with gold, I embrace mankind.

With trembling quetzal feathers,

with circlets of song,

I give myself to the community.

I will carry you with me to the palace

where we all, someday,

all must betake ourselves,

to the region of the dead.

Our life has only been

loaned to us!

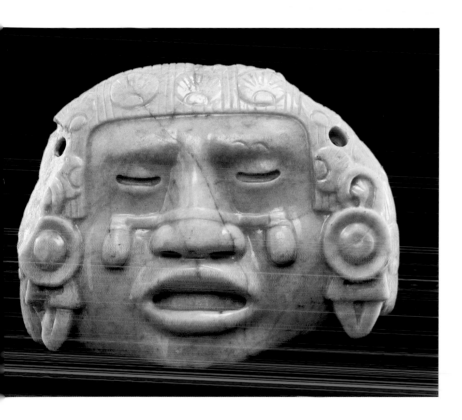

I polish jades,
sparkling in the sun.
On the paper I am putting
feathers of the green and black bird.
I know the origins of songs:
I only arrange the gold-colored feathers.
It is a beautiful song!
I, the singer, weave precious jades,
show how the blossoms open.
With this I please
the Lord of the Close and Near.

Then Coyotlinahual, the featherwork artist, fashioned it.

First he made Quetzalcoatl's feather headdress,

then he made him his turquoise mosaic mask.

He took the color red and painted his lips red.

He took the color yellow and with it painted bars on his face.

Then he gave him serpent's fangs,

and then he fashioned a beard for him of lovely cotinga feathers,

and roseate spoonbill feathers,

which covered the bottom of his face.

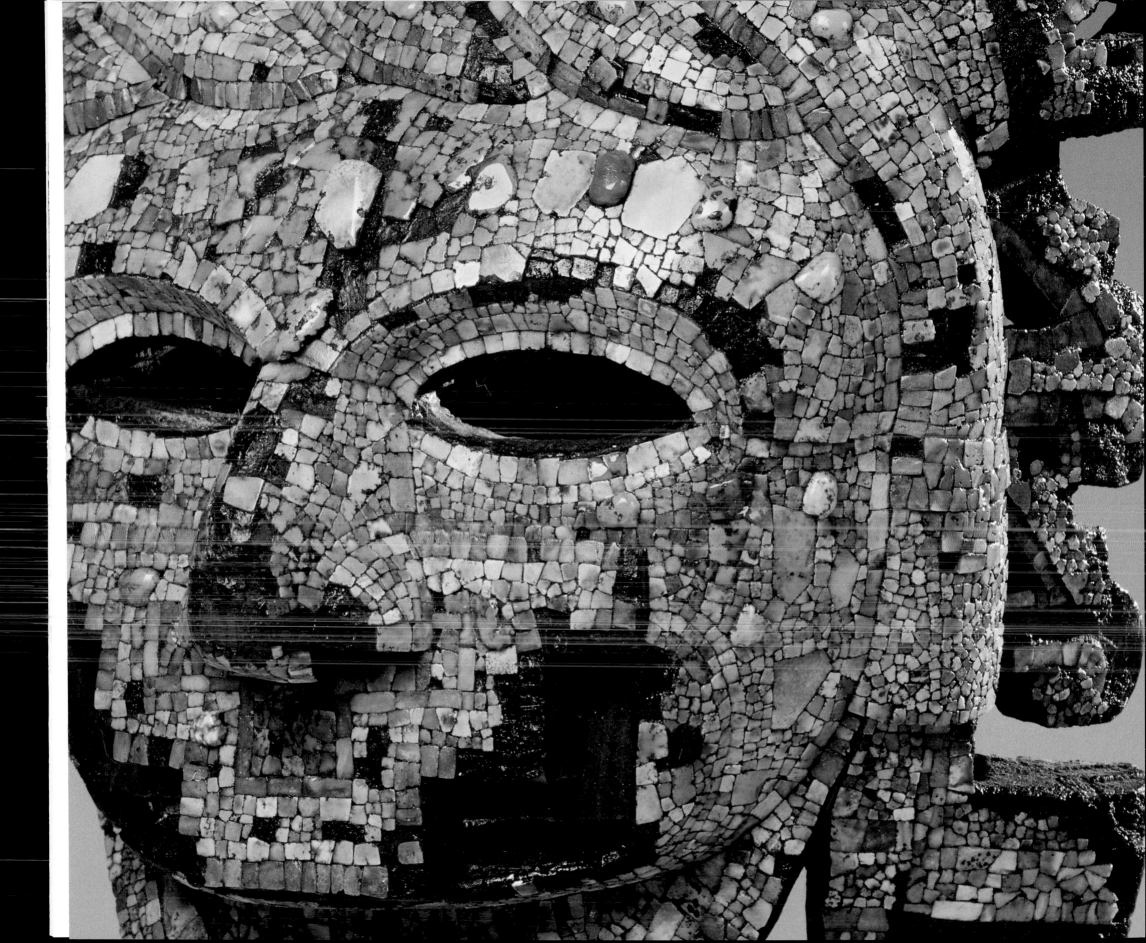

their feathers, first observed by Cabeza de Vaca, is incorporated into the associative logic of a famous Pima legend. The story tells of Morning Green, chief of Casa Grande, whose daughters discovered a mine of the blue gem.[26] Soon news of the discovery reached Sun-in-the-East, who sent a parrot to obtain the stones. When the parrot arrived, Morning Green's daughters were unaware of what it wanted and offered the bird many gifts, all of which were refused. Finally, they offered it a bowl of atole, in which the parrot spotted a turquoise bead. When it swallowed the bead, Morning Green's daughters brought more turquoise, which the parrot promptly devoured. Then it flew back to Sun-in-the-East and disgorged the turquoise.

Although the legend doesn't specify what kind of parrot visited Morning Green, the Pima were particularly well known for breeding scarlet macaws in historic times, as were the Mexica when they founded Tenochtitlan (see fig. 64).[27] Archaeologist Lyndon Hargrave has concluded that a fascination with this magnificent bird throughout the American Southwest may date to as early as A.D. 1000. After examining the remains of 145 skeletons excavated at twenty-four different Anasazi sites, he determined that all but one were scarlet macaws.[28] Hargrave's discovery, together with the appearance of so many images of scarlet macaws painted on ancient Pueblo pottery, is proof that both the bird and its plumage had become the most highly prized of ritual commodities, equivalent in many ways to the value placed on turquoise by the Toltecs. It is easy to see why. The macaws' habitat extends no further north than coastal Oaxaca and Veracruz.[29] Consequently, they were extremely rare, it being a formidable task to transport living birds so far north before the skills required for breeding them had been developed at Casas Grandes.[30]

95

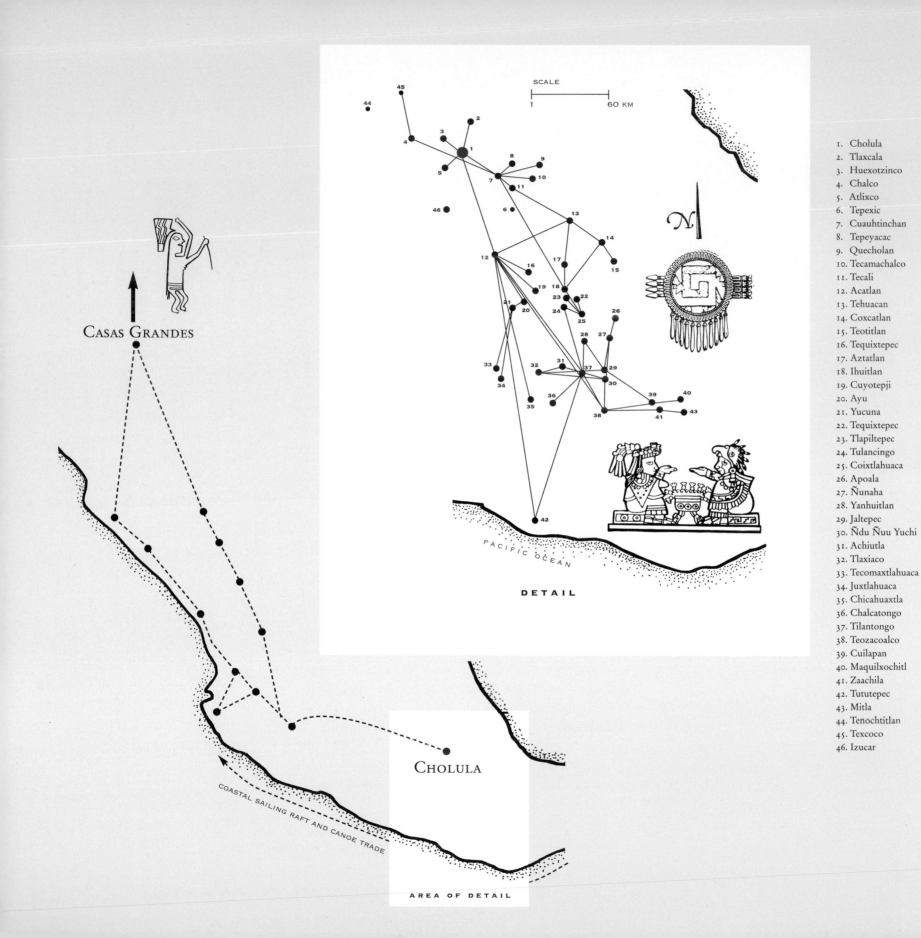

1. Cholula
2. Tlaxcala
3. Huexotzinco
4. Chalco
5. Atlixco
6. Tepexic
7. Cuauhtinchan
8. Tepeyacac
9. Quecholan
10. Tecamachalco
11. Tecali
12. Acatlan
13. Tehuacan
14. Coxcatlan
15. Teotitlan
16. Tequixtepec
17. Aztatlan
18. Ihuitlan
19. Cuyotepji
20. Ayu
21. Yucuna
22. Tequixtepec
23. Tlapiltepec
24. Tulancingo
25. Coixtlahuaca
26. Apoala
27. Ñunaha
28. Yanhuitlan
29. Jaltepec
30. Ñdu Ñuu Yuchi
31. Achiutla
32. Tlaxiaco
33. Tecomaxtlahuaca
34. Juxtlahuaca
35. Chicahuaxtla
36. Chalcatongo
37. Tilantongo
38. Teozacoalco
39. Cuilapan
40. Maquilxochitl
41. Zaachila
42. Tututepec
43. Mitla
44. Tenochtitlan
45. Texcoco
46. Izucar

SCALE
1 60 KM

N

DETAIL

PACIFIC OCEAN

CASAS GRANDES

COASTAL SAILING RAFT AND CANOE TRADE

CHOLULA

AREA OF DETAIL

Scarlet macaws are fantastic in appearance, with big, round heads, large eyes, and menacing claws. Their long red tails, tipped with iridescent blue, display some of the most brilliant hues found in the natural world. They may live as long as seventy years and so form life-long bonds with their owners. Not only are scarlet macaws intelligent and playful, but most importantly, they also mimic human speech. This ability earned them the status of oracles of the gods and ancestors in Mesoamerica. A seventeenth-century Zapotec man was accused of practicing paganism by Spanish friars, who testified that he kept in his hut a macaw, to which he made offerings of incense and blood. Then the man would kneel and pray to the bird, "whose response, or the response of the devil within it, would cause the old man to tremble in fear."[31]

The words of Vucub Caquix, the scarlet macaw god appearing in the *Popol Vuh* (a book containing the Mayan origin story), exemplify the paramount status these birds attained among the ancient Maya: "I am great. . . . I am the sun, I am their light. . . . My light is great because my eyes are made of metal and my teeth glitter as jewels of turquoise, they stand out blue with stones like the face of the sky."[32] To the Aztecs and Mixtecs, the scarlet macaw was the personification of a solar maize god named Seven Flower–Xochipilli.[33] Seven Flower was the patron of royal palaces and craftspeople. Festivals in his honor were celebrated with bacchanalian banquets involving the exchange of lavish gifts of woven garments, feathers, and jewels. Seven Flower was also thought to be the god of royal marriages and sexual procreation, and as father of the gods, he presided over the thirteenth or highest heaven, where only the royal born were admitted after death. It is therefore not surprising that he was the patron of rituals involving hallucinogenic plants. Participants in

these rituals believed that they could actually visit the royal paradise to discuss matters of utmost importance with their deceased ancestors.

Elsewhere I have proposed that the cult of Seven Flower–Xochipilli essentially embodied the ideology of elite gift giving and reciprocity that was the focus of Postclassic Mexican alliance networks.[34] During the Classic period, Mesoamerica was dominated by large urban centers such as Teotihuacan, Monte Alban, and Xochicalco. Then, for reasons that are hotly debated, elites abandoned these urban centers in favor of resettlement into small factional kingdoms that competed with one another for membership in exclusive alliance corridors that ultimately linked the Toltec-Chichimec of the Basin of Mexico, Tlaxcala, and Puebla with the Mixtecs and Zapotecs of Oaxaca (see fig. 65). It was at this time, when regional government was at its most segmented and commercially oriented, that emphasis was placed on the development of great houses. These networks of enclosed rooms and courts were ideal not only for the feasting and drinking that were such an integral part of alliance formation but also for the unparalleled level of craft production that would characterize the political and economic life of Mexico's central and southern highlands for more than five hundred years, until the arrival of the Spaniards.

Even more importantly, competitive exchange of elite craftwork in textiles, featherwork, and jewelry became the basis for intensifying bridewealth and dowry systems. The more exotic the materials and the finer the craftsmanship, the better marriages one could negotiate, allowing a kingdom to move into ever more exclusive and powerful alliance networks. Gift giving consequently became so competitive that traders and craftspeople were driven to seek out the rarest and most exotic materials, from Anasazi turquoise to

FIGURE 65

The political systems of Mexico's central highlands between 1150 and 1400 (map) were characterized by powerful confederacies of small city-states and great houses (detail).

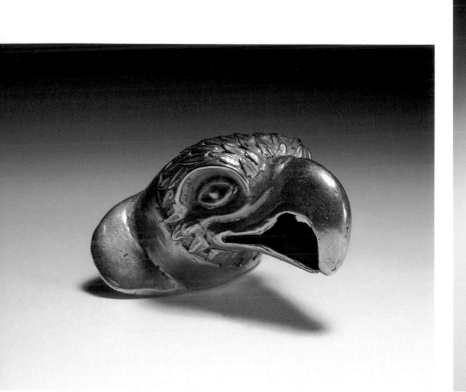

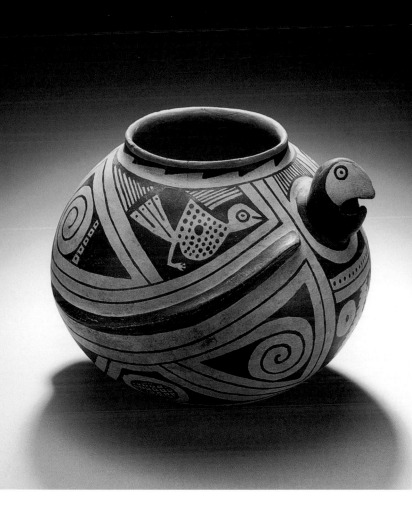

Oaxacan gold (see fig. 66), and never before had the Meso-american economy been inundated with so many new materials from such distant places.

The political ideology of the new Mesoamerican elite, embodied in the symbolism associated with ritual commodities like the scarlet macaw (see figs. 67, 68), would have had tremendous appeal for the emerging Pueblo peoples of northern Mexico and the American Southwest. Amending their past views of the Pueblo as egalitarian tribes subsisting exclusively on marginal hunting and farming, archaeologists are now examining craft production, reciprocity networks, ancestor cults,

marriage alliances, and great houses as the basis for the emergence of highly stratified societies dominated by rulers, chiefs, and councils of priests.[35] Sites like Chaco Canyon, Aztec Ruins, and Casas Grandes (Paquimé) are now perceived as major ceremonial centers founded on the monopolization of turquoise sources and the subsequent consolidation of social and economic power by a Pueblo elite.[36] The tyranny of such centers, by some accounts under the domination of the original katsinas, is actually alluded to in legend as a cause of egalitarianism in Pueblo society, not the source of it.[37] Nevertheless, their enduring legacy is such that Pueblo peoples still

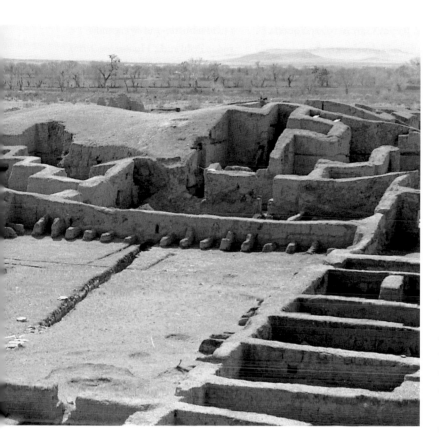

engage in systems of reciprocity by continuing to "feed" these ancestral spirits, making prayers and offerings to them, in exchange for which the spirits supply the people with rain so that their crops can grow.[38]

Dramatic changes in supply and consumption clearly led to dramatic changes in Chichimec social organization. By the twelfth and thirteenth centuries, remote areas once inhabited by simple bands of hunters, gatherers, and marginal agriculturalists saw the florescence of large communities exerting centralized authority. Pyramids were being constructed at Amapa, Nayarit, at the same time that the central residential compounds were being built at Casas Grandes. By 1480 a small empire had even emerged among the Tarascan peoples of Michoacan. Archaeologists now believe that such events were interrelated and propose that they resulted from the coordinated long-distance procurement and exchange strategies developed by Chichimec peoples in response to the demands of the highly competitive Toltec economies of the central and southern highlands.

Although certain Toltec symbols and ideas were doubtless passed along to the Chichimecs through exchange networks, most ceremonial behavior, architecture, and art styles were so varied that they do not appear to be the products of direct contact, but evolved largely with the local intensification of feasting networks that bound community specialists together into ever more effective corporations. From turquoise kiva to parrot clan, Zuni, Hopi, and Rio Grande Pueblo Indian peoples continue to preserve the names of the craft and trade specializations that have been integral parts of the sociopolitical, religious, and economic organization across Chichimecatlalli for centuries.

FIGURE 68

Macaw breeding pens at Casas Grandes
The Amerind Foundation, Inc., Dragoon, Arizona

FIGURE 69

MIXTECA-PUEBLA-STYLE VESSEL
Mexico, Nayarit, c. 1350–1500
(Cat. no. 157)

THE BREATH OF LIFE

THE SYMBOLISM OF WIND IN MESOAMERICA AND THE AMERICAN SOUTHWEST

KARL TAUBE

In recent years it has become increasingly apparent that ancient Mesoamerica and the American Southwest were by no means isolated entities but were in direct and sustained contact for millennia. There is abundant material evidence of ancient contact between the two areas, but perhaps even more striking is the degree of similarity in religious beliefs and practices. In studies of religious concepts relating to agricultural fertility in Mesoamerica and the American Southwest, much of the focus has been on rain and its product, life-giving maize. But, although invisible, wind constitutes the ultimate source from which rain, maize, and human life are derived. Among the Aztec this force was embodied by Ehecatl-Quetzalcoatl (see fig. 70), the duck-billed wind god who plays a central role in the creation mythology of Postclassic highland Mexico. To the Postclassic Mixtec of Oaxaca, he was Nine Wind, and like the Aztec being, he is both a creator god and the source of life-giving rain: "Nine Wind is the god of air, one of the primordial forces that gave rise to the world, the breath that spread wind and rain to the four corners of the cosmos."[1] To the horticultural Navajo, who share many traditions with the Hopi and Zuni, wind is an essential, generative force: "Suffusing all of nature, Holy Wind gives life, thought, speech, and the power of motion to all living things and serves as the means of communication between all elements of the living world."[2] Although invisible, wind is an essential conduit for forces of life and fertility.

This is by no means a comprehensive study of wind in Mesoamerica and the greater Southwest. For one, the principal focus will be on the ancient Olmec and Aztec

destructive forces, served as powerful weapons for the war twins of the Zuni and Hopi. Of the four directional winds described in the Aztec Florentine Codex, only the gentle wind of the east is regarded favorably.[3] This type of breathlike breeze—the warm bringer of rain and life—is the central focus of this study. Jane Hill and Kelley Hays-Gilpin have called attention to a major symbolic complex shared between Uto-Aztecan peoples of Mesoamerica and the Greater Southwest.[4] Labeled the Flower World by Hill, this complex revolves around flowers and, by extension, brightly colored butterflies, birds, the shining diurnal sun, heat, music, and ancestral souls (see fig. 71). The wind of life and growth directly relates to this paradisiacal realm. In fact, among the

FIGURE 70

EHECATL-QUETZALCOATL
Mexico, Aztec, Calixtlahuaca,
14th–15th century
(Cat. no. 177)

FIGURE 71

GOD WITH MAIZE AND FLOWERS
Mexico, Aztec, c. 1200–1519
(Cat. no. 161)

103

of Mesoamerica and the Western Pueblo communities of Zuni and Hopi, as well as the neighboring Navajo. A great deal of this symbolism can be documented in Classic Maya writing and art, but for reasons of space, it cannot be included in this study. In addition, not all forms of wind will be discussed. Although I will examine the live-giving, fructifying aspect of wind, there are also highly negative types, including foul, evil winds that cause death and disease. Strong gales, decidedly

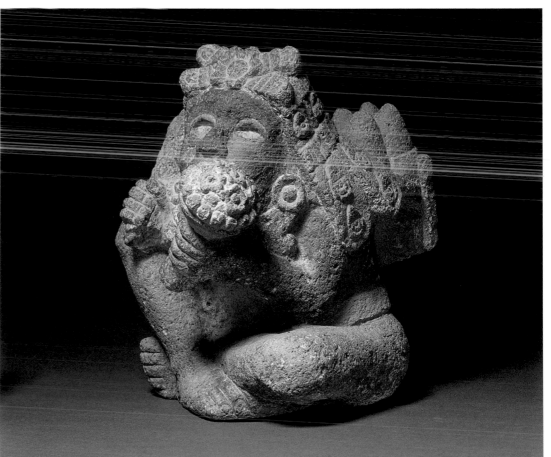

The breath spirit is widespread in Puebloan belief. Frank Hamilton Cushing recorded the prayer of a Zuni hunter inhaling the breath of a dying deer: "This day I have drunk your sacred wind of life."[19] The Zuni identify this soul with both sunlight and breath: "The word for life is tekohanan e, literally daylight. The breath is the symbol of life. It also is the means by which spiritual substances communicate and the seat of power or mana."[20] For the Zuni and Hopi, a feather portrays the breath spirit. The Hopi consider both the food and essence of the ancestors as breath: "They never eat the food, but only the odor or the soul of the food. . . . And that is the reason why the clouds into which the dead are transformed are not heavy and can float in the air."[21] On Hopi katsina masks, breath, or *hi'ksi*, can appear as one or more strings with a tied feather hanging from the mouth region. A feather string known as *pöötavi* is prominent in Hopi kiva ritual, where it constitutes the road by which the katsina travel to the *tiponi* maize fetish, a symbol of the *axis mundi*.[22] In Puebloan thought, the dead become aeolian spirits of clouds and rain, as can be seen in a Zuni account: "The Clouds are people, just as we are people. They are our ancestors, the ones who have died. They are the rain. . . . When they put on their beautiful garments, they are just like the clouds. Therefore they just impersonate clouds with their breath, but they are people."[23] Possibly because of this strongly human and personal dimension, breath is more prominent than wind in Puebloan religious thought and ritual. Nonetheless, it will be seen that this breath symbolism is part of the larger wind complex of Mesoamerica and the American Southwest.

THE OLMEC

In an extensive discussion of Maya rain gods and their relation to Tlaloc of Central Mexico, Thompson noted that these beings were extremely similar, suggesting that the rain complex is of Olmec origin.[24] Middle Formative carvings from the site of Chalcatzingo, Morelos, reflect the Olmec fascination with sacred mountains and powers of agricultural fertility. The great outcrop of Cerro Chalcatzingo is filled with Olmec-style bas-relief scenes carved into the living rock. The most famous of these, Monument 1, features a human figure wreathed in flowers and seated in a zoomorphic cave breathing elaborate scrolls (see fig. 73). The landscape surrounding this central motif features clouds, from which rain falls on growing maize.[25] As early as 1968 Florence Ellis and Laurens Hammack

106

FIGURE 73

Wind and cloud imagery at Chalcatzingo, Morelos: seated figure within breathing cave, Monument 1

73

76 77

compared this scene to Puebloan cave and rain symbolism, suggesting that the Southwest complex was ultimately derived from the Gulf Coast Olmec.[26]

The breath of the Chalcatzingo cave is generally interpreted as mist or clouds and the source of rain, but the elaborate spirals are also a clear denotation of movement and *wind*. In Mesoamerica and the American Southwest, the spiral serves as a basic wind sign. On close inspection, it can be seen that the mouth scrolls are symmetrical, with four pairs flanking two long, central scrolls, a composition possibly representing the four winds radiating from the central axis of the cave mouth. Another Chalcatzingo bas-relief, Monument 13, portrays an Olmec deity seated within the same zoomorphic cave. A fragment of the monument also displays the symmetrical scrolls, demonstrating that the scene again depicts a breathing cave.[27]

Near Monument 1 there are other breath scrolls, although here as single pairs of volutes blown out the

74 75

mouths of crocodilian beings (see fig. 74). The majority of the creatures rest on the same S-shaped double spiral that serves as a seat for the Monument 1 figure. Among the ancient Maya this motif signified a cloud, or *muyal*, and a recently discovered Chalcatzingo monument

reveals that the Olmec also regarded it as a form of rain cloud (see fig. 75).[28] In contrast to the static, symmetrical thunderheads appearing at the end of the zoomorphic breath scrolls and in the Monument 1 scene, the double spiral represents the dynamic combination of clouds and swirling wind. The breath volutes are creating rain clouds similar to the three thunderheads appearing in the Monument 1 scene. Jorge Angulo has suggested that the ancient Mayan T-shaped *ik'* wind sign is derived from the Olmec bifurcated breath scroll,[29] but although the double scroll does relate to the *ik'* sign, it more specifically represents emanating fragrance among the ancient Maya and other Mesoamerican cultures. The Olmec crocodilian rainmaker is not limited to Chalcatzingo but also appears on a boulder bas-relief from Tecaltzingo, Puebla (see fig. 76). In addition, Middle Formative greenstone carvings depict crocodilians with similarly upturned heads, as if they are blowing clouds with their misty breath (see fig. 77).[30]

Aside from Monument 1 and the adjacent crocodilian beings, another wind-related creature appears in the Chalcatzingo reliefs, a flying feathered snake accompanied by cloud scrolls (see fig. 78). Here the head is also upturned and carries in its maw a human figure, whose supine body is supported by the long, bifurcated tongue. The person's arms are pulled forward, much as if he were carried by a fierce, wind-driven tempest. Michael Coe first identified the Chalcatzingo creature

FIGURE 74
Crocodilian with bifurcated breath scroll and rain cloud, Chalcatzingo Monument 14

FIGURE 75
Cloud scroll with raindrops (detail of recently discovered monument at Chalcatzingo)

FIGURE 76
Crocodilian breathing rain cloud, Tecaltzingo, Puebla (after Dyckerhoff and Prem 1972)

FIGURE 77
Crocodilian in cloud-breathing position, greenstone carving (after Coe et al. 1995, 208)

FIGURE 78
Plumed and beaked avian serpent with human figure in maw, Chalcatzingo Monument 5

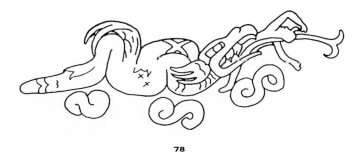

78

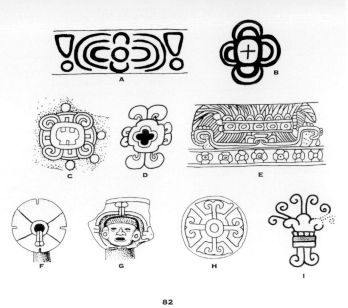

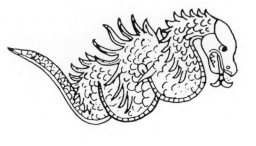

FIGURE 79

Aztec portrayal of flying *quetzalcoatl* serpent (from the Florentine Codex, bk. 11)

FIGURE 80

Detail of Calixtlahuaca wind temple stela portraying coiled and jumping serpents

FIGURE 81

Olmec jadeite earspool with bifurcated breath element, La Venta (after Benson and de la Fuente 1996, 244)

108

as an ancestral form of the Aztec Quetzalcoatl, a plumed serpent of wind, rain, and agricultural fertility.[31] In fact, the sharply undulating body is notably similar to that of a flying *quetzalcoatl* serpent appearing in the Florentine Codex (see fig. 79). The accompanying account states that "when [this serpent] flies or descends, a great wind blows."[32] The creature resembles a snake springing from a coiled position (see also fig. 80). In Olmec art the wind serpent has not only feathers but frequently a beak and flipperlike wings as well (see fig. 78), quite like winged serpents of the contemporary Huichol and Mixtec.[33]

Anatole Pohorilenko described a pair of jade earspools from La Venta portraying a bicephalic avian serpent outlining a U-shaped cave opening (see fig. 81).[34] A disk with a pair of volutes floats before the cave maw, quite like the scroll pairs emanating from Chalcatzingo cave depictions (see figs. 73, 83). In ancient Mesoamerica such volute pairs denote the breathlike fragrance emitted by flowers (see fig. 82). An incised celt portraying a flowering plant reveals that this convention was also present among the Olmec (see fig. 84). It is conceivable,

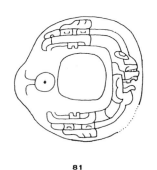

FIGURE 82

Floral imagery in ancient Mesoamerica: (a) four-lobed flower flanked by raindrops (design from roller stamp attributed to Chalcatzingo; after Gay 1972, fig. 47); (b) four-lobed flower, detail of roller stamp attributed to Tlatilco (after Feuchtwanger 1989, fig. 8); (c) floral breath element, La Mojarra Stela 1; (d) floral sign with bifurcated scrolls denoting breath or aroma (detail of Late Classic Maya vase; after Reents-Budet 1994, 17); (e) floral face emitting pair of song scrolls,

detail of Early Classic Teotihuacan vessel (after Linné 1934, fig. 25a); (f) censer chimney in form of flower, Early Classic Kaminaljuyu (after Kidder, Jennings, and Shook 1946, fig. 201j); (g) censer chimney with human face in center of flower (after Berlo 1984, pl. 224); (h) flower with four breath volutes, Monument 10, La Nueva, Guatemala (after Estrada Belli and Kosakowsky 1998, fig. 7); (i) flower with breath volutes, Late Postclassic Mixtec (from Codex Bodley, 11)

FIGURE 83

Fragment of breath scroll emanating from cave, Chalcatzingo Monument 13

84

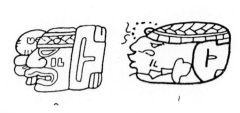

85

however, that the breath element appearing on the La Venta earspools also represents an earspool, as Classic Maya earspools are frequently of floral form and even emit aroma volutes. In addition, the earspools of the Classic Maya wind god typically display the *ik'* wind sign. Stephen Houston has noted that Naranjo Altar 1 contains a complex glyph composed of four *ik'* signs surrounding a sky glyph, representing the four celestial winds.[35] On close inspection, it can be seen that these signs are actually the earspools of the wind god (see fig. 85). This arrangement is virtually identical to an Olmec-style cache featuring four massive jade earspools

arranged around a central bowl (see fig. 86), indicating that the concept of four winds found in Mesoamerica and the American Southwest was fully present among the Middle Formative Olmec.

The quatrefoil cave of the Olmec and later Mesoamerican cultures strongly resembles a four-petaled flower (see figs. 73, 82). A cylindrical stamp attributed to Chalcatzingo portrays such a blossom flanked by falling raindrops, quite like the drops portrayed in the Chalcatzingo reliefs (see fig. 82A). In Mesoamerica flowers not only are portrayed with breathlike volutes but also serve as breath symbols (see fig. 87). Teotihuacan-style censers from highland Guatemala have chimneys with the exit hole in the center of a four-petaled flower, making the emerging smoke the aromatic "breath" of the flower (see fig. 82). One of the more important burials at Chalcatzingo contained two incense burners, with the more elaborate example displaying a form resembling a four-petaled flower (see fig. 88). David Grove, however, interprets it as a "supernatural face."[36] Both meanings are likely correct, as the censer probably alludes to the

109

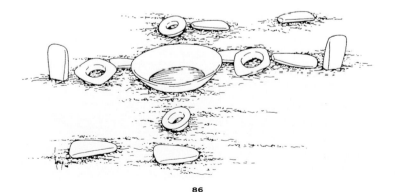

86

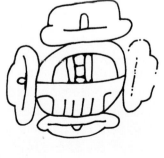

87

88

FIGURE 89

Early Formative crocodilian censer from Tlapacoya (after Benson and de la Fuente 1996, 193)

FIGURE 90

Effigy duck censer attributed to Las Bocas, Early Formative period (after Benson and de la Fuente 1996, 192)

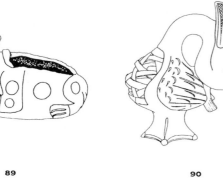

89

FIGURE 91

Plumed serpent with water spouting from mouth and raindrops falling from body, Techinantitla, Teotihuacan (from Taube 1995, fig. 10e)

FIGURE 92

Teotihuacan plumed serpent with Tlaloc in mouth (after von Winning 1987, vol. 1, chap. 6, fig. 6b)

quatrefoil cave of Chalcatzingo, which displays floral as well as zoomorphic imagery. The outpouring censer smoke represents both clouds and floral aroma. In Mesoamerica incense and other fire offerings are one of the more common means of conjuring rain, the roiling smoke signifying clouds. Buried within an impressive altar throne, the owner of the censer may have been an important rainmaker at Chalcatzingo.

A number of Early Formative Olmec-style censers are in the form of creatures exhaling smoke through their mouths. A probable censer attributed to Tlapacoya portrays the same crocodilian figure appearing at Chalcatzingo (see fig. 89). In this case, however, smoke constitutes the breath volutes and rain clouds. An elaborate Early Formative incense burner attributed to Las Bocas, Puebla, portrays a duck with a sharply upturned head (see fig. 90). The smoke of the burning offering would pass out of the beak, much as if the duck were blowing rain clouds. It will be noted that in Mesoamerica and the American Southwest the duck is an important rain bringer.

CENTRAL MEXICO

During the Early Classic period (c. A.D. 250–600), the plumed serpent became a dominant image in the iconography of Teotihuacan, a motif that continued with later cultures of Central Mexico, including the Toltec and Aztec. Whereas the Olmec avian serpent often displays a feather-crested brow, beak, or wings, the plumed ser-

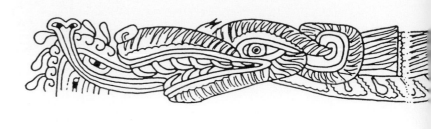

91

pent of Classic and Postclassic Mesoamerica is typically a rattlesnake covered with green quetzal plumes. Among the Aztec this creature was known as Quetzalcoatl, or quetzal serpent, and was a being of wind and rain: "The wind that is called Quetzalcoatl, we say, sweeps the road for the Tlalocs."[37] At Teotihuacan the plumed serpent is clearly a rain bringer, with rain falling from its body as well as streaming from its mouth (see fig. 91). The Teotihuacan plumed serpent also carries Tlaloc in its mouth, again denoting its role as rain carrier (see fig. 92). A similar convention appears in the Nunnery Quadrangle at Uxmal, where the Maya Chaak emerges

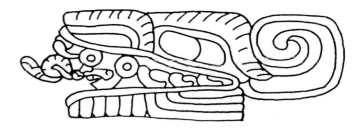

92

FIGURE 93

Plumed serpent with Chaak in mouth (detail of façade from west building of the Nunnery Quadrangle, Uxmal)

FIGURE 94

Early Classic period mural of Maya-style plumed serpent with conch signs on body (drawing by author from fragments of the Realistic Paintings at Tetitla, Teotihuacan)

FIGURE 95

Conch spiral imagery: (a) detail of conch on body of Tetitla plumed serpent (b) conch spiral on bodies of plumed serpents, Pyramid of the Feathered Serpents, Xochicalco; (c) series of conjoined conch spirals on plumed serpent (detail of column from Tula, Hidalgo); (d) serpent conflated with conch, detail of ceramic bowl from Cerro Montoso, Veracruz (after Seler 1990–98, vol. 5, 198)

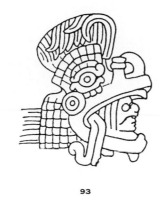

93

94

from the mouth of a plumed serpent (see fig. 93). The concept of rain- and cloud-bearing serpents continues in contemporary Mesoamerica. Among the Huichol a blue wind serpent brings the clouds: "When the clouds gather from the west, this is one of the serpents, or winds that brings them along."[38] Similarly, among the Mixtec of highland Oaxaca, the winged or feather-crested rain serpent, *koo savi*, flies in the middle of powerful storms: "It is surrounded by rain clouds, which it is said to bear on its back."[39]

A creature of wind and water, the plumed serpent is commonly identified with the conch, a spiral shell that not only evokes the form of a coiled snake and whirlwinds but also converts blown air or wind into a thunderous sound. In Aztec myth Quetzalcoatl bests death by sounding the conch in the underworld.[40] At Teotihuacan the most explicit scene of a plumed serpent with a conch appears in murals portraying Maya-style feathered serpents carrying a youthful Maya being, possibly the wind god, in their mouths (see fig. 94). The serpents have cross-sectioned conch shells on their bodies, a trait occurring in plumed serpents at the later sites of Xochicalco and Tula (see fig. 95). A Late Classic Veracruz *palma* portrays Quetzalcoatl with quetzal hands and intertwined snakes over his body (see fig. 96). The figure wears a conch pectoral, making this one of the earliest examples of Quetzalcoatl with the *ehecailaca-cozcatl* wind jewel, a basic emblem of the Late Postclassic wind god, Ehecatl-Quetzalcoatl.

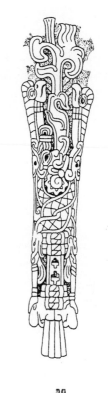

95

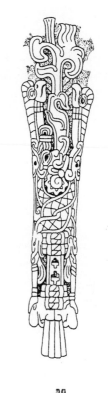

96

FIGURE 96

Late Classic Veracruz sculpture portraying Quetzalcoatl with early form of conch spiral pectoral (from Taube 1986, fig. 6)

FIGURE 97

The duck-billed wind god of
Late Postclassic period highland
Mexico: (a) Aztec portrayal of
Ehecatl-Quetzalcoatl with spiral
shell ornaments (from the
Codex Magliabechiano, 61r); (b)
Nine Wind, the Mixtec form of
the wind god, traveling on rope
with feather down (from the
Codex Vindobonensis, 48); (c)
the Mixtec deity Nine Wind car-
rying celestial water spirals (from
the Codex Vindobonensis, 47)

FIGURE 98

Mixtec wind temple with conch
on conical thatch roof (from the
Codex Vindobonensis, 48)

112

Among the Aztec, wind is of spiral form, and in
Late Postclassic central Mexican and Mixtec scenes the
wind god wears a series of shell ornaments evoking
volutes of wind. The wind jewel clearly symbolizes a
conch trumpet, and an intact conch often substitutes
directly for the cut-shell pectoral. Along with the pec-
toral, the Central Mexican and Mixtec wind gods wear
ear pendants from central conch spires and a necklace
of spiral shells. The most marked characteristic of the
Late Postclassic wind god, however, is the duck-billed
buccal mask (see fig. 97). According to Scott O'Mack,
the buccal mask is derived from the hooded merganser,
known as *ecatototl*, or "wind bird," by the Aztec.[41]
Another duck, the *atapalcatl*, was a harbinger of rain:
"If it is to rain on the next day, in the evening it begins,
and all night [continues], to beat the water [with its
wings]. Thus the water folk know that it will rain much
when the dawn breaks."[42] An aspect of Quetzalcoatl,
wind has a major role in Aztec and Mixtec myth and
ritual. In one Aztec account the forceful breath of the
wind god caused the newly created sun to move in its
path.[43] The Mixtec codices, particularly the Codex
Vindobonensis, contain graphic scenes of the mythic
doings of Nine Wind. Frequently he descends on a
celestial cord lined with feather down (see fig. 97B).
Although a sky umbilicus, this rope path is also notably
similar to the Hopi "breath road" formed of a down
tuft tied to a cotton string.[44]

In Postclassic Mesoamerica the temple of Ehecatl-
Quetzalcoatl was circular in plan. According to early
colonial Spanish sources, the unusual round form referred
to the encircling nature of wind, a concept surely relat-
ing to whirlwinds. A stela erected in front of the wind
temple at Calixtlahuaca portrays a serpent pair, one
tightly coiled and the other leaping (see fig. 80). One phase
of this temple had two symmetrically placed serpent

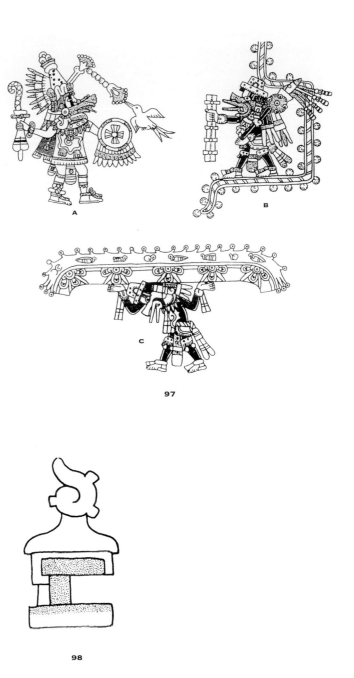

97

98

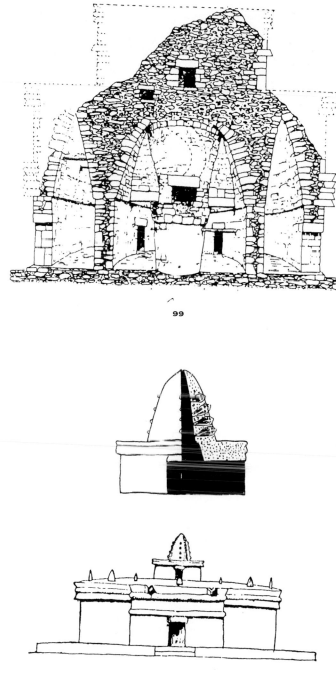

99

100

heads, much as if the round walls represented their coiled bodies.[45] The round wind temple embodies circling, spiraling wind, a form mirrored in coiled serpents and conch trumpets. In fact, Mixtec scenes portray a conch topping the conical wind temple roof (see fig. 98).

Among the earliest and best-known round wind temples is the aptly named Caracol, or conch, at Chichén Itzá, dating to approximately A.D. 900 (see fig. 99). Provided with four doorways, the two-story building contains two concentric chambers encircling a central column with a spiral stairway leading up to a small chamber. This second story contains a series of windows or apertures, and although it has often been suggested that they were used for astronomical observation, they may have had a more pertinent function—the creation of breezes within the wind temple. I have suggested that wind temples replicate the cave of emergence, offering access to netherworld sources of life and fertility.[46] The openings in the upper chamber may have created the previously noted "chimney" effect of breathing caves. During the warm, rainy summer season, air would be drawn into the upper chamber, swirl down the spiral stairway, and emerge from the doorways below, creating winds of the four directions.

This is not the only wind temple in the Maya area displaying the architectural manipulation of air movement; a remarkable example occurs at the Late Postclassic site of San Gervasio, Cozumel. Also known as the Caracol, the structure has two stories, both with doorways to the four directions (see fig. 100). The conical roof of the smaller second story contains a series of embedded conch trumpets that literally sound in the wind.[47] As in the Mixtec scenes, this wind temple and that at Chichén Itzá embody the concepts of wind and the roaring conch.

Among the Aztec the wind temple was a place of music and dance. Diego Durán noted that in the temple

113

FIGURE 101

Scenes portraying the mythic origin of music in the Codex Borgia: (a) the House of Flowers and the wind temple appearing in the Codex Borgia (p. 37); (b) the flute and smoking bundle portrayed in the Codex Borgia (p. 36); (c) detail of flute in smoking bundle; (d) detail of flute played by Xochipilli in the House of Flowers (see fig. 101A)

FIGURE 102

Portrayals of musical instruments and flowers in Late Postclassic Central Mexico: (a) red Quetzalcoatl blowing floral trumpet or flute (from the Codex Borgia, 39); (b) Aztec ceramic floral flute from the Templo Mayor, Tenochtitlan; (c) Quetzalcoatl with musical instruments, flowers, precious birds, and butterflies in spiral emerging from bundle (from the Codex Borgia, 36–38)

114

101

descend on the blue road to obtain a bundle from the underworld house of the night sun (page 35). A great stream of wind spirals out of the bundle (see fig. 102C), passing along the left side of page 37 to end with the head of Ehecatl-Quetzalcoatl. I have interpreted this curious episode as portraying the emergence or creation of humankind, and indeed it concerns a closely related theme, the origin of life-giving music.[49]

In Aztec myth the wind or a devotee of Tezcatlipoca crosses the sea to the house of the sun to obtain music for humankind.[50] The bundle taken from the night sun on page 35 of the Codex Borgia is this very music. The wind spiraling out of the bundle (page 36) contains flutes, rattles, drums, and other instruments, as well as the closely related motifs of birds, butterflies, and flowers (see fig. 102A). In addition, the bulging red item in the center of the bundle on page 36 is the same red flute

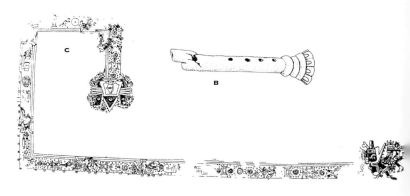

courtyard "were performed splendid dances, merry celebrations, and amusing farces," also mentioning that at dawn and dusk the temple priest struck a massive drum, representing the voice of the wind god.[48] A passage on pages 35 to 38 of the pre-Hispanic Codex Borgia illustrates the close relation of the wind god to music and the sun. Central to the episode is a sharply angled and circuitous blue road that leads directly to the wind temple (page 37; see fig. 101). While standing on this blue road, Tlaloc casts lightning on the conical wind temple roof. Two gods, Ehecatl-Quetzalcoatl and Tezcatlipoca,

102

played by the solar-related flower prince of music, Xochipilli, on page 37 (see fig. 101C, D). Although Xochipilli is the prince of music, whistling or roaring wind is its natural source. The Borgia passage vividly illustrates Ehecatl as the music bringer. Filled with flowers, birds, and articles of music and dance, the spiraling wind stream embodies the Flower World.

In ancient Tlaxcala deceased nobles became clouds as well as precious birds and jewels. Music was clearly related to rain and water.[51] Jingling bells were compared to the sound of rushing water, which was called *coyolatl*, or "bell water."[52] The conjuring of ancestors and rain through music and fire offerings is very similar to the katsina rain spirit complex of the American Southwest.

THE AMERICAN SOUTHWEST

Among the Western Pueblos, the ancestral katsinas are embodiments of rain, and the kiva and plaza dance ceremonies largely concern the bringing of the katsina clouds. According to Ruth Bunzel, the Zuni katsina dances are the "most potent form of rain making rites." Clearly a natural corollary to the ceremonial conjuring of rain is the wind that brings the clouds. Joann Kealiinohomoku described the Hopi katsina dances as creating a swirling force that brings the clouds: "A dance event at Hopi builds an energy vortex that attracts the katsina spirit beings to sail over, as clouds, to see what is going on and hear the song affirmations that describe the correct state of being."[53]

In Southwestern thought and ritual, wind is commonly of spiral form. The Navajo consider the whorls at the fingertips as marks of the winds and their ability to make human movement possible.[54] In one Navajo emergence account, people left the fourth world through a passage made by Whirlwind, "twisted like a tendril through the smooth, hard sky."[55] Jesse W. Fewkes

observed that among the Hopi, spiral petroglyphs denote whirlwinds (see fig. 103), and wind spirals are also created in Hopi ritual.[56] Alexander Stephen noted that during the "wind song" performed in the summer Flute Ceremony at Walpi, a participant scattered pollen from hollow reeds with the following movement: "beginning in an outward circle; and then describing a decreasing spiral, he sprinkles finally upon the water." During the same ceremony the Sand Chief gradually spirals into Walpi on successive days to hasten the rain clouds.[57] A very similar circuit is performed at Zuni during the winter solstice ceremonies; a Zuni cornmeal diagram illustrates a spiraling ritual circuit to the six directions and center (see fig. 104).[58] A similar series of spirals appears on a Jornada-style petroglyph from the vicinity of Cooks Peak, New Mexico (see fig. 105). These spirals contain a pair of Tlaloc eyes as well as halved versions of the stepped rain cloud often appearing with Jornada style Tlaloc figures (see fig. 106). As with the Mesoamerican double spiral, the spiral and half-cloud combination probably portrays churning clouds carried by wind.

103

FIGURE 103
Spiral wind petroglyphs (after Fewkes 1892, pl. 2)

FIGURE 104
Zuni cornmeal diagram of six directions and center (after Cushing 1892, fig. 32)

FIGURE 105
Jornada-style petroglyph of Tlaloc image with wind spirals and halved cloud signs (after Schaafsma 1990, fig 12.12)

115

104 105

I have noted that the Puebloan kiva and the round wind temple of Mesoamerica are very similar in both meaning and form.[71] Although quadrangular in plan among the Western Pueblos, ancient kivas are usually circular in form. As in the case of wind temples, kivas symbolize the cave of emergence, or *sipapu*, a place frequently marked by a pit on the kiva floor. Much of the kiva ceremony concerns the conjuring of the ancestral katsina through the reenactment of the emergence. Just as the passage of air was manipulated in certain wind temples, ancient kivas frequently have elaborate masonry ventilator shafts. Although Cosmos Mindeleff posited that such architectural engineering was invented in nineteenth-century Europe, Fewkes cogently argued that these shafts circulated air within the kiva.[72]

An especially important trait shared between the kiva and the wind temple is the prominence of the plumed serpent. During both the Hopi Soyal winter solstice and Paalölöqangw ceremonies, impressive images of the plumed serpent are manipulated through temporary kiva screens. In Soyal ceremonies recorded by Stephen and Fewkes at Walpi, the principal Moñ Kiva contained a moving Paalölöqangw figure projecting out of a façade of carved flowers.[73] During the Paalölöqangwti kiva rites, the mother of the katsina suckles the plumed serpent, and similarly the grandmother of the Zuni katsina also nurses Kolowisi, whom she regards as her "favorite grandchild."[74]

The composition of two inwardly facing plumed serpents is one of the more common motifs appearing in kiva murals and is present not only at Zuni, Isleta, and Jemez but also in Kiva III at the Pueblo IV site of Kuaua.[75] Rather than being restricted to one wall, these great serpents tend to encircle the kiva, in effect creating an interior version of the serpent pair appearing on the exterior of the Calixtlahuaca wind temple.

The duck, another major figure in Puebloan rain and water ritual, spouts water from its beak in the Kuaua murals.[76] According to Fewkes, the Hopi duck katsina is "a powerful rain god" who intercedes with the clouds to make rain.[77] Among the Zuni the katsina rain spirits travel in the form of ducks.[78] In Zuni myth the lost and blinded Kiaklo, the "great father" of the katsina, was guided to Katsina Village by a wise duck sounding shell jewelry.[79] As the bearer and teacher of katsina tradition, Kiaklo appears at ceremonies with the duck and shell jewelry, recalling the shell-bedecked duck wind god, Ehecatl-Quetzalcoatl.

Among the more important figures of Zuni ritual and myth is Pautiwa, the chief of Katsina Village, who sends and controls the katsina rain spirits and the corn maidens. Jane Young has noted that the Zuni ideals of beauty, grace, and kindness ascribed to Pautiwa accord well with attributes of Quetzalcoatl, but even more notable is that Pautiwa is a duck being. He also has a major role in the winter solstice ceremonies, spiraling, windlike, into the community: "Pautiwa proceeds with a slow, even tread. He circles around the village, four times, coil fashion."[80] Upon entering Zuni, Pautiwa throws balls of fine cornmeal into the kivas, where they are ritually inhaled by the kiva leaders, who state: "Now he has brought into us the warm breath of summer so that we can have good crops."[81] The duck bringer of maize, clouds, and warm summer breezes, Pautiwa is notably similar to Ehecatl-Quetzalcoatl.

In the American Southwest, as in ancient Mesoamerica, flowers are closely identified with music and dance. In contemporary plaza dances Hopi katsinas commonly grasp gourd rattles marked with flowers as well as flower effigies emitting the *hi'ksi* breath cord, a Puebloan version of the breathlike aromatic volutes appearing with Mesoamerican flowers (see fig. 111).

For the Hopi and Zuni, reed flutes symbolize summer warmth, rain, and flowers. In Zuni mythology the preeminent flute player is the youthful Paiyatamu (see fig. 112). Cushing noted that the Zuni instrument, "a long, beautifully painted flute of cane, trimmed with a bell-shaped gourd ornament and feathers at the lower end," is played directly over a bowl of water.[82] In the accompanying illustration, the vessel is clearly the medicine bowl widely used for rainmaking (see fig. 113). With its stepped rim, the gourd end of the flute replicates the bowl form.

During the summer flute ceremony the Hopi of Walpi also play the sacred flutes over water, blowing them in spring pools to create bubbles.[83] The Hopi flute performance and gathering of water at springs constitute a rainmaking act, the bringing of water to the Hopi towns.[84] The Hopi sacred flute also has a bell-like, cut-gourd mouth, in this case explicitly described as a flower (see fig. 114),[85] and is thus identical in concept to ancient Mesoamerican flutes with floral mouths (see fig. 102). A cotton cord with a tied feather known as *len hi'ksi*, meaning "flute breath"—emerges from the mouth of the Hopi instrument.[86]

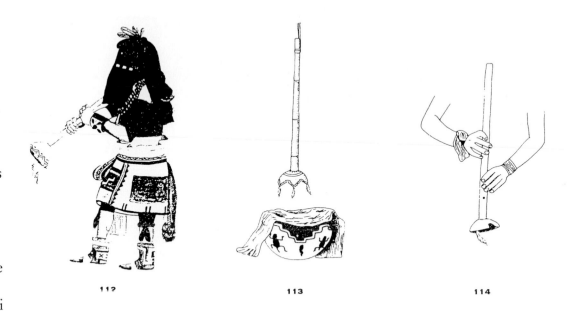

112 **113** **114**

Harbinger of the summer, the cicada is the voice of the Hopi flute, and the flute ceremony is a ritual reenactment of the emergence.[87] In this regard, Navajo emergence mythology is particularly illuminating. During the Navajo emergence, the first people came up through a great hollow reed, aided by wind and cicada.[88] Navajo singer Jeff King notes that the emergence reed contains a "little white string" for supernatural travel, clearly relating to the cotton and feather breath cord of the Hopi flute and the *pöötavi* string road on which katsina journey.[89] In a Navajo emergence account recorded in 1885, the great reed through which cicada emerges is a four-holed flute: "The first hole was for Black Wind, second for Yellow, third for Blue, and fourth White, and these winds guarded the holes in the flute."[90] Both the Hopi and Zuni share the belief that the first people emerged from a hollow reed assisted by cicada.[91] For the Hopi, the hollow reed more explicitly and directly

111

119

FIGURE 111
Flower images with feather breath cords held by Hopi katsina dancers (after Wright 1973, 105, 236)

FIGURE 112
Paiyatamu, Zuni katsina of flowers and music, with floral flute (from Wright 1985, pl. 19d)

FIGURE 113
Zuni sacred flute hanging over stepped medicine bowl (after Fewkes 1920, fig. 8)

FIGURE 114
Hopi sacred flute with *hi'ksi* breath cord (after Wright 1979, 82)

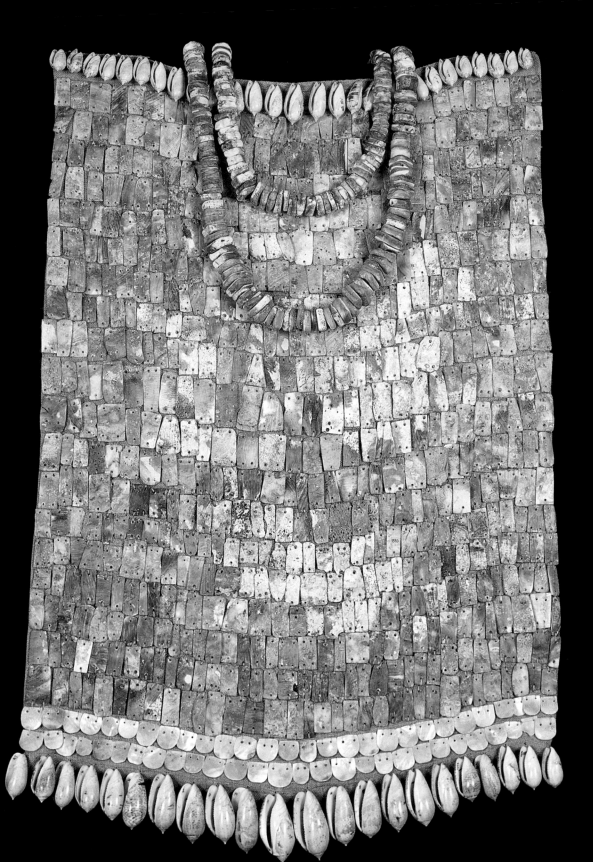

relates to the emergence and, according to Armin Geertz, constitutes the pivotal *axis mundi*.[92] Stephen collected two myths from First Mesa describing cicada playing music atop the reed of emergence, in one case blowing the flute. The other account mentions that cicada sang to make the reed grow, and a pair of painted tiles from the flute ceremony portray cicada blowing his flute over a plant, quite probably the growing reed.[93] The reed of emergence is a great flute, and its music is the breath wind of the ancestors.

The wind complex of Mesoamerica and the American Southwest is of great antiquity, with many of the more striking traits already present among the Formative Olmec. One of the basic concepts is the dynamic role of wind in creating rain by lifting water into the sky. Among the Olmec, this is graphically displayed by the cave relief at Chalcatzingo and by crocodilians and ducks breathing clouds of smoke and rain. Another essential wind metaphor, the raising and carrying of water jars, is also widespread in Mesoamerica and the American Southwest, and is frequently combined with breath imagery. In the American Southwest rising bubbles conflate the concepts of moving air and standing water. Mention has been made of the bubbling hot spring of Kolowisi, and similarly the original Hopi *sipapu* is a fiercely bubbling spring in the Grand Canyon. This place of emergence is ritually replicated by the stepped Hopi medicine bowl, in which the ancestral spirits are conjured by a bone whistle blown into the water, a miniature version of the sacred flutes blown into Sun Spring at Walpi.[94] Among the Olmec and later Mesoamerican and Southwestern cultures, wind is perceived and portrayed in spiral form, denoting its powerful, dynamic quality. In both form and function, the conch trumpet evokes the wind, as does shell jewelry. Along with the spiral shell

ornaments of Ehecatl-Quetzalcoatl, there is also the shell necklace sounded by duck to guide the Zuni Kiaklo. A water-dwelling but also flying creature, the duck serves as a widespread symbol of cloud-bringing wind.

Another essential creature of the wind complex is the plumed serpent. Although the feathers of the Mesoamerican version have usually been interpreted as alluding to avian flight and preciousness, these feathers may also incorporate the concept of breath and the breath soul. The great feathered serpents sculpted on the Xochicalco temple exhale long feathers from their nostrils, indicating that breath constitutes the essence of these plumed beings. Moreover, the *Cantares Mexicanos* describes the soul "drifting as a feather into Spirit Land."[95]

The wind complex is a cult of beauty, based not on physical force or painful and bloody sacrifice, but on the gentle and passive concept of attraction through sweetly scented flowers, incense, music, and dance. As a butterfly to a flower or a bird to song, the rain spirits are ritually attracted and compelled to supply rain and fertility. This is the function of the splendid katsina dances: "The deities are naturally attracted by beautiful objects. When the deities see elaborate and brilliantly decorated katsina personators, they say, 'Aha, what beautiful objects are those, they must be the admirable kachina of the Hopi!'"[96] The Zuni katsina chief, Pautiwa, is famed for his generosity and beauty, and these are qualities also ascribed to Quetzalcoatl. The wind complex entails an aesthetic ethos based on life and fertility, a belief system that continues to inspire and enthrall.

FIGURE 115

SHELL COAT OF ARMOR
Mexico, Hidalgo, Tula, 9th–12th century A.D.
(Cat. no. 162)

121

NOTES

I am indebted to Dominique Rissolo for introducing me to literature concerning the physics of breathing caves. I also wish to thank Virginia Fields and Karen Jacobson for their editorial help and suggestions. Finally, I am grateful to John Clark and the New World Archaeological Foundation for allowing me to reproduce the drawing of the San Isidro cache.

1. Florescano 1999, 29.

2. McNeley 1981, 1.

3. Sahagún 1950–82, vol. 8, 14.

4. Hill 1992; Hays-Gilpin and Hill 1999.

5. Bunzel 1932a, 516.

6. López Austin 1988, 56.

7. Schaafsma 1999, 184.

8. Garibay 1965, 26.

9. Schaafsma 1999, 181.

10. Reichard 1963, 164.

11. Groark 1997, 25.

12. Monaghan 1995, 107.

13. McNeley 1981, 8–21.

14. Wigley and Brown 1976, 330, 333.

15. Quiñones-Keber 1995, 165.

16. López Austin 1988, 199, 209; Sahagún 1950–82, vol. 6, 202–3.

17. Zolbrod 1984, 287.

18. Wymann et al. 1942, 15.

19. Cushing 1920, 417.

20. Bunzel 1932a, 481.

21. Voth 1905, 116.

22. Geertz 1988, 18.

23. Bunzel 1932b, 193.

24. Thompson 1970, 269.

25. See Gay 1972, fig. 11.

26. Ellis and Hammack 1968, 39.

27. Angulo 1987, fig. 10.12. There is a natural cave centered directly at the base of the western side of Cerro Chalcatzingo, between Monuments 1 and 13. It is readily possible to penetrate some twenty feet into the cave, despite its being filled with boulders and alluvium. A perennial spring just below this cave has boulders with deeply carved cupules, of the same type found in the streambed next to Monument 1. Although the cave awaits documentation and study, it may well be the actual cave that appears repeatedly in the art of Chalcatzingo.

28. Houston and Stuart 1990.

29. Angulo 1987, 137.

30. A very similar concept is portrayed on Zoomorph P at Quirigua. This Late Classic Maya monument depicts a massive crocodilian with breath volutes in the corners of its mouth. Within both breath curls are images of Chaak carrying water jars, clearly portraying the crocodilian earth breathing the Maya rain god into the sky.

31. Coe 1968, 114.

32. Sahagún 1950–82, vol. 11, 84.

33. See Lumholtz 1900, 73; Monaghan 1989.

34. Pohorilenko 1996, 126–27.

35. Stephen Houston, conversation with the author, 1999.

36. David Grove, in Fash 1987, 87.

37. Sahagún 1997, 156.

38. Lumholtz 1900, 41.

39. Monaghan 1989.

40. Bierhorst 1992, 145.

41. O'Mack 1991.

42. Sahagún 1950–82, vol. 11, 36.

43. Sahagún 1950–82, vol. 7, 56.

44. The concept of the breath cord was clearly present among the Classic Maya. Stela 40 of Piedras Negras portrays a long breath cord emerging from a deceased queen in a tomb. Like the Mixtec and Hopi examples, the rope is marked with bound feathers.

45. Pollock 1936, 7–9, 50.

46. Taube 1986.

47. Schavelson 1985.

48. Durán 1971, 134.

49. Taube 1986.

50. Garibay 1965, 111–12; Mendieta 1980, 80.

51. Mendieta 1980, 97.

52. Seler 1990–98, vol. 5, 301.

53. Bunzel 1936a, 517; Kealiinohomoku 1989, 58

54. Wyman et al. 1952, 14–15.

55. Reichard 1963, 572.

56. Fewkes 1892, 20.

57. Parsons 1936, 773, 780.

58. Cushing 1892.

59. Parsons 1939, 370–72.

60. Stevenson 1904, 21; Bunzel 1932a, 484.

61. Carlson 1982.

62. Fewkes 1892, 22.

63. Haeberlin 1916, 23.

64. Stevenson 1904, 101, 94, 95; Stevenson 1887, 549.

65. Parsons 1923, 145, n. 9.

66. See Parsons 1936, 1010–11.

67. See Fewkes and Stephen 1893; Fewkes 1898b; Parsons 1936, 12–18, 287–349; Titiev 1944, 121–23; Geertz and Lomatuway'ma 1987, 217–39.

68. Fewkes 1898, 83; Parsons 1936, 299.

69. Parsons 1936, 321.

70. Titiev 1944, 123.

71. Taube 1986, 74–75.

72. Mindeleff 1891; Fewkes 1908.

73. Fewkes 1898b; Parsons 1936, 1–29.

74. Wright 1985, 56–57.

75. Brody 1991, figs. 115, 122; Dutton 1963, 97–104.

76. Dutton 1963, figs. 82, 92.

77. Fewkes 1893, 295.

78. Bunzel 1932a, 517.

79. Wright 1985, 51.

80. Young 1994, 114; Stevenson 1904, 138.

81. Bunzel 1936b, 910.

82. Cushing 1920, 385–86.

83. Parsons 1936, 815.

84. Titiev 1944, 148.

85. Parsons 1936, 1245; Wright 1979, 82. A flute effigy from Walpi portrays the flute mouth as a four-petaled squash blossom (Parsons 1936, fig. 192).

86. Wright 1979, 82.

87. Titiev 1944, 149; Parsons 1939, 1042; Geertz 1987, 10. In many accounts, the insect helper is referred to as "locust," an unfortunate choice of terms, as this word means either a form of grasshopper or a cicada. Other sources, however, identify the creature as a cicada (Reichard 1950, 19).

88. Oakes and Campbell 1969, 21; Zolbrod 1984, 74–78.

89. Oakes and Campbell 1969, 23.

90. Stephen 1930, 101.

91. For Zuni, see Stevenson 1887, 540; Bunzel 1932c, 588–89.

92. Geertz 1984.

93. Stephen 1930, 5–7. More specifically, the reed on the Walpi tiles probably represents the Flute Society standard placed on Sichomo, Flower Mound. This hill represents the dwelling place of Mu'ingwa, however, the middle place of the underworld. The standard represents the reed passing from underworld to sky.

94. Geertz 1984, 222–23, 232.

95. Bierhorst 1985, 349.

96. Parsons 1936, 216.

Goggle Eyes and Crested Serpents of Barrier Canyon

Early Mesoamerican Iconography and the Archaic Southwest

James D. Farmer

This essay originated as an investigation of a simple hypothesis, that variations on some of the most deeply rooted iconography associated with ancient Mesoamerica exist in early rock art from the American Southwest. Specifically, I suggest that images of crested serpents and goggle-eyed figures occurring throughout Barrier Canyon Anthropomorphic style pictographic rock art centered in Utah are iconographically analogous to the better-known plumed serpent and Tlaloc images commonly associated with central Mexico.

In a broader sense, however, this issue addresses a long-running debate over the relationship between the ancient Southwest and Mesoamerica, at least as far as these areas have traditionally been archaeologically defined. Ultimately, the central philosophical issue has been the relative cultural autonomy and sovereignty of the ancient Southwest in relation to apparently more developed, sophisticated pre-Columbian cultures to the south. The tide of opinions in this debate ebbed back and forth throughout the late nineteenth and twentieth centuries, ranging from one extreme position that supported strong, independent prehistoric Southwestern culture histories with little direct influence from Mesoamerica, to the just as extreme opposite position that the Southwest was essentially the northernmost portion of a greater Mesoamerican culture area; only occasionally were moderate compromise positions championed.

This Southwestern "problem" has been debated ever since the first formal anthropological inquiries into prehistoric Southwestern culture were initiated in the mid-nineteenth century. Early explorers and anthropologists such as Adolph Bandelier accepted the basic belief that most, if not all, of the major ancient remains in the Southwest were ultimately the result of Mesoamerican influence, hence the numerous Mesoamerican (usually Aztec) misnomers given to many Southwestern sites (Aztec Ruins, Montezuma Castle, etc.). After the publication of A. V. Kidder's *An Introduction to the Study of Southwestern Archaeology* in 1924, and the subsequent Pecos Conference in 1927, however, the pendulum began to swing to the other side. For much of the twentieth century the dominant anthropological view was of strong, independent Southwestern traditions, especially in the northern Anasazi-Pueblo area of the Four Corners region, with only minimal and sporadic foreign contact or influence. As the twentieth century drew to a close, this debate was no closer to a general resolution than when it originated; archaeological evidence and interpretations continue to support both positions.[1]

The theoretical implications of this debate for understanding the early art of ancient Southwestern cultures are particularly profound. If one accepts the "independent Southwest" position, then the occasional similarities in form and content between Southwestern and Mesoamerican art and architecture would merely be coincidental examples of convergent yet independent invention. One must also explain (or perhaps explain *away*) how two areas so culturally sophisticated and developed by the fifteenth century could have evolved to such a level without intense awareness and interaction with each other, given the equally deep overall archaeological records for both areas.

The "greater Mesoamerican" position, however, implies a general lack of either a long, sustained tradition or general cultural initiative within the Southwest. If the major achievements in art and architecture were ultimately the result, either direct or indirect, of Mesoamerican influence, then the Southwest as both a distinct culture area and tradition really did not merit much independent recognition.

While the Southwest was still generally regarded as separate and categorically different from Mesoamerica, a significant amount of anthropological scholarship commencing in the 1970s developed a revised model of ancient Mesoamerica, suggesting that its northernmost boundary be extended to include the Southwest.[2] Even under this revised scenario, however, central Mesoamerica is still the "big brother" protagonist, initiating intrusive acts of cultural aggression against a normally passive, receptive (and implicitly less sophisticated) Southwest.

A second movement also originating in the 1970s, not from academic or anthropological arenas but from a more popular social perspective, has cast a somewhat different light on this issue. The coalescence of a strong, formal Chicano movement, based primarily throughout the Southwest, united people of differing Latino backgrounds under a cultural rubric that incorporates as one of its legitimizing strategies the Aztec creation myth of Aztlan, a mythic homeland located somewhere to the north and west of modern-day Mexico City and the ancient Aztec capital, Tenochtitlan.[3] The Aztec creation myth is revisited further on in this essay, but at this point it is sufficient to point out that this debate over the Southwestern "problem," long reserved for the academic arena, has now taken on a type of popular currency beyond that arena. In a sense this makes the

issue even more significant for understanding this aspect of pre-Columbian cultural history.

The intent of this essay then is simply to offer an art historical perspective on this issue, without recourse to either supporting or denying the prevailing anthropological models and theories. I believe that the artistic record for the Southwest, viewed in wide focus, offers evidence for both positions or, perhaps more appropriately, a negotiated compromise between the two.

THE BARRIER CANYON ANTHROPOMORPHIC STYLE

The focus of this essay is a pictographic rock art style centered in present-day Utah, oriented along the Colorado River drainage (see fig. 116). Polly Schaafsma originally identified the style in 1971 as the Barrier Canyon style, later changing the title to the Barrier Canyon Anthropomorphic style (henceforth BCA style), after a specific canyon located in present-day western Canyonlands National Park.[4] Schaafsma originally identified nineteen BCA sites, but by the 1990s the known number of BCA sites was well over one hundred. Schaafsma originally dated the style between around 500 B.C. and A.D. 500, but more recent analyses have suggested an earlier beginning date of around 1500 B.C.[5] Ancient rock art is abundant in the American Southwest, equal in quality, quantity, and diversity to the great rock art traditions of northern Africa, western Europe, and northern Australia, among others. Between California and Texas and from Wyoming to Baja California, hundreds of distinctively painted and carved rock art styles were produced from at least as early as 1500 B.C. until well into the present era. It has also become more apparent, however, that the BCA style represents one of the earliest great painting traditions in the Americas, and it is in this spirit that it is considered here, not as an extinct example of ancient

126

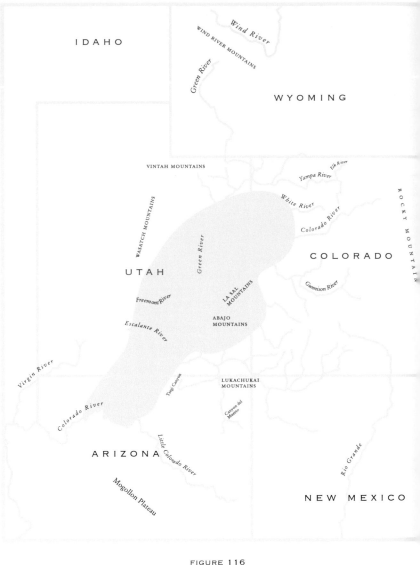

FIGURE 116

Map showing the distribution of Barrier Canyon Anthropomorphic style rock art

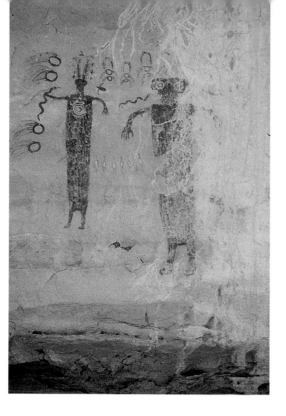

rock art, but as the early stages of a sustained artistic tradition.

It is important to note that the BCA style is not the oldest rock art style in the area; several other Archaic period styles are probably older, but the BCA style represents a notable change in form (and probably content) from these earlier styles.[6] As its name implies, the BCA style is dominated by large anthropomorphic figures in both static and narrative compositions, along with numerous other representational images of figures, animals, and plants. This is a radical departure from previous Archaic styles, which were dominated by abstract, geometric motifs with only occasional, highly abstracted or simplified human or animal figures.[7]

Discussions of prehistoric rock art automatically invite serious interpretive problems. It is notoriously difficult to positively date, other directly associated cultural materials (i.e., other art forms) frequently do not exist, and rarely is there any direct ethnographic connection to historic cultures. Each of these problems applies in particular to the BCA style. Because of this, more importance is placed on a strict and disciplined formal analysis combined with a minimal contextual approach to the iconography.

Several specific formal characteristics define the BCA style.[8] The dominant motif is an elongated anthropomorphic figure depicted in various shades of a blood-red hematite, though other hues were available and

occasionally used (see fig. 117). The variation in scale is impressive, with the figures ranging in size from more than seven feet tall to less than one inch. The larger figures tend to be static and frontal with appendages and body features minimized or absent, while smaller figures are frequently depicted in dynamic narrative scenes. Animals and occasionally plants often accompany the anthropomorphic figures, sometimes interacting directly in the smaller scenes. BCA-style panels commonly occur along the back walls of high cliffs or alcoves cut into deep sandstone canyons, providing a high degree of public visibility (see fig. 118). Figures or entire panels are often located well above normal human reach, suggesting the use of some type of scaffolding for paint application. The wide variation in figure size, however,

FIGURE 117 (ABOVE LEFT)
Head of Sinbad, site #1

FIGURE 118 (ABOVE RIGHT)
View of the Great Gallery
Panel, Canyonlands
National Park

creates multiple viewpoints for many panels. While the largest figures can be seen up to one-half mile away at times, smaller figures (often interacting directly with the larger figures) are visible only from within a few inches of the rock surface. Rather than establishing an optimal fixed point of view, BCA artists created a dynamic interactive experience incorporating both vision and motion. Many BCA alcove sites include a shallow rock shelf or staging area above the natural surrounding ground level. The painted panels appear on the wall above this shelf, creating an amphitheater-like environment for the display of the panels, with attendant variations in viewing distance.

The painting methods employed by BCA artists are also noteworthy. A wide variety of application devices were used, including pebbles and very small brushes of no more than two or three bristles for fine lines; extremely large brushes, probably of animal fur, for areas of pigment up to one-eighth-inch thick; direct application of pigment by rubbing or finger-painting, and splattering or spraying with fingers or by spitting. The sandstone cliff surface was occasionally prepared by smoothing prior to painting, and a sharpened object such as a stick or bone was sometimes used like a stylus to incise lines and patterns into the painted form, revealing the underlying cliff surface in a type of negative design. BCA artists may even have developed a concept of illusionistic spatial perspective, as some compositions seem to reflect knowledge of diminishing figure size or linear perspective (see fig. 119).[9] At the very least, BCA artists were extremely skilled specialists, not afraid to display their abilities to the world. Their paintings were planned and premeditated, not idle, spur-of-the-moment responses. Such formal and technical sophistication is unparalleled in any other Southwestern rock art tradition and, in some ways, unsurpassed in any other Southwestern art form until the arrival of European technologies. It is difficult to

conceive of such sophistication without an equal degree of underlying intellectualism and a comparably sophisticated belief system or worldview.

While the formal and technical characteristics of BCA-style paintings are relatively easy to analyze, the content and subject matter of the scenes are more difficult to assess. Nevertheless, it is precisely the subject matter of the BCA panels that is most pertinent to this essay. Nothing is known of BCA language or origins, or the specific relationship to other contemporary Southwestern groups. Archaeologically, very little attendant material culture can be directly associated with the BCA style or BCA sites. BCA artists were presumably nonsedentary, nomadic hunter-gatherers, part of the dominant Archaic lifestyle found throughout the Southwest between c. 6000 and 200 B.C.[10] It would appear at the

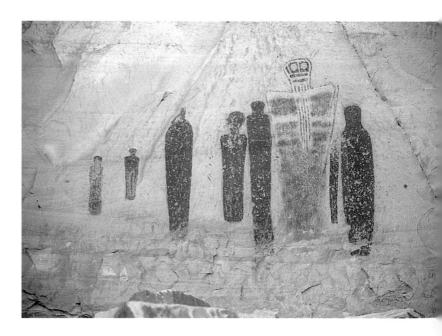

FIGURE 119

The Great Gallery "Holy Ghost" panel

very least that BCA sites were considered sacred and perhaps strictly reserved for specific rituals rather than more domestic or profane activities.[11] Most BCA sites are located along ancient trail routes or adjacent to large open meadows or valleys, prime locations for hunting and collecting, but the sites themselves show no evidence of extended occupational use.

A second problem is the apparent archaeological extinction of the style and its lack of prehistoric or historic descendants, either stylistically or culturally. No known historic Native American groups claim any direct descent from or knowledge of the painters of the BCA style (although neither in fact do they deny any long-range connection). Because of this, it is difficult and risky to suggest analogous interpretations of BCA subject matter based on similarities to historic Native American symbolism and iconography. At the same time, however, more archaeological evidence has come to light to support the premise that, at least in part, later sedentary agricultural groups such as the Anasazi of the Four Corners area, the ancestors of later historic Puebloan peoples, were descended from earlier Archaic cultures.[12] Some degree of cultural continuity between the BCA style and modern Southwestern culture may exist, at least in theory.

BARRIER CANYON CRESTED SERPENTS

Despite the apparent theoretical obstacles to the interpretation of BCA subject matter, a few basic motifs and themes can be identified. Numerous animals appear in BCA imagery, but the most interesting for the purposes of this essay are serpents and their variations. Pure natural serpents appear frequently, often in the grasp of large BCA figures (see fig. 117). Many other serpent images are in fact not ordinary serpents, however, but are better described as crested serpents (see fig. 120).

FIGURE 120 (LEFT)
Barrier Canyon Anthropomorphic style crested serpents from Utah (all painted red, except b): (a) Wild Horse Canyon, (b) Rochester Creek petroglyph, (c) Prickly Pear Flats, (d) Buckhorn Wash, (e) Calf Canyon, (f, g) Head of Sinbad

FIGURE 121 (BELOW)
Detail of panel in Wild Horse Canyon

129

They have distinguishable arms or legs with appendages and prominent head crests, and usually appear with anthropomorphic figures in small narrative compositions, investing them with a sense of the fantastic or the supernatural (see fig. 121). They often appear to be free-floating or "flying," but apparently never in direct physical contact with or in the grasp of the figures, unlike the naturalistic serpents. Compositionally, however, the crested serpents are commonly depicted in some direct relationship with the anthropomorphs.

In addition, the crested serpents are frequently combined with bird images. Serpents and birds are often

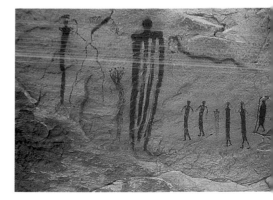

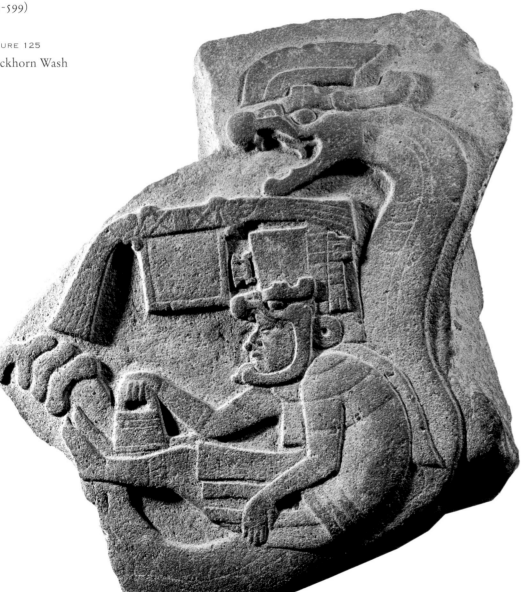

from two samples in Canyonlands National Park produced a date range between approximately twenty-seven hundred and thirty-four hundred years ago.[18] A number of BCA panels are overpainted with later non-BCA styles such as Fremont, Anasazi, and Ute, all of which are more securely dated no earlier than perhaps A.D. 200–300.[19]

Within standard North American chronology (and considering regional variations), the period between c. 1500 B.C. and A.D. 500 coincides with the mid to late Preclassic and Early Classic periods of Mesoamerica. This makes the BCA style contemporaneous with both the great Olmec and Teotihuacan cultures of Mexico, among others. Between c. 1500 and 500 B.C. the Olmecs emerged from the southern coastal area of the Gulf of Mexico to dominate most of present-day central Mexico, from the Yucatán Peninsula and the southern coast of Central America to coastal Veracruz and the Pacific coast of West Mexico, including the central valley of Mexico.[20]

No direct archaeological evidence exists of Olmec presence extending into the Southwest, but Olmec sculpture is credited with the earliest appearance of feathered serpent imagery in Mesoamerica. Specifically, La Venta Monument 19 is often cited as evidence for the early presence of the feathered serpent in Preclassic Olmec culture and the possible ancestor of later Classic period feathered serpent iconography throughout Mexico.[21] Dating to c. 900 B.C., Monument 19 was found in the southern Gulf Coast heartland, and by c. 500 B.C., at the height of Olmec influence (and the BCA style), similar feathered serpent imagery had spread as far as the central Mexican site of Chalcatzingo. The La Venta Monument 19 image of an Olmec priest or ruler in the embrace of a crested serpent bears an uncanny, if not exact, resemblance to the scene of a coiled BCA crested

serpent addressing a BCA shaman figure from a panel in Buckhorn Wash, Utah (see figs. 124, 125). Accepting the current BCA dates, these two images may well have been contemporaneous. The implication of this coincidence is either that the BCA style was in some distant way a part of the general Olmec horizon throughout greater Mesoamerica beginning around 1500 B.C. or that similar crested serpent iconography developed independently in the Southwest at about the same time.

When considering the BCA style in the overall development of ancient Southwestern iconography, the artistic record for the ancient Southwest does not clearly support the idea of intrusive influence emanating from a culturally *different* Mesoamerica, or a process of acculturation between two artistically disparate areas. The artistic evidence suggests that the Southwest viewed its southern neighbors *not* as foreign, exotic "others," but rather as cultural cousins, developing different regional styles but sharing a basic iconography. Following the BCA period, crested serpents and goggle-eyed figures reappear in later Anasazi and Pueblo styles sometime after A.D. 700 (see fig. 126). Except for the bowl illustrated here (fig. 126A), each of the other examples shown has been offered up by one scholar or another as evidence of Mesoamerican influence on the Southwest. Despite the iconographic parallels, however, there is a noticeable lack of any artwork in the Southwest during this period bearing any strong *formal* similarity to its supposed Mesoamerican counterpart. One particular image is especially compelling. Schaafsma identified this image (fig. 126D) as a version of Tlaloc, suggesting direct Mesoamerican influence in the Southwest in the fourteenth century. Mesoamerican contact may have been present, but Schaafsma's description of these Tlaloc figures might also easily be applied to earlier BCA-style figures: "abstracted anthropomorphic designs consisting of a trapezoidal or

Quetzalcoatl and the Horned and Feathered Serpent of the Southwest

POLLY SCHAAFSMA

Quetzalcoatl of Mexico and the horned and feathered serpent of the American Southwest are ancient and complex supernatural beings who share a kaleidoscope of meanings through time and space. These composite deities, who have metaphorical roots in cosmic uncertainties, play multifaceted roles in the philosophies and worldviews of both culture areas. Although they often incorporate similar personalities or traits, suggesting a historical relationship, their various manifestations reflect vastly different social milieus. In the complex urban world of Mesoamerica, Quetzalcoatl, the plumed serpent, along with Tollan, the idealized city, became a symbol of place and the authority of place.[1] In the small farming villages of the Southwest, the cosmological (as opposed to historical and political) aspects of the supernatural serpent prevailed.

The feathered serpent of Mesoamerica is a widespread symbol that has endured for more than two millennia, crossing ethnic and political boundaries. This serpent personage, who embodies elements of both earth and sky, is an ever-changing, ambiguous, multicomponent being. Quetzalcoatl as such is a phenomenon of the Epiclassic period (A.D. 700–950) in Mesoamerica, when new elements contributed to the complicated identity that the feathered serpent assumed in its later phases. During these years the deity, linked with Tlaloc, the Meso-american rain god, became the focus of a "world religion."[2]

An exploration of the symbolism of the horned serpent of the Southwest, based both on prehistoric images and on ethnographic accounts, suggests that this serpent deity is a somewhat reduced northern incarnation of the Mexican plumed serpent. The horned serpent, which may also be feathered, does not appears to be derived from ideas in place in the Southwest from the earliest beginnings of agriculture but is instead associated with a rich complex of metaphors derived from Mexico after A.D. 1000, which for 150 years or so appears to have been confined to the Mimbres and surrounding region. The parallels with the Mexican plumed serpent are not along the lines of formal imagery but in the concepts that are signaled by the late prehistoric iconography and preserved in ethnographic Pueblo texts and narratives. Late prehistoric depictions of the horned serpent in rock art and kiva murals suggest that his repertoire of meanings and symbolic vocabulary were once even more varied than ethnographic accounts several hundred years later indicate.

Due to spatial constraints, this essay highlights only some of the shared aspects and deeper cultural metaphors that these feathered serpent deities represent.

QUETZALCOATL

The plumed serpent of Mexico represents a variety of ideas and concepts, which must be considered in their many cultural, temporal, and iconographic contexts. The serpent is frequently dual or even triple in nature. Dualism, fundamental to Nahuatl cosmology, has the quality of being something more complete and all-encompassing. As Miguel León-Portilla has pointed out, a dual principle was the origin of all things. Ometeotl and his female counterpart, Omecihuatl, represented the duality that was responsible for the creation of the universe, including all the gods and humankind. Richard Townsend has noted that in the re-creation of humankind at the beginning of the present era, Quetzalcoatl and his assistant,

Cihuacoatl, are essentially equatable to the primordial male-female creative pair. Yet, to quote Inga Clendinnen: "Our notions of 'opposition,' or even of 'duality' or 'complementarity,' are unhelpfully crude, as apparently firm divisions waver and melt one into another. Relationships were revealed not through differentiation, but through permutations and transformations, and spoke more clearly of connection than opposition. Only by way of interrelationships did each part yield its meaning." Thus, in pursuing the many meanings that Quetzalcoatl embodies, one is cautioned against identifying crisp, clear, unchanging notions about the character of this supernatural.[3]

Regardless of where one pinpoints the earliest icon of Quetzalcoatl in the temporal sequence, the cosmological roots of this figure were being expressed in various art forms in ancient times, the feathered serpent being one of the most persistent images in Mesoamerica. Precedents for the feathered snake uniting earth and sky may be found in Mexican iconography beginning with the Olmecs (c. 1500 to c. 500 B.C.). Through the centuries the feathered serpent occurs in various media as a spirit of terrestrial waters, a jaguar-serpent, a winged sky serpent that combines the attributes of bird and snake, and "la serpiente emplumada preciosa" of the rain clouds.[4] Karl Taube has traced Quetzalcoatl's origins to Early Formative Olmec cave paintings in Guerrero.[5] Others assert that the first indisputable plumed serpent per se comes from Teotihuacan in the second century A.D. Here, on the so-called Temple of Quetzalcoatl, sea conches secure the feathered serpent's references to water and wind (see fig. 128).[6] Here also the feathered serpent is paired with an enigmatic saurian head, which has been explained in various ways.[7] Paired circles on the trapeze forehead or headdress of the figure have led to its interpretation by John Carlson as a "Storm God-related Tlaloc Venus War Serpent Monster."[8]

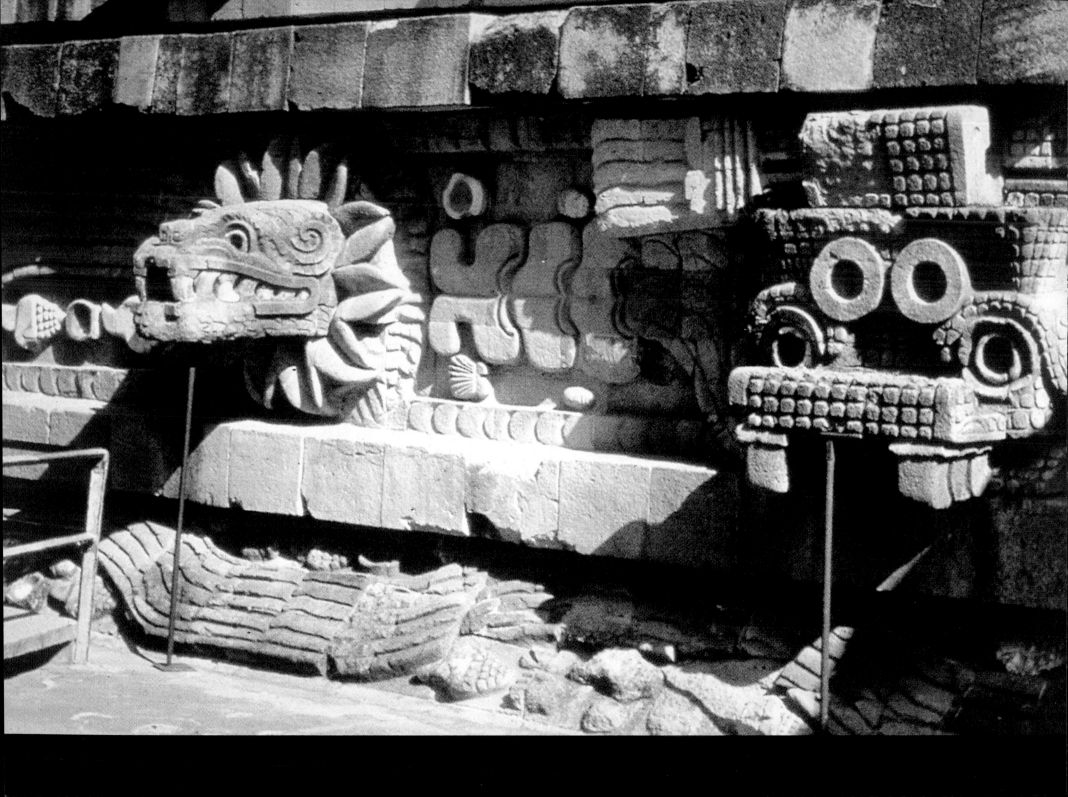

With the end of the Classic theocracies, the cult spread in Mesoamerica, developing local variations while maintaining its unity.[9] From the earliest times to the Aztecs, the plumed serpent of Mexico was a symbol of fertility and the regenerative powers of the earth. In Epiclassic and Postclassic Mexico, however, these qualities were strengthened or elaborated as they were combined with new associations from outside the Valley of Mexico. Like the Aztec Mixcoatl, the cloud serpent, Quetzalcoatl became linked with hunting and the northern areas of the Chichimecs. A duality with Ehecatl, the Huastec god of the winds that initiate the rainy season, was also secured. In the aspect of Ehecatl, Quetzalcoatl continued in the role of a creator deity associated with fertility, and the symbolism of the conch shell—representing the wind, divine breath, generation, and birth—became more prevalent. A conical cap and buccal mask distinguish this supernatural.

The Epiclassic feathered serpent cult is linked with Tlaloc, an association foreshadowed at Teotihuacan (100 B.C.–A.D. 750).[10] Both Tlaloc and Quetzalcoatl are identified not only with water and fertility, however, but with war and destruction as well. The meaning of the feathered serpent was expanded from its primary cosmological link to creation and vegetal renewal to take on social significance, as this figure became associated with military conquests and political power. Esther Pasztory has suggested that the roots of the identification of a ruler-priest with the plumed serpent may be found at Teotihuacan.[11]

The Postclassic Quetzalcoatl became identified with Venus in its dual qualities as morning star (Tlahuizcalpantecuhtli) and evening star (Xolotl), with antecedents in earlier Teotihuacan iconography (see fig. 129). At Tula (A.D. 900–1200) there are more representations of Quetzal-

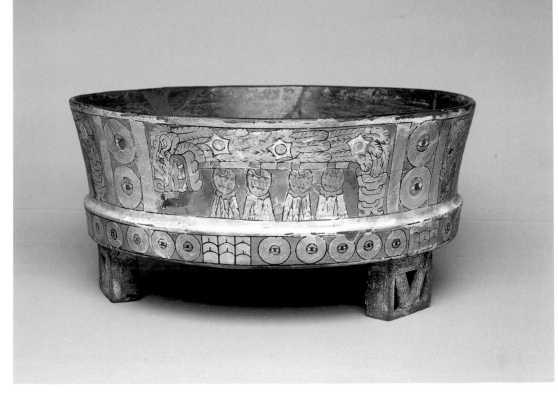

141

coatl as morning star than as a feathered serpent. Stars and Venus are associated with warfare in ancient Mesoamerica, and as a Postclassic avatar of Venus, the feathered serpent was associated with military might.

The cult of Quetzalcoatl may have been used to legitimize political control and rulership during the Postclassic in Mesoamerica.[12] The Nahuatl name Quetzalcoatl, signifying "hombre-pajaro-serpiente" (man-bird-serpent) was easily transferred to outstanding leaders during the Toltec era (A.D. 900–1200). By identifying themselves with the powers of the god, they could expand their political potential and strength. At the same time the cult ideology of Quetzalcoatl represented an institutional presence that transcended political boundaries as it also became affiliated with the elite, warriors, merchants, and social prestige.

FIGURE 128 (OPPOSITE)
Temple of Quetzalcoatl, Teotihuacan, with carved decoration of a feathered serpent and saurian head

FIGURE 129 (ABOVE)
VASE WITH FRESCO DECORATION
Mexico, Teotihuacan, c. A.D. 500
Ceramic, stucco, pigment
Diam: 13¾ in. (35 cm)
The Cleveland Museum of Art
(1965.20)

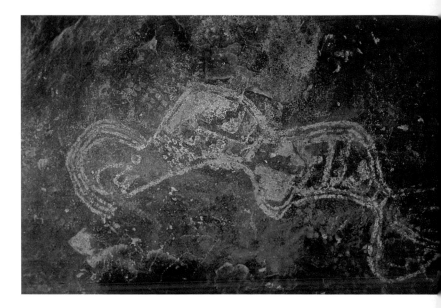

FIGURE 130 (RIGHT)

This large figure of the horned and feathered serpent, dated c. 1200–1400, is painted in white on the smoke-blackened ceiling of a rock shelter near the Rio Grande below El Paso, Texas, in the Jornada Mogollon region. Long plumes fall forward over the horn from the top of the creature's head. The body is covered with cloud motifs.

Postclassic and even earlier images portraying the face of a man emerging from the jaws of the feathered serpent synthesize man and deity.

During the Aztec period (1325–1521) the feathered serpent continued to be associated with the rainy season and the renewed fertility of the earth, although now it also recalled the Toltec ruler, Quetzalcoatl, and the legacy of the past.[13] Quetzalcoatl's role as a creator deity and culture hero is described in various sixteenth-century codices.[14] Mexica legends describe Quetzalcoatl as a bearded culture hero, linked to the origin of humankind and corn, and as the discoverer of the calendar.

Stories about the feathered serpent are still told in rural villages. John Monaghan describes Mixtec folktales from Oaxaca in which the serpent continues to be associated with the beginning of the rainy season. His skin is described as shiny, he carries all kinds of seeds, he lives in lakes and ponds, and he may bring torrential rains. According to one account, helicopters were called in to chase the serpent from a hilltop near Mexico City, where he had landed and was causing devastating floods.[15]

THE HORNED SERPENT OF THE SOUTHWEST

Following the initial dispersion of the cult of Quetzalcoatl in Mexico during the Epiclassic, the horned serpent appears in the imagery of small agrarian communities of the American Southwest.

The earliest representations occur on Classic Mimbres black-on-white bowls (A.D. 1000–1150).[16] As an aside, it is worth pointing out that this particular serpent is not present in the graphic traditions of the Colorado Plateau before 1300. Although snakes pictured in the rock art of the Anasazi and Fremont cultures occasionally have cephalic projections that may represent horns or, more rarely, antlers, indicating that they were imbued with meaning beyond that of the ordinary, these earlier ophidians are not the object of this discussion. The distinctive serpent with a large, tapering, forward-pointing single horn and caninelike head is the focus of our consideration (see fig. 130). In prehistoric depictions other mammalian features, such as ears and teeth, may be present. Only in the Pueblo rock art of the northern Tewa and Tiwa provinces, in the upper Rio Grande, does the horn usually point backward. Feathers on the head or body, a checkered neckband, and cloud symbolism are often part of its iconographic repertoire, and like the feathered serpent of Mexico, this figure is often shown in an upright position (see fig. 131).

In the handful of Mimbres pottery paintings of the horned serpent, this figure already displays a bewilderingly complex personality. A fishlike tail and fins, scrolls, and stepped cloud motifs bespeak an affiliation with water. Human protagonists wear his guise in two beheading scenes. In another example, a striped clown wears a

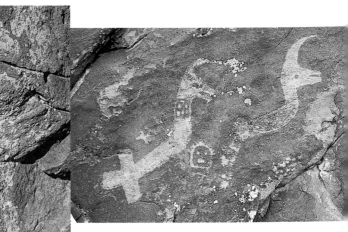

FIGURE 131

Paired horned serpents, central New Mexico, c. 1325–1672. Feathers hang from the angles of the bodies of the snakes, which are, in turn, marked with circular motifs.

FIGURE 132

A serpent with a man's head wearing a conical cap is juxtaposed to a macaw in a Mimbres region petroglyph in southern New Mexico, c. 1000–1400.

FIGURE 133

Petroglyph of the horned serpent, Galisteo Basin, New Mexico, c. 1325–1525. The checkered neckband is a typical feature of the horned serpent throughout the Southwest.

FIGURE 134

Pair of horned serpents, Galisteo Basin, New Mexico, c. 1325–1680. One has simple cloud elements on the tail.

horned serpent headdress. A petroglyph in the Mimbres region pictures a serpent with a man's head, seemingly bearded, and wearing a conical cap resembling the usual horn (see fig. 132).

Following the Mimbres, the horned serpent occurs in rock art from northern Chihuahua up the Rio Grande Valley to northern New Mexico. It also appears on ceramics and in kiva murals in these areas. Depictions of horned serpents in the Casas Grandes region and the Jornada Mogollon are dated between 1200 and 1450.[17] In the Pueblo region of the upper Rio Grande, the horned serpent does not appear until around 1325, along with mask images of katsinas, Pueblo rain-bringing supernaturals (see figs. 133, 134).

Features of the prehistoric horned serpent provide clues to its meaning. The checkerboard pattern of the neckband resembles the design representing maize in other late prehistoric Pueblo art, a staple with which he is significantly linked ethnographically (see below). The neckband could also indicate, however, a band made up of rows of small olivella shells, like the ones worn on the wrists of Pueblo dancers today. Contemporary effigies of the horned serpent wear necklaces of seashells, signifying this serpent deity's relationship to water. With a cloud on his tail, he becomes a metaphor for lightning. In late prehistoric rock art and kiva murals (1325–1525), stars, in addition to clouds and feathers, contribute to the deity's celestial aspect. Stars may be juxtaposed with the horned serpent, or a rattlesnake may wear a star mask, and such figures are often paired.[18] Hopis have said of this serpent deity, "Sometimes he looks like a shining star."[19]

In Space and
Out of Context

Picture Making in the Ancient American Southwest

J. J. Brody

Long before Europeans began to record the first written histories of the region, that part of the ancient northwestern frontier of Mexico that, in 1849, became the southwestern United States had many rich and complex pictorial traditions that bespoke an equally rich and complex history. A diversity of peoples had either passed through or lived in the region over the course of many thousands of years, and many of them left a pictorial legacy that is visible in the vast landscape or buried below it. Often an unbroken chain of traditional oral histories clearly identifies the works of ancient picture makers with modern native societies of the area.

That chain was also often interrupted or broken, however, and more than a few of the ancient peoples are known today only or primarily because some of their pictorial art survived to stimulate the imagination of much later societies. Had they not made art that survived, we would have virtually no knowledge of them, for they left no written records, no written histories. We use the ancient arts to re-create history by assuming that it can help to identify relationships between and among ancient and modern native communities. As important, we use it to conceptualize the ancient people, especially those whom we know mainly because we know their art. That art inspires us to imagine unique collective and individual personalities and the intellectual qualities of its makers; they become whom and what we think their pictures tell us they ought to be.

are employed with historic-era Pueblo altars that also use pictures made on the ground with sand or other colored materials, thus suggesting similar use of dry painting technology in former times.

Our knowledge of pictures made on wood, leather, or textiles is more certain and direct, but the number of complete or almost complete examples in these fragile media is relatively low, and most surviving examples are quite fragmentary. By contrast, tens of thousands of paintings on pottery have survived in reasonably good condition (see fig. 139), as have well over one hundred thousand drawings or paintings made on stone, which are generically referred to as "rock art" (see fig. 140). Here I focus on those two media in the ancient Pueblo world during the centuries between about 1300 and 1700, when European political control, first imposed over

FIGURE 138 (LEFT)
Painted faces or masks, pictographs near the Pueblo site of Tenebo, southern Rio Grande Pueblo Province, c. 1500–1670

FIGURE 139 (BELOW LEFT)
BOWL WITH DESIGN OF LIGHTNING AND REPEATED SQUARES
New Mexico, Chaco Canyon, c. A.D. 950–1130
(Cat. no. 96)

FIGURE 140 (BELOW RIGHT)
Face or mask petroglyph immediately below a large Piro-speaking Pueblo site above the Rio Grande, southern Rio Grande Pueblo Province, c. 1450–1680

151

PAINTING TRADITIONS OF THE AMERICAN SOUTHWEST

Beginning at least six thousand years ago, paintings and drawings were made in the Southwest in almost every conceivable medium and on virtually any surface that could support them. Our knowledge of them is deeply biased by accidents of survival and of history, and our perceptions and interpretations of these images are in a constant state of flux because they are necessarily structured by the histories of our own classification and value systems. Many were quite ephemeral and are known of today only indirectly, by analogy with modern practices or because they are shown in other pictures done in more permanent media. For example, some fifteenth-century Pueblo murals show detailed images of people whose faces and torsos are decorated with elaborate paintings (see fig. 138). Or ancient paraphernalia such as stone or wood figurines may resemble objects that

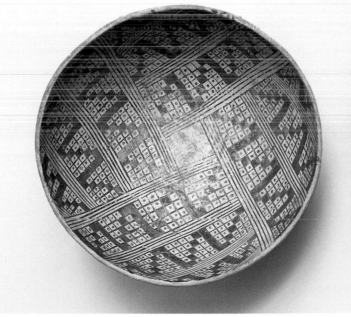

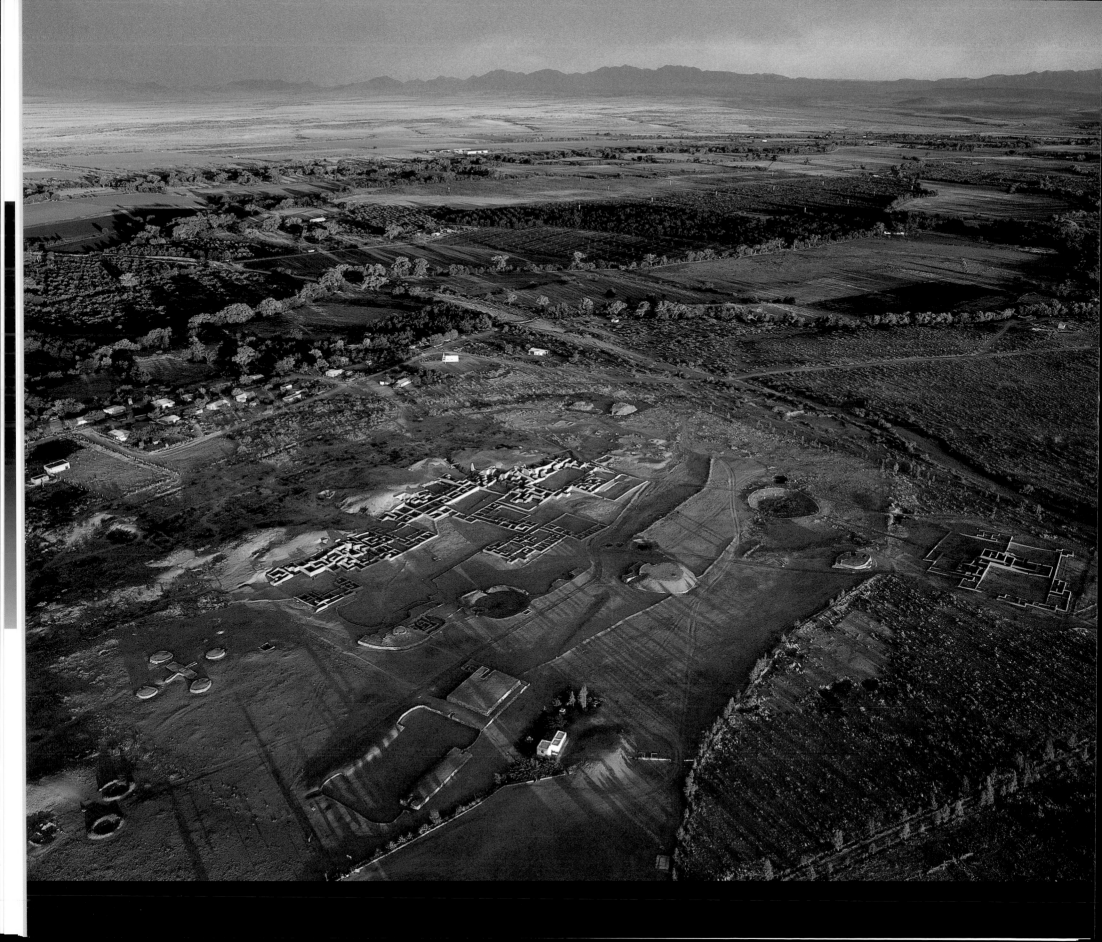

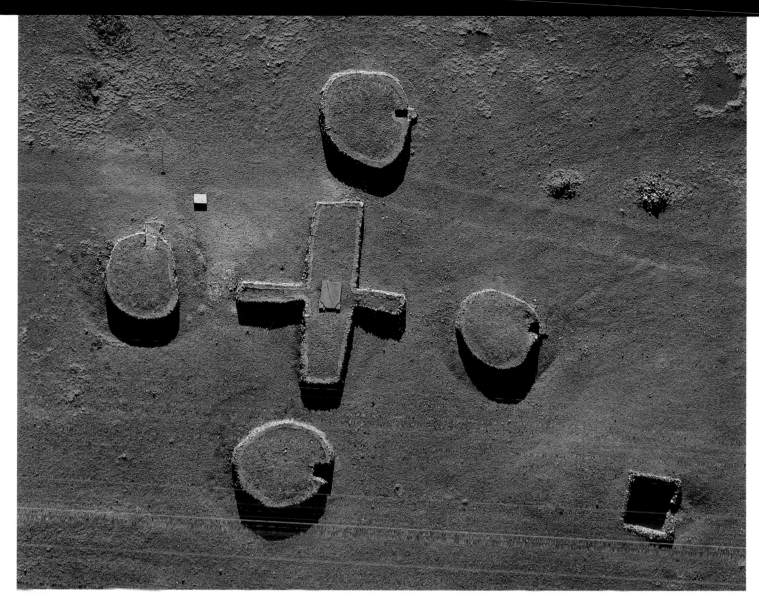

167

CASAS GRANDES, C. 1350

At Casas Grandes urban planners designed a community consisting of public and domestic architecture. Monumental civic structures included tremendous communal plazas, ball courts, and platform mounds (see fig. 154). These were the focus of ceremonies and spectator games that served to reinforce the collective social and religious identity of both the populace of the town and the inhabitants of its regional sphere of influence. The solstice

events so crucial to an agrarian calendar were marked and celebrated on platform mounds. Community-wide harvest feasts took place around gigantic roasting pits dug into the main plaza. The sacred ball game engaged onlookers and combatants in ritual warfare and play.

The residents of Casas Grandes occupied large household-courtyard combinations. Interior rooms featured sleeping platforms, plastered hearths, numerous niches, and house altars. Potable water was distributed

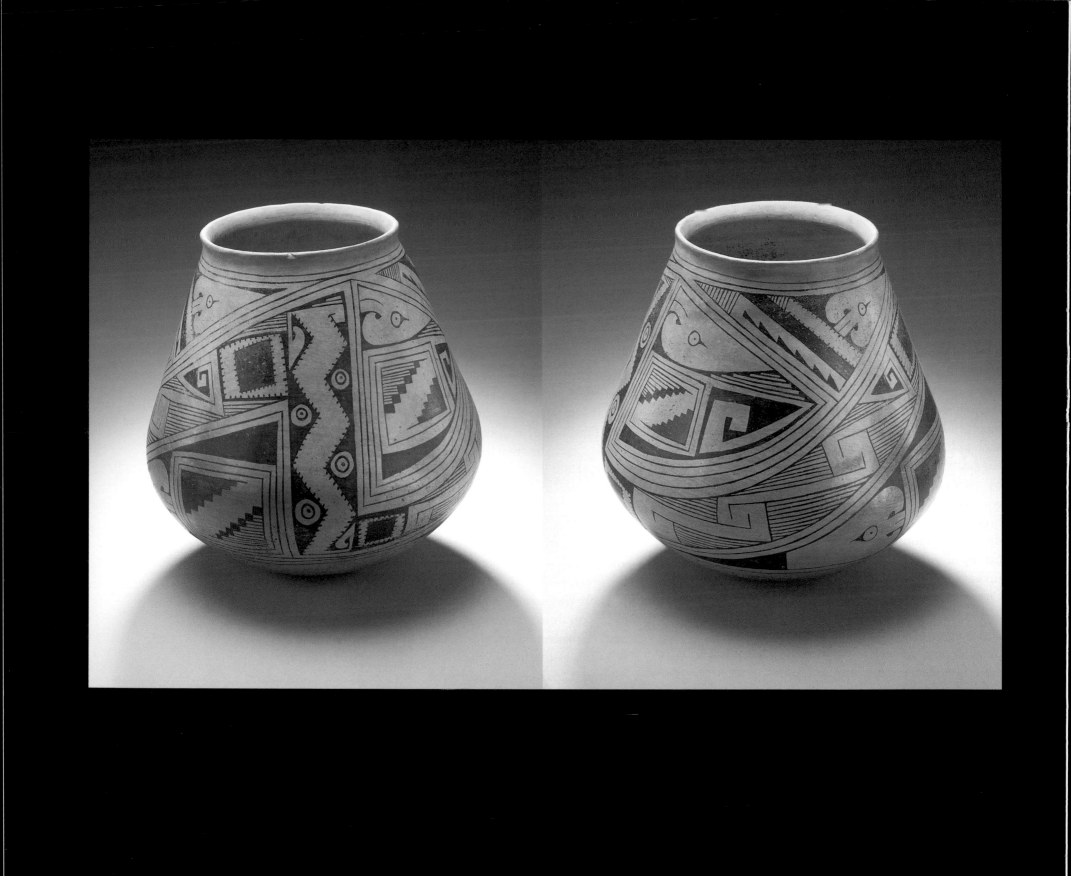

Grandes ceramic vessels were produced in quantity not only to satisfy the community's domestic and ceremonial requirements but also presumably as one of its principal trade commodities. In fact, analysis of the chemical composition of clays employed in the manufacture of vessels suggests that Casas Grandes and sites in its immediate environs defined the center of polychrome pottery production from which goods were traded to other settlements in the region of present-day northern Mexico.[5]

While the utilitarian function of Casas Grandes ceramics is obvious, consideration of the symbolic content—that is, the meaning of the decorative motifs and forms—although much more speculative, offers greater insight into the cultural fabric of its prehistoric residents. As noted earlier, Casas Grandes looks like a Southwestern pueblo in many ways. In terms of its ceramics, it appears to be part of a geographically widespread—from the Four Corners to the White Mountains of Arizona and the Rio Grande Valley of New Mexico—phenomenon. Indeed, Casas Grandes pottery fits nicely with the thirteenth- and fourteenth-century Southwestern propensity for polychrome pottery. It displays strong similarities with northern Southwest assemblages in terms of structure, technology, design layout, and simplicity of form, with effigy being the notable exception.[6] Yet to conclude that the Casas Grandes tradition is exclusively or essentially a Puebloan expression is to ignore fundamental elements that are otherwise inspired by, and most likely reflect, southern influences. Even a casual inventory of any collection of Casas Grandes pottery quickly detects iconographic themes customarily associated with the "south," or Mesoamerica, as compared with the "north," or the U.S. Southwest. And due to Casas Grandes's geographically intermediate location, a point

already made, a certain blending of southern and northern themes might well be expected. The more interesting question is not how strongly "Mesoamerican" or "Puebloan" the Casas Grandes pottery tradition is, but what the ceramics reveal about the people of Casas Grandes and their culture.

A means of framing this discussion is to view the ceramic assemblage as the material representation of cultural symbols that express the collective images accepted by Casas Grandes society. Painted designs and effigies became the tangible manifestation of a cosmos populated by human, animal, plant, and supernatural actors. Designs and effigies illustrate the sacred and the secular, tell the people's stories and myths, communicate shared imagery, and, in short, define the Casas Grandes world.

As mentioned, archaeologists interpret the Casas Grandes system as politically powerful, made wealthy by trade, and having a government of religious functionaries. A strong dependence on agriculture would be reinforced and facilitated by a religion pervaded by celestial and fertility symbolism. Religious leaders would have to propitiate the supernaturals and manipulate natural forces of weather successfully in order to ensure favorable harvests. Consequently, if ceramics do provide information about the shared concepts held by Casas Grandes people, we would expect to find aspects of their religious and philosophical beliefs depicted in the forms and designs embellishing the assemblage. At this juncture it is worthwhile to explore some of these recurring artistic themes, keeping in mind that such symbolic patterns may help define collective identity and worldview.

FIGURE 156

JAR WITH GEOMETRIC DESIGNS
(two views)
Mexico, Chihuahua,
Casas Grandes,
c. 1280–1450
(Cat. no. 128)

171

FIGURE 157

JAR

Mexico, Chihuahua,

Casas Grandes,

c. 1280–1450

(Cat. no. 123)

SYMBOL, FORM, AND MEANING

The Casas Grandes ceramic assemblage exhibits a remarkable degree of standardization, not only in the technology of its manufacture (vessel sizes, forms, wall thickness, and surface finishing) but also in the formalization of design structure and layout. Conventions of design and pattern are strictly followed as specific motifs are repeated in various combinations from vessel to vessel. Its visual impact is that of a collective statement made by a group of specialized artisans, as compared with a personal expression created by an individual potter.

Commonly observed geometric motifs combine checkerboards, cross-hatching, circles, dots, triangles, diamonds, lozenges, zigzags, bands, lines, interlocking scrolls, stepped frets, squares, and *S* and *V* motifs (see fig. 157). Some are outlined; others are solids with pendants extending from the principal element. Motifs may be painted singly and as running panels, with the forms of animal and human figures sometimes filled in, or in quartered design fields. The true meaning or range of meanings symbolized by these design elements will probably never be known, although it seems clear that some are representational. For example, a narrow band of checkerboards around the wrist of a figure indicates a bracelet. Cross-hatching on a forehead suggests the presence of a tumpline, and solid decoration across the head represents hair. Dots and lines on face and arms imply the practice of body decoration by the residents of Casas Grandes, possibly painting or tattooing. Clothing in the form of skirts, blankets, sashes, and leggings is suggested by decorative panels (see fig. 158). Combinations of geometrics into design fields and panels may well have been inspired by the patterns of woven textiles. More speculative, perhaps, are questions of whether solid step and triangle elements represent clouds and rain, whether zigzags indicate lightning, or

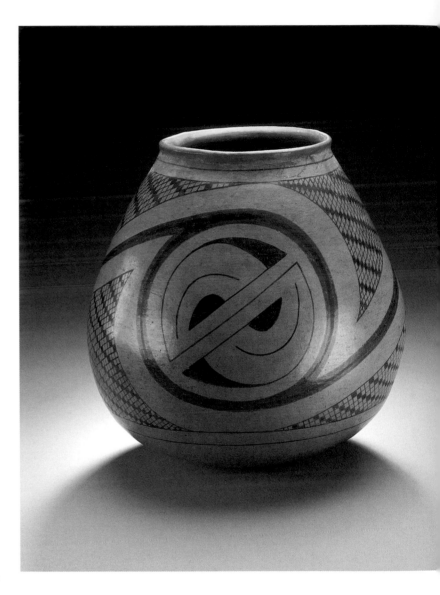

whether checkerboard patterns are symbolic of corn, as they are in contemporary Pueblo motifs.

Many geometrics have less than obvious significance. What, for example, does the frequent depiction of the circle signify? Carl Jung would interpret the circle motif as the universal human representation of the sun.[7] Sun symbolism is all-powerful for any agrarian community, and it was emphatically so at Casas Grandes, where monumental platform mounds functioned in part to mark the sun's seasonal progression across the sky. Alternatively, concentric circle motifs symbolize an equally important element, water, to modern Pueblo people who farm under arid conditions. Concentric circles pecked or painted on rock walls in prehistoric times have been interpreted as signs designating the location of a spring. The sun and water explanations both make sense; both may touch on the true meaning of the circle motif. Cultural symbols communicated in paint and clay express eternal truths, yet the same symbol may pass through many transformations through space and time before it becomes the accepted, collective image of the community.

A case in point is the figurative motifs decorating Casas Grandes ceramics. One of the most frequently depicted and dramatic iconographic elements found on pottery from the great town is the serpent. Appearing in various manifestations, among them the feathered or plumed serpent, the horned serpent, the water serpent, the turquoise sun serpent, earth serpent, star serpent, and the cloud serpent, it is the definitive symbol of Quetzalcoatl, whose origins reach far back in time and deeply into the heart of Mesoamerica.[8] This icon seems to be universal among the agrarian cultures of western North America. In its plumed serpent guise, the symbol has been linked to the breeding of the scarlet macaws so important to quetzal ceremonies. Warrior-priests wore brightly colored scarlet feather headdresses in honor of

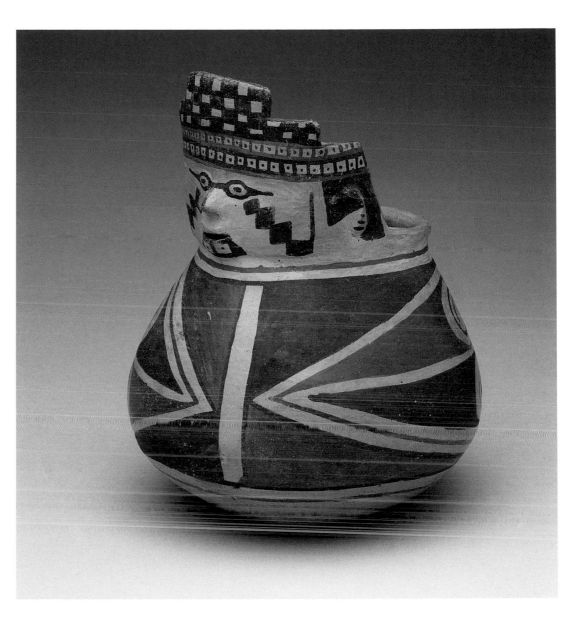

173

FIGURE 158

MALE FIGURE
Mexico, Chihuahua,
Casas Grandes,
c. 1280–1450
(Cat. no. 135)

FIGURE 159

JAR WITH HORNED SERPENT
Mexico, Chihuahua,
Casas Grandes,
c. 1280–1450
(Cat. no. 14)

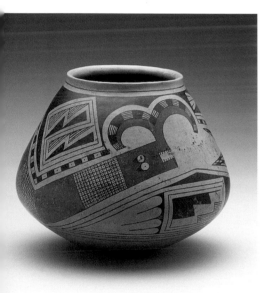

Quetzalcoatl, while at the same time birds were ritually sacrificed, some during the spring equinox ceremony. As a water serpent, the snake icon is associated with the underworld or death and rebirth. Moreover, in some myths the serpent is viewed as an intermediary between the two worlds (see fig. 159). Water or rain and rebirth symbolism fit well with the beliefs surrounding the cyclical regeneration of the world and ideas of fertility that imbue the rituals of modern Pueblo people and, presumably, prehistoric agriculturalists as well. Serpents, birds, and human figures with feathered headdresses adorn Casas Grandes painted vessels.

Of the bird motifs, macaws, parrots, and turkeys are the most easily recognizable figurative elements. It is not surprising that these birds were commonly represented, given their undisputed importance to the residents of Casas Grandes. Excavations have uncovered breeding pens and nesting boxes together with broken eggshells and the remains of birds of all ages. While scarlet macaws were especially valued for their beautiful feathers—which were, incidentally, traded north to the U.S. Southwest— all three types of birds were bred for sacrifice. The carcasses of scores of macaws were discovered under the foundations of public buildings, and headless turkeys were interred in the great plaza.[9] Propitiatory sacrifice to protect members of the community and forestall possible disasters was most likely a recurring theme in Casas Grandes ritual, and it found visual expression in the painted imagery on pottery. At Casas Grandes, however, appeals to the supernatural world did not generally involve human sacrifice, as they did in many regions to the south.

Figurative themes in the Casas Grandes ceramic tradition are most dynamic when communicated as effigies,

for the three-dimensional image makes a particularly forceful statement. Potters created the spectacular and the ordinary, the sacred and the secular, human and animal in effigy form. These portrayals reflect the archetypes that energized the Casas Grandes world of religious belief, ceremony and ritual, myth, and perceptions of self. Described in another way, effigies are tangible revelations of the Casas Grandes universe, which was inhabited by supernatural, human, and animal actors. Indeed, the profusion of human and animal imagery in clay illustrates the continuing stream of artistic expression evident throughout the entire history of pottery making in pre-Columbian Mesoamerica, virtually from its inception. The potters of Casas Grandes were late participants in a highly evolved tradition of artistry in clay by craft specialists.

Casas Grandes effigy forms are diverse and numerous because ceramists modeled almost every living creature, both animal and plant, with which they were familiar, as well as their mythic gods and heroes. A few recurring forms that seem to hold special significance in the cultural fabric of the community are explored here.

Seated male and female figurines probably convey multiple kinds of information about Casas Grandes culture, ranging from the conventions that governed their manufacture to social values and beliefs. When the entire body is modeled, human effigies are rendered in a seated position. Males generally sit with one knee bent and the other leg flexed beneath them (see fig. 160). Females sit with legs straight in front (see fig. 161). The genitalia of both male and female effigies are clearly depicted, sometimes accented with painting, emphasizing masculine and feminine principles (see fig. 162). Certain female figures are represented with a protruding belly,

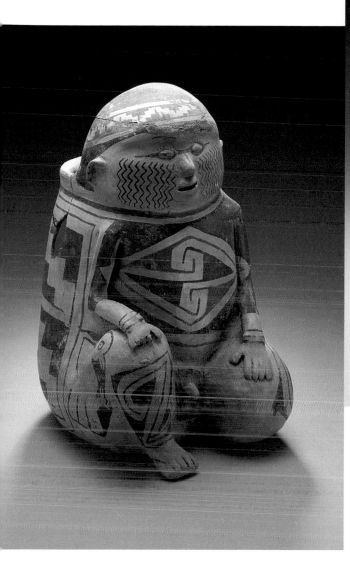

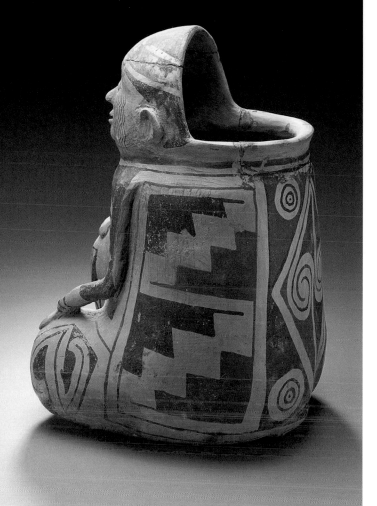

FIGURE 160
MALE FIGURE
(front and back views)
Mexico, Chihuahua,
Casas Grandes,
c. 1280–1450
(Cat. no. 132)

FIGURE 161
FEMALE FIGURE
Mexico, Chihuahua,
Casas Grandes,
c. 1280–1450
(Cat. no. 131)

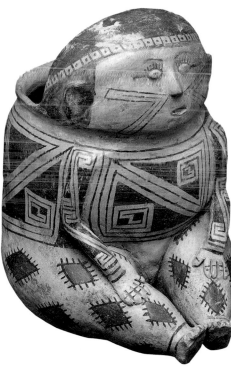

which may signify pregnancy, and others carry children or ceramic vessels. Children are symbolic of the community's continuity and regeneration, while storage pots refer to the harvest. The fertility symbolism that might be expected in the art of maize agriculturalists is conspicuous in the full-figured human effigies of Casas Grandes.

Social status may be another element illustrated by seated human effigies. Many are elaborately decorated with design panels that indicate both body decoration (painting or tattooing) and garments such as blanket wraps, sashes, belts, headbands, leggings, and sandals, or are embellished with painted armbands, bracelets, pendants, and necklaces. In some cases, effigies wear actual jewelry in the form of turquoise or copper pendants and earbobs. These elaborations suggest wealth or social rank.

FIGURE 162

MALE FIGURE

Mexico, Chihuahua,

Casas Grandes,

c. 1280–1450

176 (Cat. no. 133)

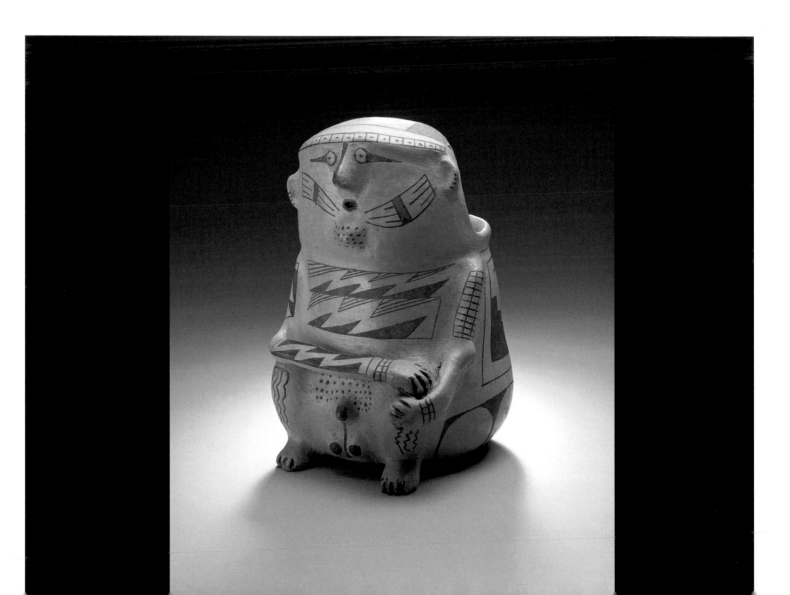

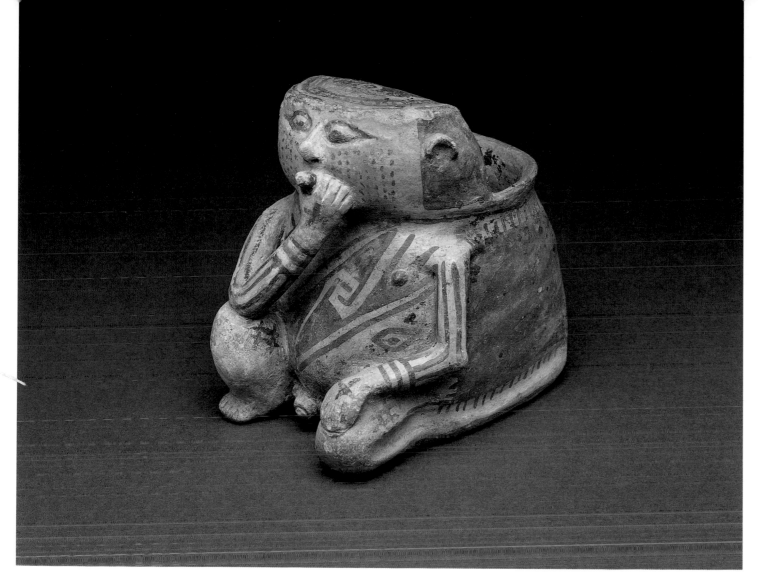

FIGURE 163

MALE FIGURE WITH CIGAR
Mexico, Chihuahua,
Casas Grandes,
c. 1280–1450
(Cat. no. 130)

Another class of seated human effigies, comprising the so-called smoker (see fig. 163) and humpback, combines the secular and the sacred. Ritual smoking is an activity of great antiquity; it was part of the religious practices of many prehistoric peoples in the Americas and has continued into modern times. Shamans communicated with supernaturals through smoke or "cloud blowing." The shaman's role as an intermediary with the spirit world demanded that messages and petitions be properly transmitted through smoke. The frequency with which the smoker effigy occurs intimates his participation in Casas Grandes ritual.

The humpback figure is also equated with shamanistic symbolism, and these individuals were in fact identified as village shamans by some Spanish chroniclers.[10] The Mesoamerican pantheon sometimes portrays Xiuhtecutli, the lord of fire, as a hunched old man. In the Casas Grandes figurative assemblage, humpback effigies can

be of either gender, and there exist as many female representations as male ones. In cultures in which humpbacks are valued, this physical deformity is viewed as a unique mark granted by supernaturals which sets these individuals apart from the ordinary members of a community. The hump affirms their exceptional knowledge, power, and ability to communicate with supernaturals. The ability of both the "smoker" and the humpback to communicate with powers beyond the secular world in order to request special assistance for individuals or for the community as a whole is well documented historically. It is compelling to conclude that such figures in clay reflect similar prehistoric ritual and related symbolism at Casas Grandes.

The more stylized versions of effigies—known as hooded effigies, with the head affixed to the final coil of an otherwise ordinary globular jar form—are more problematic to interpret. Many have been identified with those gods thought to be significant to the people of the great town. For example, Ehecatl, or the wind god, in his Quetzalcoatl guise—associated with water, fertility, and the underworld—was recognized by his beaked mask and plumed headdress. His warriors, wearing elaborately feathered headdresses, played the sacred ball game, and it has been said that the famous culture hero Ce Acatl told the people to play the game, which eventually evolved into the Ehecatl ceremony. Another deity, Xipe Totec, the god of springtime and regeneration, is known by his flaccid, puffy face and gaping mouth, which represent sacrifice but also herald the annual cyclic renewal of the world.

Certain of the Casas Grandes effigies, as well as some painted figures, exhibit numerous similarities that fit well with Ehecatl and Xipe Totec, among other Mesoamerican ideological representations. The religious architecture in the form of platform-solstice mounds

and ball courts lends further weight to the argument that certain of these gods played a role in the religious life of the community. Yet the residents of Casas Grandes may well have transformed the specific symbolic meaning of these mythic figures to accommodate their own particular needs even as their gods found their ultimate origins farther south.

Another permutation of the effigy form is the so-called Janus vessel, characterized by modeled, opposing faces, which may be anthropomorphic, zoomorphic, or a combination of the two. Some Janus vessels show the same visage on opposite sides of the jar, but many convey opposing images: upturned versus down-turned mouths, open versus closed eyes, negative versus positive painted decoration. The precise meaning of the Janus form in Casas Grandes ceramics remains unclear, although its frequency indicates a certain importance. The concept of opposition is, however, a universal theme in human myth. Good and evil, the everyday world and the underworld, twin culture heroes, life and death, or possibly two aspects of the same figure are common to many origin legends and stories. It appears likely that the Casas Grandes Janus depiction is part of this ubiquitous human tradition.

Any exploration of symbol and meaning in Casas Grandes ceramics would be incomplete without delving into the wonderful animal motifs that contributed so abundantly and diversely to the effigy component of the assemblage (see figs. 164, 165). Casas Grandes potters modeled all manner of animals in clay. Birds, dogs, badgers, rabbits, frogs, lizards, and fish were created as freestanding figures or as appliqué decoration on bowls and jars. Many were intricately painted with geometric motifs similar to those adorning their human counterparts. Distinctive animal types were depicted in combination with other animals (snake and bird motif)

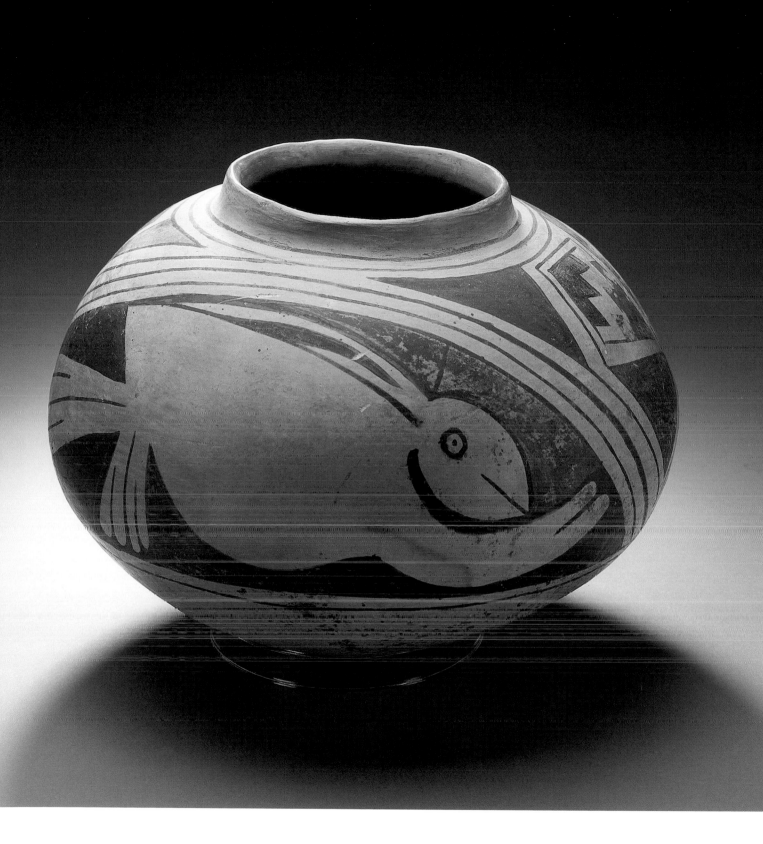

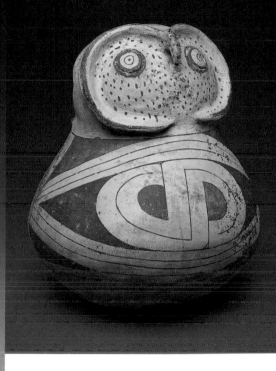

FIGURE 164 (LEFT)

JAR DEPICTING RABBITS
Mexico, Chihuahua,
Casas Grandes,
c. 1280–1450
(Cat. no. 138)

FIGURE 165 (ABOVE)

OWL EFFIGY JAR
Mexico, Chihuahua,
Casas Grandes, c. 1280–1450
(Cat. no. 137)

or with humans (animal body with human head or vice versa). In certain guises, animal effigies reflect not only ceremonial activities but also the economic endeavors of the town. It is unlikely, for instance, that the frequency of macaw, parrot, and turkey forms is the result of artistic serendipity, given that such birds were bred extensively for feathers, sacrifice, and external trade.

While the sacred dimension of Casas Grandes animals is probably significant and will be explored further, the sheer range of animals represented suggests that potters were inspired by other motives. These may include a familiarity with and the desire to represent the creatures living around them, whether wild or domesticated, food source or pet. Additionally, particular animals may have defined the exotic—for example, a blowfish effigy whose creator could only have encountered the subject on the coastal margins or in territories of West Mexico where shell was procured.

Animal imagery is evident in the material culture of many peoples, and the profusion of animal symbolism in Mesoamerican religion and art is well documented.[11] In the shaft tombs of West Mexico, exuberant ceramic figures, especially dogs, were placed with the dead. Animal effigies of Casas Grandes are reminiscent of zoomorphic figurines from the region corresponding to the modern states of Jalisco, Colima, and Nayarit. In the Aztec creation myth, Quetzalcoatl began his journey to establish a new people accompanied by his *nahual*, or animal spirit guide. Farther north, in the U.S. Southwest, animal motifs were common, although they were often pecked on rock walls or painted on pottery vessels rather than modeled in clay with the detail evident in the effigy tradition of Casas Grandes and points southward.

Animals are universal symbols of transcendence in ritual and myth and provide assistance to humans engaged in journeys and quests. Dogs, although they served as

pets and food, were believed to be important magical creatures. They guided the souls of the dead in their journey to the afterlife. Xiuhtecutli, lord of fire, was said to be assisted by a dog servant. Animals functioned as intermediaries between humans and the supernatural. Birds of prey such as owls were often believed to function as messengers to the supernatural realm. For shamans, personal animal totems provided counsel and carried messages to the spirit world. Quetzalcoatl's *nahual* was imbued with some of these qualities when, during his quest, the god died in the underworld and was revived by his animal spirit helper. Among many cultures, the snake is a creature of the underworld and serves as a mediator between lower and upper worlds. Serpent-feather iconography in the form of bird-snake composite effigies or painted symbols may be associated with Quetzalcoatl or at least some manifestation of the fertility-weather symbolism so important to Casas Grandes farmers.

The maize-based agriculturalists of Casas Grandes followed a cyclic religion with a strong interest in solar and night sky observation, rain and fertility symbolism, use of brilliantly feathered tropical birds, and various forms of specialized religious architecture. They favored luxury goods, especially shell, exotic stone and minerals, textiles, foodstuffs, and manufactured items. Some or all of these attributes may be ascribed to farming groups, whether living in simple villages or more complex communities, from central and West Mexico, through northern Mexico, and stretching into the U.S. Southwest. The archaeological record recovered from prehistoric settlements across this macroregion suggests commonly shared forms of material culture, symbols, versions of ritual and ceremony, as well as beliefs that include the invocation of supernatural assistance to maintain fundamental

cycles of life and to influence weather. Within this context, the role of traders as transmitters, if not shapers, of culture cannot be underestimated.

The world of Casas Grandes was a dynamic organism whose connective tissue was trade. Ideas, stories, commodities, and people traveled across its web. Historian Carroll L. Riley has written that traders, singly or in relatively small groups, were purveyors of esoteric knowledge as well as material goods.[12] They were responsible for transmitting major elements of Mesoamerican religion, including specific deities, in the course of trade contacts. Contact through trade meshes with the important concept of the "journey," which is echoed throughout Mesoamerican and Southwestern myths. The notion of the road or path and the journey down this road is a metaphor for life. This ceremonial and philosophical emphasis reflects the ancient importance of actual physical travel over real roads. The trader as a transmitter of ideas, then, helps to account for certain universal cultural traits found among farming peoples widely separated in both space and time.

This brief foray into the symbolic landscape of Casas Grandes proposes that the ceramics created by artisans of the great town represent the visual conduit along which humans connected with and defined their world: their status, power, wealth, and ritual. Symbols and figures take on recognizable meaning through common, recurring usage, which affirms cultural identity.

The residents embraced many deities to protect their town from misfortune. Ehecatl, the Wind God, wearing a beaked mask, ensured fertility. Xipe Totec, God of Springtime and New Life, demanding sacrifice. The smoker and humpback communicating with the spirit world and curing the sick. The wealthy wearing fine clothing adorned with jewelry. Valued scarlet macaws, turkeys, parrots, owls, and dogs modeled and painted. The ceramic artisans, familiar with their consumers' wishes, fashioned vessels and effigies, thereby illustrating the Casas Grandes world in clay.[13]

FIGURE 166

GOURD-SHAPED BOWL
Mexico, Chihuahua,
Casas Grandes,
c. 1280–1450
(Cat. no. 126)

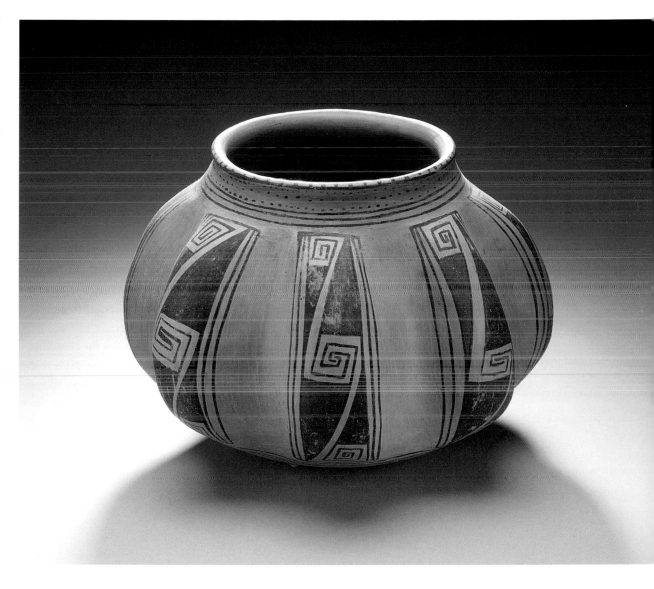

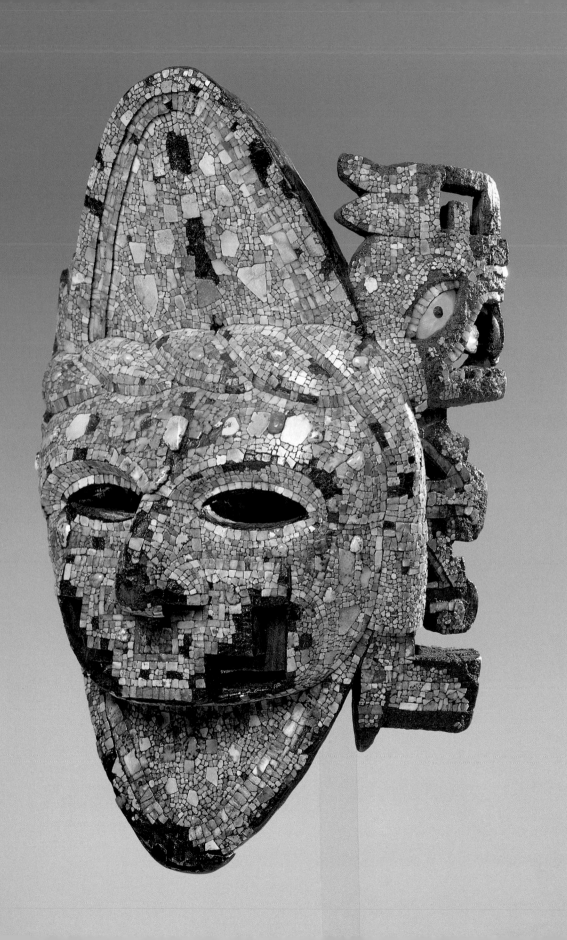

In central Mexico, as elsewhere, turquoise was a mark of high status and extreme ceremonial importance. The turquoise diadem was the symbol of noble rank. Words of wisdom were likened to turquoise. Turquoise was the mineral most befitting the gods, especially those of the Quetzalcoatl set (see fig. 169), and stood for fertility (both human and agricultural), rainfall, maize grains, the realm of the sky, and themes of renewal of all kinds. It played a central role in the Mesoamerican cosmos. It is possible that set measures of turquoise, like cotton mantas and cocoa beans, had entered the realm of special-purpose currencies. No other society, before or after, has ever valued turquoise as much as did the ancient Meso-americans. Moctezuma II sent a turquoise mosaic mask of Quetzalcoatl as a tribute to Hernán Cortés, the man he at first mistook for a god. (It is possible that this mask is the one held by the British Museum.)

Gifts of turquoise objects were routinely exchanged by noblemen and kings, and therefore the gift to Cortés was not out of context. From Bernardino de Sahagún's Florentine Codex (mid-1500s) comes this example: "And then the rulers of Anauac, Xicalanco, Cimatlán, and Coatzaqualco [cities on the western fringes of Mayan Yucatán] reciprocated [to the gift-bearing *pochteca*, or royal Aztec merchants] with large green stones, …the well colored precious green stone which today we call the finest emerald-green jade, … and turquoise mosaic shields" (see fig. 170).[14] Since there are no turquoise outcrops found anywhere near this area, this passage is of much interest. The Maya and their immediate neighbors, like the rulers of Xicalanco, had to have originally obtained their turquoise through trade with the north. Then they gave it to merchant representatives of northern rulers.

People of lower status had access to turquoise as well and had the obligation to give it as gifts to those of equal or higher ranks. The merchant class, which was not

within the nobility, had the obligation to host elaborate
ceremonial feasts, during which opulent gifts were
given, as described in the Florentine Codex: "And
the aged merchants received the people [high-
status guests] with flowers, with tubes of
tobacco, paper garlands, with turquoise
mosaics, and fine maguey fiber
plumage glistening with flecks of
mica." When noblemen gave these
elaborate feasts for one another,
turquoise figured not only as an
item to be given away but also as
part of the costumes of their
"bathed" slave servants: "He
[the nobleman host] put on the
heads of the bathed ones that
were known as the *anecuyotl*. . .
a turquoise device made with
feathers" and "he [the host] tied
'shining hair strands' about their
temples, which were decorated in
this way: alternating [strips of]
turquoise [and] gold, reddish coral
shells, [and] black mirror stones." Even
high-status artisans such as feather workers,
called *amanteca*, had the right to include
turquoise as part of their ceremonial ornamen-
tation: "Then he [a high-status *amanteca*] placed
on his radiating ornament of turquoise, his feather staff,
and his shield, his rattles, and his foam sandals."[15]

Clearly the consumption and circulation of turquoise
in the Mesoamerican world had become very complex
indeed. For the Aztecs, the word for turquoise circulat-
ing at this level was *teotlxiuitl*. The suffix *teotl* means
"god," and the root *xiuitl* means "turquoise" as a mineral,
attesting to the esteem in which the gem was held.[16]

FIGURE 169 (OPPOSITE PAGE)

MASK

Mexico, Aztec-Mixtec

15th–16th century

(Cat. no. 173)

FIGURE 170 (LEFT)

CIRCULAR SHIELD WITH

MOSAIC INLAY

Puebla, Mixtec, 1350–1519

Wood inlaid with

turquoise mosaic

Diam: 12⅝ in. (32.1 cm)

National Museum of the

American Indian,

Washington, D.C. (10.8708)

189

The *cire perdue*, or lost-wax, method was used prior to Spanish conquest to manufacture copper bells in Mesoamerica. Using this method, the artisan molds clay into the desired shape for the hollow bell resonator, embedding the jingler inside. A wax facsimile of the bell is then created over the clay form, which is then covered with clay, except for several tubular channels from the wax model to the surface. The finished mold is heated, which hardens the clay and melts the wax. The wax is emptied out of the channels and is replaced with molten copper or copper alloys. After the metal cools, the exterior clay mold is removed, and the interior clay form is broken and extracted through the mouth of the bell, leaving the jingler inside.

PREVIOUS INTERPRETATIONS

Excavations at Snaketown, a Hohokam site in present-day southern Arizona, yielded numerous copper bells, among other artifacts and traits, which were recognized as Mesoamerican.[3] Since then, additional Mesoamerican artifacts and traits recovered from sites in the Southwest/Northwest region have spurred much interest and debate regarding how they arrived from Mesoamerica and the effects those contacts had on local development.[4] In the late 1950s and early 1960s Charles Di Peso's work at Paquimé, the regional center of the Casas Grandes tradition (see fig. 179), in modern-day Chihuahua, produced new data that influenced perceptions of Southwest-Mesoamerican interaction and copper bells.[5]

Di Peso conducted extensive excavations at Paquimé and recovered unprecedented quantities of exotic items, including copper bells (see fig. 7), marine shells, and macaws. The number of copper artifacts recovered from Paquimé—664—is more than the combined total of copper items recovered from all other Southwest/Northwest region sites to date. Di Peso and his colleagues

argued that the copper artifacts were produced at Paquimé, rather than having been imported from Mesoamerica.[6]

The period of florescence and greatest interaction at Paquimé, known as the Medio period, was initially determined by dendrochronology to span from 1060 to 1340. Paquimé exhibits many unique traits for the region, including a population numbering in the thousands residing in planned multistory adobe pueblos (see fig. 178), three Mesoamerican-style ball courts, effigy and special-use mounds, numerous large-scale agave roasting pits, macaw-breeding pens, large quantities of exotic items, a dual-purpose water delivery and waste removal system, a walk-in underground well, and Mesoamerican-derived iconography.

Di Peso interpreted Medio period Paquimé as a trade entrepôt sponsored by a Mesoamerican Toltec elite. In this model, the residents of the site obtained exotic items from the Southwest/Northwest region, such as turquoise, in exchange for products of local manufacture, such as shell jewelry, macaws, ceramics, and copper bells. The goods obtained by Paquimé were sent southward into the Mesoamerican heartland. Medio period Paquimé, in Di Peso's model, produced all copper bells found at pre-Hispanic sites in the Southwest/Northwest region. Therefore, there was no longer a need to identify a Mesoamerican source for Southwest/Northwest copper bells; it was assumed that they all came from Paquimé.

RECENT RESEARCH AND INTERPRETATIONS

Recent research has led some archaeologists to dispute several aspects of Di Peso's model.[7] First, the dates of the Medio period have recently been revised to span from 1200–1250 to 1450–1500.[8] The revised dates are significantly different from the 1060–1340 dates proposed by Di Peso and his colleagues, indicating that the Medio period occurred almost two hundred years later than

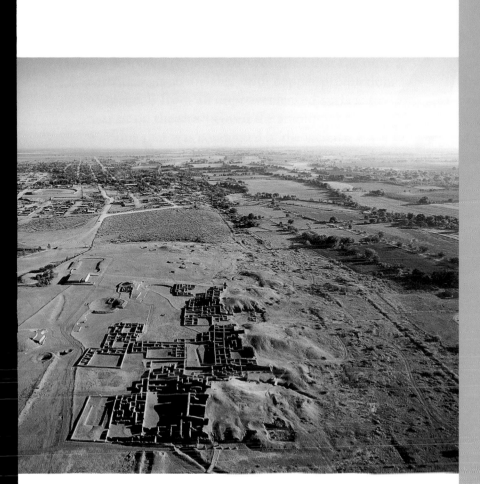

FIGURE 178

Casas Grandes (Paquimé),
Chihuahua

FIGURE 179

Map of Casas Grandes
(Paquimé), Chihuahua

1. House of the Ovens
2. Mound of the Cross
3. Ball court 1
4. Mound of the Offerings
5. Mound 1-5
6. Buena Fé Phase Ranch
7. Retaining Wall and Room

8. House of the Wall
9. Mound of the Heroes
10. Mound of the Bird
11. House of the Serpent
12. House of the Macaws
13. House of the Dead
14. House of the Pillars

15. House cluster
16. The House of the Skulls
17. Ball court II
18. Unit 18
19. House cluster
20. House cluster
21. North-House

22. House cluster
23. House cluster

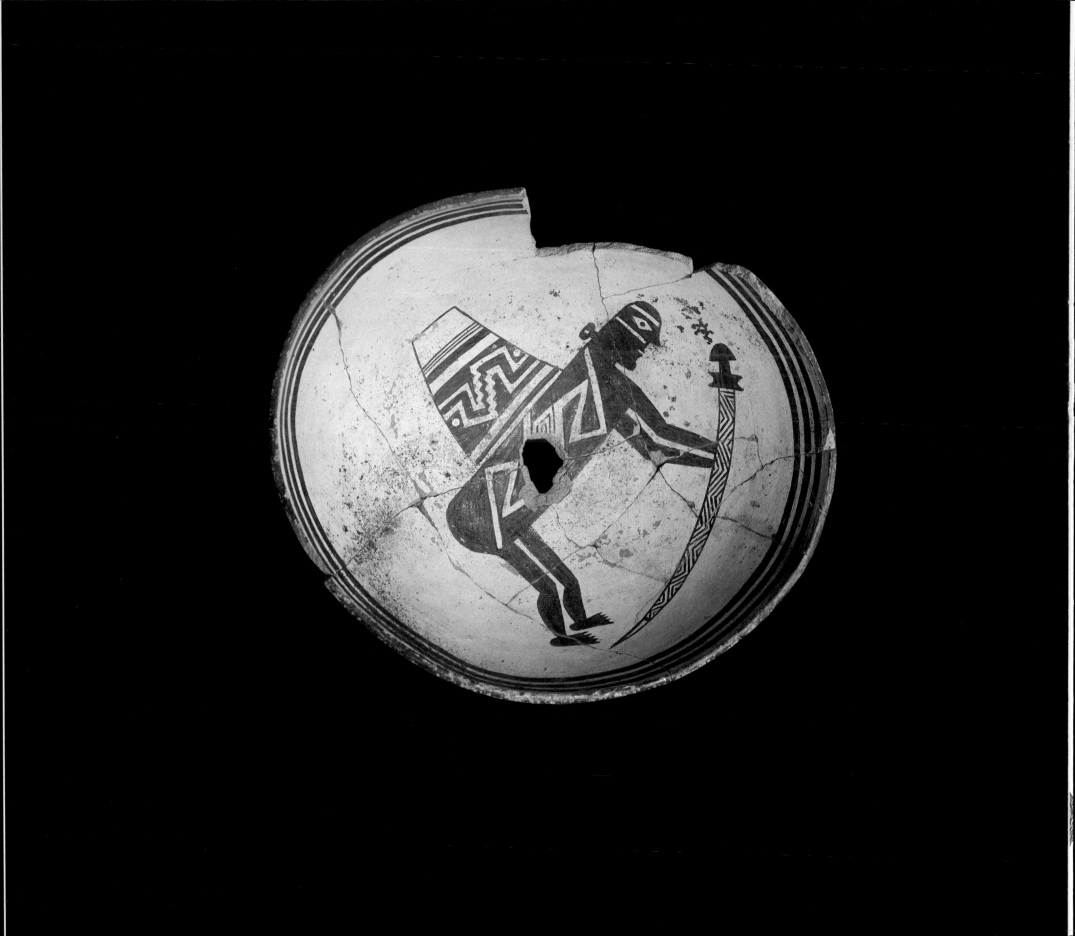

Northwest region. Current research by several scholars, including the present author, promises to contribute new data and interpretations of Paquimé–West Mexico interaction.

Hohokam–West Mexican interaction, however, appears to differ from that between Paquimé and West Mexico and is also less well understood. The relatively small number of bells that circulated in the Hohokam trade network does not appear to represent regularized or systematic contact. Further research is needed to investigate the nature of interaction between the Hohokam region and West Mexico and to explain how it differs from that between Paquimé and West Mexico.

Clearly copper bells were conveyed from West Mexico to the Hohokam region, and their distribution in the Hohokam network suggests directed exchange to Hohokam centers. The social significance of copper bells in the Hohokam region, however, is still uncertain. Bells have been recovered from graves, ritual features, pit houses, caches, storerooms, compounds, platform mounds, middens, and other contexts.[49] Although often associated with ritual, their relatively low numbers in the Hohokam area, as well as the variety of contexts in which they have been recovered, indicate that bells may have had a different social significance than is evidenced at Paquimé. Further investigation of copper bell distribution at Hohokam sites may provide a better understanding of the role of copper bells in this region, as well as offering insight into the nature of Hohokam–West Mexican interaction.

NOTES

It is due to the excellence of Charles C. Di Peso's Casas Grandes reports that a generation later we can still go back to his Paquimé data with new techniques and perspectives and derive new interpretations. I wish to express my gratitude to my partner, Don L. Dycus, for his excellent editing and organizational recommendations for this essay. His contributions and support, as always, are much appreciated. I also wish to thank Roderick Sprague, David Pendergast, David Killick, and Dorothy Hosler for their collegiality over the years. I cannot sufficiently express my appreciation for their willingness to share with me their thoughts—and, at times, even their research materials—on metallurgy and copper bells.

1. The descriptions in this section refer to bells found at archaeological sites in West Mexico, the U.S. Southwest, and Northwest Mexico.

2. Pendergast 1962; Sprague and Signori 1963; Sprague 1964; Vargas 1994, 1995.

3. Gladwin et al. 1937.

4. For example, Di Peso 1968a, 1968b, 1974; Doyel 1983; Ferdon 1955; Frisbie 1978, 1980; Kelley and Kelley 1975; Kelley 1966, 1986; Haury 1945, 1976; Mathien 1981, 1986; McGuire 1980, 1986; Minnis 1989; Nelson 1981, 1986; Plog et al. 1982; Reyman 1978; Schroeder 1981; Upham 1982; Vivian 1970; Washburn 1978, 1980; Weigand and Harbottle 1993; Weigand et al. 1977; Whitecotton and Pailes 1979, 1986; Wilcox 1986b.

5. Di Peso 1974.

6. Di Peso et al. 1974.

7. Di Peso 1974.

8. Dean and Ravesloot 1993.

9. Dean and Ravesloot 1993; McGuire 1980; Minnis 1989.

10. Minnis 1984, 1988; Rizo 1998; Vargas 1994, 1995.

11. Vargas 1994, 1995.

12. Vargas 1994, 1995.

13. Vargas 1994, 1995.

14. Vargas 1995, 9–14.

15. Vargas 1994, 1995.

16. Hosler 1986, 1994.

17. Hosler 1986, 1988, 1994.

18. Meighan 1976.

19. Hosler 1986, 1988, 1994.

20. Hosler 1988, 207.

21. Sprague and Signori 1963; Sprague 1964; Vargas 1994, 1995.

22. Hosler 1988, 209, 214.

23. The original research and data for that investigation are fully presented elsewhere (Vargas 1994, 1995).

24. See Minnis 1984, 1988; Rizo 1999, Vargas 1994–95.

25. Vargas 1996a, 1996b, 1999.

26. Vargas 1996b, 1999.

27. The original research and data for that investigation were presented at the Sixty-fourth Annual Meeting of the Society for American Archaeology, held in Seattle, and are currently being prepared for publication.

28. Craine and Reindorp 1970.

29. Pollard 1987.

30. Pollard 1991.

31. Craine and Reindorp 1970, 219–20.

32. Pollard 1991.

33. Craine and Reindorp 1970.

34. Craine and Reindorp 1970, 15.

35. Craine and Reindorp 1970, 74–75.

36. There are 664 individual pieces of copper recovered from Di Peso's (1974) excavations at Paquimé. Individual sheet copper disk and tube bead counts are standardized for the distributional analysis to allow more appropriate quantity comparisons among the different artifact types. The copper beads were often strung together to make a single ornament. For example, 234 tiny copper disk beads make up a single small ring found in a burial. To allow better comparability, disk bead counts are standardized by considering one to 250 beads in a single context as a single artifact. Similarly, tube bead counts are standardized so that one to five beads, the greatest number found together in a context, equal a single artifact. Once the quantities are standardized, the total number of copper artifacts is 204.

37. Domestic contexts include rooms with domestic assemblages and associated activity areas. Ritual contexts include (1) dedicatory subfloor caches recovered from domestic and ceremonial rooms and subsurface offerings made in public ritual, (2) unburied offertory caches, such as on the walk-in well stairs, and (3) public ritual contexts, including items found embedded in the floors of ball courts and special-use plazas. One copper artifact recovered from a footpath between two residential units could not be classified as to context type, leaving a standardized quantity of 203 artifacts for use in this study. There are thirty-nine separate occurrences of copper items at the site: eighteen from domestic contexts, seventeen from ritual contexts, and four from burials.

38. Vargas 1995.

39. Vargas 1999.

40. Brandt 1977.

41. See Helms 1993; Hosler 1994.

42. Hosler 1994.

43. Di Peso 1974; Reyman 1971; Schaafsma 1999 and this volume.

44. Hosler 1994; Vargas 1994, 1995.

45. Di Peso 1974; Reyman 1971; Schaafsma 1999 and this volume.

46. See Schaafsma (1999 and this volume) for an excellent analysis of such associations in the Southwest/Northwest.

47. Vargas 1996a.

48. As defined by Helms 1993, 180.

49. Vargas 1995.

LANDSCAPE AND POLITY

THE INTERPLAY OF LAND, HISTORY, AND POWER
IN THE ANCIENT SOUTHWEST

STEPHEN H. LEKSON

ONE HUNDRED YEARS OF PRELUDE

Archaeologists have been digging in the Southwest since 1880, when the Archaeological Institute of America sent Adolph Bandelier out to survey ruins and native peoples.[1] Almost every year thereafter scholars and interested amateurs were excavating, mapping, and studying the spectacular sites of the Four Corners states: Colorado, Utah, Arizona, and New Mexico. After a century of research, we know *a lot* about the ancient Southwest. More than one hundred thousand ancient sites have been discovered in just one state, New Mexico; thirteen thousand more have been mapped and noted in a small corner of southwestern Colorado, around Mesa Verde. Only a few hundred of these have been excavated. Arizona and Utah provide comparable numbers. We know, in great detail, the sequence of house types and pottery styles. We know, with slightly less confidence, the ancient census: population levels and distributions. And we know, with extraordinary precision, when things happened. Tree rings in the roof beams of ancient pueblos provide exact dating, to the year in which the tree was cut. More than thirty thousand wood specimens from about fifteen hundred sites have been dated by tree-ring methods.

Tree rings also provide remarkable rainfall "retrodictions"—prehistoric precipitation records. In the arid Southwest, rainfall matters: without rain, corn will not grow, and without corn, villages cannot live. Tree rings, shaped by vagaries of rainfall, tell us how much rain fell in each season of every year, far back into prehistory. A tight connection between rainfall and culture cannot be missed: Pueblo ritual, even today, addresses the clouds

and the rainfall that they bring. Archaeologists have constructed elaborate computer models linking ancient population to ancient rainfall (known through tree rings), and the models work: decades of above-average rainfall mark population increases and cultural "peaks," while local and regional droughts are linked to "abandonments." I use these terms with caution: "peaks" are in the eye of the beholder, and "abandonments" were never permanent. But the basic correlation of Southwestern archaeology and precipitation has been firmly established.[2]

There was much, much more to the ancient Southwest than a simple correlation of culture and rainfall. The world knows the artistic and architectural traditions of Pueblo peoples, ancient and modern. Those achievements transcended the limitations of a desert environment—limitations perceived by whites, but not by natives. Southwestern peoples are at home in the desert, and their arid homeland was a setting for histories and cultures as varied and vibrant as those of any European society. Pueblo origin stories—meticulously memorized oral histories, passed down through generations—recount ancient histories marked by events and incidents far removed from precipitation records: battles, rulers, migrations, revelations. Archaeology has been extraordinarily successful in defining the economic and demographic shape of Pueblo prehistory, the correlation of people and environment. I believe that archaeology has now attained a level of knowledge that makes attempts at real history not only possible but also necessary. After all, the Southwestern past was *history*, not simply an anthropological adaptation. We can begin to write that history by combining a century of archaeology with traditional Pueblo origin stories.[3]

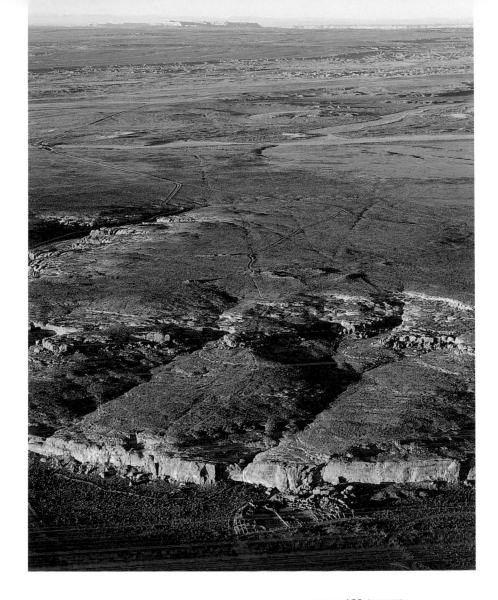

213

FIGURE 189 (ABOVE)
Pueblo Bonito, Chaco Canyon, New Mexico

FIGURE 190 (OVERLEAF)
Paquimé (Casas Grandes), Chihuahua

FIGURE 191 (OVERLEAF)
Aztec Ruins, New Mexico

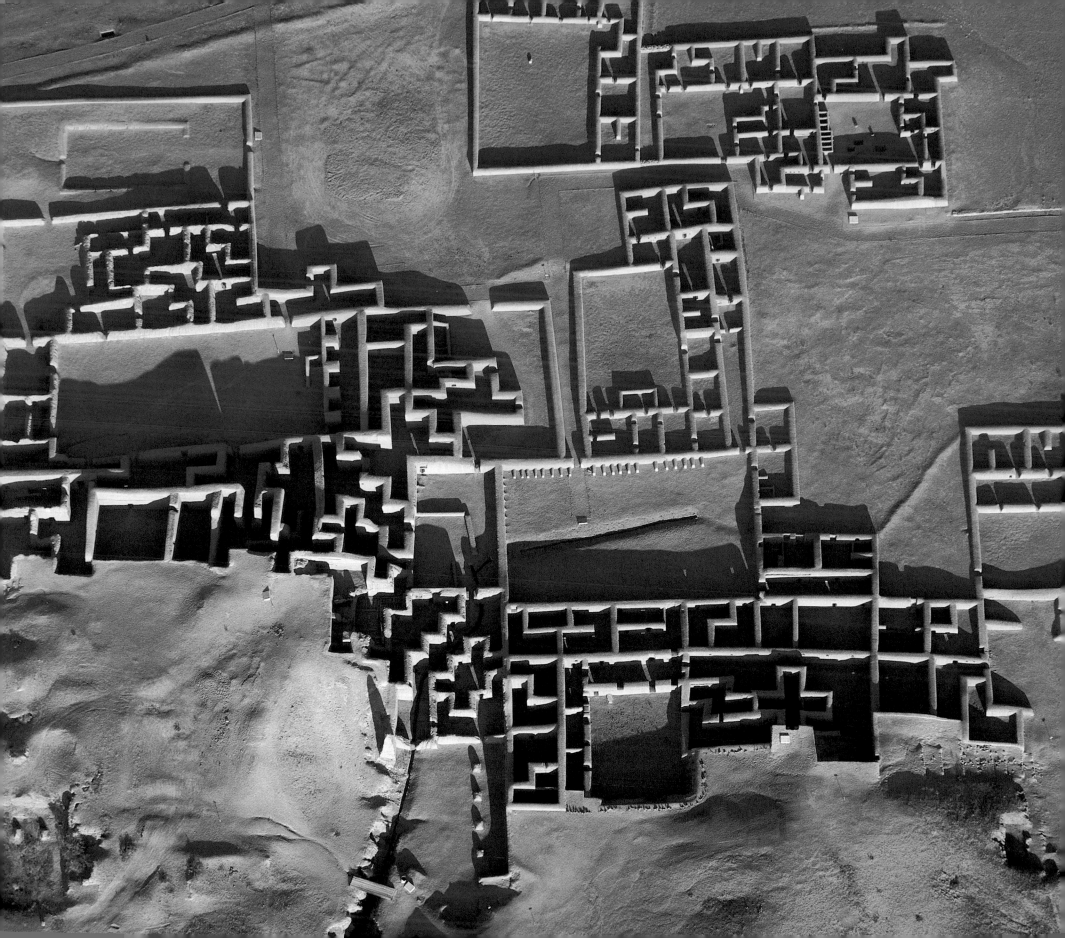

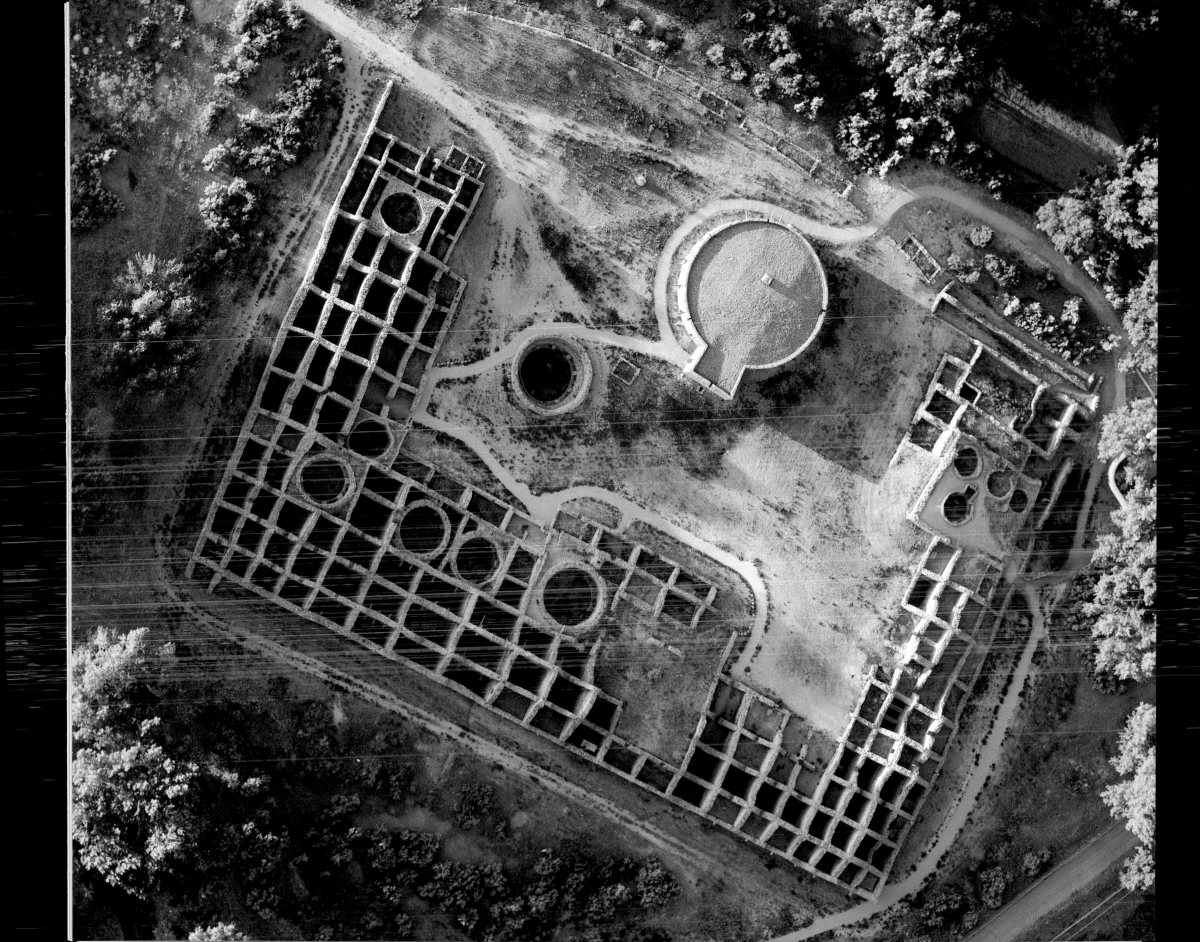

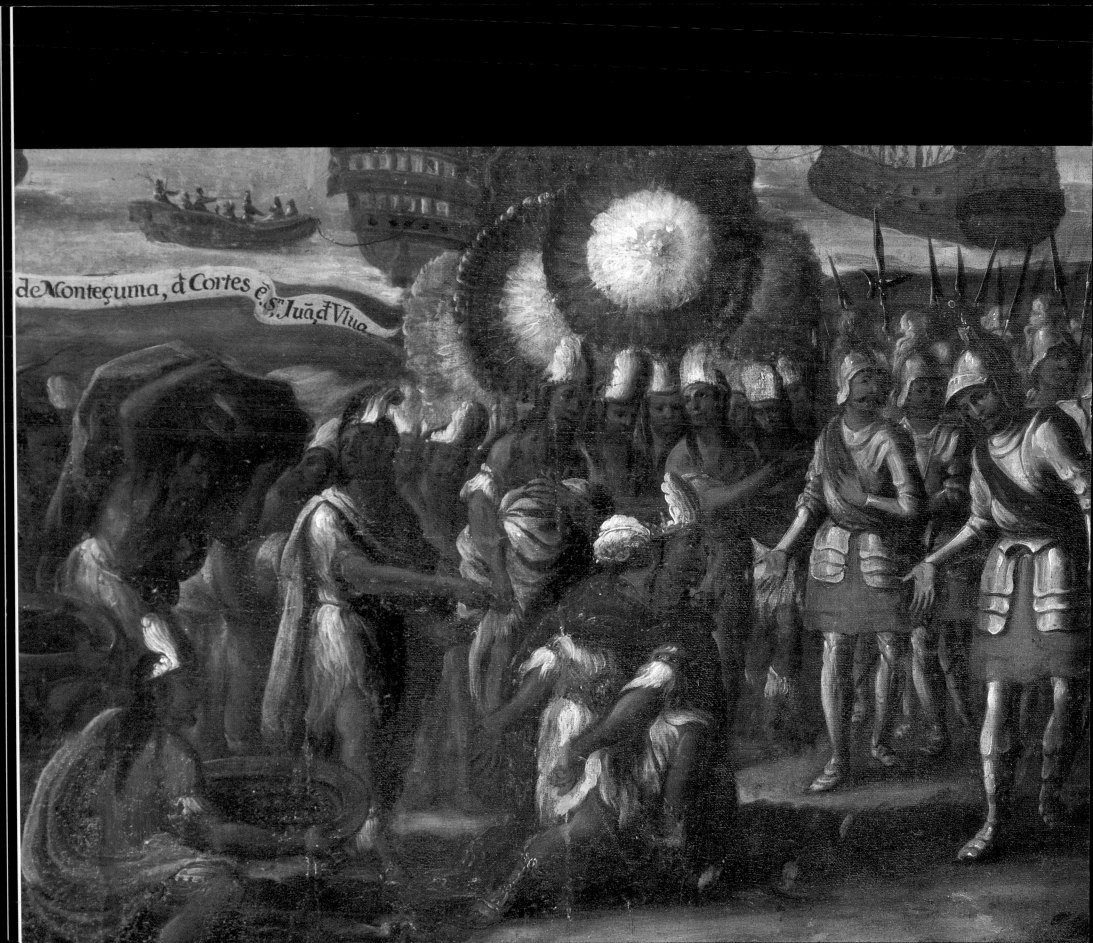

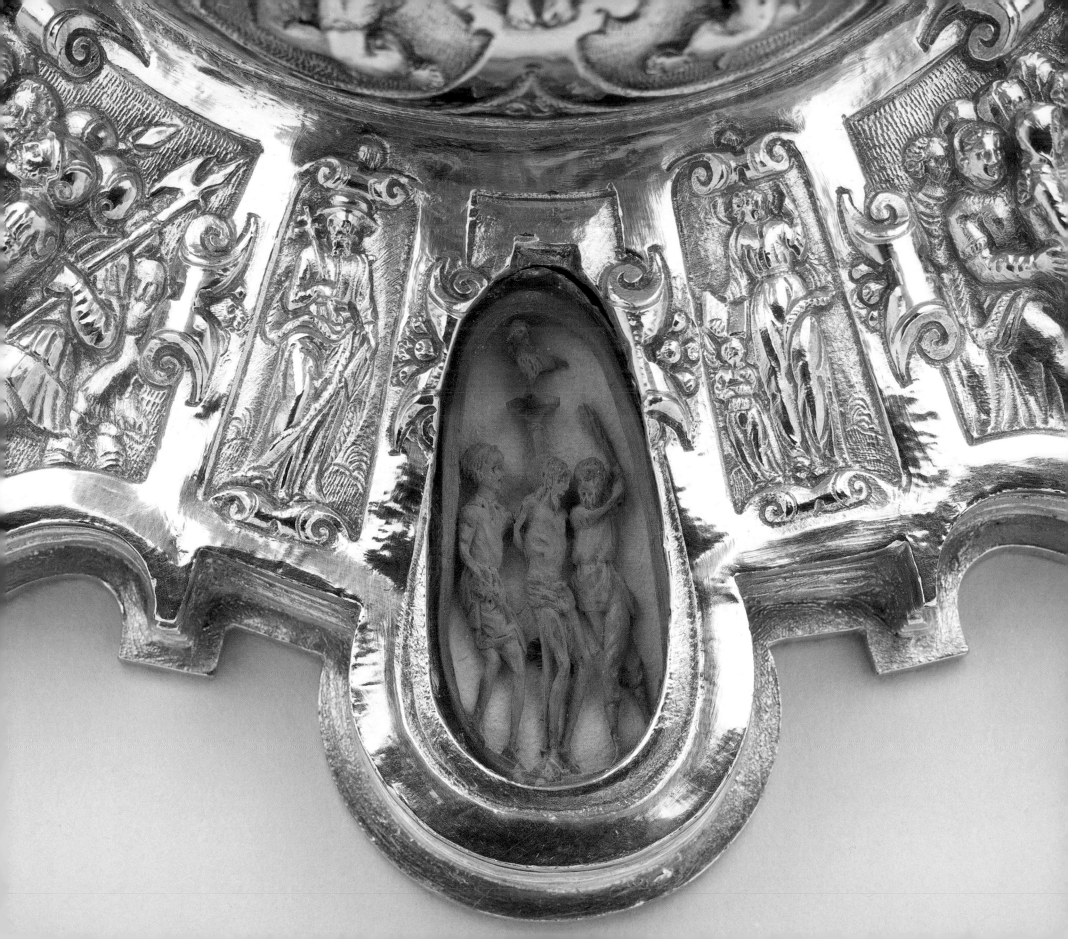

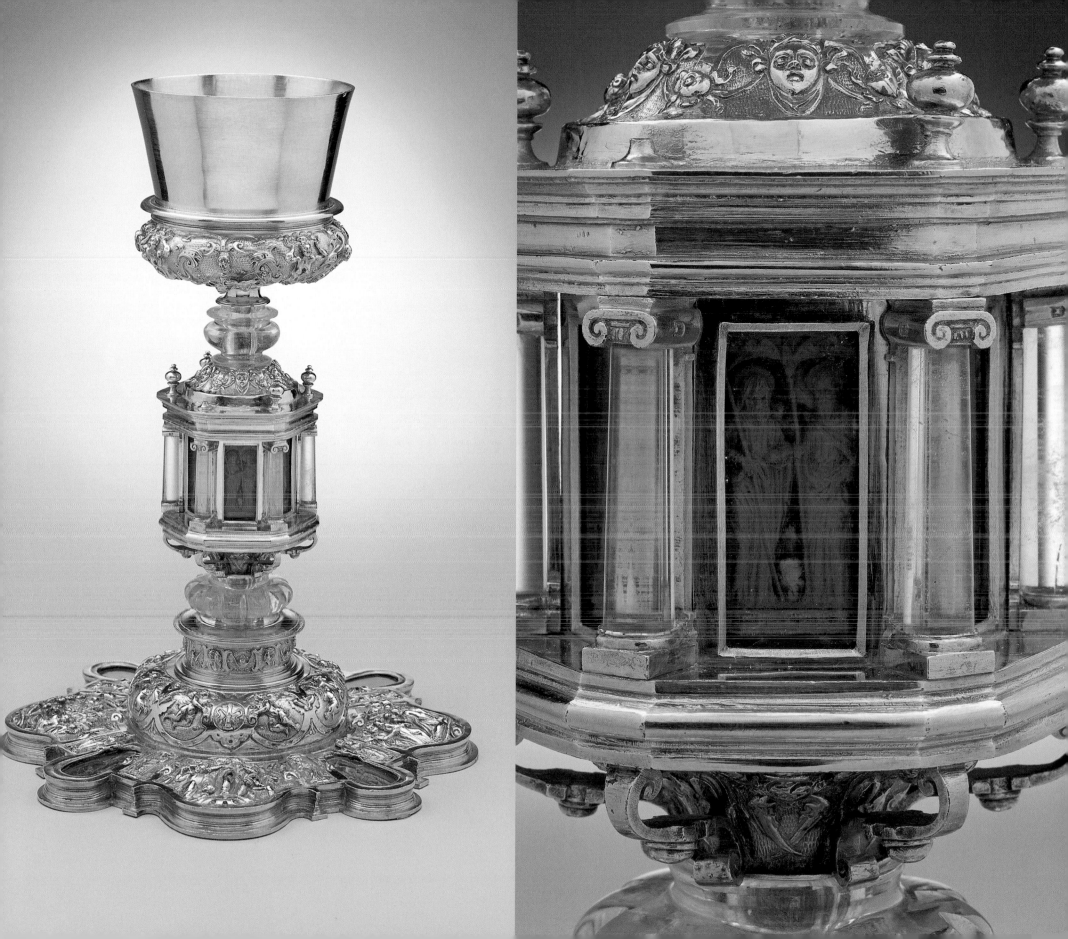

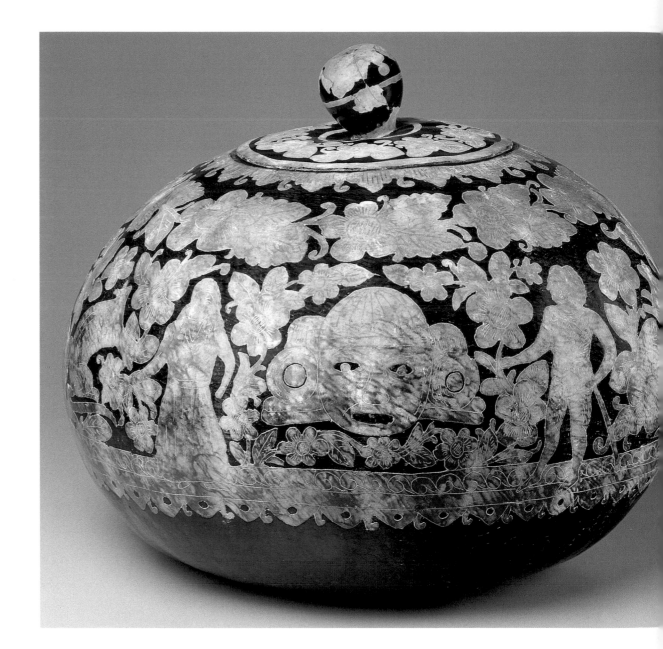

A mist wraps round the song of the shields,
over the earth falls a rain of darts,
they darken the color of all the flowers,
there is noise of thunder in the heavens.
With shield of gold
there they dance.

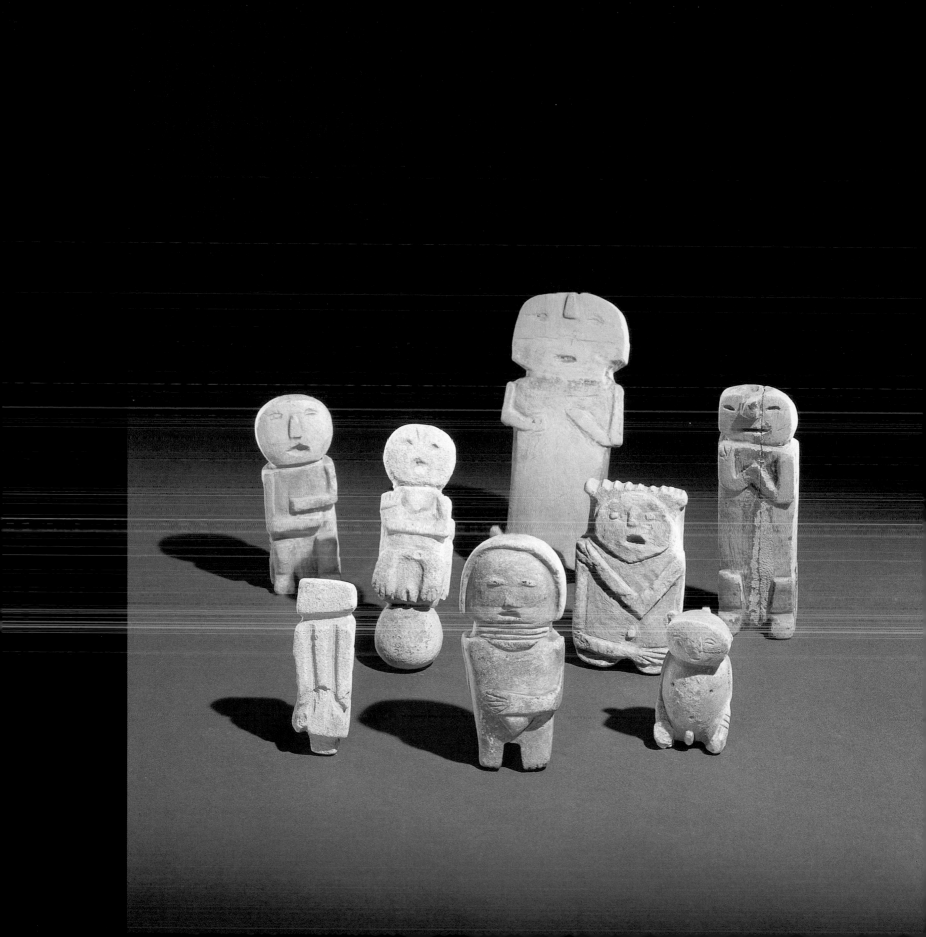

SPANIARDS IN AZTLAN

CARROLL L. RILEY

Only a handful of years after Hernán Cortés's final victory over the Aztecs of central Mexico, the Spaniards began to expand to the west. They were established on the coasts of Colima and Nayarit by the late 1520s and were poised to move northward along the Gulf of California. There were extensive farming settlements of Indians along the coastal plain of what is now Sinaloa, easy targets for tribute and loot. But the Spaniards were driven not only by the desire to conquer large aboriginal populations. The Europeans had an insatiable thirst for precious metals, and they had no difficulty believing the stories, vague but exciting, of wondrous peoples and great wealth somewhere in the unknown north.

For example, Amazons had fascinated Europeans since ancient Greek times, and Spaniards now heard rumors of an island of warrior women somewhere along the coast of the South Sea, the Spanish name for the Pacific. This province, called Ciguatán, was one of the goals of the ruthless Spanish conquistador Nuño Beltrán de Guzmán, who in 1530 and 1531 swept up the west coast of modern Nayarit and Sinaloa, leaving a trail of burned towns and murdered people. But the supposed gynecocracy of Ciguatán, however titillating, was not Guzmán's major goal. The Aztecs themselves, in their traditional histories, had contributed a more compelling story about the distant north. They told the newcomers of Aztlan, the fabled land of Aztec origins, rich, power- ful, and magical. From seven caves in Aztlan, according to the traditional stories, came the seven original tribes of the Aztec people.[1] Aztlan took on a new significance for Guzmán when he heard a tale from an Indian named

Tejo of seven large trading cities, rich in gold and silver, forty days' journey to the northwest of Tejo's home. This home was Oxitipar, the modern Valles in San Luis Potosí, so Tejo likely was a Huastec, a group tributary to the Aztecs. His seven cities may well have shared some of the mythic strands of the seven caves of Aztlan.

In any case, the story resonated quite emphatically with the Spaniards. An enduring legend in the western Mediterranean was the account of seven Portuguese bishops who with their congregations fled the eighth-century Muslim attack on the Iberian Peninsula. These bishops founded seven cities in a gold-rich land (sometimes thought of as an island) called Antilia. The seven cities myth not only attracted Guzmán but also influenced Spanish policy in the northwest of Mexico throughout the Coronado period.[2] Guzmán himself reached as far north as Culiacán, in central Sinaloa. He was eventually recalled, his record of atrocities too much for the Spanish government to stomach. But the Spaniards maintained a presence in northwest coastal Mexico.

This was the situation in 1536, when a party of four shipwrecked members of the Pánfilo de Narváez expedition arrived in Culiacán. In 1528 Narváez had attempted an exploration of Florida, a geographic area that encompassed not only the modern state but also a vast and undefined region to the west and north. Narváez soon pushed on westward along the Gulf Coast, reaching the Texas-Louisiana border area before a storm drowned him and many of his soldiers. The remnants of his army gradually died of disease and hunger or were killed by the coastal natives. Eventually there were only four men left: the treasurer of the expedition, Álvar Núñez Cabeza de Vaca; two fellow Spaniards; and an African slave named Esteban de Dorantes. Under the leadership of Cabeza de Vaca and utilizing the language skills of Esteban, the little party wandered westward,

eventually arriving in northeastern Sonora in early 1536. There the Cabeza de Vaca party found large settlements of warlike Indians, organized into what I have called statelets, in the valleys of the Sonora, Moctezuma, and Yaqui Rivers. While in the statelet area, Cabeza de Vaca heard stories of a rich land to the north, with large towns made up of multistoried houses, whose inhabitants traded emeralds and turquoise for the richly colored plumage of parrots and macaws.[3]

With the help of the Opata- and Pima-speaking people of the statelets, Cabeza de Vaca and his three companions reached Culiacán in April of 1536. Eventually the little group went on to Mexico City and were interviewed by the new viceroy of Mexico, Antonio de Mendoza. The viceroy, who had arrived in Mexico the previous year, was extremely interested in Cabeza de Vaca's account. The Spanish conquistador Francisco Pizarro had just overrun the empire of the Incas in western South America, with its immense treasure in precious metals. Gold fever was at a high pitch, and inestimable wealth seemed to be just beyond every horizon.

It was three years, however, before Mendoza acted to explore the unknown north. A cautious man, he collected information but made no concrete plans until his hand was forced by one of Pizarro's lieutenants, a man named Hernando de Soto, who launched an ambitious expedition to Florida. Faced with this competition, Mendoza now prepared his own expedition to the new lands. As leader, he chose a young associate, Francisco Vásquez de Coronado, recently appointed governor of the new west coast province of Nueva Galicia. While Coronado organized his task force, the viceroy sent a Franciscan friar named Marcos de Niza in the spring of 1539 to search out a path. With Marcos was Esteban, the black interpreter from the Cabeza de Vaca expedition. A supporter of the New Laws of 1540, designed by

FIGURE 199

Map of the New World; from Sebastian Münster's edition of *Ptolemaeus* (Basel, 1540).

the Spanish Crown to protect the Native Americans, Mendoza intended his expedition to be partly a missionary one. He also, however, expected Inca-like wealth from the north.

Marcos de Niza returned to Mexico in the late summer of 1539 with exciting news. He verified that there were seven great cities in the north and gave them a name, Cíbola. He had sent Esteban ahead, and the black adventurer had entered Cíbola (the Zuni region of western New Mexico), only to be murdered by suspicious natives. Marcos pushed on north, where he viewed one of the Seven Cities from across a valley. Perhaps misjudging the distance, or hampered by light conditions, he believed it to be larger than Mexico City. Marcos's official report contained no account of precious metals, though he did hear a rumor of gold in the Sonora Valley, to the south. Nevertheless stories, perhaps deliberately fabricated, of gold, silver, jewels, and European-like natives in Cíbola became the order of the day.[4]

One reason why the glowing accounts of Cíbola were taken at face value was that many influential members of the Franciscan clergy fervently believed in the Seven Cities of Antilia,[5] as probably did the viceroy. In any case, Mendoza in 1540 sent a large party, more than 350 Spaniards and twelve hundred or more central and western Mexican allies, under the command of Coronado, to encounter and overrun Cíbola (see fig. 200). Coronado marched northward, reaching and leaving a Spanish control post in the statelet area of northeast Sonora, the one region where Marcos had reported gold. From Sonora, Coronado pushed on into modern Arizona, passing the great ruin seen by Marcos, called Chichilticalli. In the summer of 1540 Coronado reached Zuni and was bitterly disappointed in the small mud and stone towns of Cíbola. Over the next two years he explored wide areas of the Southwest, his parties reaching as far west as the Grand Canyon. A separate expedition to supply Coronado by sea

under Hernando de Alarcón explored the lower Colorado region. Alarcón came nowhere near Coronado, but he did confirm a discovery of the previous year, that Baja California, generally considered an island, was in fact a part of the mainland. In 1542 an expedition under Juan Rodríguez Cabrillo sailed up the west side of Baja California in search of a Seven Cities seaport. Cabrillo explored parts of the California coast and heard secondhand news of Coronado. Though touched on by later expeditions, upper California did not become part of the Spanish imperium until the eighteenth century.[6]

Moving his command center to a town called Coofor in the Rio Grande province of Tiguex (modern Tiwa), Coronado in 1540–41 probed north to Taos and south almost to the Las Cruces area. With winter at hand, the undersupplied Spaniards resorted to wide-scale looting of food and clothing. The large Indian federation of Tiguex rebelled and in the early months of 1541 was largely destroyed by the Spaniards.

While this was going on, Coronado heard a new story of a rich kingdom called Quivira somewhere out in the Plains. Convinced that here was the true Antilia, he marched with his army into the barranca country of the Llano Estacado. Sending the main army back to the Rio Grande, the commander led a small force to central Kansas, where he encountered only tribal peoples, the Quivira and Harahey Indians, ancestors of the Wichita and Pawnee. With winter approaching, Coronado's detachment turned back to the Rio Grande Valley. Additional expeditions were planned for 1542, but around the beginning of that year, Coronado suffered a serious injury in a fall from his horse. Meanwhile, the Spaniards left at the halfway station in the Sonora Valley had outraged the natives, finally provoking a rebellion that destroyed the Spanish town and scattered those Spaniards who survived the attack.

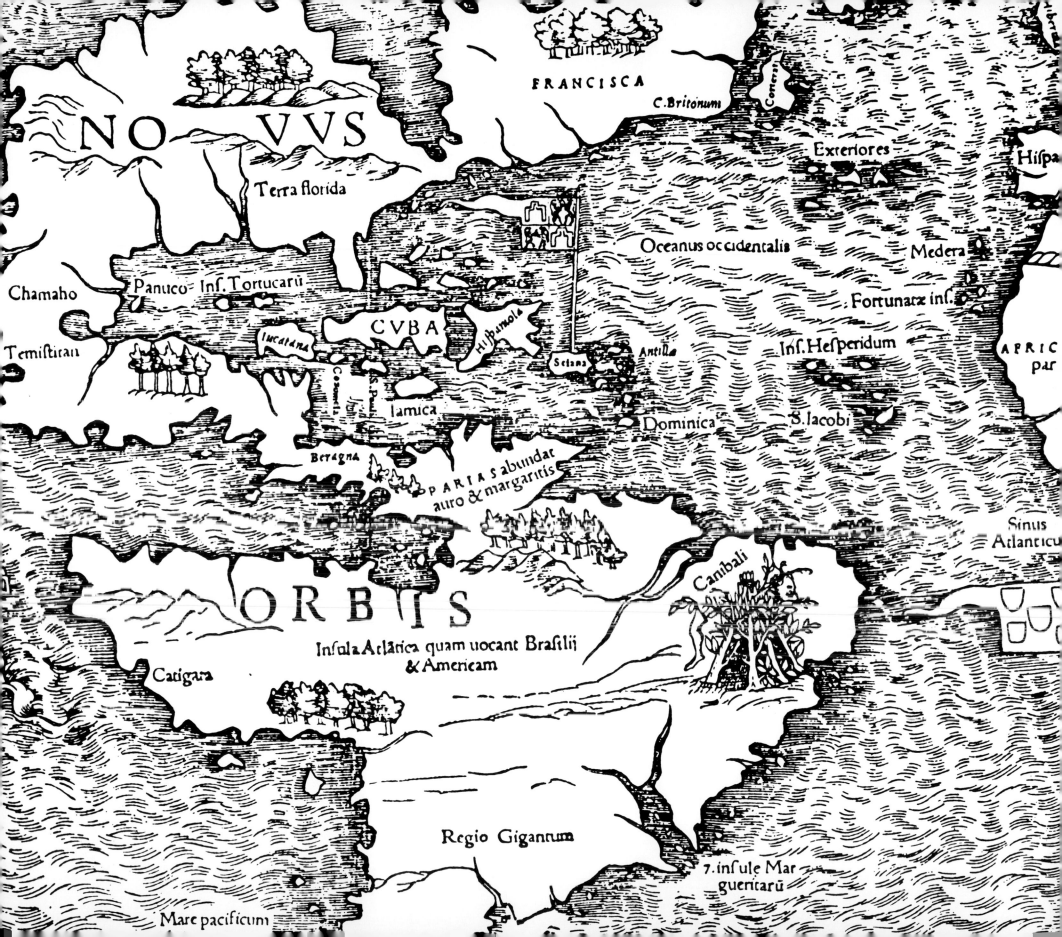

KEY

Coronado
1540–41

Main army when separate
1540–41

Cárdenas to Grand Canyon
1540

Ovando to the Piro Pueblos
1540

Barrionuevo to Taos
1541

THE CORONADO EXPEDITION TO THE SOUTHWEST, 1540–41

FIGURE 200

The routes taken by Coronado
and other Spanish explorers of
the Southwest, 1540–41

The disheartened commander decided to return empty-handed to Mexico. An influential Franciscan in the party, Father Juan de Padilla, remained certain that somewhere in the Plains was the transplanted Portuguese realm of Antilia. He insisted on returning to that area with a small party and was killed at Quivira. The first great Spanish *entrada* into the Southwest ended as a total failure. Cabrillo's exploration of upper California was not followed up, and the knowledge that Baja California was connected to North America was lost.[7]

Following the Coronado debacle, the west coast of Mexico became increasingly neglected by the Spaniards. In large part this was due to a series of discoveries along the eastern edge of Mexico's Sierra Madre Occidental, the basin and range country that in 1540 formed an unknown northern boundary of New Spain. Beginning in 1546 in Zacatecas, Spanish explorers found vast deposits of silver. Over the next several decades a series of silver strikes were made, first in Zacatecas, then in Durango and Chihuahua. The main exploiters of this silver and of associated ranching were a number of Spanish Basque families, including the Ibarras and the Oñates. These entrepreneurial families orchestrated the formation of the province of Nueva Vizcaya (named after a Basque-speaking region of Spain), founded in 1562, with Francisco de Ibarra as the first governor. Two years later Ibarra was on the west coast, searching the northwest portion of his new domain. The name Aztlan had now largely disappeared from the Spanish lexicon, but Ibarra heard of a new mysterious land, Copala, a fabulously rich province somewhere in the northwest of New Spain. Ibarra explored parts of northern Sonora and western Chihuahua, but he never found Copala.[8] The Copala legend retained its force, however, becoming the end-of-the-line mythical country for the next century and a half. It was always *más allá*, over the next horizon,

and by the seventeenth century had gravitated to some point north and west of the province of New Mexico.

But the Spaniards were now beginning to be skeptical of legends. What they did know was that silver, vast amounts of it, was coming out of the northern Sierra Madre mines. And silver meant rapid settlement along the northern frontiers of Nueva Vizcaya. It also meant a shortage of labor, which led to an endless cycle of attacks on Indian settlements all along the frontier to supply slaves for the mines and the supporting ranches of cattle and sheep. This rapacity eventually became such a scandal that the Spanish government established stringent regulations in 1573, allotting the pacification of new areas to missionaries and forbidding attacks on Indians. This gave the Franciscan missionaries of northern Nueva Vizcaya a certain amount of clout, and in the late sixteenth century they intensified their missionization agenda.

But the lands to the north still exerted a strong hold on the Spaniards. The belief in rich mines in the area and the possibility of receiving Indians in *encomienda* made the Southwest very attractive. The *encomienda* system, introduced soon after the arrival of the Spaniards in America, was the awarding to individual Spaniards the right to labor and tribute of entire towns or even tribes of Indians. The Southwest was now seen primarily in these prosaic economic terms, at least by nonmissionaries, though there was still the feeling that civilized societies might exist somewhere in the undiscovered north.

Between 1581 and 1583 two expeditions were launched from Santa Bárbara, a Spanish settlement in what is now southern Chihuahua (see fig. 201). The first of these, a tiny party of nine soldiers and three Franciscans, was led by Francisco Sánchez Chamuscado and Fray Agustín Rodríguez. Technically Chamuscado's main function may have been to act as escort to the friars, but in fact he was involved in extensive mining exploration.

FIGURE 202
John M. Valadez
THE BORDER (panel 2), 1991–93
(Cat. no. 222)

244

caught the Quivira fever and marched out into the Plains. Humaña murdered Leyva in some sort of quarrel and took command of the expedition. In a tragic repeat of the Padilla story, the entire party, with the exception of five Indian servants, was killed by hostile Indians, probably in western Kansas. One of the escapees, a man named Jusepe, eventually found his way back to the Southwest and was interviewed by Juan de Oñate in 1598.[10]

The race was now on for the colonization of the upper Southwest. After considering a number of candidates and with much backing and filling, the Spanish Crown awarded the contract to Oñate in 1595, though he was unable to start for the new province until 1598. The contract Oñate negotiated with the Crown originally gave him the right to bring ships across the Atlantic to New Mexico, a clear indication of the shaky state of Spanish geographic knowledge of lands to the north of New Spain. Oñate also expected to connect New Mexico directly via the Pacific Ocean to Spanish Mexico, Peru, and the Philippines.

In March of 1598 Oñate struck out for New Mexico with a party of some 560 men, women, and children, including Europeans, Africans, Indians, and many racially mixed individuals. There were also eight Franciscan friars and a vast amount of mining equipment. With this diverse group and heavy baggage, Oñate pioneered a new route to the Southwest, traveling northward from northern Nueva Vizcaya, eventually reaching the Rio Grande below modern El Paso. In the summer of 1598 he arrived in the upper Rio Grande area and made the first Spanish capital of the province of New Mexico at San Gabriel del Yunge, just north of modern Española. In the following decade Oñate's parties explored as far east as Kansas and as far west as the lower Colorado River. Pueblo Indians were assigned to missionaries, and everywhere Oñate sought silver mines.

Oñate's explorations finally brought the realization that there was no Antilia, no kingdom of Quivira, and that neither ocean was anywhere near New Mexico. The old myths had been exploded, and unfortunately for the Spaniards the new mythology of great silver and gold wealth in the upper Southwest also evaporated. Though colonists and missionaries clung to the idea far into the seventeenth century, there is no evidence that any significant amount of silver or gold was ever exported from the colony. There were in fact deposits of precious metals scattered throughout the Southwest, but they were beyond the technical and logistic capabilities of seventeenth-century Spaniards. What did exist were reasonably large populations of Pueblo Indians, at least fifty thousand in 1598, and uncounted thousands of Apache, Navajo, Ute, Jumano, and Manso around the borders of the Pueblo world.

By 1608 the Spaniards were ready to throw in the towel. Spanish population had been dropping as more and more individuals deserted the colony. Gripped by the Little Ice Age, the New Mexican climate was unattractive, with hot summers and chillingly cold winters. The colonists were finding it hard to grow enough food to live, and depredations on Pueblo food supplies were creating mounting tensions. Oñate was under pressure to explain certain acts of repression, especially the attacks on Acoma Pueblo in 1599 and on the Tompiro Pueblos in 1600–1601, operations that led to great losses of life. The Franciscans, whose policies were to protect the Indians, albeit on missionary terms, were at swords' points with the governor and with the settlers.[11]

FIGURE 206

Jan Mostaert (Netherlands,
c. 1475–c. 1555)
ATTACK ON HAWIKUH (EPISODE
OF CONQUEST OF AMERICA),
16th century
Oil on wood
34⅛ x 60³⁄₁₆ in.
(86.5 x 152.5 cm)
Frans Halsmuseum, Haarlem,
Holland

CÍBOLA = NEW MEXICO = AZTLAN

The region where the Pueblo Indians lived, in the heart of what is now the American Southwest, saw the arrival of the first Europeans in 1539. In the spring of that year, the Franciscan friar Marcos de Niza, accompanied by a Moorish slave named Esteban, came to the outskirts of the Zuni village of Hawikuh. By order of the viceroy of New Spain, Niza had followed the trail of the insistent rumors that various conquistadores had gathered about the existence of great cities in unknown lands located beyond the diffuse line that then marked the northern limit of the viceroy's domain. Even though the friar kept what he thought to be the indigenous name of the province, transcribing as Cíbola the word Shi-wi-nah (the Zuni name for the Zuni tribe),[12] in 1581 this toponym was officially changed to New Mexico.

Two testimonies carried the most weight in the viceroy's decision to send Marcos de Niza on his modest reconnaissance expedition. The first was the news that Nuño de Guzmán, the conqueror of Nueva Galicia, received in 1529 from an indigenous servant who claimed that as a child he had accompanied his father on a commercial trip to those distant provinces, which he "wished to compare with Mexico and its region" because he had seen there "seven cities that had streets of silver."[13] Later, Álvar Núñez Cabeza de Vaca and three other survivors of Pánfilo de Narváez's ill-fated expedition to Florida, which ended in shipwreck in the Bay of Tampa, heard tell of a supposed group of rich and populous settlements at some point along the route that they followed in searching for their compatriots between 1533 and 1536 through what are today the states of Texas, Chihuahua, Sonora, and Sinaloa.

Upon his return to Mexico City in August 1539 Marcos de Niza gave an account of his explorations that unleashed a fever of colonization that has few parallels, for the terms he used to describe his findings—a population supposedly "greater than [that of] Mexico City" situated in a province that promised to be "the biggest and best of all the discoveries"[14]—seemed to confirm the truth of those rumors. Although the Franciscan friar had only contemplated from a distance the towns that he presented under the name of Cíbola, they, like the ones that Nuño de Gúzman had described a decade before, were "seven reasonable cities," with multistory buildings. Their inhabitants, according to Fray Marcos's guides, made vessels of gold and also small spatulas to wipe off their sweat.[15] All these reports raised so many expectations among the conquistadores that Juan de Zumárraga, writing to his nephew in August 1539, excitedly noted that Fray Marcos had just discovered "another, much greater land," where the people were "more political," for they had multistory wooden buildings and fine clothes, and added that since the friar had heard of "other cities greater than this one of Mexico," many people in New Spain were "moved to set out."[16]

The viceregal authorities responded to this mounting impetus toward colonization by organizing an ostentatious expedition under the direction of Francisco Vásquez de Coronado, then governor of Nueva Galicia. The subsequent events are well known. Between 1540 and 1542 Coronado and his captains traveled through almost all the villages of the Zuni region as well as those in the Rio Grande Valley, but they decided to dismantle the colony after exploring the great prairies in a fruitless search for the kingdom of Quivira, another marvelous land that the Pueblo Indians claimed to know, supposedly located northwest of their own towns. Ultimately the seven cities of Cíbola, insignificant in comparison with Mexico-Tenochtitlan, far from satisfying the soldiers' and colonists' ambitions, only frustrated them, and this frustration was translated into rage and cruelty against the unsubmissive or rebellious people (see fig. 206).

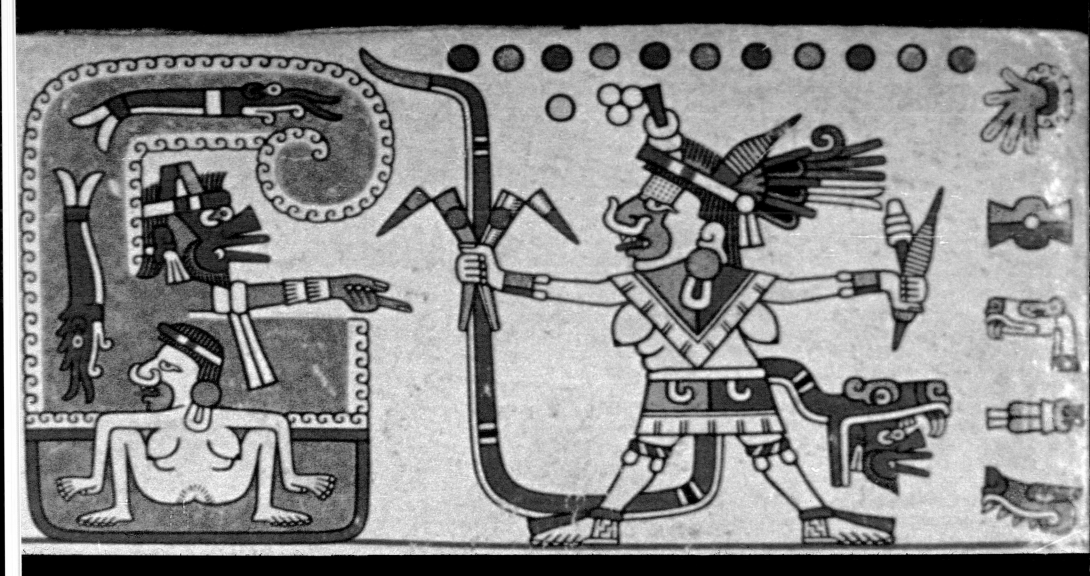

FIGURE 213

Female supernaturals
From the Codex Laud, folio 15r
Bodleian Library, University of
Oxford, MS. Laud Misc. 678

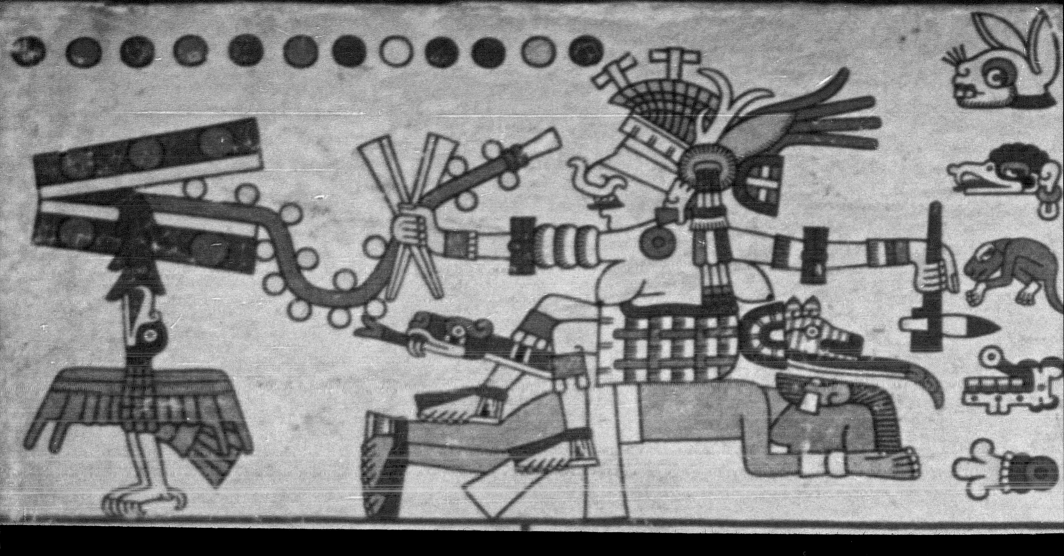

FIGURE 214

Scene of conquest

From the Codex Laud, folio 18r

Bodleian Library, University of

Oxford, MS. Laud Misc. 678

Fortunately, this linguistic opinion has recently been countered in a critical fashion by scholars such as Elizabeth Hill Boone and Walter D. Mignolo.[7] Boone reminds us, for example, that alphabetic writing is completely insufficient for transmitting musical language, and this can also be said of mathematical or binary language, maps, traffic signs, and signs in public places such as airports. But nothing discredits these other systems as forms of writing and of language, even though they do not represent specific spoken languages; moreover, they offer a distinct advantage in that people who speak different languages can read them. Travelers from all over the world passing through any international airport can find restrooms, baggage claim areas, restaurants, and ground transportation simply by following graphic symbols. Likewise, musicians who come from countries with different languages can all read Mozart's music and play it in a very similar way, with no need to base their interpretation on spoken language in written form. That would be practically impossible if the same piece by Mozart had to be read directly from an alphabetical description in German, simply because any of his symphonies would require volumes of alphabetic writing in order to be described in a manner more or less faithful to the original, given that alphabetic writing cannot render sounds of different types or tones. For example, spoken language presented in written form cannot convey the tone of voice and the timbre of a person's speech, nor the volume or the speed of his or her utterances, nor the eloquence or emotion that they project. No one today can tell, simply by reading their writings, in what tone and timbre Abraham Lincoln, Thomas Jefferson, Benito Juárez, or Sor Juana Inés de la Cruz spoke. Another, more visual example is the use of maps. One would need entire pages of alphabetic writing to describe regions of the globe, whereas a map does

so instantaneously; the little alphabetic writing that figures on the map, in the form of marks or annotations, is secondary.

Clearly certain types of visual nonalphabetic writing can be more practical for specific purposes than writing that represents spoken language; it all depends on the needs that such systems of nonverbal writing address. This is not to say that one system is better than another, but simply that they are different solutions to different problems of communication. In short, pre-Hispanic writing is no more or less advanced than phonetic or alphabetic writing; it is simply a cultural product that responds to the specific needs of certain periods and places in the history of humanity, and its evolution is more complex than the linear view implies. For example, Mayan writing went from being hieroglyphic in the Classic period to being iconographic and logographic in the late Postclassic period, because the need for communication with the neighboring cultures and among the Maya themselves changed in the space of a few centuries. There is evidence that pre-Hispanic books responded as adequately to the immediate needs of the cultures that created them as contemporary books do to our needs today. The "evolution" toward an alphabetic writing, as we can see, is not a universal process. The tree of theory will always be gray beside the green tree of life.

THE FORMS OF MEMORY

The pre-Hispanic books known today fall roughly into four different categories: (1) accordion-shaped books, read from bottom to top in a serpentine fashion, from left to right and right to left, or simply from right to left; (2) cartographic histories, read simultaneously in different directions; (3) annals, read in a single straight line from left to right, or with years sometimes clustered or arranged in a cross; (4) postconquest codices of

European format, read from left to right, top to bottom, annotated in alphabetic writing, with drawings influenced by Renaissance perspective and anatomy and painted on European paper.[8]

Each style addresses different needs. Thus, the accordion format that authors such as Boone call *res gestae* (meaning "deeds done") is ideal for relating political and dynastic histories in which the names of persons, events, dates, and places are important, as in the books of the Mixtec region, for example, the Zouche-Nuttal, Vienna (or Vindobonensis Mexicanus I), and Selden codices, as well as the Borgia Group codices. This type of book describes, among many other things, dynasties and family trees, weddings, wars and heroes, names, dates, and places both real and mythological. Mixtec books are not only the most numerous pre-Hispanic books but also the most extensive, the only ones whose stories sometimes reach epic proportions. We can often infer from them elements still present in the cultures of the region, such as the matriarchy reflected in many of the Mixtec codices, which remains a political reality in the Isthmus of Tehuantepec. Unfortunately, much of the content of these books is yet to be deciphered. One characteristic of these books is their vague and disjointed presentation of time and often also of space.

In contrast to the accordion format, the cartographic style that can be seen in hundreds of *lienzos* and *mapas* dating mostly from the sixteenth and early seventeenth centuries focuses on space. Although here space is not so much topographic as social, political, and legal, the format is ideal for establishing territorial, social, and political agreements. Perhaps the most important cartographs, or those that have the most interest today, are those that describe events of historical significance or present ancestral migrations. Given the simultaneous presentation, these stories are sometimes told less clearly than in the accordion-format books, a problem that is remedied when the information is spread out over a series of maps, as in the Codex Xolotl. But in any case, cartographic histories are unrivaled in the presentation of important political events that affected the fates of the regions they cover. Thus, for example, the *Mapas de Cuauhtinchan* and the *Historia tolteca-chichimeca* describe the migration of the Chichimecs to the center of Mexico, as they left Chicomoztoc (place of the seven caves) and arrived at places such as Cholula, in Puebla, in the hopes of mixing with the nobles of the region. The *Lienzo de Tlaxcala* recounts in great detail the fall of the Aztec empire, describing, on the one hand, the conquistadores and their Tlaxcaltec allies, led by Hernán Cortés, accompanied by his indigenous companion and interpreter Malinche, and, on the other, the Aztec resistance, with the people of Tenochtitlan stoning Moctezuma II to death in his own palace as he tried to calm their rage against Cortés. It then describes the Aztec warriors hurling themselves into bloody battles in defense of their cities, led by their last emperor, the young Cuauhtemoc.

The annals, *xiuhamatl*, are structured linearly, relating events year by year or sometimes in groups of years, to save space, when there were no events of note for several years, as in the Codex Boturini. The presentation can also be cruciform, as in the Codex en Cruz. Because annals were the Aztecs' preferred format for relating important events over the years of the empire, in general these books do not focus on naming persons and places, since it is understood that the subject is official Mexica time and the Aztec empire. In annals such as the Codex Mexicanus, imperial time begins with the migration of the Aztec people in the year 1 Flint (twelfth century), from the moment of their departure from the island of Aztlan (place of white herons), led by Huitzilopochtli after their first stop in the neighboring hill of Colhuacan.

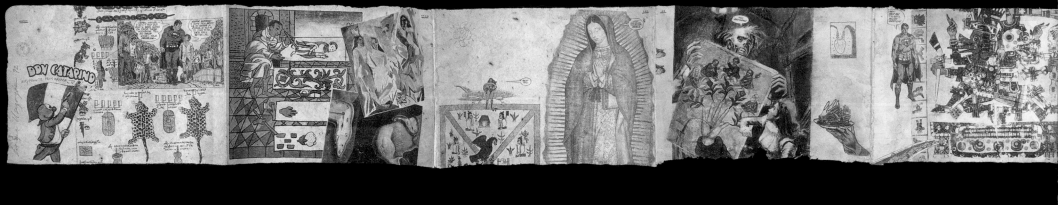

FIGURE 215

Enrique Chagoya

TALES OF THE CONQUEST—

CODEX II, 1992

(Cat. no. 231)

FIGURE 216

Santa C. Barraza

UNA VIDA CONTINUA, 1985

(Cat. no. 230)

Most of the annals include the arrival of the Spanish and continue into the colonial period, implying that Aztec time was not necessarily interrupted by the conquest.[9] The main drawback of the annal format is a lack of cause and effect, since events can be described only year by year. Although the annals cannot in themselves offer a more complete historical view, they give a wealth of information parallel to that in other codices, enabling us to verify dates and the authenticity of stories.

The last echoes of ancient history are found in books in European format. Since most of these books were commissioned by the Spanish, they were usually written in alphabetic form, either in indigenous languages or in

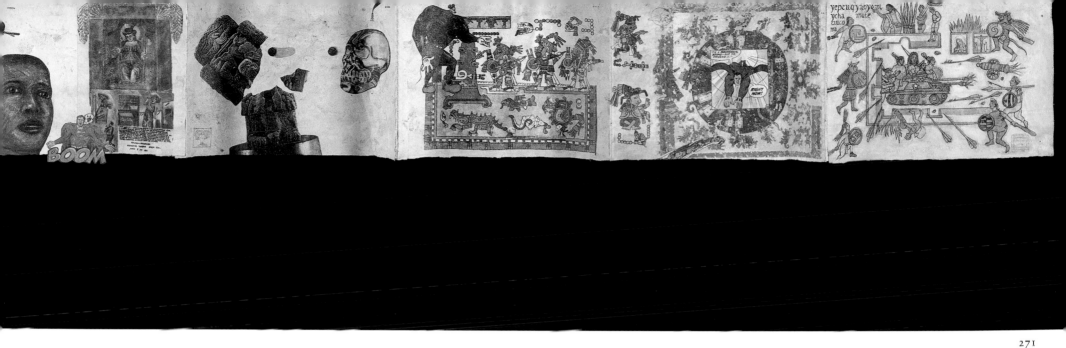

Spanish. Thus, they serve as the best bridge between the pre-Hispanic past and the present. Thanks to these books, we understand a little more about the content of the different types of pre-Columbian books. Among the codices written and painted generally on European paper and in European format are great jewels such as the *Popol Vuh* and the *Books of Chilam Balam,* which give an epic view of Maya history and mythology. Other treasure troves of information are the Aubin (see fig. 217), Aubin-Goupil, Mendoza, Boturini (or *Tira de la peregrinación*), Sigüenza, and Telleriano-Remensis codices, all important for offering various versions of the history of the Aztec empire and its coming from Aztlan.

All these types of books complement one another, and all have been indispensable in shaping our understanding of the ancestral past of Mesoamerica, even if they sometimes give contradictory information. In general, however, if we compare texts and annals such as the aforementioned Mexicanus, Boturini, and Aubin codices, we find that much of the information is corroborated.

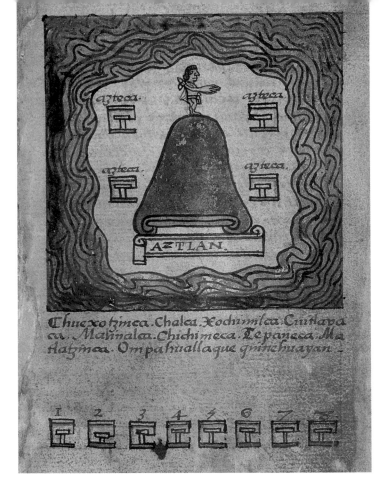

FIGURE 217

Place-sign for Aztlan
Codex Aubin, folio 3
The British Museum
(Add. Mss 21219)

272

THE MYTHICAL ISLAND OF WHITE HERONS, POINT OF DEPARTURE OR PLACE OF ARRIVAL

Of course, much information is missing. The location of the island of Aztlan, for example, remains a mystery that has given rise to much speculation. Thus, historians such as Gordon Brotherston, following the northwest-to-southeast direction shown for the Aztec migration in several of the aforementioned codices and maps, situates it in the Pacific, off the shore of Nayarit, on the island of Mexcaltitlán. This island is filled with white herons (which is what the name Aztlan means), and it belongs to the region of Huichol, a culture whose language is in the same family as that of the Mexicas.[10] Other authors,

such as Miguel León-Portilla, raise the possibility that Aztlan and Tenochtitlan may represent the same island, the point of departure and the place of arrival. This hypothesis is very interesting considering that the hill of Colhuacan is not far from where the island of Tenochtitlan was, and that several codices name Colhuacan as the first stop in the migration of the Mexicas right after leaving the island of Aztlan. It is there that Huitzilopochtli promised a future empire for the Aztec people. León-Portilla also points out that the Mexicas spoke Nahuatl when they arrived in the Valley of Mexico and that was the most common language in the region for the majority of Nahua groups that lived there; moreover, Nahuatl is not known to be spoken in any other region.[11]

Unfortunately, there is no archaeological evidence that would allow us to corroborate this hypothesis and many others. Many more questions about other groups remain unanswered. For instance, where did the Olmecs come from, and how did they disappear? Did they merge with other cultures such as the Maya or Toltec? Why were so many Mayan cities abandoned, and other cities, such as Teotihuacan? Were they sacked by invaders or destroyed by peasant rebellions? How did cultures like the Maya or Nahua, which had a more precise calendar than the European Gregorian one, make their astronomical and mathematical calculations? How much medical knowledge did they have, besides the fact that they already used antibiotics such as penicillin? How can it be that coca and tobacco, products common to the Americas, have been found on the remains of Egyptian mummies? Just how far did the ancient trade routes go? Possibly the answers to these and many other questions went up in smoke less than five hundred years ago, or five hundred revolutions around the sun, as my grandmother would say—not that long ago at all.

NOTES

1. Furtado 1970, introduction and chap. 1.

2. León-Portilla 1985, 60–75.

3. Here I must speculate that the books would have contained information ranging beyond Mesoamerica, considering that the Aztec empire engaged in cultural and commercial exchanges with both North and South America and that its concept of history was similar to that of the Greeks, with a dominant viewpoint through which interaction with other peoples and cultures was presented. We know that the calendar was the same for the Aztecs, Maya, Mixtecs, and Zapotecs, to name but a few examples. Maize, the sacred, mythological food and one of the most nutritive and versatile grains in the world—developed through Nahua agricultural engineering in the center of Mexico—spread from the south to the north of the continent centuries before the arrival of the Spanish. Mesoamerican craftsmanship in precious metals was strongly influenced by Inca gold and silver work imported through trade with Central America. In light of all this, it seems likely there were pre-Columbian books that spoke of the history of such transcontinental interactions.

4. Toltec culture was the first Nahua civilization in Mesoamerica. The Toltecs (architects), led by Quetzalcoatl (the plumed serpent, a culture hero who was later considered a god), were the bridge between the Olmec mother culture and the rest of the Mesoamerican cultures, influencing religions, mythologies, and calendars of such diverse cultures as the Aztec, Mixtec-Zapotec, Teotihuacan, and even the Maya, among many others.

5. Martínez 1984.

6. Here we should mention the importance of the indigenous oral tradition as an indispensable complement to the performed reading of the books. The reading of the known pre-Columbian books was not in general a phonetic or alphabetic reading but rather a pictographic manner of transmitting ideas and knowledge with the help of memories that had been passed down from generation to generation through mnemonic and oratorical exercises. It is a known fact that some Spanish priests during the colonial period of Christianization greatly admired the capacity of many of the indigenous people to memorize and recite entire chapters of the Bible thanks to this oral tradition.

7. Boone and Mignolo 1994, introduction.

8. Boone and Mignolo 1994, 54–72.

9. Boone and Mignolo 1994, 67.

10. Brotherston 1995, 47.

11. See León-Portilla 1983.

An Unbroken Thread

The Persistence of Pueblo Textile Traditions
in the Postcolonial Era

Laurie D. Webster

The arrival of Europeans in the "New World" introduced
dramatic changes to America's native societies, leading
to the transformation and loss of innumerable artistic
traditions. In this essay I discuss postcontact changes in
the textile traditions of the Pueblo Indians of the south-
western United States and the ways in which Pueblo
societies compensated for these changes to ensure the
perpetuation of their craft.[1] The group known collectively
as the Pueblo Indians includes the Hopi tribe of north-
ern Arizona, the Zuni and Acoma tribes of western New
Mexico, and a cluster of Tiwa, Tewa, Towa, and Keresan-
speaking communities along or near the Rio Grande in
the vicinity of modern-day Albuquerque, Santa Fe, and
Taos, New Mexico (see fig. 218). From 1540 to 1821 this
region was under the control of New Spain and was then
part of Mexico until annexed by the United States in 1848.

Among the many accomplishments of the ancestral
Pueblo Indians was a highly developed weaving tradition,
one derived from Mesoamerica but with its own local
stamp and flavor. We know a great deal about prehistoric
weaving in the Southwest due to the arid climate of the
region and intensive human use of the region's many caves
and overhangs, conditions favorable to the preservation
of textiles. Thousands of textiles survive from the region,
providing us with a rich picture of the beauty, complexity,
and diversity of ancient Southwestern fabrics and dress
(see figs. 219, 220).[2]

Textiles hold a prominent place in the rituals of most
societies, and the ancestral Pueblos were no exception.
Mural paintings unveiled by archaeologists from cere-
monial structures known as kivas contain abundant

274

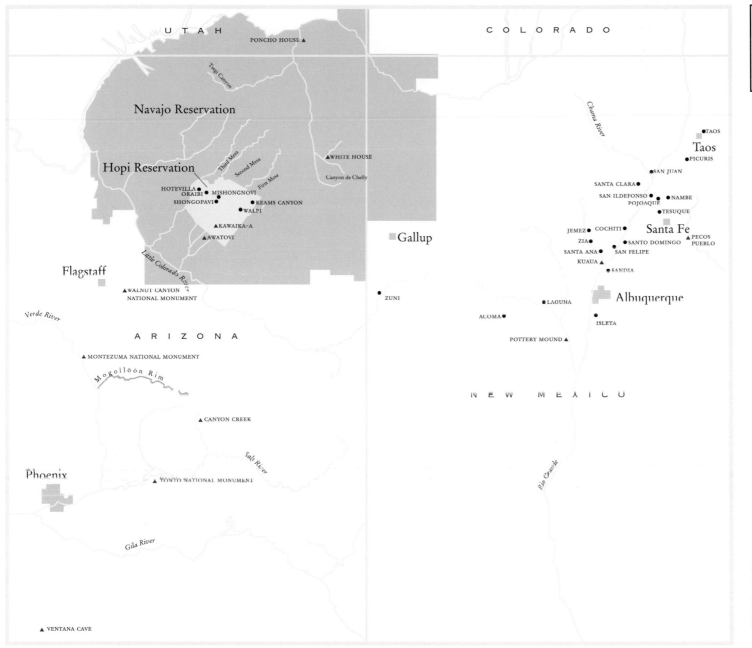

UTAH
COLORADO

PONCHO HOUSE ▲

Tsegi Canyon

Navajo Reservation

Chama River

TAOS ●
Taos
PICURIS ●

WHITE HOUSE ▲

Hopi Reservation

Third Mesa
Second Mesa
First Mesa

Canyon de Chelly

SAN JUAN ●

SANTA CLARA ●

HOTEVILLA ●
ORAIBI ● MISHONGNOVI ●
SHONGOPAVI ●
WALPI ●
KEAMS CANYON ●

SAN ILDEFONSO ● ● NAMBE
POJOAQUE ●
● TESUQUE

▲ KAWAIKA-A

JEMEZ ● COCHITI ●
ZIA ●
SANTA ANA ●

Santa Fe

▲ AWATOVI

Gallup ■

SANTO DOMINGO ●
SAN FELIPE ●

▲ PECOS PUEBLO

Little Colorado River

KUAUA ●
▲ SANDIA

Flagstaff

Verde River

▲ WALNUT CANYON
NATIONAL MONUMENT

ZUNI ●

ARIZONA

LAGUNA ●

Albuquerque

ACOMA ●

ISLETA ●

▲ MONTEZUMA NATIONAL MONUMENT

POTTERY MOUND ▲

Mogollon Rim

NEW MEXICO

▲ CANYON CREEK

Salt River

Rio Grande

Phoenix

▲ TONTO NATIONAL MONUMENT

Gila River

▲ VENTANA CAVE

FIGURE 218

Locations of contemporary Pueblo villages and some important late prehistoric and early historic sites

FIGURE 221

Mural reproduction from
Kiva 8, Pottery Mound, New
Mexico. Female figure wears a
manta dress with resist-dye(?)
decoration and a white sash
with elaborate tassels. Hair
whorls such as those seen here
were worn by unmarried Hopi
girls until the early part of the
twentieth century.

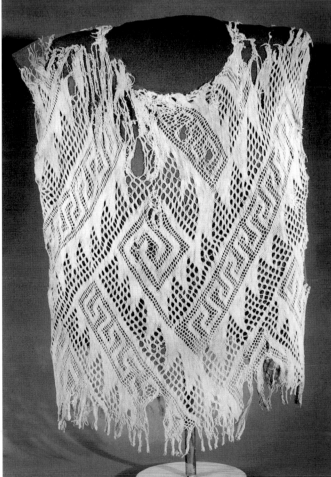

FIGURE 219

Painted blanket from
Hidden House, central Arizona,
Sinagua culture, 1200–1300
Arizona State Museum,
University of Arizona

FIGURE 220

Interlinked shirt from Tonto
Ruins, east central Arizona,
Salado culture, 1400–1500
Arizona State Museum,
University of Arizona

imagery of male and female personages in elaborate ritual dress (see fig. 221). These rare and significant paintings testify to the intricacy of Pueblo ceremonial life and the tremendous importance of textiles to late prehistoric Pueblo ritual.[3]

EARLY SPANISH ACCOUNTS OF PUEBLO WEAVING

The Spanish conquistadores were clearly awestruck by the beauty and quality of Pueblo clothing. Their chronicles, and the testimonies of early Spanish settlers, provide our most detailed descriptions of Pueblo dress and textile production for the entire Spanish colonial period. The following translation of Hernán Gallegos's description of his visit to a southern Tiwa town in the 1580s illustrates the richness of some of these early eyewitness accounts:

Some [men] adorn themselves with pieces of colored cotton cloth three-fourths of a vara in length and two-thirds in width, with which they cover their privy parts. Over this they wear, fastened at the shoulders, a blanket of the same material, decorated with many figures and colors, which reaches to their knees, like the clothes of the Mexicans. Some (in fact, most) wear cotton shirts, hand-painted and embroidered, that are very pleasing. . . . Below the waist the women wear cotton skirts, colored and embroidered; and above, a blanket of the same material, figured and adorned like those used by the men. They adjust it after the fashion of Jewish women, and gird it with embroidered cotton sashes adorned with tassels.[4]

From such writings we know that Pueblo dress at the time of contact consisted of woven cotton garments, some elaborately decorated with painted or embroidered designs, as well as buckskin clothing, bison robes, and turkey feather blankets. Men wore shirts and kilts or breechcloths, and women wore blankets wrapped around the body and tied at the waist with a sash (cf. fig. 221). The people of Hopi, Zuni, Pecos, and the middle Rio Grande villages had more elaborate clothing than the Pueblos on the northern and eastern peripheries, who relied more on hides for their clothing needs.

Early chroniclers also provide valuable information about the organization of textile production among the Pueblos.[5] They identify the Hopi villages and the towns along the Rio Grande as major centers of cotton production and males as the principal weavers. According to these accounts, most spinning and weaving took place in the kivas during the winter months, when men were free of agricultural responsibilities (see fig. 222).

Since the Hopi and middle Rio Grande villages specialized in the growing of cotton, it comes as no surprise that they also specialized in the production of loom-woven cotton cloth. Early Spanish accounts make special mention

FIGURE 222
Hopi man spinning yarn near kiva entryway, c. 1917. The traditional division of textile labor has been retained at Hopi into modern times.
Museum of New Mexico

277

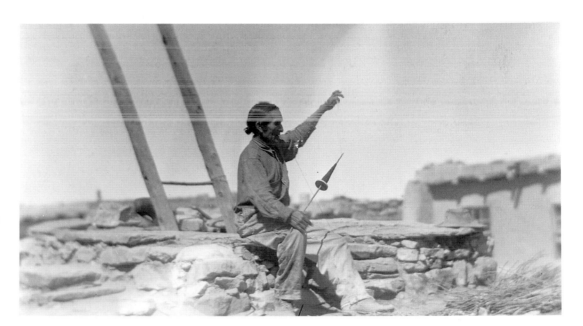

of the blankets produced in the Piro, Tiguex (Tiwa), and Hopi towns.[6] Climate limited the places where cotton could be grown, and a lively trade arose by late prehistory based on the exchange of cotton, corn, and other agricultural products for bison robes, deer hides, meat, and salt.[7] The Eastern Pueblo villages situated along the floodplain of the Rio Grande supplied cotton to their neighbors to the north and east, whereas the Hopi villages supplied Zuni and their nomadic neighbors to the south and west. Although Hopi cotton textiles doubtless made their way into Eastern Pueblo societies through trade and gift exchange, the Eastern Pueblos met most of their cotton needs through local exchange networks. All of this was to change in the wake of Spanish colonization.

IMPACTS OF SPANISH SETTLEMENT

New Mexico's first Spanish colony was established in 1598 near present-day Santa Fe. Thus began two centuries of change, resistance, and adjustment as Pueblo societies reacted to the effects of Spanish colonial rule. As in other parts of New Spain, the *encomienda* system of tribute and the *repartimiento* system of forced labor were imposed upon New Mexico's settled populations, with the Pueblo Indians their primary targets. The Franciscans also established missions among the Pueblo villages, diverting their goods and labor to mission purposes. Much of the friction that arose between the secular and religious authorities during the Spanish colonial period derived from competition over Pueblo labor.

With the establishment of the province of New Mexico came the rise of a frontier market system, an internal system based on the barter of local products and an external one involving exchange with other regions of New Spain. The mission supply service, originally founded to supply just the missions, soon became the vehicle for all commerce between New Mexico and the

markets of Parral, Nueva Vizcaya, and Mexico City. The friars and governors alike utilized the service to ship New Mexico's few profitable exports—hides, livestock, salt, pine nuts, and Pueblo textiles—south to New Spain in exchange for imported goods, the friars to acquire new vestments and furnishings for their missions, the governors to amass wealth in the form of fancy textiles, metal goods, and other imported luxuries.[8]

TEXTILE PRODUCTION FOR THE CIVIL AUTHORITIES

The *encomienda* and *repartimiento* systems operated for eight decades in New Mexico, until the Pueblo uprising of 1680. Pueblo households made their *encomienda* payments twice a year in the form of corn, hides, and woven blankets, or *mantas*. In addition to supplying their *encomenderos* with weavings, Pueblo workers supplied vast quantities of textiles to the provincial governors during the seventeenth and eighteenth centuries. Within thirty years of colonization, the Pueblos were producing weavings for the governors, with nearly all of these goods destined for outside markets in New Spain. At least one governor, Luis de Rosas, is known to have operated a weaving workshop, or *obraje*, in Santa Fe in the 1630s, staffed with Indian and Spanish labor. A surviving trade invoice itemizes the shipment of more than five hundred textiles—many produced on European treadle looms—to Parral in the fall of 1638.[9]

Other seventeenth-century governors also enlisted Pueblo weavers to produce great quantities of weavings on their behalf.[10] One of the most notorious was Bernardo López de Mendizábal, known for squeezing the colony for "every manta and every last *fanega* of pine nuts he could."[11] In addition to exacting Pueblo blankets, Mendizábal also collected huge quantities of knitted stockings for export. Inquisition documents itemize the

collection of six hundred pairs from the village of Socorro in 1660 and fourteen hundred pairs from several Pueblo villages in 1661.[12] With the assistance of his officials, the *alcaldes mayores*, Mendizábal distributed fleeces and raw woolen fiber to workers in the Pueblo villages, returning to collect the finished goods for shipment south on the mission train.[13] Although some of Mendizábal's Pueblo textile workers were compensated in knives or livestock, many of his debts went unpaid.[14]

In 1680 the Pueblo Indians threw off the yoke of Spanish domination, but in less than two decades the Spaniards had returned. Both the civil authorities and the missionaries continued to regard the Pueblos as their rightful source of labor. Fray Serrano, in his account of 1761, paints a dramatic picture of how woolen textiles were requisitioned from the Pueblo villages during this time:

Alas for thee, kingdom, that must supply all the continual weaving, because the governors distribute all the wool from what they call their tenths [tithes paid by Spanish citizens], and as much more as their alcaldes, lieutenants, and Indian governors can collect. In each town where weaving is done they leave a portion of this wool, allotting to the Indians the task of washing, combing, carding, and spinning it, and making the blankets, all to be done within a certain number of days. When the work is finished, the distributors of the wool return for the blankets, and the unfortunate Indians, as a reward for their labor, are forced to toil further in taking the blankets, either on their backs, afoot, or on horses if they have them, to the governor's palace. No attention is paid to respective distances of each pueblo.... The Indians of the mission of Zuni declare that they travel seventy leagues, loaded.[15]

The textiles collected from these Pueblo households were considered a form of taxation akin to Spanish tithes. Most of this production took place in the southern and western

Pueblo villages in the Rio Abajo region, where sheep and cotton were most plentiful. The Hopi alone were exempt from these demands. Never reconquered after the Pueblo Revolt, the Hopi lived beyond the sphere of Spanish control for the remainder of the Spanish colonial period. For this reason, the traditional organization of textile production survived far longer at Hopi than at the other Pueblo villages.

TEXTILE PRODUCTION AT THE MISSIONS

The Pueblo Indians already lived in established farming communities at the time of contact and thus provided an ideal focus for the missionary program in New Mexico. By 1629 New Mexico was home to nearly fifty Franciscan friars ministering to some thirty-five thousand Pueblo Indians at thirty-five missions and *visitas*.[16] Once established, the missions became ready sources of food, European goods, and other material benefits. In exchange for the economic security provided by the missions, many Pueblo peoples accepted the outward tenets of Christianity and the labor demands of the friars. Inquisition documents indicate that by 1660, if not before, the friars were actively exporting blankets and knitted stockings made by their Pueblo converts to the mining centers of Parral. These textile exports, together with the sale of sheep, provided the friars with their principal means of acquiring imported furnishings for their missions. Much of the spinning, weaving, and knitting of these textiles was done by Pueblo women.[17] Pueblo men also produced tribute textiles and, in at least one mission, La Isleta, were evidently put to work weaving long lengths of cloth on European treadle looms.[18] In the better-documented Jesuit and Franciscan missions of California and Texas, it was women who performed much of the treadle-loom weaving, often laboring under a demanding quota system.[19]

Information about the organization of production in the New Mexico missions is considerably sparser. One Inquisition document, however, describes the existence of a quota system at the Hopi mission at Shungopavi in the 1650s, in which the missionary, Fray Salvador de Guerra, distributed raw fiber to the Indians, demanding a stipulated number of finished pieces in return.[20] This practice at Hopi is reminiscent of Mendizábal's activities among the Rio Grande Pueblos during the same period, suggesting that by the mid-seventeenth century both the civil authorities and friars were employing similar tactics to exact textiles from the Pueblo villages.

Textile production for the missions continued well into the eighteenth century. Pueblo-made goods were generally destined for export, although at least one textile, "a beautiful carpet dyed with cochineal," was made by Acoma weavers for their mission church in the 1740s.[21] Most information about the production of textiles for the missions during this time comes from correspondence related to the Ornedal report of 1750, which charged the Franciscans with forcing the Indians to weave wool and cotton textiles without payment.[22] As with production for the civil authorities, most of these activities occurred at the nine Rio Abajo missions, where sources of wool and cotton were most abundant.

CHANGE AND ACCOMMODATION IN PUEBLO TEXTILE PRODUCTION

Four hundred years have now passed since the first Spanish colony was established in New Mexico. Despite the impact of Spanish and then American rule, Pueblo textiles remain an active —albeit transformed—craft tradition. Why did Pueblo textiles survive when so many other New World artistic traditions were lost? More importantly, how were Pueblo societies able to perpetuate their craft in spite of these disruptions?

The *why* of Pueblo weaving is not hard to explain. Pueblo textiles survive because Pueblo religion survives, and traditional garments are key elements of Pueblo ritual practice. Put another way, Pueblo textiles survive because a demand for these items has been maintained throughout the centuries. Early on in the colonial period, Pueblo leaders realized that the only way to preserve core elements of their religion was to take it underground. Aspects of Pueblo ceremonial life are still conducted in secrecy today. But publicly performed dances, some involving a hundred or more participants, are an equally important aspect of Pueblo ritual life (see figs. 223, 224). In order to participate, each dancer must have access to the appropriate suite of garments, which might include an embroidered or painted kilt, embroidered manta, woven manta, embroidered shirt, openwork shirt, braided sash, "brocaded" sash, woven belt, and crocheted or knitted leggings (see figs. 225–29).

More difficult to elucidate is *how* Pueblo craftspersons managed to keep these traditional textiles in production. Five aspects of Pueblo textile production were affected by Spanish colonial rule: (1) gender of producers, (2) settings of production, (3) scheduling of production, (4) materials and tools of production, and (5) networks of textile exchange. Ironically these changes contributed to the ultimate survival of the craft by relaxing the cultural rules associated with weaving and paving the way for the systems of production we find today.

CHANGES IN THE GENDER OF PRODUCERS

At the time of contact, Pueblo textile production was organized along highly gendered lines, with weaving one important aspect of the adult male role.[23] After colonization Pueblo male labor was diverted almost immediately to Spanish agricultural and construction projects,

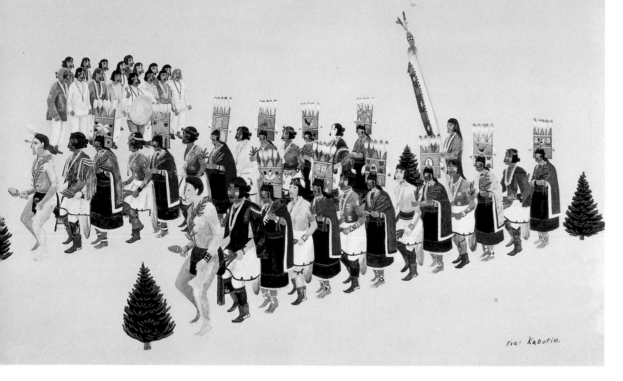

Fred Kabotie,
PINE DANCE, c. 1920–21
School of American Research
Collections at the Museum of
New Mexico (SAR/MNM
35488/13)

Harvest dance, Santa Clara
Pueblo, c. 1990s. Female dancers
wear embroidered white cotton
mantas with sash belts; male
dancers wear white mantas with
red-and-black borders and cro-
cheted openwork leggings. Most
of the embroidered mantas are
made of commercial cotton
cloth. Some of the red-and-
black mantas were probably
woven on treadle looms.

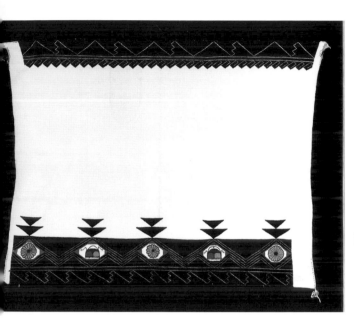

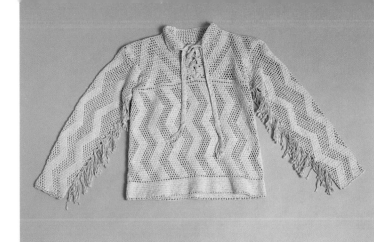

FIGURE 227 (LEFT)

San Juan crocheted shirt, made by Maria Ortiz, San Juan Pueblo, c. 1969. Commercial cotton string.
Maxwell Museum of Anthropology, University of New Mexico (69.55.1)

FIGURE 228 (BELOW)

Jemez embroidered cotton shirt, purchased from Frank Toledo, Jemez Pueblo, 1927. Commercial cotton sacking embroidered with commercial wool yarns. Bands of blue-gray stripes, characteristic of early cotton sacking, are faintly visible on body and sleeves.
School of American Research, Santa Fe (SAR T.12)

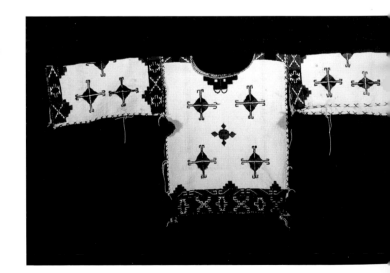

FIGURE 225

Zuni embroidered cotton manta, maker unknown, c. 1926. Warp, commercial cotton string; weft, handspun commercial cotton batting; embroidery, commercial wool yarns.
School of American Research, Santa Fe (SAR T.11)

FIGURE 226

Acoma embroidered black wool manta, maker unknown, c. 1850–60. Warp and weft, handspun woolen yarn; embroidery, raveled red *bayeta* and handspun blue yarns.
School of American Research, Santa Fe (SAR T.699)

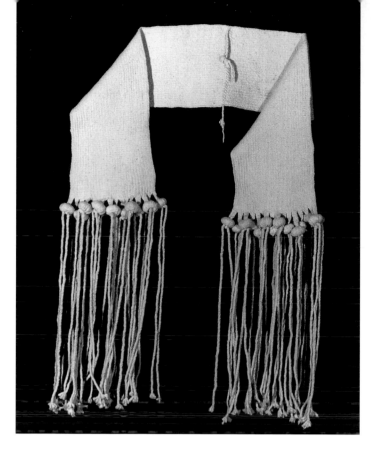

twentieth-century accounts describe Zuni, Acoma, Isleta, and Cochiti women weaving woolen blankets, belts, and garters, but not their own blanket dresses or ceremonial cotton fabrics (see fig. 230).[24] The participation of women in textile production was further encouraged by needle-work instruction in government and mission schools.

The earliest reference I have found to the production of ritual garments by Pueblo women involves the embroidery of a ceremonial woolen manta by a Cochiti woman in the 1850s; the manta itself was acquired in trade.[25] Of course, women may have been embroidering textiles long before this time. By the 1930s they were performing virtually all of the embroidery at Acoma, much of it at Zuni, and some in the Tewa, Tiwa, and Keresan villages.[26] Today women are the principal weavers and embroiderers among the New Mexico Pueblos,

FIGURE 229 (LEFT)
Hopi braided cotton sash, maker unknown, purchased from a Santo Domingo woman who acquired it from a Hopi, c. 1950s. Probably made from handspun commercial cotton batting.
School of American Research, Santa Fe (SAR T.708)

FIGURE 230 (BELOW)
Pueblo woman weaving belt, Isleta Pueblo, 1894.

requiring a reorganization of weaving labor to meet demand for Spanish tribute. By the mid-seventeenth century Pueblo textile production had been transformed into a dual-gendered system of labor, with women performing many of the tribute-related spinning, weaving, and knitting tasks, and men weaving tribute textiles and producing ritual goods.

The recruitment of women into the tribute labor pool broke down the traditional division of labor along gender lines, sanctioning women's participation in the production of certain textiles and leading ultimately to their involvement in the production of ritual garments. Women's textile labor supplemented but did not supplant the labor of men during the Spanish colonial period. Later, as New Mexico Pueblo men became more involved in the American cash economy, their textile production duties fell largely to women. Late nineteenth- and early

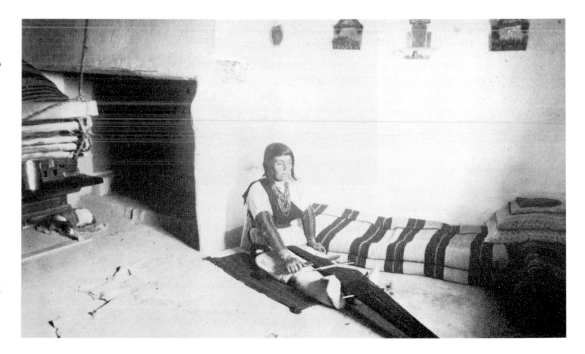

FIGURE 234

Detail of embroidered manta by Lucy Yepa Lowden. Design replicates a nineteenth-century heirloom piece. Work of this caliber is usually purchased by museums and collectors rather than Pueblo consumers. Museum of Indian Arts and Culture/Laboratory of Anthropology, Museum of New Mexico

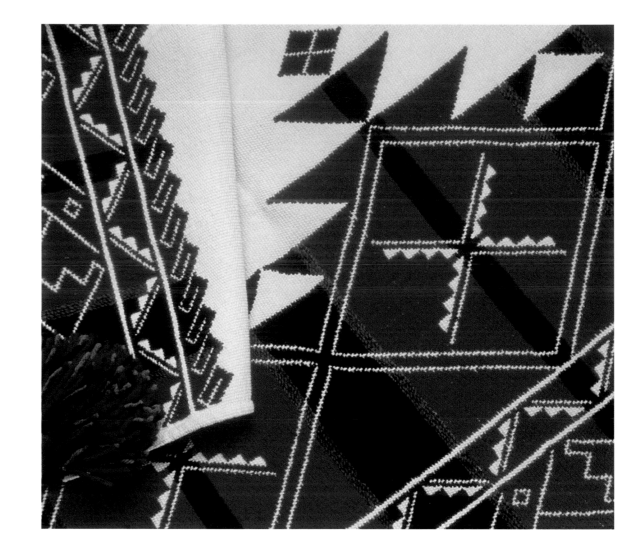

describe Pueblo weavers in New Mexico weaving at various times of the year.[30]

Hopi men continued to weave in kivas during the winter months well into the twentieth century, although some also wove during other parts of the year.[31] Today's Hopi weaver is a recognized specialist who weaves for income and is kept busy fulfilling orders for wedding gifts and dance garments. Weaving in all of the pueblos is now scheduled around a variety of activities—traditional dances, initiations, and weddings, as well as craft shows and outside jobs (see fig. 234).

Changes in the Materials and Tools of Production

Virtually all types of garments—kilts, shirts, shoulder blankets, sash belts—made at the time of contact are still produced for ceremonial use today. Yet the appearance of most items has changed dramatically. Many of these changes can be traced to the adoption of wool, a Spanish introduction that spawned an explosion of color in Pueblo textiles, especially embroidered fabrics (see figs. 224–26, 228). Although the Pueblos received wool from the friars and governors in the 1600s to make their tribute textiles, they probably had only limited access to wool for their own clothing needs until the early 1700s, when they began to amass sizable flocks of their own. As soon as was feasible, the Pueblos substituted sheep wool for most of their day-to-day clothing, reserving cotton for ceremonial use. With the adoption of wool came access to new dyes, most importantly indigo, and other imported materials, including red cloth (*bayeta*), which was unraveled for its brilliant threads (see fig. 226). In the mid-nineteenth century Pueblo needleworkers acquired access to commercial woolen yarns, which they used for belts and embroidery. Today yarns of synthetic fiber are also used.

The growth of the Pueblo wool supply accompanied a decrease in the supply of cotton, as many of the Pueblos' prime cotton-growing lands were lost to Spanish settlement. Although the production of cotton declined, cotton textiles did not disappear. Cotton occupies an important place in Pueblo cosmology and is a vital component of Pueblo ritual fabrics. Well into the nineteenth century, Isleta, Jemez, the Rio Grande Keresan villages, and especially the Hopi towns continued to grow cotton and weave it into ceremonial garments.

Despite efforts to maintain supplies of native-grown cotton, the cotton supply continued to decline, leading Pueblo weavers to seek out new sources of this material.

One of the most ingenious early adaptations was the use of commercial cotton sacking for ceremonial kilts, breechcloths, and shirts (see fig. 228). This cloth, first acquired in the form of grain sacks by the Pueblos in the late 1800s, was perfectly suited for embroidery purposes and eagerly embraced as a ready source of cotton fabric. The adoption of this material paved the way for the use of monkscloth and other commercial fabrics in modern times. Today nearly all ceremonial textiles made by the New Mexico Pueblos utilize commercial cloth (see fig. 231).

Cotton string, cotton batting, and bales of raw cotton also became available to the Pueblos in the late 1800s and early 1900s. These new supplies of cotton revolutionized the production of ceremonial textiles, freeing Pueblo weavers from a reliance on native-grown fiber. Formerly available only in limited quantities, cotton was now accessible on a wider scale, leading to a resurgence in production, especially among Hopi weavers. Virtually all Pueblo cotton textiles woven after 1900 incorporate cotton from commercial sources (see figs 225, 227, 229).

Other than the weaving carried out on treadle looms in the seventeenth-century *obrajes* in Santa Fe and at the Isleta mission, textile production for tribute seems to have been performed in the Pueblo villages using traditional looms and tools. The major exception was the knitting needle, introduced for the tribute production of stockings. Although the treadle loom made only minor inroads into the Pueblo villages in colonial times, its use has become more widespread in recent years. Today some weavers at San Juan, Isleta, and Laguna, among other villages, are using treadle looms to produce woolen manta dresses and maiden shawls,[32] items formerly acquired from the Hopi in trade. Simpler and coarser in weave than their predecessors, these treadle-loom-woven items can

287

be produced in only a fraction of the time. The traditional loom is still used, however, to produce most hand-woven cotton textiles.

CHANGES IN NETWORKS OF EXCHANGE

Whereas the Eastern Pueblos were relatively self-sufficient in terms of the production of cotton fiber and textiles at the time of contact, the decline of cotton cultivation and diversion of Pueblo textiles to Spanish purposes altered this situation. By the end of the Spanish period, two long-distance networks had emerged for the supply of Pueblo textiles to Pueblo consumers, one based on woolen textiles and the other on ceremonial cotton fabrics, both centered far to the west of the Rio Grande Valley. The Western Pueblos—Acoma, Laguna, Zuni, and Hopi—developed huge flocks of sheep in the 1700s and emerged as the leading suppliers of woolen textiles to all the Pueblo villages.[33] With the adoption of Western styles of dress and increasing access to commercial fabrics and Pendleton blankets, demand for most of these woolen goods declined, although Hopi continued to supply women's woolen mantas to the other Pueblo villages well into the twentieth century.[34]

Weavers in the middle Rio Grande were the major cotton textile producers among the New Mexico Pueblos at the time of contact and continued to play this role in a limited capacity well into the 1800s.[35] By this time, however, Hopi weavers were probably filling much of this demand. Situated beyond the sphere of Spanish influence after 1700, Hopi emerged as a major supplier of cotton ceremonial fabrics to the Eastern Pueblos in the eighteenth century. With this influx, the middle Rio Grande towns gradually shifted their emphasis from weaving to serving as middlemen.[36] Innumerable Hopi cotton kilts and mantas were imported into the Eastern Pueblo villages, there to be embroidered with local designs.

In recent years the Pueblo textile exchange network has witnessed yet another fascinating shift. Woolen manta dresses and maiden shawls—items formerly made at Hopi and traded east—are now being woven on treadle looms in some Rio Grande villages and traded west to Hopi. Due to the widespread availability of commercial cloth and yarn, the Rio Grande Pueblos now manufacture most of their own ceremonial cotton textiles, although Hopi-made goods are still held in high regard. Such changes underscore the flexibility and functionality of the Pueblo textile exchange network, which over the years has continued to link producers in one region with consumers in another, keeping important traditional garments and beliefs in circulation, while maintaining relations between widespread Pueblo communities.

In the centuries since contact, numerous weaving techniques have been lost, and materials and tool types have changed. A Pueblo person born in 1500 would scarcely recognize the garments worn in ceremonies today. But he or she would certainly recognize their overall style and most of their designs. The survival of Pueblo textiles into the twenty-first century may seem remarkable to outsiders, but it is no accident. As long as these traditions continue, a demand for this clothing will endure, and Pueblo people will find a way to keep these items in production.

Notes

1. Information presented in this essay is summarized from Webster 1997. The interested reader will find a more detailed discussion of these trends in this work.

2. Hays-Gilpin et al. 1998; Kent 1983a; Teague 1998.

3. Dutton 1963; Hibben 1975; Smith 1952.

4. Hammond and Rey 1966, 85.

5. Hammond and Rey 1953, 610, 627, 636, 645, 660; Hammond and Rey 1966, 82–83; Winship 1896, 521, 575.

6. Bolton 1963, 146–47; Hammond and Rey 1953, 1014; Winship 1896, 587.

7. Spielmann 1989.

8. Scholes 1930; Scholes 1935.

9. Bloom 1935; Scholes 1937.

10. Kessell 1979, 156.

11. Kessell 1979, 177.

12. Hackett 1937, 153; Scholes 1942, 48.

13. Kessell 1979, 178.

14. Scholes 1942, 47–49.

15. Hackett 1937, 484; for additional accounts, see Hackett 1937, 427, 471; Kelly 1941, 76.

16. Espinosa 1988, 19.

17. Bloom 1927, 229.

18. Hackett 1937, 213.

19. Castañeda 1939, 15; Van Well 1942, 100; Webb 1952, 207–9, 215–16.

20. Scholes 1942, 12.

21. Adams and Chavez 1956, 191.

22. Hackett 1937, 448; Kelly 1941, 66–67.

23. Kent 1983b, 9.

24. Bourke 1936, 116, 198; Houlihan and Houlihan 1986, 32, 34; Lange and Riley 1966, 216; Sedgwick 1926, 22; Stevenson 1987 [1911], 306, 311.

25. Lange and Riley 1966, 199, 219–20.

26. Douglas 1939a, 154; Douglas 1939b, 159; Douglas 1939c, 162; Douglas 1940, 183.

27. Anawalt 1979.

28. Bourke 1936, 116; Houlihan and Houlihan 1986, 34, 90; Lange and Riley 1966, 216, 368; Stevenson 1987 [1911], 306.

29. Donaldson 1893, 19; Parsons 1936.

30. Bourke 1936, 116; Lange and Riley 1966, 216, 368.

31. Beaglehole 1937, 23–31.

32. Kent 1983b, 21; Schaaf 1996.

33. Kessell 1980, 246.

34. Ford 1972, 36–38.

35. Adams and Chavez 1956, 205; Lange 1990, 95.

36. Ford 1972, 36–38.

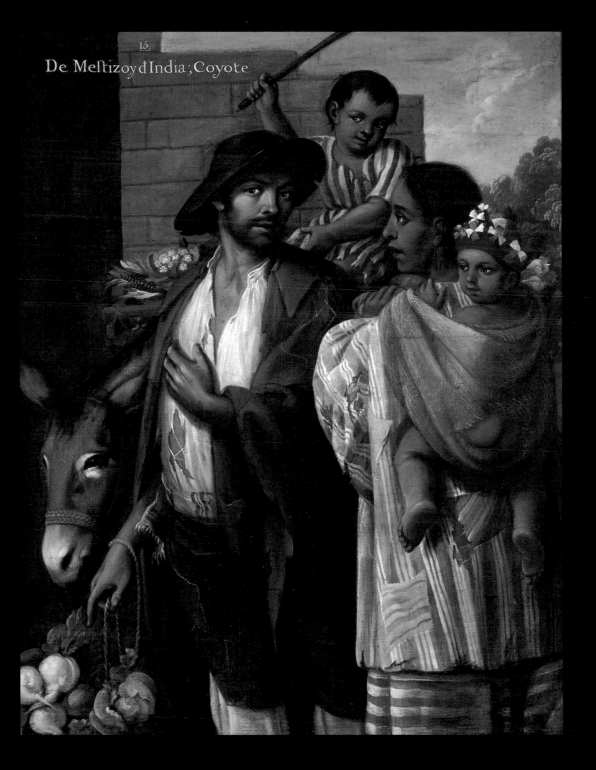

economic policies known collectively as the Bourbon Reforms to quicken the colonial economy and heighten the levels of surplus extraction. The Bourbon plan to develop and safeguard Mexico's northern provinces included the establishment of new industries, the construction of communication links, the lowering of trade barriers, the pacification of the nomadic Indians who disrupted exchange, the colonization of areas such as Alta California, and the promotion of migration from Mexico's center to the far north. These activities stimulated the economy, as was fully expected, but also disrupted local hierarchies of prestige and status. As social bonds were loosened through population mobility and the original hierarchies of the conquest began to crumble under the weight of economic development, the Spanish state and members of the local nobility turned to racial discrimination and legal codes—the Régimen de Castas—to buttress their waning power. Liberal economic policy thus had to be combined with conservative social policy to placate the elite.

During these years of rapid social change an intense preoccupation with racial categories dominated civil and ecclesiastical discourse, even though individuals who were classified as belonging to different categories were often physically indistinguishable from one another. The rhetoric of racial purity, increasingly a fiction as the population expanded and intermixed, became the basis on which the nobility asserted its claim to privilege. To strengthen this claim, in 1776 King Charles III issued the Royal Pragmatic on Marriage, which required children to obtain parental consent to form sacramental unions, under pain of disinheritance. Where previously the clergy had been free to perform marriages even if disparities in race or rank existed between the proposed partners, now parents had state sanction to intervene to curtail unequal unions.

The appearance, frequency, and temporal distribution of descriptions of racial category in Mexico during the second half of the eighteenth century pose a number of interpretive problems. Sometimes a racial classification was given as part of a personal declaration; at other times it was the subjective assessment of, say, a census taker or official. Clerics and bureaucrats gave race differing amounts of significance and thus could classify the same person quite differently. The use of certain racial categories varied enormously over time and from place to place, with the same term often carrying different meanings. Aside from their place in legal proceedings, we have little information about how racial classifications operated in daily life. Take, for example, the use of the word *mulato*. The University of Wisconsin's Medieval Spanish Dictionary Project maintains that this word was initially used to describe a racial mixture of any sort. The children of Spaniards and Moors were known as *mulatos* in medieval Spain, as were later the offspring of unions between blacks and Indians, and between Frenchmen and Indians in North America. By the mid-eighteenth century, however, a *mulato* was specifically the child of a Spanish father and a black mother.

If this was the legal definition of *mulato* throughout Spanish America, should this not have been the case in the kingdom of New Mexico too? Theoretically, yes, but in reality, no: the word *mulato* appears in eighteenth-century New Mexican church records, though clearly there was no evidence that persons so classed had any black African ancestry. From 1700 to 1744 Fathers Junco and Maulanda listed all the children baptized at the Spanish outpost of Cañada de Cochiti as Indians. After 1744 the same priests listed the race of all the children they baptized as *mulatos*. We can only speculate that they must have had the most antique uses of the word in mind.[3] For when Father Prada of Abiquiu spoke of

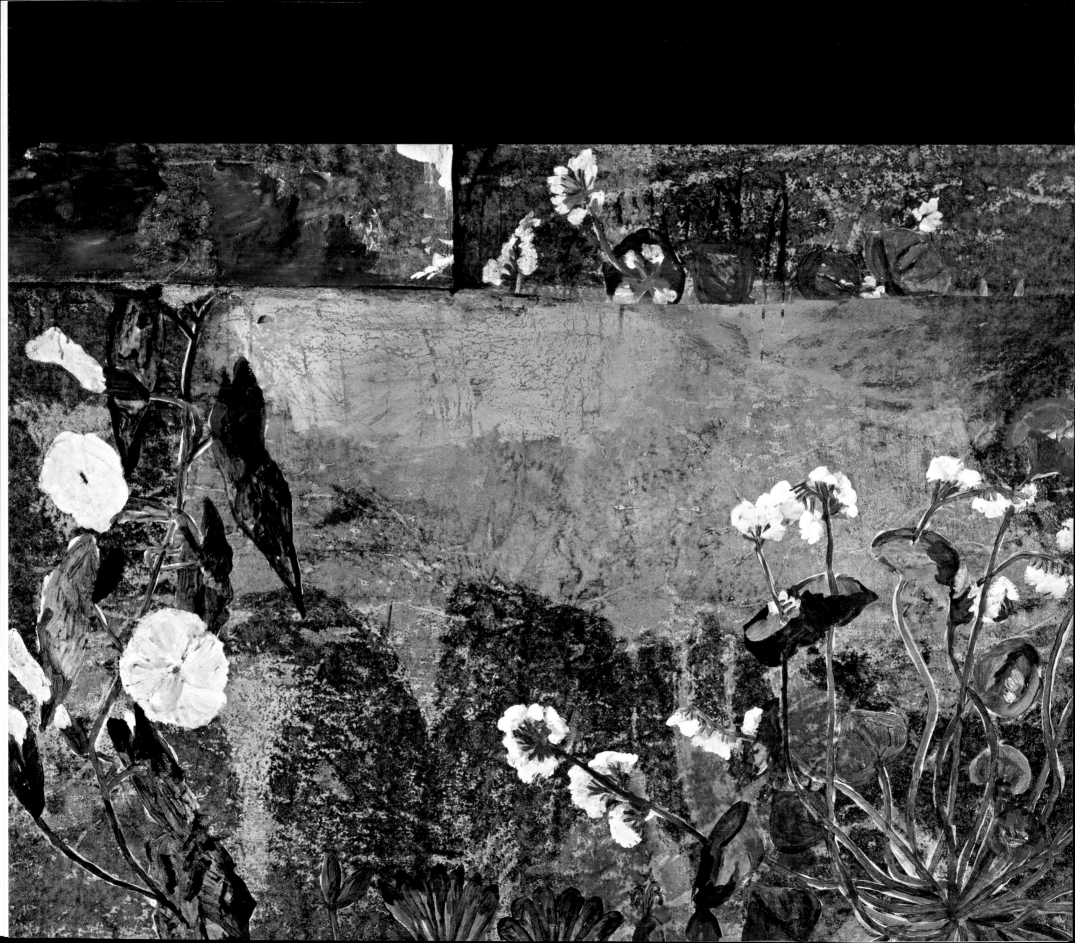

One

when raza?
when . . .
 yesterday's gone
and
 mañana
mañana doesn't come
 for he who waits
no morrow
 only for he who is now
to whom when equals now
he will see a morrow
mañana la Raza
 la gente que espera
no verá mañana
our tomorrow es hoy
 ahorita
que VIVA LA RAZA
 mi gente
our people to freedom
 when?
now, ahorite define tu mañana hoy

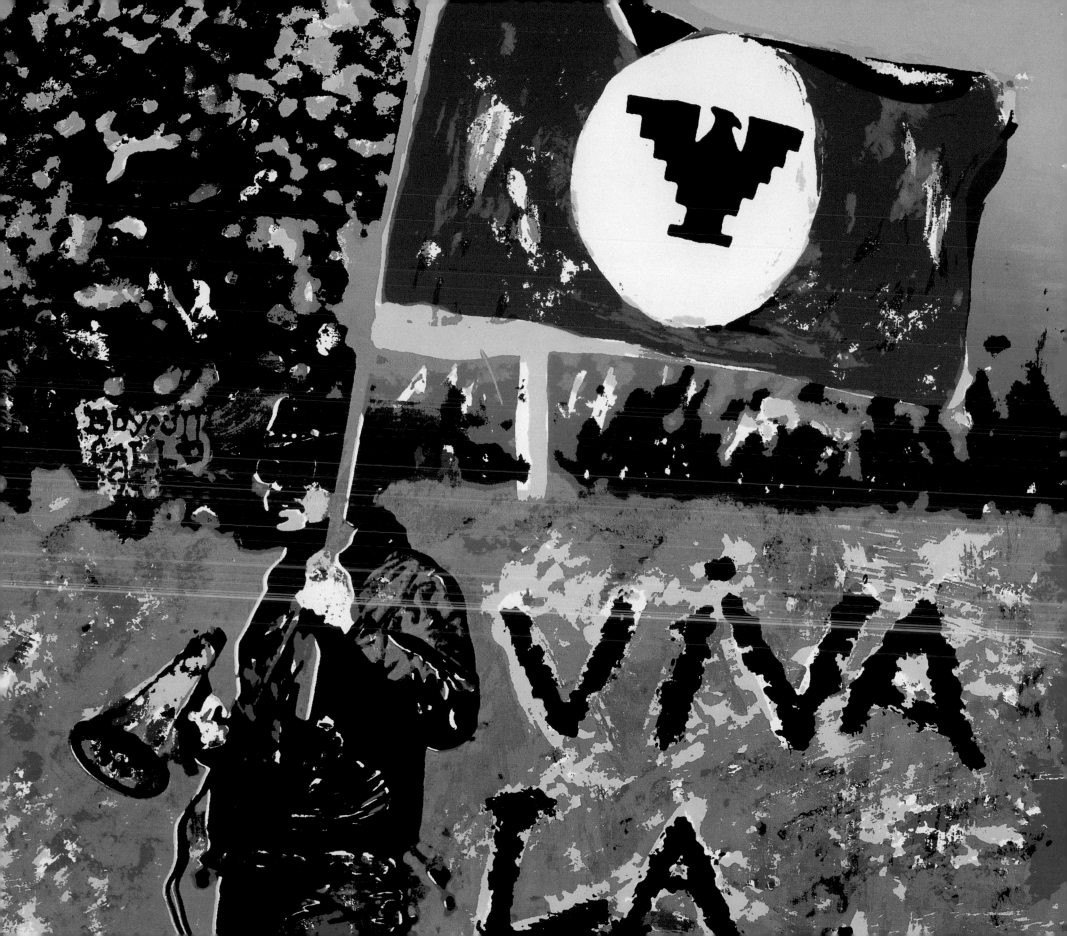

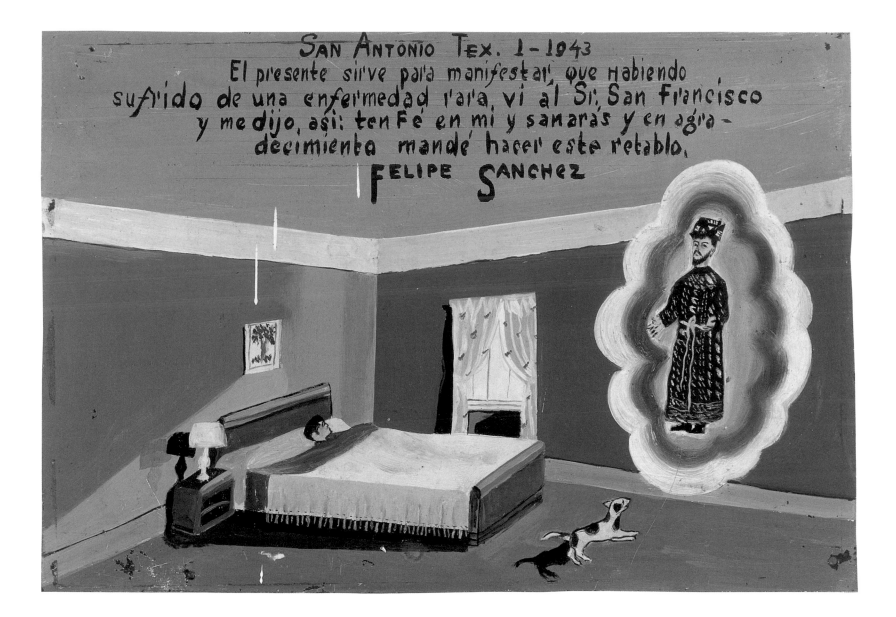

SAN ANTONIO TEX. 1 - 1943
El presente sirve para manifestar, que habiendo
sufrido de una enfermedad rara, vi al Sr. San Francisco
y me dijo, así: ten Fe en mi y sanarás y en agra-
decimiento mandé hacer este retablo.
FELIPE SANCHEZ

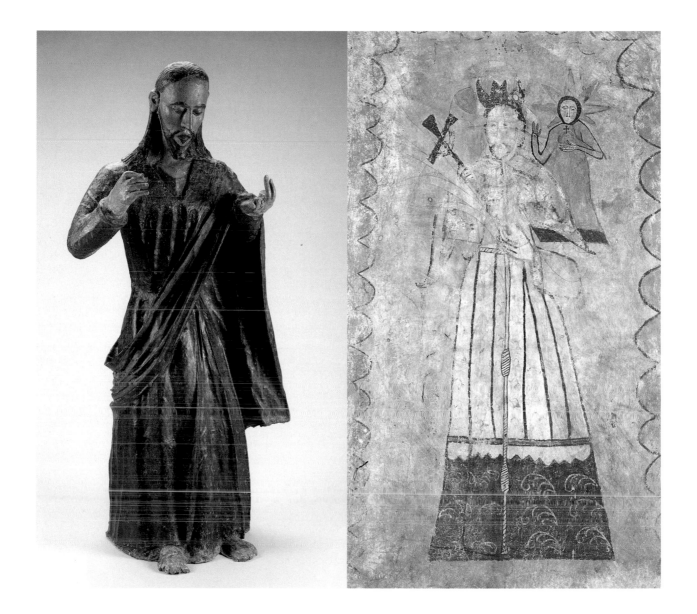

Proud of itself
is the city of Mexico-Tenochtitlan.
Here no one fears to die in war.
This is our glory.
This is your command,
oh Giver of Life!
Have this in mind, oh princes,
do not forget it.
Who could conquer Tenochtitlan?
Who could shake the foundation
of heaven?

With our arrows,
with our shields,
the city exists.
Mexico-Tenochtitlan remains.

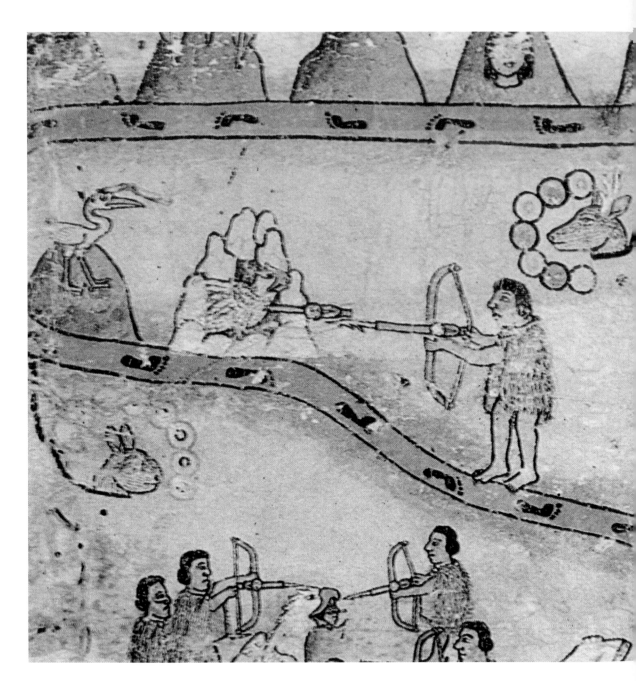

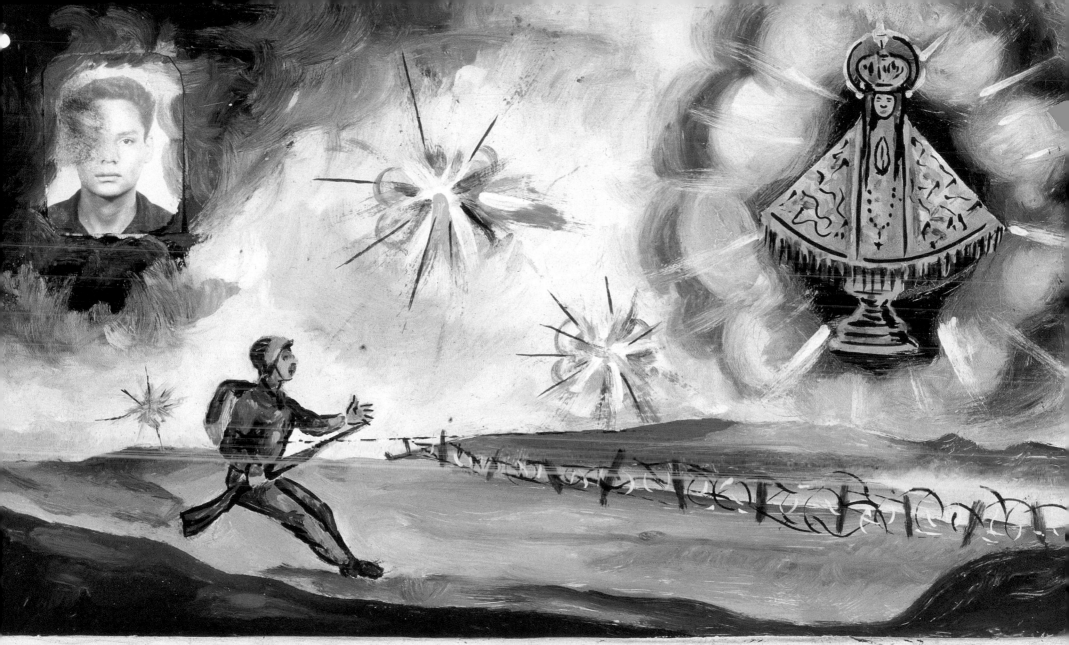

Doy gracias a la Stma. Virgen de Zapopan por haberme protejido y salvarme la vida al ser herido en Combate. VIETNAM - FEBRERO 19-1967.
= JOSE LUIS PALAFOX =

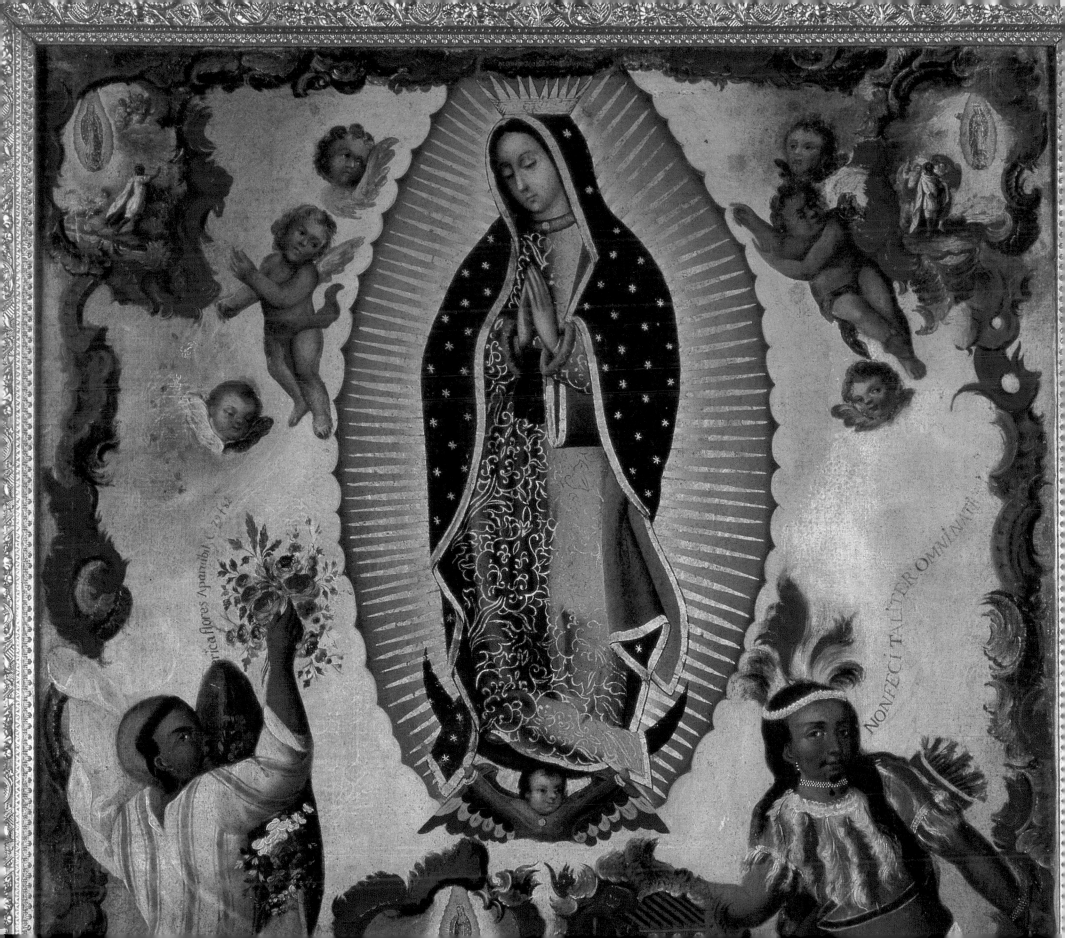

CENTERS IN THE PUEBLO WORLD

RINA SWENTZELL

When I was a child, I would stand at the doorway of my great-grandmother's house and watch the men of the village gather with the rising sun at the *nansipu*, or the female opening of the earth. They would offer cornmeal, say a prayer of gratitude for the new day, and acknowledge their oneness with the mother, with the earth place. The *nansipu*, which literally translates as "earth belly root," is the symbolic place from which we emerged from the earth mother's womb into this world. We know it to be the center around which we—and our existence—swirl. Yet it is marked only by an inconspicuous half-buried stone in the plaza of the pueblo. The houses, hills, and mountains are one enclosure after another around this stone, this place of emergence, this breathing place. It is a place of creation that connects and reconfigures.

My great-grandmother lived in one of the houses surrounding the plaza. I watched the men come alone or with one other. Oftentimes my great-grandmother, with whom I lived, would walk, with help, a few steps toward that center place from our doorway and throw cornmeal while breathing in scoops of the sacred breath through which we moved.

Although I grew up in Santa Clara Pueblo, the entire region, northern New Mexico, has an overwhelming quality of significance and mystery. It may be because Pueblo people have lived in this area for thousands of years and have acknowledged that the unknowable is everywhere. We continue to know that the world cannot be understood only in explicit thoughts and words. It is a "multiverse" in which everywhere, everything, and everyone has significance—to such an extent that the

mood of the mountains, hills, rocks, plants, and clouds helps define the character of each day. They are in the swirl of life, as they also breathe the life force we call the *powaha*: the water, wind, breath. The men who even today gather daily at the *nansipu* reaffirm that we humans are part of the swirl of life and that we live within the center of it. We live in a physical center described by the hills and mountains, and every day they remind us that we dwell at the middle of a sacred whole, a sacred living place. But because we live in a multiverse, we believe that ants also dwell at their own centers, as do plants, whose center places may intersect with human centers. It is a world where humans are not isolated, elevated beings who have other living things at their service. Humans are part of a whole, a wondrous, interrelated, living whole.

In prehistoric Pueblo times, the primacy of living at the center, between the earth and sky, was a way of life. It was simply the way the world was organized. As Westerners understand the earth to be one of many planets revolving around a luminous, burning celestial body (the sun), so the Pueblo people conceived a spatial world system that relied on visual boundaries (sky, mountains, and buildings) and multiple centers (ants, plants, people, and *nansipus*) to describe the interrelationship of the physical and spiritual realms. In today's Pueblo world, the center is where one can find nurturance and security from the pressures of the outside world. During the ongoing dances and ceremonies, the modern Pueblo person can derive a sense of meaning as the *powaha* flows through the spatial center, into the individual, and on to the clouds.

Western people, I think, are vaguely aware of centers. Somewhere along the way Western culture opted for knowledge over wisdom, words over place, and thoughts over feelings, devaluating the mysticism that is still honored in less technological, tribal cultures. Rationalism became highly valued in the West, and with it came an adherence to the idea of linear time, in which place and experience do not intersect in a multidimensional way. This modern world, which we all share, feels like a world-space moving in a straight line without much swirling around centers. But I do think that there were once strong centers in the Western world, when agrarian activities and understandings were more common.

And so it still is, somewhat, in the Tewa Pueblo Indian world of northern New Mexico. Although there is probably greater closeness to a lifestyle that is connected to the land or earth, things are changing rapidly. Enough of the old understanding remains, however, that some people of that community know that the *nansipu* connects many levels of existence and that this realm that we are experiencing is only one of many realities. The *nansipu* is located within the plaza, or *bupingeh*—literally, the "center heart place." The *bupingeh* is the outdoor community space and another symbolic center of physical and spiritual intersections. The center place of emergence, the *nansipu*, is located within the center-heart-place, where daily human life happens. Absolute truths and either/ors are not part of our thinking, and we can therefore have many centers and many simultaneous world levels. Center places are located within other center places, and they all swirl, intersect with, and influence one another.

In this Pueblo world-space the house structures define and enclose the *bupingeh*, just as the nearby hills surround the community and the far mountains contain the entire world of the pueblo. The *bupingeh* is the space defined by the human-made structures, which traditionally were from two to five stories high. These structures were terraced to replicate the enclosing far mountains. As the mountains defined the feminine concavity, or

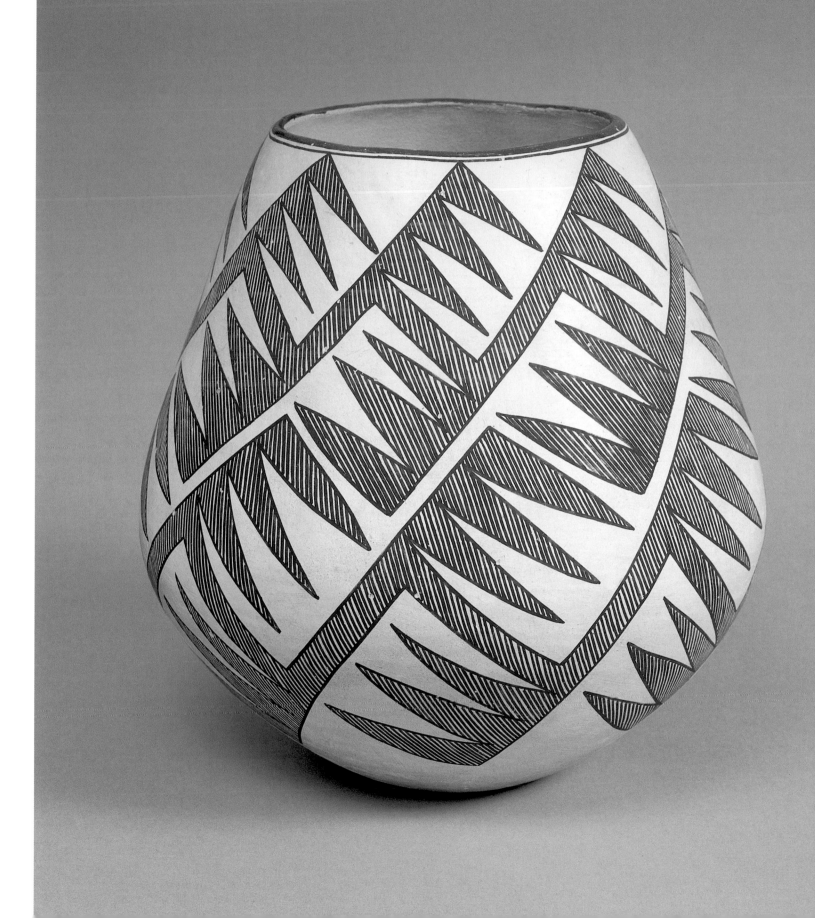

FIGURE 238
Lucy M. Lewis
BLACK-ON-WHITE JAR, 1972
(Cat. no. 215)

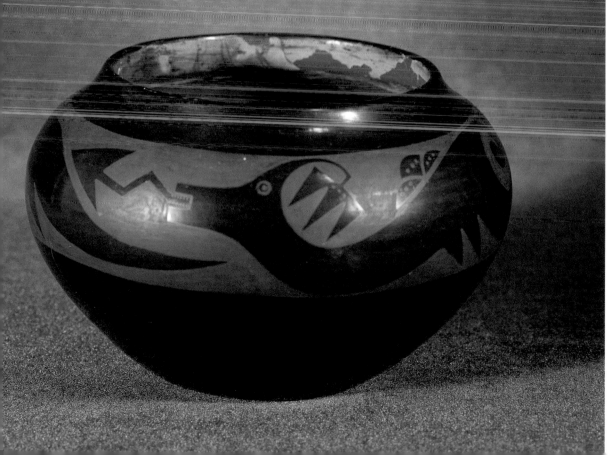

FIGURE 239 (ABOVE)

Al Qöyawayma

SIKYATI-STYLE JAR WITH

REPOUSSÉ CORN EARS, 1976

(Cat. no. 214)

FIGURE 240 (LEFT)

Maria Martínez

BOWL ETCHED WITH IMAGE OF

HORNED SERPENT, c. 1925

(Cat. no. 212)

WHERE PAST AND PRESENT MEET

THE EX-VOTOS OF MEXICAN IMMIGRANTS

MICHELE BELTRÁN
AND
ELIN LUQUE

Translated from the Spanish by Rose Vekony

This miraculous apparition was the best means our fortune could find to dispel that peril: and if in the memories of the benefit brought by the Apparition of Mary Most Holy, this city has secured the remedy that Your Excellency so diligently seeks, once this news comes to light, under Your Excellency's aegis, all peril will utterly cease, and the heavens in which storms were brewing, ready to wreak destruction, now grow calm and ready to succor us. May God keep Your Excellency in all happiness for many years to come.[1]

In 1675 the priest Luis Becerra y Tanco wrote *Felicidad de México en el principio y milagroso origen del Santuario de la Virgen de Guadalupe*, in which he attempted to give scientific proof of the mysterious imprint of the image of the Virgin that has been revered at El Tepeyac, north of Mexico City, since the middle of the sixteenth century. This learned writer belonged to a group of four priests who sought to glorify the Guadalupan miracle, giving it a foundation so that it might take root and spread. The title of his book brings us straight to the subject of this essay: the origin of certain myths that Mexican immigrants have brought to the United States over the last hundred years and that still give them deep happiness, serving as a powerful tool for identifying with their origins.

It seems appropriate to mention the Italian immigrant Lorenzo Boturini Benaducci (1702–59), who came to New Spain as an illegal, bypassing the entry procedures required by the Council of the Indies. He disembarked in Veracruz in about 1736; his activities on Mexican territory were driven by two great interests: to promote the cult of the Coronation of the Virgin of Guadalupe

and to gather historiographic material on ancient Mexico. To realize his projects, he assembled a valuable collection of codices, paintings, and books, as well as various documents and objects that made up his Indian museum. In 1743 he was charged with unlawful entry to New Spain; as a result he was imprisoned and subsequently deported, losing his rich collection. In Spain he was absolved and later named chronicler of the Indies, a position that would enable him to return to New Spain, receive payment for damages, and draw a salary; nonetheless, Lorenzo Boturini never returned to the Americas, although he did leave important works.[2] His story gives a clear example of the general difficulties that immigrants would face and the diverse and fascinating myths that would inspire them.

In Mexico the interest in researching origins and myths has its roots in the religious syncretism that evolved from uniting, reinterpreting, and forging correspondences between certain pre-Hispanic and Christian concepts—an effort undertaken by missionaries during the colonial period. In the nineteenth century the pastoral letters and diocesan edicts promoted the important cults that arose in the center of Mexico during the colonial period. These messages sought to engage the population through the practice of novenas, exclamatory prayers, processions, ex-votos,[3] and pilgrimages. An example of the latter is a pilgrimage that took place in 1885, during which a bishop declared that "the Most Holy Virgin Mary is the recourse that we Mexicans have in all our misfortunes and afflictions, for we are certain that with her powerful intercession we shall receive the goods and graces of which we are in need, since we are under the special protection of the Most Holy Virgin herself, *sub singulari patrocinio constituti*. That is why history teaches us that in great calamities our forefathers always appealed with success to this supreme recourse. They did so in the raging plague of 1554, in the terrible flood of 1629, and again in the other devastating plague of 1737."[4] The above-mentioned documents provided guidelines for the many sermons through which the priests shaped the people's consciences.

The constant exhortation to see the Virgin, Christ, or the various saints as strong intercessors and the sole saviors in all manner of personal or communal misfortune is evident in recommendations such as this one: "We recommend to all the priests of our diocese that in their preaching, their exhortations at Confession, and even in family conversations they make the faithful see the importance of devotion to Mary as a very effective means to obtain divine protection and to awaken patriotic national spirit…and extol the solemn, official pilgrimages to venerate the Virgin in her Shrine."[5] This approach obviously encouraged the development of various cults of patron saints, especially in central Mexico.

It was in the nineteenth century, however, that, through powerful considerations based on tradition, pilgrimages to the Mexican shrines—especially that of the Virgin of San Juan de los Lagos, in Jalisco—took hold.[6] This devotion to the Virgin of San Juan would become, during the twentieth century, the most potent intercessory practice for Mexicans immigrating to the United States.

Since the seventeenth century multitudes of pilgrims have converged on San Juan de los Lagos. Pilgrimage is a practice bound up with the liturgy of the shrines, an essential component of the devotional structure present in these religious sites. Those who participate do so out of a need to "construct the path," to prepare the optimal conditions for realizing their visit to the shrine, whether individually or in a group. The pilgrimage is deemed necessary to fill one with the sense of sacrifice, meditation, and prayer with which one should enter sacred places: the shrines are luminous abodes that impart their glow to the pilgrim's heart, bestowing their curative powers.

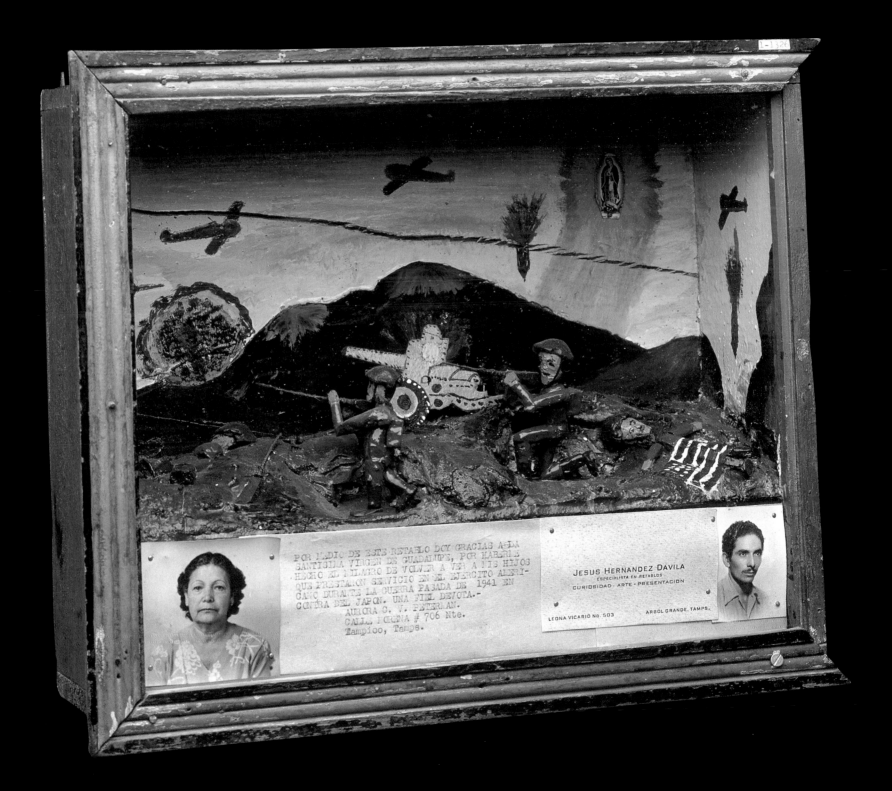

POR MEDIO DE ESTE RETABLO DOY GRACIAS A LA
SANTISIMA VIRGEN DE GUADALUPE, POR HABERLE
HECHO EL MILAGRO DE VOLVER A VER A MIS HIJOS
QUE PRESTARON SERVICIO EN EL EJERCITO AMERI-
CANO DURANTE LA GUERRA PASADA DE 1941 EN
CONTRA DEL JAPON. UNA FIEL DEVOTA.-
AURORA G. V. PETERLAN.
CALLE IDEMA # 706 Nte.
Tampico, Tamps.

JESUS HERNANDEZ DAVILA
ESPECIALISTA EN RETABLOS
CURIOSIDAD - ARTE - PRESENTACION

LEONA VICARIO No. 503 ARBOL GRANDE, TAMPS.

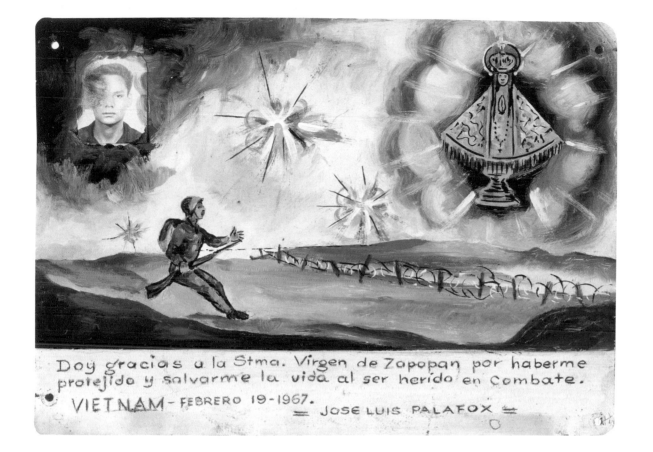

Doy gracias a la Stma. Virgen de Zapopan por haberme protejido y salvarme la vida al ser herido en Combate.
VIETNAM - FEBRERO 19-1967. — JOSE LUIS PALAFOX —

327

since the event is dated 1941). The model contains four soldiers, two of them dead (one draped in the U.S. flag) and the other two in combat alongside an artillery unit; bombs explode around them and planes fly overhead. In the sky, on the upper right, the Virgin appears surrounded by golden light. In the lower section of the box, to either side of the typewritten legend, are two photographs.

The second, dated 1967, was presented by José Luis Palafox to the Virgin of Zapopan (fig. 248). The action takes place in Vietnam. A lone soldier is shown on the battlefield, while bombs explode on all sides; in the upper right corner appears the Virgin, who, but for her greater size and her intense luminosity, could almost be taken for another explosion. This ex-voto also includes a photograph that serves as a personal imprint, proof that this soldier, who fought in unknown lands for a foreign cause, is an actual individual with a name of his own.

The immigrant's condition becomes particularly distressing in times of illness. Then life in a foreign

FIGURE 249 (RIGHT)

Anonymous

(Mexico, 20th century)

Ex-voto of Felipe Sánchez,

1943

Oil on tin plate

8 15/16 x 13 in. (22.7 x 33 cm)

Collection of the Arquidiócesis

de San Luis Potosí, San Luis

Potosí

FIGURE 250 (FAR RIGHT)

Anonymous

(Mexico, 20th century)

Ex-voto of Daniel Rojas,

1952

Collage and enamel on tin plate

5 7/8 x 8 7/8 in. (14.9 x 22.5 cm)

Collection of the Santuario de

Plateros, Fresnillo, Zacatecas

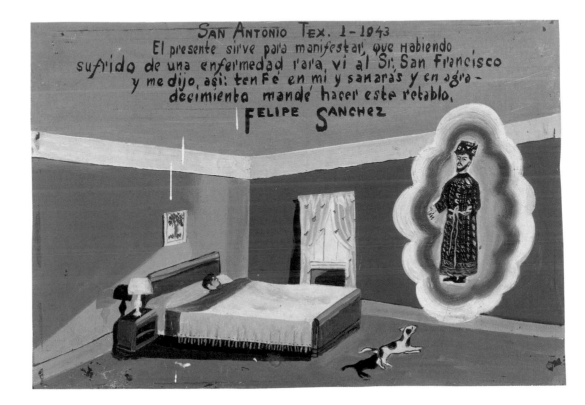

country, where the immigrant knows no one and has trouble communicating, reaches a crisis. Ex-votos concerning health problems follow the traditional pattern of depicting the sickbed, but here the patient is usually alone, in marked contrast to the more common examples, in which the sick are always surrounded by family members who pray for their health. Interestingly, an ex-voto from 1943 shows its donor, Felipe Sánchez, in his room with only his dog, perhaps because he is in San Antonio, Texas, far from his family. The room's sober setting, with its green walls, underlines the desolation that dominates the scene. By contrast, the light radiating from the saint's apparition projects the shadow of the animal, full of life, across the floor. The legend of this ex-voto is found in the upper section, contrary to the usual format (fig. 249).

Daniel Rojas found himself in a similar situation, sick and all alone, far from his native land (fig. 250). In this case the patient in his hospital bed, the larger image occupying the lower section of the painting, defines the composition. Images of the Holy Child of Atocha and of a nurse, whose presence identifies the space as a hospital, appear in smaller scale. The setting is not clearly defined, but for that very reason it serves to focus the viewer's attention on the patient's plight.

EL SR. DANIEL ROJAS DA INFINITAS GRACIAS AL Sto. NIÑO DE PLATEROS AL SALVARLO DE GRAVE ENFERMEDAD CALENTURA A 100 GRADOS Y SIN ESPERANZA DE CURARSE. en agradecimiento ofrece este Retablo.

Tulare California Noviembre de 1952.

334

and landscape have rarely served as the basis for an examination of visual representations of identity. In order to approach the intersection of geography, identity, and spirituality, it is necessary to reexamine the issues of land and politics inherent in the formation of community identity for Chicanas/os. The history and geopolitical framework of Aztlan are relevant to concerns with place and landscape in contemporary art.

The Chicano struggle for homeland has its roots in a fragmented and discontinuous past. In the 1960s Aztlan became a signpost for the reclaimed nationhood of Chicanos. Chon Noriega has described the conception of this complex geopolitical space:

By 1965 diverse social protests in the Southwest had coalesced into a national civil rights movement known as the Chicano Movement. *Aztlan*—now considered its fundamental ideological construct or living myth—provided an alternative geography for these efforts to reclaim, reform, or redefine social space—land, government, schools, and the urban *barrio*. *Aztlan* also helped set in motion a cultural reclamation project in literature, the arts, scholarship and everyday culture and in its current sense, *Aztlan* now refers to those places where Chicano culture flourishes.[3]

Aztlan was mythologized beyond its Mesoamerican meaning into a territorial point of rebirth. During the most active days of the Chicano movement, key figures such as Reies Lopez Tijerina, who led the Federal Alliance of Land Grants, attempted to reclaim their Spanish land grants in New Mexico. Despite their failure, these efforts point to a social reality. Homeland, return, decolonization, however impossible as social goals, remained imaginary sites of meaning. Aztlan as an imagined space carried with it the call to unity. This memory of a fragmented geography structures the call to self that drives much of the Chicana/o artistic vision.[4]

The language of social space and human geography in much Chicana/o art brings together concerns with place, history, economics, and politics. The focus on Aztlan and its forms of representation rests within these areas of knowledge. The representation of Aztlan has been aimed at a multiplicity and simultaneity of meanings. The Chicana/o perspective on homeland is a mapping of shifting relations of Spanish and Anglo-European colonial domination and aggression. In this sense Aztlan is a contemporary reflection of the concept of a social space in which no place is empty when we find it but rather is filled with the ghosts of a previous time. The paradigms associated with the border and related issues of political and human geography are linked to the ways in which physical and social boundaries are meant to include and exclude.[5]

The construction of social space through labor and commerce takes on an enormous irony when we examine the role that Mexicans have played historically in the creation of agricultural wealth in the Southwest. This awareness gave tremendous potency to the early language surrounding Aztlan, such as Alurista's declaration: "With our heart in our hands and our hands in the soil, we declare our independence as a Mestizo nation."[6] The themes of land and harvest associated with the visual narratives of artists such as Texas-born Carmen Lomas Garza are extensions of this definition of social space. Lomas Garza's well-known *monitos* (little figures) paintings depicting family outings, labor, and public and communal life offer an alternative geography relevant to the rural histories of many Chicanas/os (see fig. 253).

Other artists have mapped human geographies within an urban context. The works of Carlos Almaraz, Judith F. Baca, Gronk, John Valadez, and Patssi Valdez all establish Los Angeles as a place of Chicana/o struggle. Baca's mural *The Great Wall of Los Angeles* (1976–83) captures stories of barrio displacement and political

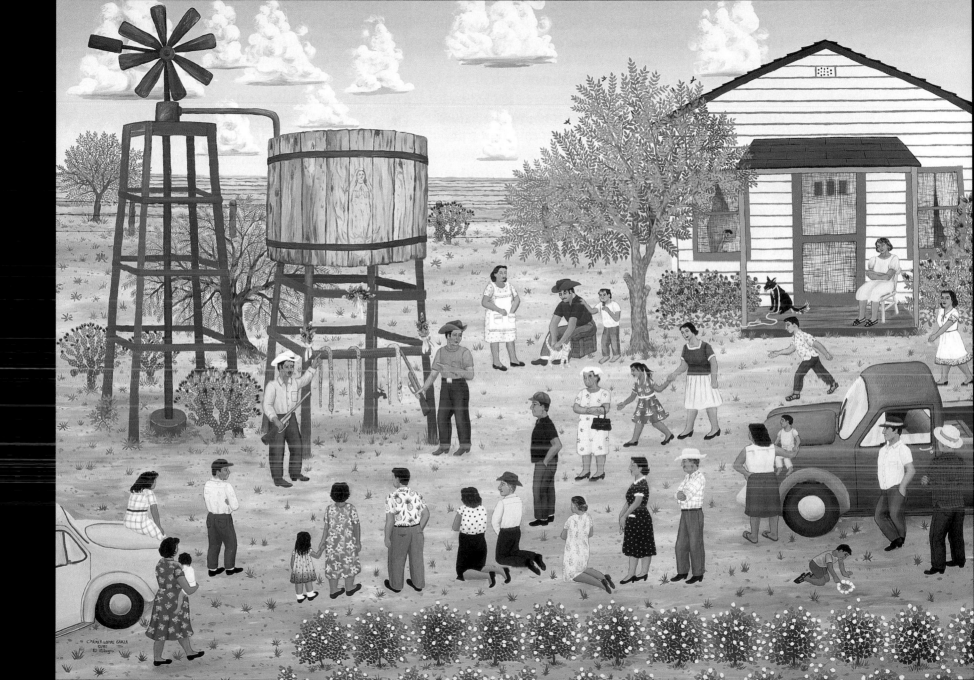

FIGURE **255**

Celia Alvarez Muñoz
CHAMELEON, 1986
Mixed-media installation
40 x 20 x 14½ in.
(101.6 x 50.8 x 36.8 cm)
Collection of the artist

FIGURE 256
Santa C. Barraza
LA MALINCHE, 1991
(Cat. no. 228)

of the theme of homeland and landscape. This inspired new genre of installation represents a revitalization of the spiritual beliefs of a community that has faced economic and social exploitation. The making of place is accomplished through a contemporary form of ancestor worship. The social space becomes a spiritual geography, manifested through the practices of welcoming the dead. This place, or *lugar*, is the site of a qualitatively different relationship with nature in which the acute conditions of displacement can be overcome.[12]

Particularities of geography and spirituality are expressed through the hybrid forms and complex meanings of Chicana/o art. The arts have often both sustained and disguised the politicized spirituality of Chicana/o communities. The relationship of faith, land, and self-determination has also been one of spirit, land, and

FIGURE 257

Diego Rivera (Mexico,
1886–1957)
FLOWER DAY, 1925
Oil on canvas
58 x 47½ in. (147.2 x 120.6 cm)
Los Angeles County Museum
of Art, Los Angeles County
Fund (25.7.1)

pre-Columbian objects from key private and public U.S. collections as well as painting and sculpture from such "contemporaries" as Jean Charlot, Carlos Mérida, Diego Rivera, David Alfaro Siqueiros, Max Weber, and William Zorach.

Rivera, like Gauguin, is another important figure whose positioning remains contradictory and problematic. The scholarly record has highlighted Rivera's precocious engagement with pre-Columbian cultures and their monuments, paintings, codices, and other objects.[16] Yet his stay in Europe from 1910 to 1921, with the exception of its impact on his relationship to Cubism,[17] has received scant attention with respect to the modernist vogue for primitivism. Most certainly, Rivera viewed non-Western objects during his Parisian and Italian *séjours*. The question remains, however, as to how viewing objects and painted manuscripts or codices in metropolitan frameworks informed his aesthetic project regarding the pre-Columbian past, particularly with respect to Mesoamerican cultures.[18] What is clear in his mammoth artistic production and in the scholarly record is his idealization of the Mesoamerican past and its influence on his iconographic and formal approach.

PRE-COLUMBIAN HISTORY, *MEXICANIDAD*, AND ART

Mexicanidad is a complex and contradictory set of discourses and representations that formed the ideological and cultural focus of Mexican nationalism after the revolution. Art, from the outset, played a crucial role in the fashioning, nurturing, and ongoing trajectory of the national cultural project. Rivera's idealization of the pre-Columbian past had a political and social function that was absent from the primitivist endeavors of his European counterparts. Fashioning a mythic past to promote the ideas, values, and programs of the Mexican Revolution,

he reaffirmed a history that had been devalued in colonial and postcolonial Mexico. Bringing together Italian Renaissance precepts and formal devices such as the predella; Cubist use of space; and Mesoamerican iconography, styles, and sources, Rivera conceived his murals as modern-day visual histories for the masses. This approach imbued his mural production, as well as his works on canvas and paper, with an avant-garde character. In one of the first paintings in his ongoing series depicting calla lily vendors, *Flower Day* (1925; fig. 257), the composition and stylistic rendering of the figures are inspired by pre-Columbian sculpture, yet the theme emphasizes the vitality of indigenous culture in contemporary Mexico.

Well informed by his dialogues with scholars in the field, Rivera was a prime supporter of the rewriting of Mexican history. Like the Russian Revolution—which linked the arts, culture, and the new society—the Mexican Revolution triggered a parallel process, with a similar project linking art to education and the vision of the new society. The call and imperative for a revalorization of tradition and the past was stated by Siqueiros in his 1921 Barcelona manifesto: "Let us observe the work of our ancient people, the Indian painters and sculptors (Mayas, Aztecs, Incas, etc.). Our nearness to them will enable us to assimilate the constructive vigor of their work. We can possess their synthetic energy without falling into lamentable archeological reconstruction."[19] The leftist Syndicate of Technical Workers, Painters, and Sculptors—which included among its members Charlot, Mérida, and Rivera—played a significant role in carrying out Siqueiros's dictum through diverse styles and conceptual underpinnings. Mexico, like the Soviet Union, became an avant-garde magnet for artists, cultural producers, political figures, and bohemians, attracting Sergei Eisenstein, Tina Modotti, John Reed, Paul Strand, and Edward Weston, among others.

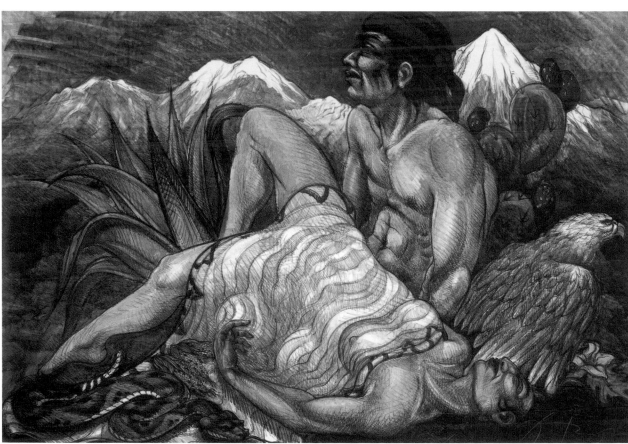

FIGURE 260

Luis Jiménez

SOUTHWEST PIETA, 1983

(Cat. no. 223)

FIGURE 261

Luis Jiménez

BORDER CROSSING WITH

HALOES, 1990

(Cat. no. 224)

which represent a *mestiza* genealogy and are an index of Chicano/a reinvention of tradition, Barraza articulates lyrically infused narratives. Dealing with aspects of her own experience and incorporating it into a discourse that combines contemporary imagery with tradition and myth, Barraza's works deal with the tenacity of the Chicana universe. Her references to the Virgen de los Remedios, who appeared to her followers sprouting from a maguey plant, have a transcultural importance given the life-sustaining symbolism of the plant and its multiple uses in pre-Columbian cultures (see fig. 262). In Barraza's oeuvre, a diverse pantheon of Chicanos/as take the place of the Virgen de los Remedios, casting the past into contemporary registers.

Yolanda M. López, who was born and raised in San Diego and has lived in the San Francisco Bay Area, has produced a diverse body of work that is conceptually based and informed by performance. In her videos and installations, she has researched and dealt with the representation of Chicano/a cultures by mainstream cultures in the mass media. López recasts foundational feminine religious icons, linking them to the contemporary life of Chicanas such as the artist, her mother, and her grandmother. Her ongoing series on the Virgin of Guadalupe, for example, conflates myth and history with contemporary concerns. The symbolic and metaphorical matrix of the Virgin of Guadalupe's association with Mexica female deities such as Tonantzin and Coatlicue exemplifies the layering of cultures as a hybrid process. López's painting *Nuestra Madre* (1981–88; fig. 263) depicts the Mexica deity (excavated in Coxcatlán, Puebla) with all the attributes of the Virgin of Guadalupe, thereby fusing the two figures and calling attention to their centrality in the Mexica-Mexican-Chicano/a social imaginary. In her portrait series depicting the Virgin of Guadalupe in different apparitions and guises—as well as in her performances representing her as the "brown Virgin," or

FIGURE 262
Santa C. Barraza
ZAPATA CON MAGUEY, 1991
(Cat. no. 229)

353

of two distinct traditions is the subject of the work. We are invited to join the woman as she gazes at the distant mountains, the place where the ancient ancestors are said to reside. These ancestors intervene in the life of individuals and bring the life-giving rain that nourishes the crops. At the same time, the Virgin of Guadalupe, the product of a colonial past, is also part of the woman. The Virgin literally guards her back, an appropriate positioning given her modern universal association with resistance and the struggle of *campesinos* (farmers) everywhere. This linkage between the Madonna and politics is indicated by a faint *huelga* eagle just behind the icon. This is the eagle associated with the struggle of the United Farm Workers in the United States.

Barraza's painting is not an invocation of Aztlan. It is a communion between self, personal and social histories, and choices. By self-consciously situating the subject and, by extension, the viewer, in this discursive space, Barraza has opened up both to the infinite possibilities of *nepantla*.

The resituation of self within an often contradictory and hostile past is the subject of a 1995 triptych by the Los Angeles artist Yreina Cervántez.[17] Each image represents a personal journey through *nepantla*—one that is to be traveled in sequence. In all three lithographs, the artist examines indigenous roots, spirituality, and the ideological and artistic perspectives that have been imposed on her by the dominant white culture. In *Nepantla* (fig. 274), Cervántez introduces us to herself and to the zone of transformation. She faces the viewer holding a sprig of sage and a feather, references to an indigenous past that will be repeated in the accompanying works. Surrounding her are images from the past and the present. A quotation by the scholar of Aztec culture Miguel León-Portilla situates us in the space of *nepantla*. The pre-Columbian transformation mask represents duality of personality and of reality, while above it a perspective diagram with ground lines and orthogonals is presented as a metaphor for the imposed ideological framework of Europeans. In the upper left-hand corner, the artist lampoons nineteenth-century anthropological studies and evolutionary theory by presenting the viewer with a page from the *California Annals of San Francisco* (1865) showing Native Americans who have been defined as reflecting various stages of "civilization." Skeletons similar to those found in old anthropological texts are superimposed on images of people protesting recent events, including the passage of Prop. 187.[18]

Mi Nepantla (fig. 275), the second lithograph, gives us a much more personal view of Cervántez and the many choices and directions of her life as an artist. A pre-Columbian Janus-faced fertility figure from Tlaltilco represents ancient roots and duality. This figure is superimposed on images of Frida Kahlo (who wears Coatlicue's necklace of hands) and the Virgin of Guadalupe. The Virgin and Frida are engaged in conversation about Frida's cult status—a reference to the commodification of Latino and Latin American iconography. We see Cervántez as a child playfully wearing a crown and then as an adult wearing the bells of Coyolxauhqui. The perspective drawing in the area of her forehead references her academic training, as does the Renaissance image of a man using a grid-form *velo* to capture the correct perspective on his model, who reclines in a suggestive position. Cervántez substitutes her torso and head for the model's, thereby becoming not only the observer but also the observed, an object forced to conform to an imposed framework. Texts that accompany this image include Anzaldúa's commentary on *nepantla* from *Borderlands* and a poem by Gloria Alvarez.

In *Beyond Nepantla* (fig. 276), a coiled feathered serpent represents both the earth and resurrection. Elements of earth (the offering bowl with seeds), wind (feather), fire (the soon-to-be-lit sage), and water (seashells)

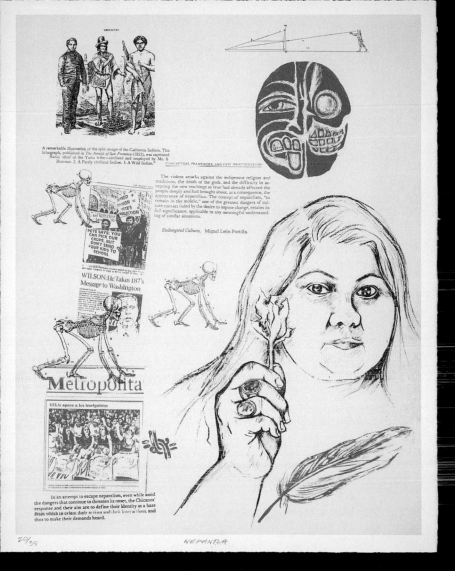

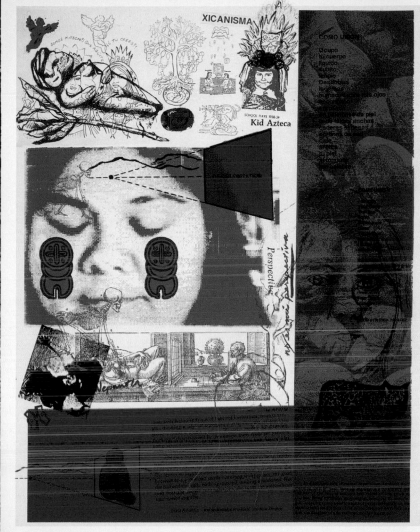

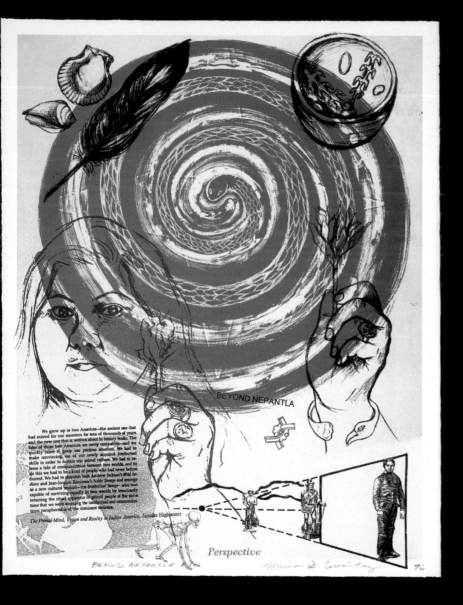

We grew up in two Americas—the ancient one that had existed for our ancestors for tens of thousands of years, and the new one that is written about in history books. The styles of these two American are rarely compatible—and we quickly came to grasp our perilous situation. We had to make convincing use of our newly acquired intellectual skills in order to sustain our mind culture. We had to release a tide of communication between two worlds, and to do this we had to be a kind of people who had never before existed. We had to abandon both Andrew Jackson's Wild Indians and Jean-Jacques Rousseau's Noble Savage and emerge as a new cultural mutant—the Intellectual Savage—who is capable of surviving equally in two worlds by tenaciously retaining the ritual apparatus of tribal people at the same time that we were acquiring the intellectual and communications paraphernalia of the dominant societies.

The Primal Mind, Vision and Reality in Indian America, Jamake Highwater

BEYOND NEPANTLA

Perspective

BEYOND NEPANTLA Yreina D. Cervántez 96

are placed at the four directions. The quotation by Jamake Highwater speaks of the challenges of cultural hybridity in the United States and of cultural survival. Situated to the right are the figures of the three Native Americans from the first lithograph. They have now been resituated within the orthogonals of Western perspective. As they recede in space and time, they become fainter, for, as noted by Cervántez, "the only time the Indian came into focus for the colonizer was when he was 'civilized.'" The artist states that the title of the final piece in the triptych should be understood as tongue-in-cheek, pointing out that "we never truly get beyond Nepantla, the closest we can come is negotiation."[19]

Like those of Yreina Cervántez, James Luna's works take on a decidedly anti-anthropological edge. In *Half Indian, Half Mexican* (1991; fig. 277), the Luiseño/Diegueño artist deliberately undergoes self-objectification by presenting two profiles and one frontal view of himself in a posture reminiscent of those found in early anthropological photographs taken by taxonomists of race. In the left image, he is shown clean-shaven, with long hair and an earring. In the right image, his hair has been styled so that he appears to have a short haircut, and he sports a mustache. In the central image, the artist presents both aspects simultaneously. Indian? Mexican? Or both? Moreover, the long hair / short hair juxtaposition can be understood on the level of gender ambiguity. The viewer is asked to visit Luna's *nepantla* and consider the roles multiple cultures play in the formation of identity. At the same time, assessments of race and gender based on appearance are thrown into question.

The conflict between European and indigenous culture is also the topic of Enrique Chagoya's *Uprising of the Spirit* (1994; fig. 278). Here two cultural icons—Superman and Nezahualcoyotl, the Aztec king of Texcoco—are shown positioned for combat. Superman, X-ray vision in operation, flies out of a scene of contact-

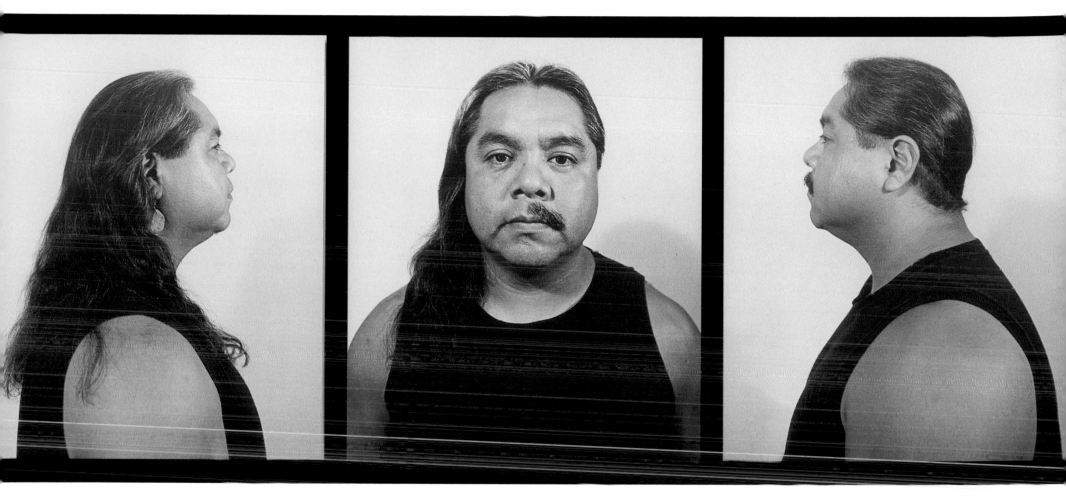

FIGURE 277

James Luna

HALF INDIAN, HALF MEXICAN,

1991

(Cat. no. 220)

period carnage, seemingly onto a page inhabited by the Aztec warrior from the famous Codex Ixtlilxochitl. A collector's stamp reading "Goupil" reminds the viewer that, although the original image is of indigenous production, Nezahualcoyotl has been properly recorded and collected by outsiders. At the same time, in Nezahualcoyotl's potential to escape the bonds of the page (and collector?) and to address the contemporary culture hero who would replace him, we find an opportunity for redemption. The winner is not stated here. Rather, the viewer is asked to look into the future and construct alternative scenarios. The piece can therefore be read as an object lesson on the possibilities of challenging prescribed role models and the potential cost of such a challenge. Only in *nepantla* can such a war be waged.

FIGURE 278

Enrique Chagoya
UPRISING OF THE SPIRIT, 1994
(Cat. no. 235)

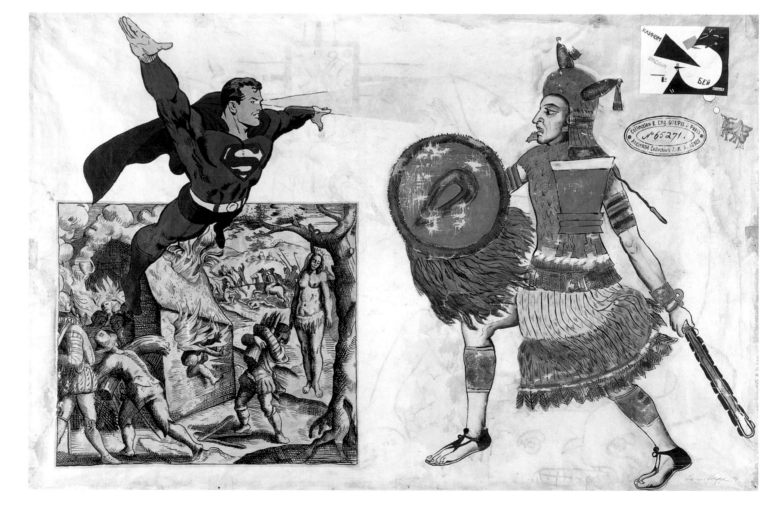

5. *NEPANTLA* REVISITED

Nepantla is not a safe place. But for those of us who occasionally find ourselves lost in its labyrinthine medieval and/or postmodern streets, it is a very necessary place. It is a site of conflict, negotiation, and growth.

It can also be a place of learning. Earlier in this essay, I bemoaned my loss of objective distance after reading a nineteenth-century historical manuscript. This occurred years ago. I have since learned that there are worse things in this life than to lose objective distance. To become emotionally detached from history, perhaps, is to become immune to its lessons.

Artists who engage *nepantla* create spaces wherein they can challenge cultural perceptions as well as history and its creators and managers. Moreover, they can freely develop their own sense of the spiritual and explore its basis in the past. While the artists and their artworks do not provide all the answers, the questions that they pose allow us as viewers to reevaluate our own multiple positions in culture.

NOTES

1. Anzaldúa 1993, 110.

2. AGI México 3168, Informe Bartolomé del Granado Baeza, 1 April 1813.

3. Broda, Carrasco, and Matos Moctezuma 1988.

4. Matos Moctezuma 1987, 199–200. For comparison, see the serpent toponym located on top of the hill in fig. 3.

5. Klein 1994, 118–20.

6. Klein 1994, 120. For a discussion of the political use of Aztec visual culture, see Townsend 1979.

7. Leal 1989, 11.

8. Gonzáles 1989, 1–5.

9. For a discussion of Chicano/a solidarity with Latin America, see Barnett 1984 and Goldman 1984.

10. Leal 1989, 8.

11. For an analysis of the texts as they pertain to Rascón's work, see Sorrell 1998.

12. Cooper Alarcón 1997, 7.

13. Cooper Alarcón 1997, 22–25.

14. Karttunen 1992, 169.

15. Angulo 1987, 135–36.

16. Anzaldúa 1993, 110.

17. Yreina Cervántez, interview with the author, October 1999.

18. Proposition 187 was a ballot measure passed in California in 1994, which barred the state's estimated 1.7 million undocumented workers and their children from receiving education and nonemergency medical care.

19. Yreina Cervántez, interview with the author, October 1999.

CHECKLIST OF THE EXHIBITION

1. THE CENTER PLACE

1. RATTLESNAKE TAIL
WITH MAIZE EARS
Mexico, Aztec, c. 1325–1521
Basalt
39 x 21 ⅝ x 49 ¼ in.
(99 x 54.9 x 125 cm)
CNCA-INAH, Museo Nacional de
Antropología, Mexico City
(24-810; 11-3197)

2. STANDING FERTILITY
GODDESS
Mexico, Aztec, c. 1325–1521
Stone
26 ¾ x 10 ⅜ x 5 ½ in.
(67.9 x 26.3 x 14 cm)
Staatliche Museen zu Berlin,
Preussischer Kulturbesitz,
Ethnologisches Museum
(IV Ca 46167)
(Los Angeles only)

3. STONE CELT
Arizona, 13th–16th century
Stone
11 ¾ x 3 ¾ x ⅝ in.
(29.5 x 9.5 x 1.5 cm)
Denver Museum of Nature and
Science, Mary W. A. and Francis
V. Crane American Indian
Collection (AC.6046)

4. STONE CELT
Arizona, 13th–16th century
Stone
7 x 2 ½ x ⅝ in.
(18 x 6.5 x 1.5 cm)
Denver Museum of Nature and
Science, Mary W. A. and Francis
V. Crane American Indian
Collection (AC.7406)

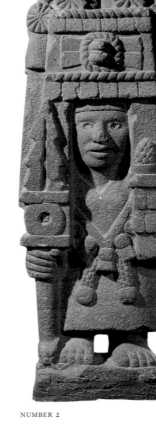

NUMBER 2

5. STONE CELT WITH HANDLE
Arizona, 13th–16th century
Stone
6 ½ x 3 ¼ x ⅝ in.
(16.5 x 8 x 1.5 cm)
Denver Museum of Nature
and Science (A783.166)

6. STONE CELT
Mexico, Olmec,
8th–6th century B.C.
Jadeite
5 ½ x 2 ¼ x ¾ in.
(14 x 5.7 x 1.9 cm)
Los Angeles County Museum
of Art, Gift of Constance
McCormick Fearing
(AC1998.209.67)

7. STONE CELT
Mexico, Olmec,
8th–6th century B.C.
Jadeite
3 ¾ x 2 ¼ x ¾ in.
(9.5 x 5.7 x 1.9 cm)
Los Angeles County Museum
of Art, Lent by Constance
McCormick Fearing
(L.83.11.726)

8. STANDING FIGURE
Mexico, Olmec, Paso de Oveja,
c. 1200–600 B.C.
Greenstone
5 ¹³⁄₁₆ x 2 ¾ in. (14.7 x 7 cm)
CNCA-INAH, Museo Nacional de
Antropología, Mexico City

9. BOWL WITH ALTAR DESIGN
Arizona, Hopi, Tusayan
Province (Sikyatki Polychrome),
c. 1425–1625
Ceramic with pigment
4 ³⁄₁₆ x 9 ¹⁵⁄₁₆ in.
(10.6 x 25.3 cm)
Arizona State Museum, Tucson
(4097)

10. FACE OR MASK ORNAMENTS
Mexico, Maya, Chichén Itzá,
Sacred Cenote,
9th–13th century A.D.
Gold (with about 3 percent
silver)
Mouth: 3 in. (7.6 cm);
eyes: 6 ¼ in. (15.9 cm)
Peabody Museum of
Archaeology and Ethnology,
Harvard University,
Anonymous Gift
(mouth: 10-71-20/C7678; eyes:
10-71-20/C7679.1–2)

NUMBER 6

NUMBER 8

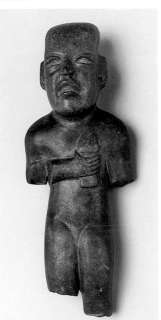

374

11. RAIN GOD VESSEL
Mexico, Colima, El Chanal,
12th–15th century
Ceramic, incised and painted
9¾ x 8¼ x 11¼ in.
(24.7 x 21.0 x 28.5 cm)
Kimbell Art Museum, Fort
Worth (Apx74.2)

12. TLALOC FIGURE
Mexico, Mixtec (Templo Mayor
Offering 11), c. A.D. 700–1521
Greenstone
9⅛ x 3⅛ in. (23.2 x 8 cm)
CNCA-INAII, Museo del Templo
Mayor, Mexico City
(10-162.935)

13. JAR WITH SERPENTS
Mexico, Michoacán, Jiquilpan,
c. A.D. 400–600
Ceramic with pigment
Height: 9¼ in. (23.5 cm)
Musées Royaux d'Art et
d'Histoire, Brussels (AAM/0.6)

14. JAR WITH HORNED SERPENT
Mexico, Chihuahua, Casas
Grandes, c. 1280–1450
Ceramic with pigment
Height: 6⅛ in. (16.2 cm); diam:
7½ in. (19 cm)
Museum of Indian Arts and
Culture, Laboratory of
Anthropology Collections,
Museum of New Mexico
(8313/11)

15. BOWL DEPICTING DANCER
WITH HORNED SERPENT
HEADDRESS
New Mexico, Mimbres, Pruitt
site, c. A.D. 1000–1150
Ceramic with pigment
Height: 4¼ in. (10.8 cm);
diam: 9¼ in. (23.5 cm)
The Taylor Museum, Colorado
Springs Fine Arts Center, Gift
of Alice Bemis Taylor (4589)

16. BOWL WITH
MOUNTAIN DESIGN
New Mexico, Mimbres,
c. A.D. 1000–1150
Ceramic with pigment
Height: 4⅜ in. (11 cm);
diam: 11 in. (28 cm)
University of Colorado
Museum, Boulder (9369)

17. BOWL WITH
FOUR PART DESIGN
Arizona (Flagstaff Black-on-
White), 12th century
Ceramic with pigment
Height: 3⁵⁄₁₆ in. (8.4 cm);
diam: 6 in. (15.2 cm)
Museum of Indian Arts and
Culture, Laboratory of
Anthropology Collections,
Museum of New Mexico,
Gift of Mr. and Mrs. Harris
Masterson (46427/11)

18. BOX WITH
QUINCUNX DESIGN
Mexico, Aztec, c. 1325–1521
Stone
7½ x 16⁵⁄₁₆ x 20 in.
(19 x 41.5 x 50.8 cm)
CNCA-INAH, Museo Nacional de
Antropología, Mexico City
(24-1035; 10-46505)

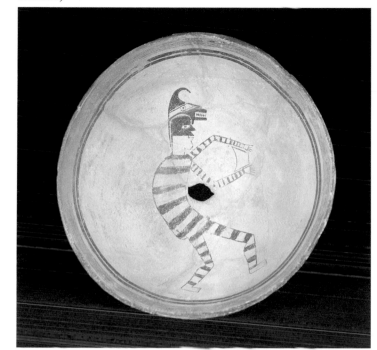

19. WATER STORAGE JAR
New Mexico (Gallup Black-on-
White), 11th century
Ceramic with pigment
Height: 20 in. (50.8 cm);
diam: 17 in. (43.2 cm)
Museum of Indian Arts and
Culture, Laboratory of
Anthropology Collections,
Museum of New Mexico
(8552/11)

20. BOWL WITH
FOUR-PART DESIGN
New Mexico, Mimbres,
c. 1100–1180
Ceramic with pigment
Height: 4¾ in. (12 cm);
diam: 11 in. (27.9 cm)
Museum of Northern Arizona,
Flagstaff (NA3288.74)

21. BOWL WITH
FOUR-PART DESIGN
Arizona, Hohokam,
c. A.D. 700–900
Ceramic with pigment
Diam: 11¹³⁄₁₆ in. (30 cm)
Montgomery Gallery, Pomona
College, Claremont, CA, Gift
of Dr. E. H. Parker (2649)

22. BOWL DEPICTING MAN
WITH STAFF AND BACKPACK
New Mexico, Mimbres,
c. A.D. 1000–1150
Ceramic with pigment
Height: 4 in. (10.2 cm);
diam: 9¼ in. (23.5 cm)
Maxwell Museum of
Anthropology, Albuquerque
(40.4.277)

375

23. TURQUOISE MOSAIC PLAQUE
Mexico, Mixtec-Aztec,
15th century
Turquoise, gold, shell
Diam: 12 in. (30.5 cm)
The Art Institute of Chicago,
through prior gifts of Louise A.
and Ruth G. Allen and Mrs.
Daniel Catton Rich
(1997.57)

24. ANTHROPOMORPHIC
KNIFE HANDLE
Mexico, Aztec,
15th–16th century
Wood, turquoise, mother-of-
pearl, malachite, shell
2 x 2⁹⁄₁₆ x 4¹⁵⁄₁₆ in.
(5 x 6.5 x 12.5 cm)
Museo Nazionale Preistorico ed
Etnografico "L. Pigorini,"
Rome (4215)
(Los Angeles only)

25. FROG EFFIGY MOSAIC
PENDANT
Arizona, Mogollon, White
River Province, c. 1200–1400
Shell (*Dosinia, Spondylus*),
turquoise
3⁵⁄₁₆ x 3⁹⁄₁₆ in.
(8.4 x 9.1 cm)
Arizona State Museum, Tucson
(6748)

26. INLAID BONE SCRAPER
New Mexico, Chaco Canyon,
Pueblo Bonito, c. A.D. 700–1130
Bone, turquoise, jet, shell
1⁹⁄₁₆ x 6⅛ x 1⁹⁄₁₆ in.
(4 x 15.5 x 4 cm)
Department of Anthropology,
Smithsonian Institution,
Washington, D.C. (A335156)

NUMBER 32

27. PARROT EFFIGY FIGURE
Mexico, Colima,
c. 200 B.C.–A.D. 500
Ceramic with burnished
red and buff slip
10½ x 11 x 6½ in.
(26.7 x 27.9 x 16.5 cm)
Los Angeles County Museum
of Art, The Proctor Stafford
Collection, museum purchase
with Balch Funds
(M.86.296.175)

28. BOWL FRAGMENT WITH
PARROT DESIGN
New Mexico, Mimbres,
c. A.D. 1000–1150
Ceramic with pigment
3¾ x 12⅜ x 8¼ in.
(9.5 x 31.5 x 21.0 cm)
Department of Anthropology,
Smithsonian Institution,
Washington, D.C. (A326309)

29. BOWL WITH MYTHICAL
BEING AND PARROTS
New Mexico, Mimbres,
McSherry Ruin,
c. A.D. 1000–1150
Ceramic with pigment
Height: 3½ in. (8.9 cm);
diam: 6⅞ in. (17.5 cm)
University of Colorado
Museum, Boulder (3238)

30. BOWL DEPICTING PARROTS
Arizona, Anasazi (Jeddito
Black-on-Yellow), c. 1325–1600
Ceramic with pigment
Height: 3⅛ in. (7.9 cm);
diam: 7³⁄₁₆ in. (18.3 cm)
Dallas Museum of Art,
Foundation for the Arts
Collection, Anonymous Gift
(1991.347.FA)

31. JAR WITH MODELED
PARROT HEADS
Mexico, Chihuahua,
c. 1280–1450
Ceramic with pigment
Height: 8⁷⁄₁₆ in. (21.5 cm);
diam: 9⁷⁄₁₆ in. (24 cm)
Denver Museum of Nature and
Science, Mary W. A. and Francis
V. Crane American Indian
Collection (AC.9066)

32. SHELL
Mexico, Aztec, c. 1440–1521
Basalt
20 x 29½ x 39¾ in.
(51 x 75 x 101 cm)
CNCA-INAH, Museo del Templo
Mayor, Mexico City (10-
208251)

33. FROG EFFIGY FIGURE
Arizona, Hohokam, Navajo
County, c. 1345–1362
Carved shell
(*Glycymeris gigantea*)
2³⁄₁₆ x 2³⁄₁₆ x ¾ in.
(5.6 x 5.5 x 1.9 cm)
Arizona State Museum, Tucson
(A-23646)

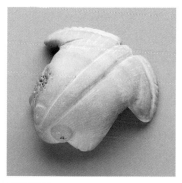

NUMBER 33

34. Human Effigy Pendant
Arizona, Mogollon, White River Province,
9th–12th century(?) A.D.
Shell (*Haliotis*)
1¾ x 1³⁄₁₆ x 1 ⁹⁄₁₆ in.
(4.5 x 3.0 x 4 cm)
Arizona State Museum, Tucson
(A-33865)

35. Shell Trumpet with Holes for Suspension
New Mexico, Chaco Canyon,
c. A.D. 700–1130
Shell
6¹¹⁄₁₆ x 3¾ x 3¼ in.
(17 x 9.5 x 8.3 cm)
American Museum of Natural History, New York (H/7594)

36. Shell
Arizona, Hohokam,
c. 1100–1450
Shell (*Turitella*)
Width: 2½ in. (6.4 cm)
Pueblo Grande Museum,
Phoenix (96.17.60)

37. Shell Pendant
Arizona, Hohokam,
c. A.D. 900–1100
Pectin shell
2¼ x 2¼ in. (5.7 x 5.7 cm)
Pueblo Grande Museum,
Phoenix
(92.25, U:9:1, N5E4, SH:26)

38. Ball Game Model
Mexico, Nayarit, c. 200
B.C.–A.D. 500
Ceramic with red, white, and
yellow slip
5½ x 8 x 13 in.
(14 x 20.3 x 33 cm)
Los Angeles County Museum
of Art, The Proctor Stafford
Collection, museum purchase
with Balch Funds (M.86.296.34)
(Los Angeles only)

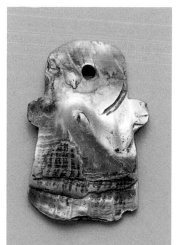

NUMBER 34

39. Drinking Vessel Depicting Hero Twins
Mexico, Maya, Central
Campeche, c. A.D. 593–830
Ceramic with pigment
Height: 8 in. (20.3 cm);
diam: 6¾ in. (17.1 cm)
Museum of Fine Arts, Boston,
Gift of Landon T. Clay
(1988.1169)

40. Bowl with Twin Figures and a Fish
New Mexico, Mimbres,
c. A.D. 1000–1150
Ceramic with pigment
6¼ x 12⅝ x 10¼ in.
(16 x 32 x 26 cm)
The Art Museum, Princeton
University, Gift of
Michael D. Coe (y1982-85)

41. Bowl with Twin Figures
New Mexico, Mimbres,
Treasure Hill site, c. 1100–1180
Ceramic with pigment
Height: 4¼ in. (11.4 cm);
diam: 10 in. (25.4 cm)
Museum of Northern Arizona,
Flagstaff (NA3288.4)

42. Effigy Vessel with Modeled Turkey Head
Mexico, Hidalgo,
c. 10th–13th century A.D.
Ceramic with plumbate surface
Height: 6¾ in. (17.1 cm)
CNCA-INAH, Museo Nacional de
Antropología, Mexico City
(10-047584)

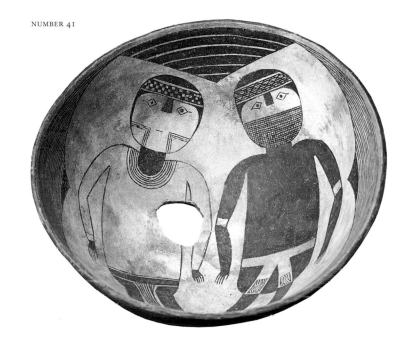

43. Bowl with Turkey Design
New Mexico, Mimbres,
c. A.D. 1000–1150
Ceramic with pigment
Height: 5 in. (12.7 cm);
diam: 10¾ in. (27.3 cm)
The Amerind Foundation, Inc.,
Dragoon, AZ (7009)

44. Bowl Depicting Four Turkeys
New Mexico, Mimbres, Swarts
Ruin, c. A.D. 1000–1150
Ceramic with pigment
Height: 5½ in. (14 cm);
diam: 12 in. (30.5 cm)
Peabody Museum of
Archaeology and Ethnology,
Harvard University, Peabody
Museum Expedition
(25-11-10/94916)

45. Carved Palette
Arizona, Hohokam,
10th–12th century
Stone
7⅝ x 4½ in. (19.3 x 11.4 cm)
CNCA-INAH, Museo Nacional de
Antropología, Mexico City
(10-2547)

46. Carved Palette
Mexico, Guerrero,
c. 300–100 B.C.
Stone
2 x 12¼ x 5½ in.
(5.1 x 31.1 x 14 cm)
Los Angeles County Museum
of Art, Gift of Constance
McCormick Fearing
(AC1992.134.7)

**47. Bell with Copper
Clapper**
Arizona, Hohokam, c. A.D.
600–1000
Copper
1½ x 1½ in. (3.8 x 3.8 cm)
Pueblo Grande Museum,
Phoenix (specimen number 893)

48. Three Bells
New Mexico, Mimbres,
c. A.D. 1000–1150
Copper
Approx. ¾ x 1 in.
(1.8 x 2.5 cm) each
Museum of Indian Arts and
Culture, Laboratory of
Anthropology, Thompson
Collection, Museum of New
Mexico (27128/11, 27130/11,
27131/11)

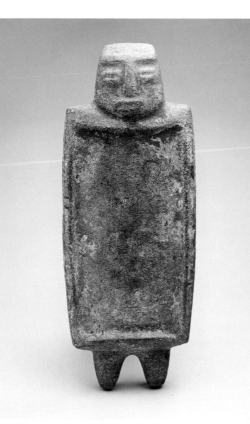

NUMBER 45

NUMBER 46

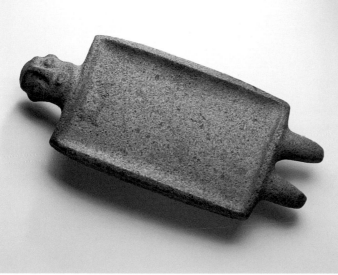

49. Three Bells
Mexico, c. A.D. 1000–1400
Copper
Approx. 2 x 1 in.
(5 x 2.5 cm) each
The Field Museum, Chicago
(278192)

50. Three Bells
Mexico, c. A.D. 1000–1400
Copper
Approx. 2 x 1 in.
(5 x 2.5 cm) each
The Field Museum, Chicago
(241559)

51. Four Bells
Mexico, Chihuahua,
Casas Grandes, c. 1280–1450
Copper
Approx. 1³⁄₁₆–1⁹⁄₁₆ x 1³⁄₁₆ in.
(3–4 x 3 cm) each
The Amerind Foundation, Inc.,
Dragoon, Arizona (CG/1820b,
CG/8126b, CG/8356, CG/8383)

2. The Hohokam World

**52. Cauldron with
Human Figures**
Arizona, Hohokam,
c. A.D. 850–950
Ceramic with pigment
Height: 10 in. (25.4 cm);
diam: 10¼ in. (26 cm)
Dallas Museum of Art,
Foundation for the Arts
Collection, Anonymous
Gift (1991.406.FA)

53. Jar with Textile Design
Arizona, Hohokam,
c. A.D. 850–950
Ceramic with pigment
Height: 6 in. (15.2 cm);
diam: 8½ in. (21.6 cm)
Dallas Museum of Art,
Foundation for the Arts
Collection, Anonymous Gift
(1988.105.FA)

54. Bowl with Basket Design
Arizona, Hohokam,
10th–11th century A.D.
Ceramic with pigment
Height: 9¹⁵⁄₁₆ in. (25.3 cm);
diam: 9⅞ in. (25 cm)
Courtesy Southwest Museum,
Los Angeles (2.C.527)
(Los Angeles only)

55. Jar
Arizona, Hohokam,
10th–11th century A.D.
Ceramic with pigment
3¼ x 3⅛ in. (8.2 x 8 cm)
Montgomery Gallery, Pomona
College, Claremont, CA, Gift of
Dr. E. H. Parker (P2658)

56. Plate
Arizona, Hohokam,
10th–11th century A.D.
Ceramic with pigment
Height: 3³⁄₁₆ in. (9 cm);
diam: 11⁵⁄₁₆ in. (28.7 cm)
Denver Museum of Nature and
Science, Mary W. A. and Francis
V. Crane American Indian
Collection (AC.9043)

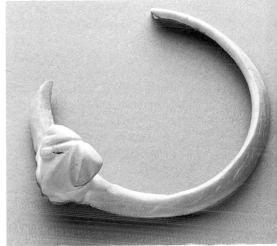

NUMBER 61

NUMBER 63

57. PALETTE WITH DOGS
Arizona, Hohokam,
8th–11th century(?) A.D.
Stone
8⅝ x 3¾ in. (22 x 9.5 cm)
Montgomery Gallery, Pomona
College, Claremont, CA, Gift
of Dr. E. H. Parker (P3053)

58. PALETTE WITH
INCISED BORDER
Arizona, Hohokam,
8th–11th century(?) A.D.
Stone
7⅝ x 3⅜ in. (19.3 x 8.5 cm)
Montgomery Gallery, Pomona
College, Claremont, CA, Gift
of Dr. E. H. Parker (P3249)

59. PALETTE WITH TURTLE
Arizona, Hohokam,
8th–11th century(?) A.D.
Stone
10 x 5½ in. (25.5 x 13.9 cm)
Montgomery Gallery, Pomona
College, Claremont, CA, Gift
of Dr. E. H. Parker (P3393)

60. COILED SNAKE-SHAPED
PALETTE
Arizona, Hohokam, 8th–11th
century(?) A.D.
Incised stone
Diam: 6 in. (15.4 cm)
Montgomery Gallery, Pomona
College, Claremont, CA, Gift
of Dr. E. H. Parker (P3264)

61. BOWL WITH SNAKE
Arizona, Hohokam, Snake-Gila
Province, c. A.D. 850–1000
Vesicular basalt
2⁵⁄₁₆ x 4⁹⁄₁₆ x 4 in.
(5.8 x 11.6 x 10.1 cm)
Arizona State Museum, Tucson
(16978)

62. BIRD EFFIGY VESSEL
Arizona, Hohokam,
c. A.D. 850–975
Carved stone
3⅜ x 6³⁄₁₆ x 3¹⁄₁₆ in.
(8.5 x 15.7 x 7.8 cm)
National Park Service,
Casa Grande Ruins National
Monument (CAGR 3239)

63. BRACELET
Arizona, Hohokam, Gila Bend
Province, c. A.D. 775–1000
Carved shell (Glycymeris
gigantea)
¾ x 2½ x 2¹⁄₁₆ in.
(1.8 x 6.4 x 5.2 cm)
Arizona State Museum, Tucson
(90-78-1)

64. BRACELET
Arizona, Hohokam,
c. A.D. 200–900
Carved shell (Glycymeris)
Diam: 3⅝ in. (9.3 cm)
Montgomery Gallery, Pomona
College, Claremont, CA, Gift of
Dr. E. H. Parker (P3002)

65. FROG PENDANT
Arizona, Hohokam,
c. 1100–1450
Carved shell (Glycymeris),
turquoise
2 x 1¹⁄₁₆ in. (5 x 4.3 cm)
Montgomery Gallery, Pomona
College, Claremont, CA,
Gift of Dr. E. H. Parker (P3728)

66. BUTTERFLY
Arizona, Hohokam,
10th–13th century(?) A.D.
Shell, turquoise
1¹⁄₁₆ x 1½ in. (2.9 x 3.3 cm)
Montgomery Gallery, Pomona
College, Claremont, CA, Gift of
Dr. E. H. Parker (P605)

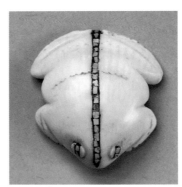

NUMBER 65

67. BIRD-SHAPED PENDANT
Arizona, Hohokam,
10th–13th century(?) A.D.
Shell, turquoise, coral(?)
3¾ x 3½ in. (9.6 x 8.9 cm)
Montgomery Gallery, Pomona
College, Claremont, CA, Gift
of Dr. E. H. Parker (P3004a)

68. BIRD-SHAPED PENDANT
Arizona, Hohokam,
10th–13th century(?) A.D.
Shell, turquoise
3¼ x 4¹⁄₁₆ in. (8.3 x 10.3 cm)
Montgomery Gallery, Pomona
College, Claremont, CA, Gift of
Dr. E. H. Parker (P3004b)

69. FIGURINE
Arizona, Hohokam, Tres
Alamos, c. 8th–10th
century A.D.
Ceramic
7 x 1⁹⁄₁₆ in. (17.7 x 4.0 cm)
The Amerind Foundation, Inc.,
Dragoon, Arizona (TA 862)

70. FIGURINE
Arizona, Hohokam,
Tres Alamos, c. 8th–10th
century A.D.
Ceramic
3½ x 1¼ in. (8.8 x 3.2 cm)
The Amerind Foundation, Inc.,
Dragoon, Arizona (TA 290)

71. SCOOP WITH HUMAN FACE
Arizona, Hohokam,
c. A.D. 700–900
Ceramic with pigment
5⅜ x 3⅜ in. (13.7 x 8.6 cm)
Montgomery Gallery, Pomona
College, Claremont, CA, Gift of
Dr. E. H. Parker (P2864)

105. PITCHER FRAGMENT WITH
HUMAN FACE
New Mexico, Chaco Canyon,
Pueblo Bonito, c. A.D. 700–1130
Ceramic with pigment
5¼ x 3¹⁵⁄₁₆ x 3¹⁵⁄₁₆ in.
(13.3 x 10 x 10 cm)
American Museum of Natural
History, New York (H/5243)

106. FIGURINE
Arizona, Anasazi, Río Puerco
Province, c. A.D. 900–1300
Sandstone with traces
of pigment
1¹¹⁄₁₆ x 1 x ⁷⁄₁₆ in.
(4.3 x 2.5 x 1.2 cm)
Arizona State Museum, Tucson
(A-31,250)

107. JAR WITH SPIRAL DESIGN
New Mexico, Anasazi, Cíbola
area (Snowflake Black-on-
White), c. A.D. 950–1200
Ceramic with pigment
Height: 12½ in. (31.8 cm);
diam: 14¼ in. (36.2 cm)
Dallas Museum of Art,
Foundation for the Arts
Collection, Anonymous Gift
(1991.59.FA)

108. BOWL WITH SPIRAL DESIGN
Colorado (Mesa Verde Black-
on-White), 13th century
Ceramic with pigment
Height: 9 in. (22.9 cm);
diam: 7½ in. (19 cm)
University of Pennsylvania
Museum of Archaeology and
Anthropology, Philadelphia
(22976)

109. LIDDED JAR
Colorado (Mesa Verde Black-
on-White), 13th century
Ceramic with pigment
Jar: height: 8 in. (20.3 cm);
diam: 12⅜ in. (31.4 cm)
Lid: height: 1¹⁄₁₆ in. (2.7 cm);
diam: 3¹¹⁄₁₆ in. (9.3 cm)
Denver Museum of Nature and
Science (783.104a, b)

110. FROG EFFIGY FIGURE
New Mexico, Chaco Canyon,
Pueblo Bonito, c. A.D. 700–1130
Jet, turquoise
¾ x 3⅛ x 2¾ in.
(2 x 8 x 7 cm)
American Museum of Natural
History, New York (H/10426)

111. INLAID BONE SCRAPER
New Mexico, Chaco Canyon,
Pueblo Bonito, c. A.D. 700–1130
Bone, turquoise, jet, shell
1¼ x 4⅞ x 1³⁄₁₆ in.
(3.1 x 12.3 x 3 cm)
Department of Anthropology,
Smithsonian Institution,
Washington, D.C. (A335158)

112. TWO DISK PENDANTS
Arizona, Anasazi, Kayenta
Province, c. A.D. 450–1300
Turquoise, shell (*Spondylus*)
Diam: 1¼ in. (3.1 cm) each
Arizona State Museum, Tucson
(431a, b)

113. STRAND OF DRILLED BEADS
New Mexico, Chaco Canyon,
c. A.D. 700–1130
Turquoise
⅜ x 20½ x 1 in.
(1 x 52 x 2.5 cm)
American Museum of Natural
History, New York (H/9235)

114. BOWL DEPICTING PARROTS
Arizona (Pinedale Polychrome),
c. 1275–1325
Ceramic with pigment
Height: 3 in. (7.6 cm);
diam: 7 in. (17.8 cm)
Denver Museum of Nature and
Science (A2034.35)

115. BOWL
Arizona (Four Mile Ruin),
c. 1300–1400
Ceramic with pigment
Height: 2¹³⁄₁₆ in. (7.2 cm);
diam: 6½ in. (16.5 cm)
Denver Museum of Nature and
Science, Mary W. A. and Francis
V. Crane American Indian
Collection (AC.7466)

116. BOWL WITH BISECTED
GEOMETRIC COMPOSITION
Arizona, Anasazi (Pinedale
Polychrome), c. 1275–1325
Ceramic with pigment
Height: 5 in. (12.7 cm);
diam: 11 in. (27.9 cm)
Dallas Museum of Art,
Foundation for the Arts
Collection, Anonymous Gift
(1988.88.FA)

117. JAR
Arizona or New Mexico,
Salado, c. 1250–1400
Ceramic with pigment
Height: 8 in. (20.3 cm);
diam: 15½ in. (39.4 cm)
Dallas Museum of Art,
Foundation for the Arts
Collection, Anonymous Gift
(1991.395.FA)

118. BOWL DEPICTING PARROT
AND DWELLING
Arizona, Hopi (Sikyatki
Polychrome), c. 1400–1625
Ceramic with pigment
Height: 3¾ in. (9.5 cm);
diam: 9⁷⁄₁₆ in. (24 cm)
Department of Anthropology,
Smithsonian Institution,
Washington, D.C. (A155608)

119. BOWL
Arizona, Hopi (Sikyatki
Polychrome), c. 1400–1625
Ceramic with pigment
Height: 3¹³⁄₁₆ in. (9.7 cm);
diam: 9⅝ in. (24.5 cm)
University of Pennsylvania
Museum of Archaeology and
Anthropology, Philadelphia
(29-77-723)

120. BOWL DEPICTING A
FEATHERED SERPENT
Arizona, Hopi (Sikyatki
Polychrome), c. 1400–1625
Ceramic with pigment
Height: 3⁷⁄₁₆ in. (8.7 cm);
diam: 8⅞ in. (22.5 cm)
Department of Anthropology,
Smithsonian Institution,
Washington, D.C. (A155498)

121. BOWL DEPICTING
A HAND AND BOW
Arizona, Hopi (Sikyatki
Polychrome), c. 1400–1625
Ceramic with pigment
Height: 3¹⁵⁄₁₆ in. (10 cm);
diam: 10⅝ in. (27 cm)
Department of Anthropology,
Smithsonian Institution,
Washington, D.C. (A155468)

122. JAR WITH TEXTILE DESIGN
New Mexico, Anasazi (Tularosa
Black-on-White), c. 1100–1250
Ceramic with pigment
Height: 11 in. (27.9 cm);
diam: 14¾ in. (37.5 cm)
Dallas Museum of Art,
Foundation for the Arts
Collection, Gift of Mrs. Edward
S. Marcus (1983.150.FA)

5. THE CASAS GRANDES WORLD

123. JAR
Mexico, Chihuahua,
Casas Grandes, c. 1280–1450
Ceramic with pigment
Height: 7⅝ in. (19.4 cm);
diam: 7¹¹⁄₁₆ in. (19.5 cm)
Arizona State Museum, Tucson
(GP3640)

124. LIDDED JAR
Mexico, Chihuahua, Casas
Grandes, c. 1280–1450
Ceramic with pigment
Height: 10 in. (25.4 cm);
diam: 8¼ in. (21 cm)
Dallas Museum of Art,
Foundation for the Arts
Collection, Anonymous Gift
(1990.96.a–b.FA)

125. JAR WITH HUMAN FIGURES
Mexico, Chihuahua,
Casas Grandes, c. 1280–1450
Ceramic with pigment
Height: 9¾ in. (24.7 cm);
diam: 10 in. (25.4 cm)
Dallas Museum of Art,
Foundation for the Arts
Collection, Anonymous Gift
(1991.351.FA)

126. GOURD-SHAPED BOWL
Mexico, Chihuahua,
Casas Grandes, c. 1280–1450
Ceramic with pigment
Height: 6⅛ in. (15.6 cm);
diam: 8⅜ in. (21.3 cm)
The Amerind Foundation, Inc.,
Dragoon, Arizona (9329)

127. JAR WITH ABSTRACT FACE
Mexico, Chihuahua,
Casas Grandes, c. 1280–1450
Ceramic with pigment
Height: 5¹³⁄₁₆ in. (14.8 cm); diam:
5¹¹⁄₁₆ in. (14.4 cm)
The Amerind Foundation, Inc.,
Dragoon, Arizona (9368)

128. JAR WITH GEOMETRIC
DESIGNS
Mexico, Chihuahua, Casas
Grandes, c. 1280–1450
Ceramic with pigment
Height: 7³⁄₁₆ in. (18.2 cm);
diam: 7⅞ in. (20.1 cm)
The Amerind Foundation, Inc.,
Dragoon, Arizona (4605)

129. FEMALE FIGURE
WITH BOWL
Mexico, Chihuahua, Casas
Grandes, c. 1280–1450
Ceramic with pigment
8⁵⁄₁₆ x 8 x 7³⁄₁₆ in.
(21.1 x 20.4 x 18.2 cm)
Arizona State Museum, Tucson
(GP3723)

130. MALE FIGURE WITH CIGAR
Mexico, Chihuahua, Casas
Grandes, c. 1280–1450
Ceramic with pigment
Height: 6¹⁄₁₆ in. (15.4 cm);
diam. 6⅝ in. (16.8 cm)
Denver Museum of Nature and
Science, Mary W. A. and Francis
V. Crane American Indian
Collection (AC.9094)

131. FEMALE FIGURE
Mexico, Chihuahua, Casas
Grandes, c. 1280–1450
Ceramic with pigment
Height: 9³⁄₁₆ in. (23.3 cm);
diam: 8⅛ in. (20.6 cm)
Denver Museum of Nature and
Science, Mary W. A. and Francis
V. Crane American Indian
Collection (AC.9070)

132. MALE FIGURE
Mexico, Chihuahua, Casas
Grandes, c. 1280–1450
Ceramic with pigment
Height: 10⁷⁄₁₆ in. (26.5 cm);
diam: 6⅜ in. (16.3 cm)
The Amerind Foundation, Inc.,
Dragoon, Arizona (9415)

133. MALE FIGURE
Mexico, Chihuahua,
Casas Grandes, c. 1280–1450
Ceramic with pigment
7⅜ x 5⅝ in. (18.7 x 14.2 cm)
Arizona State Museum, Tucson
(20676)

134. VESSEL WITH
MODELED FACES
Mexico, Chihuahua, Casas
Grandes, c. 1280–1450
Ceramic with pigment
6¼ x 7⅞ in. (15.9 x 20.1 cm)
The Amerind Foundation, Inc.,
Dragoon, Arizona (3395)

135. MALE FIGURE
Mexico, Chihuahua,
Casas Grandes, c. 1280–1450
Ceramic with pigment
Height: 7¹¹⁄₁₆ in. (19.5 cm);
diam: 5¹¹⁄₁₆ in. (14.5 cm)
Museum of Indian Arts and
Culture, Laboratory of
Anthropology Collections,
Museum of New Mexico
(8321/11)

136. MALE FIGURE
Mexico, Chihuahua,
Casas Grandes, c. 1280–1450
Ceramic with pigment
Height: 6⅛ in. (15.6 cm);
diam: 6¾ in. (17.1 cm)
CNCA-INAH, Museo Nacional de
Antropología, Mexico City
(10-55366)

137. OWL EFFIGY JAR
Mexico, Chihuahua,
Casas Grandes, c. 1280–1450
Ceramic with pigment
Height: 9⁹⁄₁₆ in. (24.3 cm);
diam: 8 in. (20.3 cm)
Denver Museum of Nature and
Science, Mary W. A. and Francis
V. Crane American Indian
Collection (AC.9068)

138. JAR DEPICTING RABBITS
Mexico, Chihuahua,
Casas Grandes, c. 1280–1450
Ceramic with pigment
Height: 6⁵⁄₁₆ in. (16 cm);
diam: 9⅛ in. (23.2 cm)
The Amerind Foundation, Inc.,
Dragoon, Arizona (4002)

139. JAR WITH PARROT-HEADED
SERPENT
Mexico, Chihuahua,
Casas Grandes, c. 1280–1450
Ceramic with pigment
Height: 5⁹⁄₁₆ in. (14.2 cm);
diam: 6⁵⁄₁₆ in. (16.1 cm)
The Amerind Foundation, Inc.,
Dragoon, Arizona (1335)

140. JAR WITH MODELED
PARROT HEAD
Mexico, Chihuahua, Casas
Grandes, c. 1280–1450
Ceramic with pigment
Height: 5¹¹⁄₁₆ in. (14.4 cm);
diam: 4¹¹⁄₁₆ in. (11.8 cm)
The Amerind Foundation, Inc.,
Dragoon, Arizona (185)

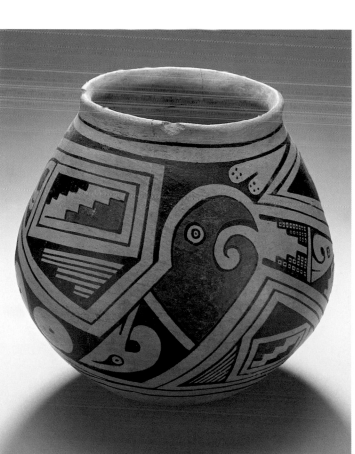

NUMBER 139

141. TRUMPET
Mexico, Chihuahua,
Casas Grandes, c. 1200–1500
Shell, turquoise
5⅞ x 3¾ in. (14.9 x 9.5 cm)
CNCA-INAH, Museo Nacional de
Antropología, Mexico City
(12-1-946)

142. NECKLACE
Mexico, Chihuahua,
Casas Grandes, c. 1200–1500
Shell, copper, turquoise
Length: 39½ in. (100.3 cm)
CNCA-INAH, Museo Nacional de
Antropología, Mexico City
(12-1-945)

143. PENDANT
Mexico, Chihuahua,
Casas Grandes, c. 1200–1500
Bone, turquoise
Length: 3 in. (7.6 cm)
CNCA-INAH, Museo de las
Culturas del Norte, Casas
Grandes, Chihuahua

144. TURTLE CROTAL
Mexico, Chihuahua, Casas
Grandes, c. 1200–1500
Copper alloy
4 x 3 in. (10.2 x 7.6 cm)
CNCA-INAH, Museo Nacional de
Antropología, Mexico City
(12-1-978)

6. THE WEST MEXICO WORLD

145. JAR WITH MODELED FACE
Mexico, Jalisco, Hacienda
Estanzuela, c. A.D. 900–1300
Ceramic, pseudo-cloisonné
decoration
Height: 5½ in. (14 cm);
diam: 4¹⁵⁄₁₆ in. (12.5 cm)
American Museum of Natural
History, New York (30/5894)

146. JAR
Mexico, Jalisco, Hacienda
Estanzuela, c. A.D. 900–1300
Ceramic, pseudo-cloisonné
decoration
Height: 9⁷⁄₁₆ in. (24 cm);
diam: 9¹⁄₁₆ in. (23 cm)
The Brooklyn Museum, Ella C.
Woodward Memorial Fund
(64.9)

147. PEDESTAL BOWL
Mexico, Jalisco, vicinity of
Guadalajara, c. A.D. 900–1300
Ceramic, pseudo-cloisonné
decoration
Height: 2⅝ in. (6.7 cm);
diam: 3¹⁄₁₆ in. (7.8 cm)
American Museum of Natural
History, New York (30.2/3704)

148. BOWL
Mexico, Michoacán,
c. A.D. 900–1300
Ceramic, pseudo-cloisonné
decoration
Height: 6⅛ in. (15.6 cm);
diam: 3¾ in. (9.5 cm)
Los Angeles County Museum
of Art, purchased with funds
provided by Lillian Apodaca
Weiner (M.2001.11)

149. THREE BRACELETS
Mexico, Sinaloa, Guasave,
c. A.D. 600–1000
Shell
Approx. ⁵⁄₁₆ x 3¾ x 3⁷⁄₁₆ in
(.8 x 9.5 x 8.7 cm) each
American Museum of Natural
History, New York
(30.2/4991a, b, f)

150. CARVED BRACELET
Mexico, Colima,
c. A.D. 600–1000
Shell
Length: 6 in. (15.3 cm);
width: 4⅝ in. (11.8 cm)
Denver Museum of Nature and
Science, Mary W. A. and Francis
V. Crane American Indian
Collection (AC.9256)

151. LIP ORNAMENT
West Mexico, c. A.D. 900–1300
Obsidian, turquoise
Length: 2½ in. (6.3 cm)
CNCA-INAH, Museo Nacional de
Antropología, Mexico City

152. TRIPOD VESSEL
Mexico, Sinaloa, Guasave,
c. A.D. 900–1200
Ceramic with pigment
Height: 8 in. (20.3 cm);
diam: 9 in. (22.9 cm)
Denver Museum of Nature and
Science, Mary W. A. and Francis
V. Crane American Indian
Collection (AC.7351)

153. SPOUTED VESSEL
Mexico, Sinaloa, Guasave,
c. A.D. 900–1200
Ceramic with pigment
Height: 9 in. (22.9 cm);
diam: 9⅞ in. (25 cm)
Denver Museum of Nature and
Science, Mary W. A. and Francis
V. Crane American Indian
Collection (AC.8105)

154. TWO SPINDLE WHORLS
Mexico, Sinaloa, Guasave,
c. A.D. 900–1200
Ceramic with pigment
1¾ x ¹³⁄₁₆ in. (3.3 x 2.1 cm);
1⁷⁄₁₆ x ¹³⁄₁₆ in. (3.6 x 2.2 cm)
American Museum of Natural
History, New York
(30.2/4956, 30.2/4957)

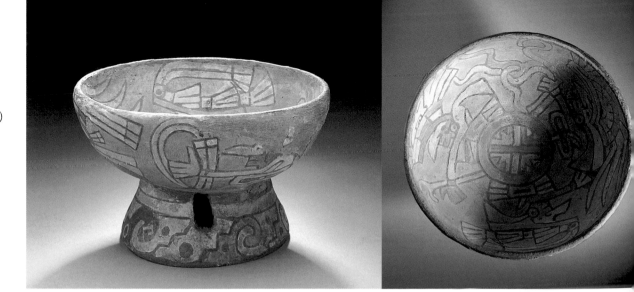

NUMBER 148

155. TRIPOD BOWL
Mexico, Sinaloa, Guasave,
c. A.D. 900–1200
Ceramic, pigment
Height: 7 ¾ in. (19.7 cm);
diam: 4 in. (10.2 cm)
The Field Museum, Chicago
(241218)

156. FEMALE FIGURE AND
MALE FIGURE VESSELS
Mexico, Colima, reportedly El
Chanal, 12th–15th century
Ceramic with pigment
Female: height: 9⅝ in.
(24.3 cm)
Male: height: 9⅜ in. (23.8 cm)
Metropolitan Museum of Art,
Louis V. Bell Fund
(1993.16.1, 1993.16.2)

157. MIXTECA-PUEBLA-STYLE
VESSEL
Mexico, Nayarit, c. 1350–1500
Ceramic with pigment
Height: 13 in. (33 cm)
Los Angeles County Museum
of Art, purchased with funds
provided by Camilla Chandler
Frost (M.2000.86)

7. TENOCHTITLAN AND
THE POSTCLASSIC WORLD

158. Facsimile of the CODEX
BOTURINI (Tira de la peregri-
nación)
Originally made in Mexico,
first half of the 16th century
Facsimile made by Taller de
Artes Graficas, Mexico City,
in 1991
Amate paper and ink
8 x 192 ½ in. (20.3 x 489 cm)
Original in Biblioteca Nacional
de Antropología e Historia
Facsimile in Mr. and Mrs. Allan
C. Balch Art Research Library,
Los Angeles County Museum
of Art

159. Scott Gentling
Model of the TEMPLO MAYOR
of TENOCHTITLAN, 1988
7 x 14 ¾ x 14 ¾ in. (17.8 x 36.8 x
36.8 cm)
Scott and Stuart Gentling

160. CALENDAR STONE
Mexico, Aztec, c. 1325–1521
Greenstone
Height: 19 ½ in. (49.5 cm),
diam: 33 in. (83.8 cm)
Philadelphia Museum of Art,
The Louise and Walter
Arensberg Collection, 1950
(1950-134-403)

161. GOD WITH MAIZE AND
FLOWERS
Mexico, Aztec, c. 1200–1519
Stone with pigment
10⅞ x 11¾ x 9¹⁵⁄₁₆ in.
(27.7 x 29.9 x 25.2 cm)
The Cleveland Museum of Art,
the Norweb Collection
(1949.555)

162. SHELL COAT OF ARMOR
Mexico, Hidalgo, Tula,
9th–12th century A.D.
Shell
49 x 16½ in. (124.5 x 41.9 cm)
CNCA-INAH, Centro INAH,
Hidalgo (10-568991-1)
(Los Angeles only)

163. PENDANT
Mexico, Aztec, c. 1250–1521
Shell
3¼ x 2¾ x ¼ in.
(8.2 x 7 x .6 cm)
The Field Museum, Chicago
(164669)

164. NECKLACE
Mexico, Aztec,
14th–15th century
Mother-of-pearl, greenstone,
gold
21 x 20 in. (53.3 x 50.8 cm)
CNCA-INAH, Museo del Templo
Mayor, Mexico City

165. FIGURE OF
HUITZILOPOCHTLI
Mexico, Aztec, c. 1461–1521
Jadeite
Height: 2⅝ in. (6.7 cm)
Musée de l'Homme, Paris
(30.100.43)

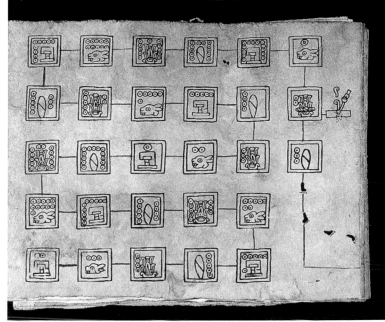

NUMBER 158

166. COYOLXAUHQUI MASK
Mexico, c. 1500
Jade
4½ x 5¾ in. (11.4 x 14.6 cm)
Peabody Museum of
Archaeology and Ethnology,
Harvard University,
Anonymous Gift
(28-40-20/C10108)

167. MASK OF NINE-EHECATL
Mexico, Aztec, c. 1325–1521
Volcanic stone
5½ x 5½ in. (14 x 14 cm)
Staatliche Museen zu Berlin,
Preussischer Kulturbesitz,
Ethnologisches Museum
(IV Ca 26027)

168. XIPE TOTEC EFFIGY VESSEL
Mexico, West Mexico,
c. 1200–1500
Ceramic with slip and gold leaf
6⅜ x 3¹³⁄₁₆ x 4¹⁵⁄₁₆ in.
(16.2 x 9.7 x 12.5 cm)
UCLA Fowler Museum of
Cultural History, Gift of Mr.
Arthur Addis (x73.273)

169A. FEATHERED SERPENT
SCULPTURE
Mexico, Aztec, c. 1350–1500
Stone
18⅞ x 10¼ x 10¼ in.
(47.9 x 26 x 26 cm)
Museum für Völkerkunde,
Vienna (12,406)

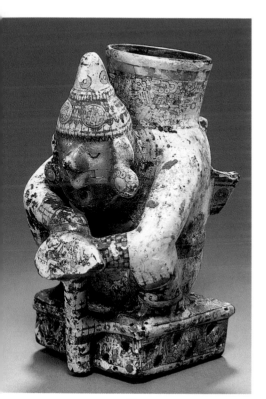

NUMBER 168

169B. QUETZALCOATL
Mexico, Aztec, c. 14th–15th
century
Basalt
27½ x 19¼ x 17⁵⁄₁₆ in.
(70 x 49 x 44 cm)
Museo Arqueológico de
Apaxco, Instituto Mexiquense
de Cultura, Estado de México

170. LABRET IN THE
FORM OF A BIRD
Mexico, Aztec-Mixtec,
15th or early 16th century
Gold, rock crystal
2⁷⁄₁₆ x 1 x ⁹⁄₁₆ in.
(6.2 x 2.6 x 1.4 cm)
Museum für Völkerkunde,
Vienna (59,989)

171. LABRET IN THE FORM OF
AN EAGLE HEAD
Mexico, Mixteca-Puebla,
c. 1200–1500
Gold
Height: 1½ in. (3.8 cm)
Los Angeles County Museum
of Art, Gift of Constance
McCormick Fearing
(AC1992.134.29)

172. PLATE DEPICTING A
SERPENT
Mexico, Puebla, Cholula,
c. 1200–1450
Ceramic with pigment
Diam: 9ⁱⁱ⁄₁₆ in. (23 cm)
The Saint Louis Art Museum,
Purchase (85:1950)
(Los Angeles only)

173. MASK
Mexico, Aztec-Mixtec,
15th–16th century
Wood, turquoise, jadeite, shell,
mother-of-pearl, coral
9⅞ x 5⅞ x 3⅛ in.
(25 x 15 x 8 cm)
Museo Nazionale Preistorico
ed Etnografico "L. Pigorini,"
Rome (4213)
(Los Angeles only)

174. KNIFE HANDLE
Mexico, Aztec-Mixtec,
15th–16th century
Wood, turquoise, malachite,
shell, mother-of-pearl,
gold flakes
2³⁄₁₆ x 2³⁄₁₆ x 5½ in.
(5.5 x 5.5 x 14 cm)
Museo Nazionale Preistorico
ed Etnografico "L. Pigorini,"
Rome (4216)
(Los Angeles only)

175. SERPENT KNIFE
Mexico, Aztec, c. 1325–1521
Silex, turquoise, pyrite
½ x 14⅛ x 3¼ in.
(1.3 x 35.9 x 8.3 cm)
CNCA-INAH, Museo del Templo
Mayor (Room III), Mexico City
(10-253044)

176. MOSAIC ORNAMENT
Mexico, Puebla, Tehuacán-
Mixtec, c. A.D. 900–1519
Wood, shell, stone
Diam: 2½ in. (6.4 cm)
The Field Museum, Chicago
(167740)

177. EHECATL-QUETZALCOATL
Mexico, Aztec, Calixtlahuaca,
14th–15th century
Basalt
69⁵⁄₁₆ x 22 x 19ⁱⁱ⁄₁₆ in.
(176 x 56 x 50 cm)
Museo de Antropología e
Historia del Estado de México,
Instituto Mexiquense de
Cultura (10-109262)

8. CONVERGENCE AND NEGOTIATION: THE IMPACT OF THE SPANISH

178. Bernardo de Miera y
Pacheco (Spain, active New
Mexico, 1714–85)
MAPA DE NUEVO MÉXICO,
18th century
Oil on canvas
42½ x 38⁹⁄₁₆ in. (108 x 98 cm)
CNCA-INAH, Museo Nacional del
Virreinato, Tepotzotlán (10-
54125)

179. AZTEC MAP OF
UNKNOWN AREA
Central Mexico, 16th century
Deer hide and pigment
34 x 27½ in. (86.4 x 69.9 cm)
Princeton University Library
(Los Angeles only)

180. WATER JAR
New Mexico, Zuni Pueblo,
late 19th century
Ceramic and pigment
10¾ x 13¾ in.
(27.3 x 34.9 cm)
The Brooklyn Museum,
Museum Expedition 1904
(04.297.5248)

181. CARVED BRACKETS
New Mexico, Zuni Pueblo,
1775–76
Wood, pigment, iron
(a) 11½ x 9½ x 1¼ in.
(29.2 x 24.1 x 3.2 cm)
(b) 11½ x 9¼ x 1¼ in.
(29.2 x 23.5 x 3.2 cm)
The Brooklyn Museum,
Museum Expedition 1903,
Museum Collection Fund
(03.325.3489a, b)

182. CEREMONIAL BOWL
New Mexico, Zuni Pueblo,
19th century
Ceramic and pigment
5ⁱⁱ⁄₁₆ x 9⁷⁄₁₆ in. (14.5 x 24 cm)
Department of Anthropology,
Smithsonian Institution,
Washington, D.C. (E234580)

183. Anonymous, 18th century
PRESENTES DE LOS INDIOS DE
MOCTEZUMA A HERNÁN
CORTÉS EN SAN JUAN DE ULUA
Oil on canvas
15½ x 28 in. (39.3 x 71 cm)
CNCA-INAH, Museo Nacional de
Historia, Mexico City
(10-230516; 10-92278)

184. MADONNA AND CHILD
Mexico, Michoacán, c. 1550–75
Hummingbird feathers, wood,
agave paper
6⅛ x 4⁵⁄₁₆ in. (15.5 x 11 cm)
Museum für Völkerkunde,
Vienna (125,211)
(Los Angeles only)

185. SAN JOSÉ
Mexico, 16th century
Feathers
13½ x 9½ x ½ in.
(34.3 x 24.1 x 1.3 cm)
Collection of Michael Haskell

186. CHALICE
Mexico, Mexico City,
c. 1575–78
Silver gilt, rock crystal,
boxwood, feathers
Height: 13 in. (33 cm)
Los Angeles County Museum
of Art, Gift of William
Randolph Hearst (48.24.20)

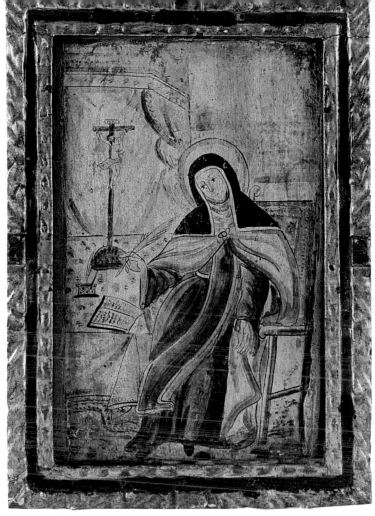

187. PRAYER TABLET
Mexico, Michoacán, Pátzcuaro,
c. 1550–80
Hummingbird, quetzal, and
parrot feathers, paper with
gilt wood
11 x 13¾ in. (27.8 x 35 cm)
Kunsthistorisches Museum,
Vienna, Kunstkammer (Kup
323)
(Los Angeles only)

188. Anonymous, Mexico,
17th century
SANTA TERESA DE AVILA
Oil on wood
19¹¹/₁₆ x 13¾ in.
(50 x 35 cm)
Museo Franz Mayer, Mexico
City (APB-0151)

189. Quill Pen Santero
(New Mexico, mid-19th century)
OUR LADY OF GUADALUPE,
c. 1820–40
Paint on wood
14 x 10¼ in. (35.6 x 26 cm)
The Amerind Foundation, Inc.,
Dragoon, Arizona (2196)

190. Molleno
(New Mexico, active 1805–50)
SANTIAGO
Gesso and water-soluble
pigments on wood
16 x 11 in. (40.6 x 27.9 cm)
Collection of the Museum of
New Mexico at the Museum of
International Folk Art, Santa Fe
(A.92.119.11)

191. Truchas Master (New
Mexico, active 1780–1840)
SANTA BÁRBARA
Gesso and water-soluble
pigments on wood
16½ x 11½ in. (41.9 x 29.2 cm)
Gift of Mrs. Raymond E. Lee in
memory of her husband to the
Museum of New Mexico at the
Museum of International Folk
Art, Santa Fe (A8.1959.28)

192. SANTO NIÑO DE ATOCHA
Mexico (figure and pottery jars),
mid to late 19th century
Taos (chair), 19th century
Wood, gesso, water-based paint,
brass, fabric, ceramic
Figure: height: 7 in. (17.8 cm)
Chair: 8¾ x 4½ x 3¾ in.
(22.2 x 11.4 x 9.5 cm)
Museum of Spanish Colonial
Art, Santa Fe, NM (1 5.68.32)

193. Anonymous (Mexico, late
18th–early 19th century)
SANTIAGO ASTRIDE A HORSE
Gilded and ornamented wood
20⅞ x 18⅛ x 8¼ in.
(53 x 46 x 21 cm)
Museo Franz Mayer, Mexico
City (BEA-0035)

194. Quill Pen Santero (New
Mexico, mid-19th century)
SAN LORENZO
Paint on wood
15 x 10 in. (38.1 x 25.4 cm)
The Taylor Museum, Colorado
Springs Fine Arts Center
(TM 865)

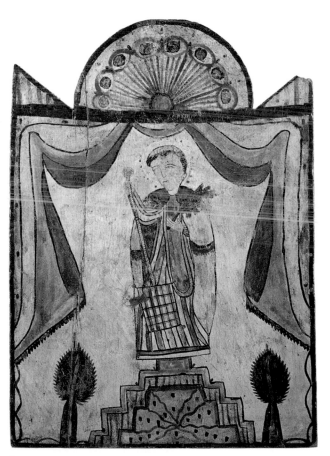

195. Quill Pen Santero
(New Mexico, mid-19th century)
SAN MIGUEL, ARCÁNGEL
Gesso and water-soluble
pigments on pine
10 x 7 in. (25.4 x 17.8 cm)
Bequest of Charles D. Carroll
to the Museum of New Mexico
at the Museum of International
Folk Art, Santa Fe (A.71.31.75)

196. The A. J. Santero
(New Mexico, active 1820's)
SANTA BÁRBARA
New Mexico, early 19th century
Gesso and water-soluble
pigments on wood
13 x 7 in. (33 x 17.8 cm)
Museum of Spanish Colonial
Art, Santa Fe, NM
(L.5.90-144/V.57.1-R)

197. SAN ISIDRO LABRADOR
New Mexico,
mid to late 19th century
Wood, gesso, water-based paint,
paper, gold paint
39½ x 24 x 17½ in.
(100.3 x 61 x 44.5 cm)
Museum of Spanish Colonial
Art, Santa Fe, NM (L.5.73-14)
(Los Angcles only)

198. RÍO ABAJO SAN JOSÉ
Southern New Mexico,
19th century
Wood and pigment
31 x 13½ x 9½ in.
(78.7 x 34.3 x 24.1 cm)
Gift of Carter Harrison to the
Museum of New Mexico at the
Museum of International Folk
Art, Santa Fe (A.8.1959.26)

199. SERAPE
Mexico, Saltillo, 19th century
Wool, cotton
90 x 49½ in.
(228.6 x 125.7 cm)
The Brooklyn Museum,
Museum Collection Fund
and the Dick S. Ramsay Fund
(52.166.20)

200. SERAPE
Mexico, Saltillo,
mid-19th century
Wool weft, cotton warp, silk,
metallic thread, natural dyes
91⅛ x 48½ in.
(232.1 x 123.2 cm)
Fred Harvey Collection of the
International Folk Art
Foundation at the Museum of
International Folk Art, Santa Fe
(FA.1979.64.90)

201. RIO GRANDE SALTILLO
BLANKET
New Mexico, c. 1800–1860
Wool, vegetal dyes
76¾ x 50¾ in.
(194.9 x 128.9 cm)
Museum of Spanish Colonial
Art, Santa Fe, NM
(L.5.63-4)

202. SAN MIGUEL, ARCÁNGEL
New Mexico, 17th century
Hide with pigment
31½ x 18½ in. (80 x 47 cm)
Fred Harvey Collection of the
International Folk Art
Foundation at the Museum of
International Folk Art, Santa Fe
(FA.1979.64.120)

NUMBER 195

203. SHIELD
New Mexico, Tesuque Pueblo,
c. 1850
Hide with pigment
Diam: 19 in. (48.3 cm)
Courtesy Southwest Museum,
Los Angeles (491.G.1058)
(Los Angeles only)

204. Anonymous (Mexico,
18th century)
SAN HIPÓLITO
Oil on canvas
68½ x 50 in. (174 x 127 cm)
Museo Franz Mayer, Mexico
City (APB-0234)

NUMBER 200

388

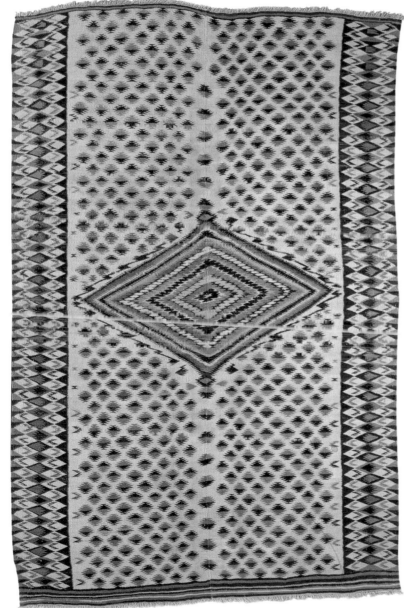

NUMBER 201

205. Josefus de Ribera y Argomanis
(Mexico, 18th century)
VERDADERO RETRATO DE SANTA MARÍA VIRGEN DE GUADALUPE, PATRONA PRINCIPAL DE LA NUEVA ESPAÑA JURADA EN MÉXICO, 1778
Oil on canvas
64 x 68 in. (162.6 x 172.7 cm)
Museo de la Basílica de Guadalupe, Mexico City

206. Miguel Cabrera
(Mexico, 1695–1768)
DE MESTIZO Y D INDIA, COYOTE, 1763
Oil on canvas
52 x 40½ in. (132 x 102.9 cm)
Collection of Elisabeth Waldo-Dentzel, Multicultural Music and Art Foundation, Northridge, California

207. Attributed to Conde Sifuentes (Mexico, 18th century)
NOBLEZA TLAXCALTECA EN LA ÉPOCA DE LA CONQUISTA
Oil on canvas
46⅞ x 33 in. (119 x 84 cm)
CNCA-INAH, Museo Nacional de Historia, Mexico City (10-230009; 10-92285)

9. SURVIVAL AND TRANSLATION: CONTEMPORARY CONCEPTS OF AZTLAN

208. Richard S. Duardo
(United States, b. 1952)
AZTLAN, 1982
Silkscreen
25¼ x 38 in. (64.1 x 96.5 cm)
Collection of Shifra M. Goldman

209. Rupert García
(United States, b. 1941)
FESTIVAL DEL SEXTO SOL, 1974
Lithograph, offset silkscreen on paper
24 x 18 in. (61 x 45.7 cm)
Fine Arts Museums of San Francisco, Achenbach Foundation for Graphic Arts, Gift of Mr. and Mrs. Robert Marcus (111.1.117)
(Los Angeles only)

210. Rupert García
(United States, b. 1941)
MAGUEY DE LA VIDA, 1973
Color silkscreen on white wove paper
20 x 26 in. (50.8 x 66 cm)
Fine Arts Museums of San Francisco, Achenbach Foundation for Graphic Arts, Gift of Mr. and Mrs. Robert Marcus (111.1.116)
(Austin and Albuquerque only)

211. Louie "the Foot" González
ANNOUNCEMENT POSTER FOR A UFW BENEFIT AND DANCE, 1976
Silkscreen on paper
25 x 17 in. (63.5 x 43.2 cm)
California Ethnic and Multicultural Archives, Department of Special Collections, Davidson Library, University of California, Santa Barbara (record number 91)

212. Maria Martínez (New Mexico, San Ildefonso Pueblo, 1887–1980)
BOWL ETCHED WITH IMAGE OF HORNED SERPENT, c. 1925
Ceramic
Diam: 10 in. (25.4 cm)
The Taylor Museum, Colorado Springs Fine Arts Center, Gift of Alice Bemis Taylor (TM 4365)

213. Maria Martínez (New Mexico, San Ildefonso Pueblo, 1887–1980) and Popovi Da (New Mexico, San Ildefonso Pueblo, 1922–71)
PLATE WITH RADIATING FEATHER DESIGN, 1960s,
Ceramic, slip
Height: 2 in. (5.1 cm); diam: 16 in. (40.6 cm)
Dallas Museum of Art, Foundation for the Arts Collection, Anonymous Gift (1987.342.FA)

236. Javier de la Garza
(Mexico, b. 1954)
MEXICA SOBRE FONDO ROJO,
1992
Graphite on paper
39⅜ x 55⅛ in.
(100 x 140 cm)
Fundación Cultural Televisa /
Centro de Cultura Casa Lamm
A.C.

237. Rubén Ortiz Torres
(Mexico, b. 1964) and Jesse
Lerner (United States, b. 1962)
FRONTIERLAND/
FRONTERILANDIA, 1995
Videotape, 77 min.
Collection of the artist

238. Rubén Ortiz Torres
(Mexico, b. 1964)
HOW TO READ MACHO MOUSE,
1991
Videotape, 8:21 min.
Collection of the artist

239. Silvia Gruner
(Mexico, b. 1959)
IN SITU, 1995
Videotape, 15 min.
Collection of the artist

240. Silvia Gruner
(Mexico, b. 1959)
500 KILOS DE IMPOTENCIA
(O POSIBILIDAD), 1997
Volcanic stone and steel cable
600 x 9⅞ x 9⅞ in.
(1524 x 25 x 25 cm)
Collection of the artist

241. Silvia Gruner
(Mexico, b. 1959)
500 KILOS DE IMPOTENCIA
(O POSIBILIDAD), 1998
Videotape, 10:30 min.
Collection of the artist

242. Gabriel Orozco
(Mexico, b. 1962)
LINEA PERDIDA, 1993–96
Plasticine and cotton string
(ed. 3/3)
Diam: 19 in. (48.3 cm)
Los Angeles County Museum
of Art, Gift of the Peter Norton
Family Foundation
(AC1996.109.1)
(Los Angeles only)

243. Thomas Glassford
(United States, active Mexico,
b. 1963)
INVITATION TO PORTAGE 2, 1992
Leather (saddle), nickel-plated
steel, gourd
49 x 52 x 18 in.
(124.5 x 132.1 x 45.7 cm)
Collection of the artist

244. Amalia Mesa-Bains
(United States, b. 1943)
REFLECTIONS ON A
TRANSPARENT MIGRATION, 2001
Mixed media
96 x 180 x 96 in.
(243.8 x 457.2 x 243.8 cm)
Collection of the artist; courtesy
of the Bernice Steinbaum
Gallery

245. Teresa Serrano
(Mexico, b. 1936)
RIVER, from the View of Four
Rivers series, 1996
Embroidered blankets, iron,
leather belts
177³⁄₁₆ x 31½ x 31½ in.
(450 x 80 x 80 cm)
Collection of the artist

246. Carlos Almaraz
(Mexico, active United States,
1941–89)
TWO OF A KIND, 1986
Oil on canvas
80 x 66 in. (203.2 x 167.6 cm)
Los Angeles County Museum
of Art, Gift of Francie Seiniger
(AC1999.134.1)

247. Roberto Juarez
(United States, b. 1952)
CALAMUS BORDER, 1995
Acrylic, peat moss, ink, rice
paper, and charcoal on canvas
48 x 64 in. (121.9 x 162.6 cm)
Private collection

248. Roberto Juarez
(United States, b. 1952)
THOREAU BORDER, 1995
Japanese rice paper and
charcoal on canvas
48 x 64 in. (121.9 x 162.6 cm)
Collection of Diana and Moisés
Berezdivin

249. Robert Gil de Montes
(Mexico, active United States,
b. 1950)
L.A. AZTEC, 1987
Oil and mixed media on wood
12 x 10 in. (30.5 x 25.4 cm)
Collection of Paul and Suzanne
Muchnic

250. Gilbert (Magu) Sánchez
Luján (United States, b. 1940)
TRAILING LOS ANTEPASADOS,
2000
Mixed wood, canvas, acrylic,
metal hardware
Painting: 72 x 102 x 3 in.
(182.9 x 259.1 x 7.6 cm)
Base (in front of painting):
20 x 96 x 42 in.
(50.8 x 175.3 x 106.7 cm)
Collection of the artist

NUMBER 239

392

LENDERS TO THE EXHIBITION

The Albuquerque Museum
American Museum of Natural History
The Amerind Foundation, Inc., Dragoon, Arizona
Arizona State Museum
The Art Institute of Chicago
The Art Museum, Princeton University
Santa C. Barraza
Beloit College, Logan Museum of Anthropology
Charles and Marjorie Benton
Diana and Moises Berezdivin
Brooklyn Museum of Art
California Ethnic and Multicultural Archives, Department of
 Special Collections, Davidson Library, University of California,
 Santa Barbara
Carnegie Art Museum, Oxnard
Centro INAH, Hidalgo
Yreina Cervántez
The Cleveland Museum of Art
Dallas Museum of Art
Denver Museum of Nature and Science
The Field Museum, Chicago
Fine Arts Museums of San Francisco, Achenbach Foundation
 for Graphic Arts
Frederick R. Weisman Art Museum, University of
 Minnesota, Minneapolis
Fundación Cultural Televisa/Centro de Cultura Casa Lamm
Scott and Stuart Gentling
Thomas Glassford
Shifra M. Goldman
Silvia Gruner
Michael Haskell
Kimbell Art Museum, Fort Worth, Texas
Kunsthistoriches Museum, Vienna
Yolanda M. López
Los Angeles County Museum of Art
Gilbert (Magu) Sánchez Luján
Maxwell Museum of Anthropology
Amalia Mesa-Bains
The Metropolitan Museum of Art
Montgomery Gallery, Pomona College, Claremont, California
Paul and Suzanne Muchnic
Henry R. Muñoz III
Musée de l'Homme, Paris
Musées Royaux d'Art et d'Histoire, Brussels

Museo Arqueológico de Apaxco, Instituto Mexiquense
 de Cultura
Museo de Antropología e Historia del Estado de México,
 Instituto Mexiquense de Cultura
Museo de la Basílica de Guadalupe, Mexico City
Museo de las Culturas del Norte, Casas Grandes
Museo del Templo Mayor, Mexico City
Museo Franz Mayer, Mexico City
Museo Nacional de Antropología, Mexico City
Museo Nacional de Historia, Mexico City
Museo Nacional del Virreinato, Tepotzotlán
Museo Nazionale Preistorico ed Etnografico "L. Pigorini," Rome
Museum für Völkerkunde, Vienna
Museum of Contemporary Art, San Diego
Museum of Fine Arts, Boston
Museum of Fine Arts, Museum of New Mexico
Museum of Indian Arts and Culture, Laboratory of Anthropology,
 Museum of New Mexico
Museum of International Folk Art, Museum of New Mexico
Museum of Northern Arizona
Museum of Spanish Colonial Art
National Park Service, Casa Grande Ruins National Monument
Peabody Museum of Archaeology and Ethnology,
 Harvard University
Gobi Stromberg Pellizzi
Philadelphia Museum of Art
Princeton University Library
Pueblo Grande Museum, Phoenix
Armando Rascón
The Saint Louis Art Museum
Teresa Serrano
Smithsonian Institution, Department of Anthropology
The Southwest Museum, Los Angeles
Staatliche Museen zu Berlin, Preussischer Kulturbesitz,
 Ethnologisches Museum
The Taylor Museum, Colorado Springs Fine Arts Center
UCLA Fowler Museum of Cultural History
University of Colorado Museum
The University of Pennsylvania Museum of Archaeology
 and Anthropology
Elisabeth Waldo-Dentzel, Multicultural Music and Arts Studios

Four anonymous lenders

Acknowledgments

Every exhibition begins with a core idea, and in the case of *The Road to Aztlan: Art from a Mythic Homeland,* that idea came from Karl Taube, professor of anthropology at the University of California, Riverside. In a conversation we had in 1991, Karl suggested that the interaction between the southwestern United States and Mexico would make an interesting topic for an exhibition. He outlined a chronological overview that would trace such interaction from the Late Formative period (c. 200 B.C.–A.D. 200) to the ethnographic present among the peoples of the Southwest and northern Mexico. When Karl also proposed the title *The Road to Aztlan,* I knew that a thought-provoking exhibition could result.

Aztlan was the legendary homeland of the Aztecs, who in the fifteenth and early sixteenth centuries established a vast empire centered in what is now Mexico City. More than four centuries after the fall of the Aztec empire, in the late 1960s, the Chicano movement revived the notion of Aztlan as a spiritual homeland, locating it somewhere in the American Southwest. Since my own expertise is in pre-Columbian cultures, I knew I would need a collaborator in order to explore the complex historical and cultural links between these eras. I spoke with artist and educator Amalia Mesa-Bains, who recommended art historian and curator Victor Zamudio-Taylor. Victor's enthusiastic response to the basic outline of the exhibition moved its conceptualization to a new stage, and we began working together as cocurators in 1995 to further refine the project themes. I would like to express my deepest thanks to Karl Taube for his compelling initial idea and for his enthusiasm and input throughout the exhibition planning. I extend my heartfelt gratitude to Victor for enriching the project in multiple ways with his deep knowledge of and passion for Mexican and Chicano art and culture. For additional guidance in articulating themes and concepts in the course of the exhibition planning and development, I express my appreciation to John M. D. Pohl, whose insights and innovative ideas greatly enriched the project.

I would like to express my appreciation to several other individuals for their input and for their ongoing interest in the topic of the exhibition. Early in the planning stages of the project, I received helpful bibliographic suggestions from Cecelia Klein and references to authoritative sources from Diana Fane. Patricia Anawalt provided guidance in understanding a sixteenth-century map, and Richard Townsend offered thoughtful remarks on an early version of the exhibition proposal as well as eleventh-hour assistance in facilitating a loan request. Margaret Hardin offered sensitive advice on matters of cultural importance, and Benjamin Schmidt shared his knowledge of sixteenth-century European depictions of the peoples of the Americas. Discussions Victor and I had with Tomás Ybarra-Frausto regarding Aztlan and its articulation in Chicano art and culture were key to the development of the exhibition. For his insights on contemporary Mexican art and pre-Columbian civilizations, I would like to thank Raúl Zamudio.

I am grateful to the Ethnic Arts Council of Los Angeles for their support of the exhibition planning. Council members individually and as a group have provided support and enthusiasm for the project from its inception, and I appreciate and value that support. Exhibition planning was further enriched by a grant from the National Endowment for the Humanities, for which we are grateful. The grant permitted us to convene two meetings of scholars, artists, and educators, who provided invaluable assistance in defining the concepts, themes, and content of the exhibition and catalogue. One committee, made up of archaeologists and historians of art and architecture, focused primarily on pre-Columbian issues of cultural exchange and identity and

398

Smith, Susana Bautista, Ramón Carrillo, Ivelisse Estrada, Pete Gomez, Dan Guerrero, Samuel Mark, Oralia Michel, Patricia Ramos, and Sandra Rojas.

The exhibition and catalogue greatly benefited from the dedication and enthusiastic support of the administration and staff at LACMA. I would like to express my heartfelt appreciation to a number of individuals, beginning with President and Director Andrea L. Rich and former director Graham Beal. From the exhibitions department, Assistant Director Irene Martín, Financial Analyst Beverley Sabo, and Coordinator Christine Lazzaretto oversaw all phases of the project, from planning to installation. Registrar Ted Greenberg, Associate Registrar Portland McCormack, and Assistant Registrar Jennifer Garpner coordinated the complex logistics of foreign and domestic loans. From the conservation department, Maureen Russell and Sabrina Carli in objects, Elma O'Donoghue in paintings, Catherine McLean in textiles, and Soko Furuhata in paper lent their expertise to the task of assessing numerous works. I am grateful to Curatorial Administrator Sarah Sherman, and to her predecessor, Rosanna Zonni, who contributed in many ways to the success of the project. Librarian Anne Diederick was instrumental in gathering resources through interlibrary loan, and I appreciate her efforts as well as those of her colleagues in the research library, who consistently helped me track down obscure references. Interns Marie Timberlake, Nicole Dunn, and Susan Croteau provided assistance with various aspects of the exhibition, and I am grateful for their interest and efforts.

The varied educational programming accompanying the exhibition is a result of the efforts of many people, and I would like to thank Jane Burrell, chief, art museum education, for her dedication and for devoting the resources of her staff to the project. Various aspects were capably handled by Elizabeth Caffry, assistant

museum educator; Karen Satzman, senior education coordinator; Ximena Minotta, senior education coordinator; Juanita Purner, education coordinator; Andrea Saenz, education coordinator; Alicia Vogl Saenz, family programs assistant; and Randi Hokett, intern. Consulting art historian Charlotte Eyerman wrote the script for the audio tour, and we are grateful for her sensitive treatment of the exhibition concepts. I would also like to thank art writer Hillary Rollins, who wrote the engaging script for the family audio tour.

Bernard Kester provided an exhibition design that presents the works of art to their best advantage, and I would like to thank him for his vision of the landscape of Aztlan. Senior Graphic Designer Amy McFarland brought her customary creativity to the design of the exhibition graphics, and Editor Nola Butler oversaw the refinement of the exhibition textual materials. Juan José García translated the exhibition texts into Spanish with his customary care and efficiency. I am also grateful to the manager of art preparation and installation, Lawrence Waung, and the art preparation staff for their dedicated efforts in installing the exhibition. Elvin Whitesides, manager of the audiovisual department, and his staff ensured the timely presentation of the exhibition films. Assistant Director of Communications and Marketing Keith McKeown and Media Relations Manager Kirsten Schmidt organized the complexities of publicity and marketing.

I would like to thank the authors of the catalogue essays for their insightful contributions. The development and production of the catalogue and exhibition texts were overseen by Garrett White, director of publications, and Stephanie Emerson, managing editor. I am especially grateful to Karen Jacobson, who edited this volume, for her considerable skill in bringing together the voices of more than twenty authors. Dianne Woo

provided invaluable assistance in compiling the reference list and in proofreading the catalogue, and Bonny McLaughlin prepared the index. We are grateful to Rose Vekony for her exceptional translations of the Spanish-language texts. The inspired design of the catalogue, which accommodates a wide variety of materials, is the work of Amy McFarland. Peter Brenner, supervising photographer, photographic services, and photographer Steve Oliver managed the quality control of the images. I would especially like to thank Steve for photographing many exhibition objects from California and Arizona. Giselle Arteaga-Johnson, rights and reproductions assistant, expertly coordinated the enormous task of securing rights to images, under the supervision of Cheryle Robertson, coordinator of rights and reproductions, and I am grateful for their efforts.

Finally, my warmest thanks go to David Miller, whose thoughtful perceptions, comments, and suggestions through the course of countless hours of discussion and travel over the byways of Aztlan have immeasurably enriched me and the development of *The Road to Aztlan*.

Virginia M. Fields

REFERENCES

Acuña, Rene, ed. 1984. *Relaciones geográficas del siglo XVI*. Vol. 4, *Tlaxcala*. Mexico City: Universidad Nacional Autónoma de Mexico, Instituto de Investigaciones Históricas.

Adams, E. Charles. 1991. *The Origin and Development of the Katsina Cult*. Tucson: University of Arizona Press.

———. 1994. "The Katsina Cult: A Western Pueblo Perspective." Pp. 35–46 in Schaafsma 1994.

Adams, Eleanor B., and Fray Angélico Chávez, trans. 1956. *The Missions of New Mexico, 1776: A Description by Fray Francisco Atanasio Dominguez, with Other Contemporary Documents*. Albuquerque: University of New Mexico Press.

Alexander, Hartley Burr. 1964. *North American [Mythology]*. Mythology of All Races, no. 10. New York: Cooper Square.

Alurista. 1971. *Floricanto en Aztlan: Poetry by Alurista, Art by Judith Hernandez*. Los Angeles: Chicano Studies Center, University of California.

Alva Ixtlilxochitl, Fernando de. 1975–77. *Obras históricas*, ed. Edmundo O'Gorman. 2 vols. Mexico City: Universidad Nacional Autónoma de México, Instituto de Investigaciones Históricas.

Alvar, Manuel. 1970. *Americanismos en la historia de Bernal Díaz del Castillo*. Suppl. 89 to *Revista de Filologia Española*. Madrid: Consejo Superior de Investigaciones Científicas.

Alvarado Tezozomoc, Fernando. 1980. *Crónica mexicana*. Biblioteca Porrúa, no. 61. Mexico City: Editorial Porrúa.

———. 1992a. *Crónica mexicana*, ed. José M. Vigil. Mexico City: Editorial Leyenda.

———. 1992b. *Crónica mexicáyotl*, trans. Adrián León. Mexico City: Universidad Nacional Autónoma de México, Instituto de Investigaciones Históricas.

Álvarez Santaló, Carlos, María Jesús Buxó i Rey, and Salvador Rodríguez Becerra. 1989. *La religiosidad popular*. Barcelona: Anthropos, Editorial del Hombre.

Anawalt, Patricia R. 1979. "The Ramifications of Treadle Loom Introduction in Sixteenth-Century Mexico." Pp. 170–87 in *Looms and Their Products: Irene Emery Roundtable on Museum Textiles, 1977 Proceedings*, ed. Irene Emery and Patricia L. Fiske. Washington, D.C.: Textile Museum.

Anaya, Rudolfo A., and Francisco A. Lomeli. 1989. *Aztlán: Essays on the Chicano Homeland*. Albuquerque: University of New Mexico Press.

Angulo V., Jorge. 1987. "The Chalcatzingo Reliefs: An Iconographic Analysis." Pp. 132–58 in Grove 1987.

Anton, Ferdinand. 1969. *Ancient Mexican Art*. London: Thames and Hudson.

Anzaldúa, Gloria. 1987. *Borderlands=La frontera: The New Mestiza*. San Francisco: Spinsters/Aunt Lute Books.

———. 1993. "Border Arte: Nepantla, el Lugar de la Frontera." Pp. 107–15 in *La Frontera/The Border: Art about the Mexico/United States Border Experience*. San Diego: Centro Cultural de la Raza; Museum of Contemporary Art.

Aveni, Anthony F. 1993. *Ancient Astronomers*. Montreal: St. Remy Press.

Baldwin, Percy M. 1926. *Discovery of the Seven Cities of Cibola by the Father Fray Marcos de Niza*. Publications in History, vol. 1. Albuquerque: Historical Society of New Mexico.

Ball, Sydney H. 1941. *The Mining of Gems and Ornamental Stones by American Indians*. Bureau of American Ethnology, Anthropological Papers, no. 13, Bulletin no. 128. Washington, D.C.: Smithsonian Institution.

Barkan, Elazar, and Ronald Bush, eds. 1995. *Prehistories of the Future: The Primitivist Project and the Culture of Modernism*. Stanford: Stanford University Press.

Barnet-Sánchez, Holly. 1993. "The Necessity of Pre-Columbian Art in the United States: Appropriations and Transformations of Heritage, 1933–1945." Pp. 177–208 in *Collecting the Pre-Columbian Past*, ed. Elizabeth Hill Boone. Washington, D.C.: Dumbarton Oaks.

Barnett, Alan W. 1984. *Community Murals: The People's Art*. Philadelphia: Art Alliance Press.

Barrera, Mario. 1990. *Beyond Aztlan: Ethnic Autonomy in Comparative Perspective*. Notre Dame, Ind.: University of Notre Dame Press.

Basch, Lucie. 1981. *Ex-voto marins dans le monde: De l'antiquité à nos jours*. Paris: Musée de la Marine.

Bassie-Sweet, Karen. 1996. *At the Edge of the World: Caves and Late Classic Maya World View*. Norman: University of Oklahoma Press.

Bauer, Brian S. 1998. *The Sacred Landscape of the Inca: The Cusco Ceque System*. Austin: University of Texas Press.

Beaglehole, Ernest. 1937. *Notes on Hopi Economic Life*. Yale University Publications in Anthropology, no. 15. New Haven: Yale University Press.

Becerra Tanco, Luis. 1675. *Felicidad de México en el principio, y milagroso origen, que tubo el santuario de la Virgen María N. Señora de Guadalupe*. Mexico City: Viuda de Bernardo Calderón.

Benedict, Ruth. 1935. *Zuni Mythology*. 2 vols. New York: Columbia University Press.

Benjamin, Walter. 1983. "N [Re: The Theory of Knowledge: Theory of Progress]." In *Walter Benjamin: Philosophy, History, and Aesthetics*, ed. Gary Smith. Chicago: University of Chicago Press.

Bennett, Wendell C. 1954. *Ancient Art of the Andes*. New York: Museum of Modern Art.

Benson, Elizabeth P., and Beatriz de la Fuente, eds. 1996. *Olmec Art of Ancient Mexico*. Washington, D.C.: National Gallery of Art.

Berdan, Frances F., and Patricia Rieff Anawalt, eds. 1992. *The Codex Mendoza*. Berkeley: University of California Press.

Berlo, Janet. 1984. *Teotihuacan Art Abroad: A Study of Metropolitan Style and Provincial Transformation in Incensario Workshops*. International Series, no. 199. Oxford: B.A.R.

Bernand, Carmen, and Serge Gruzinski. 1992. *De la idolatría: Una arqueología de las ciencias religiosas*. Mexico City: Fondo de Cultura Económica.

Berrin, Kathleen, ed. 1988. *Feathered Serpents and Flowering Trees: Reconstructing the Murals of Teotihuacan*. Seattle: University of Washington Press.

Bierhorst, John. 1985. *Cantares Mexicanos: Songs of the Aztecs*. Stanford, Calif.: Stanford University Press.

———. 1992. *History and Mythology of the Aztecs: The Codex Chimalpopoca*. Tucson: University of Arizona Press.

Black, Mary. 1984. "Maidens and Metaphors: An Analysis of Hopi Corn Metaphors." *Ethnology* 23: 279–88.

Blake, William P. 1858. "The Chalchuhuitl of the Ancient Mexicans: Its Locality and Associations, and Its Identity with Turquoise." *American Journal of Science* 25 (2d ser.): 227–32.

Bloom, Lansing B. 1927. "Early Weaving in New Mexico." *New Mexico Historical Review* 2: 228–38.

———. 1935. "A Trade Invoice of 1638 for Goods Shipped by Governor Rosas from Santa Fe." *New Mexico Historical Review* 10, no. 3: 242–48.

Bolton, Herbert E. [1908] 1963. *Spanish Exploration in the Southwest, 1542–1706.* New York: Barnes and Noble.

———. [1949] 1964. *Coronado: Knight of Pueblo and Plains.* Albuquerque: University of New Mexico Press.

Boone, Elizabeth Hill. 1991. "Migration Histories as Ritual Performance." Pp. 121–51 in Carrasco 1991.

Boone, Elizabeth Hill, and Walter D. Mignolo, eds. 1994. *Writing without Words: Alternative Literacies in Mesoamerica and the Andes.* Durham, N.C.: Duke University Press.

Bourke, John G. 1936. "Bourke on the Southwest," ed. Lansing B. Bloom. *New Mexico Historical Review* 11, no. 1: 77–122, and 11, no. 2: 188–207.

Brandt, Elizabeth A. 1977. "The Role of Secrecy in a Pueblo Society." Pp. 11–28 in *Flowers of the Wind: Papers on Ritual, Myth, and Symbolism in California and the Southwest,* ed. T. C. Blackburn. Socorro, N.M.: Ballena Press.

Braun, Barbara. 1992. *Pre-Columbian Art and the Post-Columbian World.* New York: Harry N. Abrams.

Brenner, Anita. 1929. *Idols behind Altars.* New York: Payson and Clarke.

Brew, J. O. 1944. "Upon the Pueblo IV and on the Katchina-Tlaloc Relations." Pp. 241–44 in *El norte de México y el sur de Estados Unidos: Tercera reunión de la Mesa Redonda sobre Problemas Antropológicos de México y Centro América.* Mexico City: Talleres de la Editorial Stylo.

———. 1979. "Hopi Prehistory and History to 1850." Pp. 514–23 in Ortiz 1979.

Broda, Johanna. 1991. "The Sacred Landscape of Aztec Calendrical Festivals: Myth, Nature, and Society." Pp. 74–120 in Carrasco 1991.

Broda, Johanna, David Carrasco, and Eduardo Matos Moctezuma. 1988. *The Great Temple of Tenochtitlan: Center and Periphery in the Aztec World.* Berkeley: University of California Press.

Brody, J. J. 1977. *Mimbres Painted Pottery.* Santa Fe, N.M.: School of American Research; Albuquerque: University of New Mexico Press.

———. 1990a. *The Anasazi: Ancient Indian People of the American Southwest.* New York: Rizzoli International.

———. 1990b. *Beauty from the Earth.* Philadelphia: University Museum of Archaeology and Anthropology.

———. 1991. *Anasazi and Pueblo Painting.* Albuquerque: University of New Mexico Press.

Brody, J. J., and Rina Swentzell. 1994. *To Touch the Past: The Painted Pottery of the Mimbres People.* New York: Hudson Hills Press.

Brotherston, Gordon. 1995. *Painted Books from Mexico: Codices in UK Collections and the World They Represent.* London: British Museum Press.

Brown, Betty Ann. 1986. "The Past Idealized: Diego Rivera's Use of Pre-Columbian Imagery." Pp. 149–66 in *Diego Rivera: A Retrospective.* Detroit: Detroit Institute of Arts.

Brundage, Burr C. 1972. *A Rain of Darts: The Mexica Aztecs.* Austin: University of Texas Press.

Buchloh, Benjamin H. D., et al. 2000. *Gabriel Orozco.* Los Angeles: Museum of Contemporary Art.

Bunzel, Ruth L. 1929. *The Pueblo Potter: A Study of Creative Imagination in Primitive Art.* Columbia University Contributions to Anthropology, no. 8. New York: Columbia University Press.

———. 1932a. "Introduction to Zuñi Ceremonialism." Pp. 457–544 in *Forty-seventh Annual Report of the Bureau of American Ethnology, 1929–1930.* Washington, D.C.: Smithsonian Institution.

———. 1932b. "Zuñi Katcinas: An Analytical Study." Pp. 837–1086 in *Forty-seventh Annual Report of the Bureau of American Ethnology, 1929–1930.* Washington, D.C.: Smithsonian Institution.

———. 1932c. "Zuñi Origin Myths." Pp. 545–610 in *Forty-seventh Annual Report of the Bureau of American Ethnology, 1929–1930.* Washington, D.C.: Smithsonian Institution.

———. 1932d. "Zuñi Ritual Poetry." Pp. 611–835 in *Forty-seventh Annual Report of the Bureau of American Ethnology, 1929–1930.* Washington, D.C.: Smithsonian Institution.

Burgoa, Francisco de. 1934. *Palestra Historial.* Publicaciones del Archivo General de la Nación, no. 24. Mexico: Talleres Gráficos de la Nación.

Cabeza de Vaca, Alvar Núñez. 1993. *Adventures in the Unknown Interior of America,* trans. and ed. Cyclone Covey. Albuquerque: University of New Mexico Press.

Cahill, Holger. [1933] 1969. *American Sources of Modern Art.* Reprint, New York: Museum of Modern Art and Arno Press.

Carey, Henry A. 1931. "An Analysis of the Northwestern Chihuahua Culture." *American Anthropologist* 37: 325–74.

Carlson, John B. 1991. *Venus-Regulated Warfare and Ritual Sacrifice in Mesoamerica: Teotihuacan and the Cacaxtla "Star Wars" Connection.* Center for Archaeoastronomy Technical Publications, no. 7. College Park, Md.: Center for Archaeoastronomy.

———. 1993. "Venus-Regulated Warfare and Ritual Sacrifice in Mesoamerica." Pp. 202–52 in *Astronomies and Cultures,* ed. Clive L. N. Ruggles and Nicholas J. Saunders. Boulder: University Press of Colorado.

Carlson, Roy L. 1982. "The Mimbres Kachina Cult." Pp. 147–55 in *Mogollon Archaeology: Proceedings of the 1980 Mogollon Conference,* ed. Patrick H. Beckett. Ramona, Calif.: Acoma Books.

Carrasco, David. 1982. *Quetzalcoatl and the Irony of Empire: Myths and Prophecies in the Aztec Tradition.* Chicago: University of Chicago Press.

———, ed. 1991. *To Change Place: Aztec Ceremonial Landscapes.* Boulder: University Press of Colorado.

Caso, Alfonso. 1969. *El tesoro de Monte Alban.* Mexico City: Instituto Nacional de Antropología e Historia.

Castañeda, Carlos E. 1939. *Our Catholic Heritage in Texas.* Vol. 4. Austin, Tex.: Von Boeckmann-Jones.

Castro Leal, Antonio, Alfonso Caso, Manuel Toussaint, Roberto Montenegro, and Miguel Covarrubias. 1940. *Twenty Centuries of Mexican Art / 20 Siglos de arte mexicano.* New York: Museum of Modern Art.

Chang, Amos Ih Tiao. 1956. *The Tao of Architecture.* Princeton, N.J.: Princeton University Press.

Chávez, Fray Angélico. 1957. *Archives [of the Archdiocese of Santa Fe, New Mexico], 1678–1900.* Washington, D.C.: Academy of American Franciscan History.

———. 1968. *Coronado's Friars.* Washington, D.C.: Academy of American Franciscan History.

402

Chimalpahin [Cuauhtlehuanitzin], Francisco de San Antón Muñón. 1965. *Relaciones originales de Chalco Amaquemecan*, trans. Silvia Rendón. Biblioteca américana: Serie de literatura indigena. Mexico City: Fondo de Cultura Económica.

———. 1991. *Memorial breve acerca de la fundación de la ciudad de Culhuacán*, trans. Victor M. Castillo Farreras. Serie de cultura náhuatl: fuentes 9. Mexico City: Universidad Nacional Autónoma de México, Instituto de Investigaciones Históricas.

Christensen, Alexander P. 1996. "Cristobal del Castillo and the Mexican Exodus." *Americas* 52, no. 4: 441–64.

Clendinnen, Inga. 1991. *Aztecs: An Interpretation*. Cambridge: Cambridge University Press.

Clifford, James. 1988. *The Predicament of Culture: Twentieth-Century Ethnography, Literature, and Art*. Cambridge: Harvard University Press.

Codex Vindobonensis. 1963. *Codex Vindobonensis Mexicanus I, Österreichische Nationalbibliothek Wien*. History and description by Otto Adelhofer. Graz: Akademische Druck- u. Verlagsanstalt.

Coe, Michael D. 1968. *America's First Civilization: Discovering the Olmec*. New York: American Heritage.

Coe, Michael D., and Gordon Whittaker. 1982. *Aztec Sorcerers in Seventeenth-Century Mexico: The Treatise on Superstitions by Hernando Ruiz de Alarcón*. Institute for Mesoamerican Studies, Publication no. 7. Albany: State University of New York.

Coe, Michael D., et al. 1995. *The Olmec World: Ritual and Rulership*. Princeton, N.J.: Art Museum, Princeton University; New York: Harry N. Abrams.

Cole, Sally J. 1990. *Legacy on Stone: Rock Art of the Colorado Plateau and Four Corners Region*. Boulder, Colo.: Johnson Books.

Cooper Alarcón, Daniel. 1997. *The Aztec Palimpsest: México in the Modern Imagination*. Tucson: University of Arizona Press.

Cordell, Linda. 1994. *Ancient Pueblo Peoples*. Montreal: St Remy Press.

———. 1995. *Archaeology of the Southwest*. 2d ed. San Diego: Academic Press.

Cortés, Hernán. 1960. *Cartas de relación*. Colección Sepan Cuantos 7. Mexico City: Editorial Porrúa.

Cosgrove, H. S., and C. B. Cosgrove. 1932. *The Swarts Ruin: A Typical Mimbres Site in Southwestern New Mexico*. Papers of the Peabody Museum of American Archaeology and Ethnology, Harvard University, vol. 15, no. 1. Cambridge: Peabody Museum.

Craine, Eugene R., and Reginald C. Reindorp, trans. and eds. 1970. *The Chronicles of Michoacán*. Norman: University of Oklahoma Press.

Creel, Darrell, and Charmion McKusick. 1994. "Prehistoric Macaws and Parrots in the Mimbres Area, New Mexico." *American Antiquity* 59, no. 3: 510–24.

Cuevas, Mariano. 1930. *Album histórico guadalupano del IV centenario*. Mexico City: Escuela Tipográfica Salesiana.

———, ed. 1924. *Historia de los descubrimientos antiguos y modernos de la Nueva España, escrita por el conquistador Baltasar de Obregón, año de 1584*. Mexico: Departamento Editorial de la Sra. de Educación.

Cushing, Frank Hamilton. 1892. "Manual Concepts: A Study of the Influence of Hand-Usage on Culture-Growth." *American Anthropologist* 5, no. 4: 289–318.

———. 1920. *Zuni Breadstuff*. Indian Notes and Monographs, no. 8. New York: Museum of the American Indian, Heye Foundation.

Davies, Nigel. 1977. *The Toltecs until the Fall of Tula*. Norman: University of Oklahoma Press.

———. 1980a. *The Aztecs*. Norman: University of Oklahoma Press.

———. 1980b. *The Toltec Heritage, from the Fall of Tula to the Rise of Tenochtitlan*. Norman: University of Oklahoma Press.

Davis, Carolyn O'Bagy. 1995. *Treasured Earth: Hattie Cosgrove's Mimbres Archaeology in the American Southwest*. Tucson: Sanpete Publications and Old Pueblo Archaeology Center.

Dean, Jeffrey S. 1996. "Demography, Environment, and Subsistence Stress." Pp. 25–56 in *Evolving Complexity and Environmental Risk in the Prehistoric Southwest*, ed. Joseph A. Tainter and Bonnie Bagley Tainter. Santa Fe Institute Studies in the Science of Complexity, no. 24. Reading, Mass.: Addison-Wesley.

Dean, Jeffrey S., and John Ravesloot. 1993. "The Chronology of Cultural Interaction in the Gran Chichimeca." Pp. 83–104 in Woosley and Ravesloot 1993.

De la Torre Villar, Ernesto, and Ramiro Navarro de Anda, eds. 1982. *Testimonios históricos guadalupanos*. Mexico City: Fondo de Cultura Económica.

Detroit. 1986. *Diego Rivera: A Retrospective*. Detroit: Detroit Institute of Arts.

Di Peso, Charles C. 1968a. "Casas Grandes: The Fallen Trading Center of the Gran Chichimeca." *Masterkey* 42: 20–37.

———. 1968b. Casas Grandes and the Gran Chichimeca. *Palacio* 75, no. 4: 45–61.

———. 1974. *Casas Grandes: A Fallen Trading Center of the Gran Chichimeca*. Vols. 1–3. Publication no. 9. Dragoon, Ariz.: Amerind Foundation.

———. 1983. "The Northern Sector of the Mesoamerican World System." Pp. 11–22 in *Forgotten Places and Things: Archaeological Perspectives on American History*, ed. A. E. Ward. Albuquerque, N.M.: Center for Anthropological Studies.

Di Peso, Charles C., John B. Rinaldo, and Gloria J. Fenner. 1974. *Casas Grandes: A Fallen Trading Center of the Gran Chichimeca*. Vols. 4–8. Dragoon, Ariz.: Amerind Foundation.

Donaldson, Thomas C. 1893. *Moqui Pueblo Indians of Arizona and Pueblo Indians of New Mexico*. Extra Census Bulletin, Eleventh Census of the United States. Washington, D.C.

Douglas, Frederic H. 1939a. *Acoma Weaving and Embroidery*. Denver Art Museum Leaflet no. 89. Denver: Denver Art Museum.

———. 1939b. *Weaving in the Tewa Pueblos*. Denver Art Museum Leaflet no. 90. Denver: Denver Art Museum.

———. 1939c. *Weaving of the Keres Pueblos, Weaving of the Tiwa Pueblos and Jemez*. Denver Art Museum Leaflet no. 91. Denver: Denver Art Museum.

———. 1940. *Weaving at Zuni Pueblo*. Denver Art Museum Leaflets, nos. 96–97. Denver: Denver Art Museum.

Douglas, Frederic H., and Rene D'Harnoncourt. 1941. *Indian Art of the United States*. New York: Museum of Modern Art and Simon and Schuster.

Doyel, David E. 1980. "Hohokam Social Organization and the Sedentary to Classic Transition." Pp. 23–40 in *Current Issues in Hohokam Prehistory, Proceedings of a Symposium*, ed. D. E. Doyel and F. Plog. Anthropological Research Papers, no. 23. Tempe: Arizona State University.

Dozier, Edward P. 1983. *The Pueblo Indians of North America.* Prospect Heights, Ill.: Waveland Press.

Dozier, Thomas S. 1921. "Historical Pageantry at Santa Clara Pueblo." *Palacio* 10: 98–99.

Durán, Fray Diego. 1967. *Historia de las Indias de Nuevas España*, ed. Angel María Garibay K. 2 vols. Mexico City: Editorial Porrúa.

———. 1971. *Book of the Gods and Rites and the Ancient Calendar.* Norman: University of Oklahoma Press.

———. 1994. *The History of the Indies of New Spain*, trans. Doris Heyden. Norman: University of Oklahoma Press.

Durand, Jorge, and Douglas S. Massey. 1990. *Doy gracias: Iconografía de la emigración México–Estados Unidos.* Guadalajara: Programa de estudios Jaliscienses.

———. 1995. *Miracles on the Border: Retablos of Mexican Migrants to the United States.* Tucson: University of Arizona Press.

Dutton, Bertha P. 1963. *Sun Father's Way: The Kiva Murals of Kuaua, a Pueblo Ruin, Colorado State Monument, New Mexico.* Albuquerque: University of New Mexico Press.

Ellis, Florence Hawley, and Laurens Hammack. 1968. "The Inner Sanctum of Feather Cave: A Mogollon Sun and Earth Shine Linking Mexico and the Southwest." *American Antiquity* 33, no. 1: 25–44.

Ericson, Jonathon E., and Timothy G. Baugh. 1993. *The American Southwest and Meso-america: Systems of Prehistoric Exchange.* New York and London: Plenum Press.

Espinosa, J. Manuel. 1988. *The Pueblo Indian Revolt of 1696 and the Franciscan Missions in New Mexico.* Norman: University of Oklahoma Press.

Estrada Belli, Francisco, and Laura J. Koskakowsky. 1998. "Survey in Jutiapa, Southeastern Pacific Guatemala, 1997." *Mexicon* 20, no. 3: 55–59.

Farmer, James D. 1997. "Iconographic Evidence of Basketmaker Warfare and Human Sacrifice: A Contextual Approach to Early Anasazi Art." *Kiva, the Journal of Southwestern Anthropology and History* 62, no. 4: 391–420.

Fash, William. 1987. "The Altar and Associated Features." Pp. 82–94 in Grove 1987.

Favela, Ramón. 1984. *Diego Rivera: The Cubist Years.* Phoenix: Phoenix Museum of Art.

Ferdon, Edwin N., Jr. 1955. *A Trial Survey of Mexican-Southwestern Architectural Parallels.* Monographs of the School of American Research, no. 21. Santa Fe, N.M.: School of American Research.

Feuchtwanger, Franz. 1989. *Cerámica Olmeca.* Mexico City: Editorial Patria.

Fewkes, Jesse W. 1892. "A Few Tusayan Pictographs." *American Anthropologist*, o.s., 5: 9–26.

———. 1893. "A Central Mexican Ceremony Which Suggests the Snake Dance of the Tusayan Villages." *American Anthropologist*, o.s., 6: 284–306.

———. 1897. "Tusayan Katcinas." Pp. 145–313 in *Fifteenth Annual Report for the Years 1893–4.* Washington, D.C.: Bureau of American Ethnology.

———. 1898a. "Archaeological Expedition to Arizona in 1895." Pp. 519–752 in *Seventeenth Annual Report of the Bureau of American Ethnology, 1895–1896.* Washington, D.C.: Smithsonian Institution.

———. 1898b. "The Winter Solstice Ceremony at Walpi." *American Anthropologist*, o.s., 11, nos. 3–4: 100–187.

———. 1900. "A Theatrical Performance at Walpi." Pp. 605–29 in *Proceedings of the Washington Academy of Sciences*, vol. 2. Washington, D.C.: Academy of Sciences.

———. 1914. *Archaeology of the Lower Mimbres Valley, New Mexico.* Smithsonian Miscellaneous Collections, vol. 63, no. 10. Publication no. 2316. Washington, D.C.: Smithsonian Institution.

Fewkes, Jesse W., and A. M. Stephen. 1893. "The Pá-lu-lu-koñ-ti: A Tusayan Ceremony." *Journal of American Folklore* 6: 269–84.

Fletcher, Valerie. 1992. *Crosscurrents of Modernism: Four Latin American Pioneers: Diego Rivera, Joaquín Torres-García, Wifredo Lam, and Matta.* Washington, D.C.: Hirshhorn Museum and Sculpture Garden.

Flores, William V., and Rina Benmayor. 1997. *Latino Cultural Citizenship: Claiming Identity, Space, and Rights.* Boston: Beacon Press.

Florescano, Enrique. 1994. *Memory, Myth, and Time in Mexico: From the Aztecs to Independence*, trans. Albert G. Bork with the assistance of Kathryn R. Bork. Austin: University of Texas Press.

———. 1999. *The Myth of Quetzalcoatl*, trans. Lysa Hochroth. Baltimore: Johns Hopkins University Press.

Ford, Richard I. 1972. "Barter, Gift, or Violence: An Analysis of Tewa Intertribal Exchange." Pp. 21–45 in *Social Exchange and Interaction*, ed. Edwin N. Wilmsen. Anthropological Paper no. 46. Ann Arbor: Museum of Anthropology, University of Michigan.

Forshaw, Joseph M. 1977. *Parrots of the World.* Illustrated by William T. Cooper. Neptune, N.J.: T.F.H. Publications.

Foster, Hal. 1985. *Recodings: Art, Spectacle, Cultural Politics.* Seattle: Bay Press.

———, ed. 1987. *Discussions in Contemporary Culture.* Dia Art Foundation Discussions in Contemporary Culture, no. 1. Seattle: Bay Press.

Fowler, Andrew P., and John R. Stein. 1992. "The Anasazi Great House in Space, Time, and Paradigm." Pp. 101–22 in *Anasazi Regional Organization and the Chaco System*, ed. David E. Doyel. Papers of the Maxwell Museum of Anthropology, no. 5. Albuquerque: University of New Mexico.

Fowler, Don, and David Wilcox. 1997. "From Thomas Jefferson to the Pecos Conference: Changing Anthropological Agendas in the North American Southwest." Unpublished ms. on file at the Museum of Northern Arizona, Flagstaff. (Short version to be published in the *Proceedings of the American Philosophical Society*.)

Freidel, David, Linda Schele, and Joy Parker. 1993. *Maya Cosmos: Three Thousand Years on the Shaman's Path.* New York: William Morrow.

Frisbie, Theodore R. 1978. "High Status Burials in the Greater Southwest: An Interpretive Synthesis." Pp. 202–27 in Riley and Hedrick 1978.

———. 1980. "Anasazi-Mesoamerican Relationships: From the Bowels of the Earth and Beyond." Pp. 215–27 in *Proceedings of the Anasazi Symposium*, ed. J. E. Smith. Mesa Verde National Park, Colo.: Mesa Verde Museum Association.

Furtado, Celso. 1970. *Historia de la economía Latinoamericana.* Mexico City: Siglo XXI.

403

Garcia, Ignacio M. 1997. *Chicanismo: The Forging of a Militant Ethos among Mexican Americans.* Tucson: University of Arizona Press.

García Icazbalceta, Joaquín. 1889. *Nueva colección de documentos para la historia de México.* Vol. 2, *Códice Franciscano.* Mexico City: Imprenta de Francisco Díaz de León.

Garibay K., Angel Maria. 1965. *Teogonía e historia de los Mexicanos: Tres opúsculos del siglo XVI.* Mexico City: Editorial Porrúa.

Gay, Carlo T. E. 1972. *Chalcacingo.* Portland, Ore.: International Scholarly Book Services.

Geertz, Armin W. 1984. "A Reed Pierced the Sky: Hopi Indian Cosmography on Third Mesa, Arizona." *Numen* 31: 216–41.

———. 1987. *Hopi Indian Altar Iconography.* Iconography of Religions, sec. 10, no. 5. Leiden: E. J. Brill.

Geertz, Armin W., and Michael Lomatuway'ma. 1987. *Children of Cottonwood: Piety and Ceremonialism in Hopi Indian Puppetry.* Lincoln: University of Nebraska Press.

Gibbs, Jerome F. 1954. "The Retablo Ex-Voto in Mexican Churches." *Palacio* 61, no. 12.

Giffords, Gloria. 1992. *Mexican Folk Retablos.* 2d ed. Albuquerque: University of New Mexico Press.

Gillespie, Susan D. 1989. *The Aztec Kings: The Construction of Rulership in Mexican History.* Tucson: University of Arizona Press.

———. 1991. "Ballgames and Boundaries." Pp. 317–46 in *The Mesoamerican Ballgame,* ed. Vernon L. Scarborough and David R. Wilcox. Tucson: University of Arizona Press.

Gladwin, Harold S., Emil W. Haury, E. B. Sayles, and Nora Gladwin. 1937. *Excavations at Snaketown: Material Culture.* Medallion Papers, no. 25. Globe, Ariz.: Gila Pueblo.

Goldman, Shifra M. 1984. "Mexican Muralism: Its Social-Educative Roles in Latin America and the United States." In *Chicano Art History: A Book of Selected Readings,* ed. Jacinto Quirarte. San Antonio: Research Center for the Arts and Humanities, University of Texas.

Gonzáles, Rodolfo "Corky." 1989. "El Plan Espiritual de Aztlán." Pp. 1–5 in Anaya and Lomeli 1989.

Gradie, Charlotte M. 1994. "Discovering the Chichimecas." *Americas* 51, no. 1: 67–88.

Griswold del Castillo, Richard, Teresa McKenna, and Yvonne Yarbro-Bejarano, eds. 1991. *Chicano Art: Resistance and Affirmation, 1965–1985.* Los Angeles: Wight Art Gallery, University of California.

Groark, Kevin P. 1997. "To Warm the Blood, to Warm the Flesh: The Role of the Steambath in Highland Maya (Tzeltal-Tzotzil) Ethnomedicine." *Journal of Latin American Lore* 20, no. 1: 3–95.

Grove, David C., ed. 1987. *Ancient Chalcatzingo.* Austin: University of Texas Press.

Gruzinski, Serge. 1988. *La colonisation de l'imaginaire: Sociétés indigènes et occidentalisation dans le Mexique espagnol, XVIe–XVIIIe siècle.* Paris: Gallimard.

———. 1989. *Man-Gods in the Mexican Highlands,* trans. Eileen Corrigan. Stanford, Calif.: Stanford University Press.

———. 1994. *La guerra de las imágenes: De Cristóbal Colón a "Blade Runner" (1492–2019).* Mexico City: Fondo de Cultura Económica.

Gumerman, George J., ed. 1988. *The Anasazi in a Changing Environment.* Cambridge: Cambridge University Press.

Gutiérrez, Ramón A. 1991. *When Jesus Came, the Corn Mothers Went Away: Marriage, Sexuality, and Power in New Mexico, 1500–1846.* Stanford, Calif.: Stanford University Press.

Hackett, Charles W., ed. and trans. 1937. *Historical Documents Relating to New Mexico, Nueva Vizcaya, and Approaches Thereto, to 1773.* Vol. 3. Carnegie Institution of Washington Publication no. 330. Washington, D.C.

Haeberlin, H. K. 1916. "The Idea of Fertilization in the Culture of the Pueblo Indians." *Memoirs of the American Anthropological Association* 3, no. 2: 1–55.

Hammond, George Peter, and Agapito Rey. 1940. *Narratives of the Coronado Expedition, 1540–42.* Albuquerque: University of New Mexico Press.

———. 1953. *Don Juan de Oñate, Colonizer of New Mexico.* 2 vols. Albuquerque: University of New Mexico Press.

———. 1966. *The Rediscovery of New Mexico, 1580–1594: The Explorations of Chamuscada, Espejo, Castano de Sosa, Morlete, and Leyva de Bonilla and Humana.* Coronado Cuarto Centennial Publications, no. 3. Albuquerque: University of New Mexico Press.

Harbottle, Garman, and Phil C. Weigand. 1992. "Turquoise in Pre-Columbian America." *Scientific American* 266, no. 2: 78–85.

Hargrave, Lyndon L. 1970. *Mexican Macaws: Comparative Osteology and Survey of Remains from the Southwest.* Anthropological Papers, no. 20. Tucson: University of Arizona.

Harvey, H. R. 1971. "The *Relaciones geográficas,* 1579–1586: Native Languages." Pp. 279–323 in *Guide to Ethnohistorical Sources, Part I,* ed. Howard F. Cline. Vol. 12 of *Handbook of Middle American Indians,* ed. Robert Wauchope. Austin: University of Texas Press.

Haury, Emil W. 1945. "The Problem of Contacts between the Southwestern United States and Mexico." *Southwestern Journal of Anthropology* 1: 55–74.

———. 1976. *The Hohokam: Desert Farmers and Craftsmen: Excavations at Snaketown, 1964–1965.* Tucson: University of Arizona Press.

Hays-Gilpin, Kelley A., Ann C. Deegan, and Elizabeth A. Morris. 1998. *Prehistoric Sandals from Northeastern Arizona: The Earl H. Morris and Ann Axtell Morris Research.* Anthropological Papers of the University of Arizona, no. 62. Tucson: University of Arizona Press.

Hays-Gilpin, Kelley A., and Jane H. Hill. 1999. "The Flower World in Material Culture: An Iconographic Complex in the Southwest and Mesoamerica." *Journal of Anthropological Research* 55, no. 1: 1–37.

Hedrick, Basil C., J. Charles Kelley, and Carroll L. Riley, eds. 1971. *The North Mexican Frontier.* Carbondale: Southern Illinois University Press.

———. 1974. *The Mesoamerican Southwest: Readings in Archaeology, Ethnohistory, and Ethnology.* Carbondale: Southern Illinois University Press.

Hedrick, Basil C., and Carroll L. Riley, eds. 1974. *Journey of the Vaca Party.* University Museum Studies, no. 2. Carbondale: Southern Illinois University.

Helms, Mary W. 1979. *Ancient Panama: Chiefs in Search of Power*. Austin: University of Texas Press.

———. 1988. *Ulysses' Sail: An Ethnographic Odyssey of Power, Knowledge, and Geographical Distance*. Princeton, N.J.: Princeton University Press.

———. 1993. *Craft and the Kingly Ideal: Art, Trade, and Power*. Austin: University of Texas Press.

Hers, Mari-Areti. 1987. *Toltecas en Tierras Chichimecas*. Mexico City: Universidad Nacional Autónoma de México, Instituto de Investigaciones Estéticas.

Hibben, Frank C. 1975. *Kiva Art of the Anasazi at Pottery Mound*. Las Vegas, Nev.: KC Publications.

Hieb, Louis A. 1979. "Hopi World View." Pp. 577–80 in Ortiz 1979.

Hill, Jane H. 1992. "The Flower World of Old Uto-Aztecan." *Journal of Anthropological Research* 48: 117–44.

Hodge, Frederick W. 1907. "The Narrative of Alvar Nuñez Cabeça de Vaca." P. 126 in *Spanish Explorers of the Southern United States, 1528–1543*, ed. F. W. Hodge and T. H. Lewis. New York: Charles Scribner's Sons.

Holmes, William H. 1895–97. *Archaeological Studies among the Ancient Cities of Mexico*. Field Columbian Museum Publication no. 8, 16. Chicago.

Hosler, Dorothy. 1986. "The Origins, Technology, and Social Construction of Ancient West Mexican Metallurgy." Ph.D. diss., Massachusetts Institute of Technology.

———. 1988. "Ancient West Mexican Metallurgy: South and Central American Origins and West Mexican Transformations." *American Anthropologist* 90, no. 4: 832–55.

———. 1994. *The Sounds and Colors of Power: The Sacred Metallurgical Technology of Ancient West Mexico*. Cambridge: MIT Press.

Hosler, Dorothy, Heather Lechtman, and Olaf Holm. 1990. *Axe-Monies and Their Relatives*. Studies in Pre-Columbian Art and Archaeology, no. 30. Washington, D.C.: Dumbarton Oaks.

Hosler, Dorothy, and Guy Stresser-Pean. 1992. "The Huastec Region: A Second Locus for the Production of Bronze Alloys in Ancient Mesoamerica." *Science* 257: 1215–20.

Houlihan, Patrick T., and Betsy E. Houlihan. 1986. *Lummis in the Pueblos*. Flagstaff, Ariz: Northland Press.

Houston, Stephen, and David Stuart. 1990. "T632 as *Muyal*, 'Cloud.'" *Central Tennessean Notes on Maya Epigraphy* 1.

Instituto Nacional de Bellas Artes. 1999. *Los pinceles de la historia: El origen del reino de la Nueva España, 1680–1750*. Mexico City: Instituto Nacional de Bellas Artes.

Jiménez Moreno, Wigberto. 1972. "La migración Mexica." Pp. 167–77 in *Atti del xl Congreso internazionale degli americanisti, Roma-Genova, 3–10 settembre 1972*. Genoa: Tilgher.

Jones, Kellie. 1998. "Crown Jewels." Pp. 29–36 in *Silvia Gruner: Collares/reliquias*. Mexico City: Centro de la Imagen y FONCA.

Judd, Neil M. 1954. *The Material Culture of Pueblo Bonito*. Publication no. 124. Washington, D.C.: Smithsonian Institution.

Judge, W. James. 1989. "Chaco Canyon—San Juan Basin." Pp. 209–61 in *Dynamics of Southwest Prehistory*, ed. Linda S. Cordell and George J. Gumerman. Washington, D.C.: Smithsonian Institution Press.

Jung, Carl G., ed. 1964. *Man and His Symbols*. London: Aldus Books.

Karttunen, Frances. 1992. *An Analytical Dictionary of Nahuatl*. Norman: University of Oklahoma Press.

Katzew, Ilona, ed. 1996. *New World Orders: Casta Painting and Colonial Latin America*, trans. Roberto Tejada and Miguel Falomir. New York: Americas Society Art Gallery.

Kealiinohomoku, Joann W. 1989. "The Hopi Katsina Dance Event 'Doings.'" Pp. 51–63 in *Seasons of the Kachina*, ed. Silvia Brakke Vane and Lowell John Bean. Ramona, Calif.: Ballena Press.

Keen, Benjamin. 1984. *La imagen Azteca en el pensamiento occidental*, trans. Juan José Utrilla. Mexico City: Fondo de Cultura Económica.

Kelen, Leslie, and David Sucec. 1996. *Sacred Images: A Vision of Native American Rock Art*. Layton, Utah: Gibbs Smith.

Kelley, David H. 1955. "Quetzalcoatl and His Coyote Origins." *Mexico antiguo* 8: 397–415.

Kelley, J. Charles. 1966. "Mesoamerica and the Southwestern United States." Pp. 95–110 in *Archaeological Frontiers and External Relations*, ed. G. F. Ekholm and G. R. Willey. Vol. 4 of *Handbook of Middle American Indians*, ed. Robert Wauchope. Austin: University of Texas Press.

———. 1971. "Archaeology of the Northern Frontier: Zacatecas and Durango." Pp. 768–804 in *Archaeology of Northern Mesoamerica*, ed. G. F. Elkholm and I. Bernal. Vol. 11 of *Handbook of Middle American Indians*, ed. Robert Wauchope. Austin: University of Texas Press.

Kelley, J. Charles, and Ellen Abbott Kelley. 1975. "An Alternative Hypothesis for the Explanation of Anasazi Culture History." Pp. 178–223 in *Collected Papers in Honor of Florence Hawley Ellis*, ed. T. R. Frisbie. Papers of the Archaeological Society of New Mexico, no. 2. Norman, Okla.: Hooper Publishing.

———. 1986. "The Mobile Merchants of Molino." Pp. 81–104 in Mathien and McGuire 1986.

———. 1992. "Chalchihuites Cultural Development: A Reassessment of the Chalchihuites Tradition and Presentation of New Data from Recent Excavations at Alta Vista." Paper presented at symposium, "Cultural Dynamics of West and Northwest Mesoamerica," Center for Indigenous Studies in the Americas, Phoenix.

Kelly, Henry W. 1941. *Franciscan Missions of New Mexico, 1740–1760*. Historical Society of New Mexico Publications in History, no. 10. Albuquerque: University of New Mexico Press.

Kent, Kate Peck. 1983a. *Prehistoric Textiles of the Southwest*. Santa Fe, N.M.: School of American Research Press.

———. 1983b. *Pueblo Indian Textiles*. Santa Fe, N.M.: School of American Research Press.

Kessell, John L. 1979. *Kiva, Cross, and Crown: The Pecos Indians and New Mexico, 1540–1840*. Washington, D.C.: National Park Service, U.S. Department of the Interior.

———. 1980. *The Missions of New Mexico since 1776*. Albuquerque: University of New Mexico Press.

Kidder, Alfred V. 1924. *An Introduction to the Study of Southwestern Archaeology*. New Haven, Conn.: Yale University Press.

406

Kidder, Alfred V., Jesse D. Jennings, and Edwin M. Shook. 1946. *Excavations at Kaminaljuyu, Guatemala.* Carnegie Institution of Washington Publication no. 561. Washington, D.C.

Kirchhoff, Paul. 1961. *Se puede localizar Aztlan?* Anuario de historia, no. 1. Mexico City: Universidad Nacional Autónoma de Mexico, Facultad de Filosofía y Letras.

Kirchhoff, Paul, Luis Reyes García, and Lina Odena Güemes, trans. 1992. *Historia tolteca-chichimeca.* Mexico City: Fondo de Cultura Económica.

Klein, Cecelia F. 1994. "Fighting with Femininity: Gender and War in Aztec México." In *Gender Rhetorics: Postures of Dominance and Submission in History,* ed. Richard C. Trexler. Binghamton, N.Y.: Medieval and Renaissance Texts and Studies.

Knab, Timothy J. 1983. "En que lengua hablan los Tepalcates Teotihuacanos? (No era Nahuatl)." *Revista mexi cana de estudios antropológicos* 29, no. 1: 145–58.

———, ed. 1994. *A Scattering of Jades: Stories, Poems, and Prayers of the Aztecs,* trans. Thelma D. Sullivan. New York: Simon and Schuster.

Kowalski, Jeff. 1999. "The Feathered Serpent at Uxmal and Chichen Itza." Paper presented at the Sixty-fourth Annual Meeting of the Society for American Archaeology, Chicago.

Krupp, E. C. 1997. *Skywatchers, Shamans, and Kings: Astronomy and the Archaeology of Power.* New York: Wiley.

Lamphere, Louise. 1983. "Southwestern Ceremonialism." Pp. 743–63 in Ortiz 1979.

Lange, Charles H. [1959] 1990. *Cochiti: A New Mexican Pueblo Past and Present.* Albuquerque: University of New Mexico Press.

Lange, Charles H., and Carroll L. Riley. 1966. *The Southwestern Journals of Adolph F. Bandelier, 1880–1882.* Vol. 1. Albuquerque: University of New Mexico Press.

———. 1996. *Bandelier: The Life and Adventures of Adolph Bandelier, American Archaeologist and Scientist.* Salt Lake City: University of Utah Press.

Leal, Luis. 1989. "In Search of Aztlán." Pp. 6–13 in Anaya and Lomeli 1989.

LeBlanc, Steven A. 1999. *Prehistoric Warfare in the American Southwest.* Salt Lake City: University of Utah Press.

Leclerc, Gustavo, Raúl Villa, and Michael J. Dear. 1999. *La vida latina en L.A.: Urban Latino Cultures.* Thousand Oaks, Calif.: Sage Publications.

Lefebre, Henri. 1993. *The Production of Space.* Oxford: Blackwell Publishers.

Lekson, Stephen H. 1997. "Rewriting Southwestern Prehistory." *Archaeology* 50, no. 1: 52–55.

———. 1999. *The Chaco Meridian: Centers of Political Power in the Ancient Southwest.* Walnut Creek, Calif.: Altamira Press.

León-Portilla, Miguel. 1961. *Los antiguos mexicanos a través de sus crónicas y cantares.* Mexico: Fondo de Cultura Económica.

———. 1963. *Aztec Thought and Culture: A Study of the Ancient Nahuatl Mind,* trans. Jack Emory Davis. Norman: University of Oklahoma Press.

———. 1969. *Pre-Columbian Literatures of Mexico,* trans. Grace Lobanov and Miguel León-Portilla. Norman: University of Oklahoma Press.

———. 1983. *Toltecayotl: Aspectos de la cultura náhuatl.* Mexico City: Fondo de Cultura Económica.

———. 1985. *Los antiguos mexicanos a través de sus crónicas y cantares.* Lecturas Mexicanas, no. 3. Mexico City: Fondo de Cultura Económica.

———. 1990. *Endangered Cultures,* trans. Julie Goodson-Lawes. Dallas: Southern Methodist University Press.

———. 1992. *Fifteen Poets of the Aztec World.* Norman: University of Oklahoma Press.

Linné, Sigvald. 1934. *Archaeological Researches at Teotihuacan, Mexico.* The Ethnographical Museum of Sweden, New Series, Publication no. 1. Stockholm: V. Petterson.

———. 1943. "Humpbacks in Ancient America." *Ethnos* 8: 161–86.

Liebsohn, Dana. 1994. "Primers for Memory: Cartographic Histories and Nahua Identity." Pp. 161–87 in Boone and Mignolo 1994.

Lister, Robert H. 1946. "Survey of Archaeological Remains in Northwestern Chihuahua." *Southwestern Journal of Anthropology* 2, no. 4: 433–53.

Lockhart, James. 1992. *The Nahuas after the Conquest: A Social and Cultural History of the Indians of Central Mexico, Sixteenth through Eighteenth Centuries.* Stanford, Calif.: Stanford University Press.

López Austin, Alfredo. 1988. *The Human Body and Ideology: Concepts of the Ancient Nahuas,* trans. Thelma Ortiz de Montellano and Bernard Ortiz de Montellano. 2 vols. Salt Lake City: University of Utah Press.

Lumholtz, Carl. 1900. "Symbolism of the Huichol Indians." In *Memoirs of the American Museum of Natural History.* Vol. 1. New York: American Museum of Natural History.

———. 1902. *Unknown Mexico.* 2 vols. New York: Charles Scribner's Sons.

———. 1987. *Unknown Mexico: Explorations in the Sierra Madre and Other Regions, 1890–1898.* 2 vols. New York: Dover.

Mallory, Garrick. 1886. "Pictographs of the North American Indians." In *Fourth Annual Report of the Bureau of American Ethnology.* Washington, D.C.: Bureau of American Ethnology.

Malotki, Ekkehart, ed. 1993. *Hopi Ruin Legends: Kiqututuwuti.* Narrated by Michael Lomatuway'ma, Loena Lomatuway'ma, and Sidney Namingha Jr. Lincoln: University of Nebraska Press.

Malotki, Ekkehart, and Michael Lomatuway'ma. 1987. *Maasaw: Profile of a Hopi God.* Lincoln: University of Nebraska Press.

Marcus, Joyce, and Kent V. Flannery. 1996. *Zapotec Civilization: How Urban Society Evolved in Mexico's Oaxaca Valley.* London and New York: Thames and Hudson.

Marshall, Michael P. 1997. "The Chacoan Roads—A Cosmological Interpretation." Pp. 62–74 in *Anasazi Architecture and American Design,* ed. Baker H. Morrow and V. B. Price. Albuquerque: University of New Mexico Press.

Martínez, José Luis. 1984. *Nezahualcoyotl.* Lecturas Mexicanas, no. 39. Mexico City: Fondo de Cultura Económica.

———, ed. 1990. *Documentos Cortesianos, I: 1518–1528, secciones I a III.* Mexico City: UNAM and Fondo de Cultura Económica.

Martínez-Alier, Verena. 1974. *Marriage, Class, and Colour in Nineteenth-Century Cuba: A Study of Racial Attitudes and Sexual Values in a Slave Society.* London and New York: Cambridge University Press.

Mathien, Frances Joan. 1981. "Economic Exchange Systems in the San Juan Basin." Ph.D. diss., University of New Mexico.

——. 1986. "External Contacts and the Chaco Anasazi." Pp. 220–42 in Mathien and McGuire 1986.

Mathien, Frances Joan, and Randall H. McGuire, eds. 1986. *Ripples in the Chichimec Sea: New Considerations of Southwestern-Mesoamerican Interactions.* Carbondale: Southern Illinois University Press.

Matos Moctezuma, Eduardo. 1987. "Symbolism of the Templo Mayor." Pp. 185–209 in *The Aztec Templo Mayor*, ed. Elizabeth Hill Boone. Washington, D.C.: Dumbarton Oaks.

——. 1988. *The Great Temple of the Aztecs: Treasures of Tenochtitlan.* London: Thames and Hudson.

McGuire, Randall H. 1980. "The Mesoamerican Connection in the Southwest." *Kiva* 46, nos. 1–2: 3–38.

——. 1986. "Economies and Modes of Production in the Prehistoric Southwestern Periphery." Pp. 243–69 in Mathien and McGuire 1986.

McKenna, Peter J., and H. Wolcott Toll. 1992. "Regional Patterns of Great House Development among the Totah Anasazi, New Mexico." Pp. 133–43 in *Anasazi Regional Organization and the Chaco System*, ed. David E. Doyel. Papers of the Maxwell Museum of Anthropology, no. 5. Albuquerque: Maxwell Museum of Anthropology, University of New Mexico.

McNeley, James Kale. 1981. *Holy Wind in Navajo Philosophy.* Tucson: University of Arizona Press.

Meighan, Clement. 1976. *The Archaeology of Amapa, Nayarit.* Berkeley: University of California Press.

Mendieta, Geronimo. 1980. *Historia eclesiastica indiana.* Mexico City: Editorial Porrúa.

Mesa-Bains, Amalia. 1993a. *Ceremony of Spirit: Nature and Memory in Contemporary Latino Art.* San Francisco: Mexican Museum.

——. 1993b. "Indigenismo: A Call to Unity." In *Voices from the Battlefront: Achieving Cultural Equity*, ed. Marta Moreno Vega and Cheryll Y. Greene. Trenton, N.J.: Africa World Press.

——. 1993c. Pp. 14–73 in *Art of the Other Mexico: Sources and Meanings*, ed. René H. Arceo-Frutos, Juana Guzmán, and Amalia Mesa-Bains. Chicago: Mexican Fine Arts Center Museum.

——. 1994. "Guardians of the Land." In *Rejoining the Spiritual: Land in Contemporary Latin American Art.* Baltimore: Maryland Institute, College of Art.

——. 1995. "Domesticana: The Sensibility of the Chicana Rasquache." In *Distant Relations: Chicano, Irish, Mexican Art, and Critical Writing*, ed. Trisha Ziff. Santa Monica: Smart Art Press.

Michaelis, Helen. 1981. "Willowsprings: A Hopi Petroglyph Site." *Journal of New World Archaeology* 4, no. 2: 3–32.

Milbrath, Susan. 1999. *Star Gods of the Maya: Astronomy in Art, Folklore, and Calendars.* Austin: University of Texas Press.

Mindeleff, Victor. 1891. *A Study of Pueblo Architecture in Tusayan and Cibola.* Eighth Annual Report of the Bureau of American Ethnology for the Years 1886–1887. Washington, D.C.: Smithsonian Institution.

Minnis, Paul E. 1984. "Peeking under the Tortilla Curtain: Regional Interaction and Integration on the Northeastern Periphery of Casas Grandes." *American Archaeology* 4, no. 3: 181–93.

——. 1985. "Domesticating People and Plants in the Greater Southwest." Pp. 309–40 in *Prehistoric Food Production in North America*, ed. Richard I. Ford. Ann Arbor: Museum of Anthropology, University of Michigan.

——. 1989. "The Casas Grandes Polity in the International Four Corners." Pp. 269–305 in *The Sociopolitical Structure of Prehistoric Southwestern Societies*, ed. S. Upham, K. G. Lightfoot, and R. A. Jewett. Boulder, Colo.: Westview Press.

Monaghan, John. 1989. "The Feathered Serpent in Oaxaca: An Approach to the Study of Mixtec Codices." *Expedition: The University Museum Magazine of Archaeology/Anthropology* 31, no. 1: 12–18.

——. 1995. *The Covenants with Earth and Rain.* Norman: University of Oklahoma Press.

Mora, Carmen de, ed. 1992. *Las siete ciudades de Cíbola: Textos y testimonios sobre la expedición de Vázquez de Coronado.* Seville: Ediciones Alfar.

Moulard, Barbara L. 1984. *Within the Underworld Sky: Mimbres Ceramic Art in Context.* Pasadena, Calif.: Twelvetrees Press.

Myerhoff, Barbara G. 1986. *Peyote Hunt: The Sacred Journey of the Huichol Indians.* Ithaca, N.Y.: Cornell University Press.

Nabokov, Peter. 1986. *Architecture of Acoma Pueblo.* Santa Fe, N.M.: Ancient City Press.

Naranjo, Tito. 1972. "Back to the River of Life."

Nelson, Richard S. 1981. "The Role of a Puchteca System in Hohokam Exchange." Ph.D. diss., New York University.

——. 1986. "Pochtecas and Prestige: Mesoamerican Artifacts in Hohokam Sites." Pp. 154–82 in Mathien and McGuire 1986.

Nequatewa, Edmund. 1936. *Truth of a Hopi and Other Clan Stories of Shung-Opovi*, ed. Mary-Russell F. Colton. Flagstaff: Northern Arizona Society of Science and Art.

——. 1994. *Truth of a Hopi: Stories Relating to the Origin, Myths and Clan Histories of the Hopi.* Flagstaff, Ariz.: Northland Publishing.

Noguez, Xavier, ed. 1996. *Tira de Tepechpan: Códice colonial procedente del valle de México.* Facsimile ed. 2 vols. Biblioteca Nezahualcoyotl. Mexico City: Instituto Mexiquense de Cultura.

Noriega, Chon. 1993. "This Is Not a Border." *Spectator* 13 (fall).

——. 2000. "From Beats to Borders: An Alternative History of Chicano Art in California." Pp. 353–71 in *Reading California: Art, Image, and Identity, 1900–2000.* Los Angeles: Los Angeles County Museum of Art; Berkeley, Los Angeles, and London: University of California Press.

Northrop, Stuart. 1959. *Minerals of New Mexico.* Albuquerque: University of New Mexico Press.

Oakes, Maud, and Joseph Campbell. 1969. *Where the Two Came to Their Father: A Navaho War Ceremonial Given by Jeff King.* Princeton, N.J.: Princeton University Press.

Obregón, Baltasar de. 1924. *Historia de los descubrimientos antiguos y modernos de la Nueva España.* Mexico City: Departamento Editorial de la Secretaria de Educación Pública.

O'Mack, Scott. 1991. "Yacatecuhtli and Ehecatl-Quetzalcoatl: Earth-Divers in Aztec Central Mexico." *Ethnohistory* 38: 1–33.

Orozco, Gabriel. 1999. *Gabriel Orozco: Photogravity.* Philadelphia: Philadelphia Museum of Art.

Ortiz, Alfonso. 1969. *The Tewa World: Space, Time, Being, and Becoming in a Pueblo Society.* Chicago: University of Chicago Press.

———. 1972. "Ritual Drama and the Pueblo World View." Pp. 125–61 in *New Perspectives on the Pueblos,* ed. Alfonso Ortiz. Albuquerque: University of New Mexico Press.

———, ed. 1979. *Southwest.* Vol. 9 of *Handbook of North American Indians,* ed. William Sturtevant. Washington, D.C.: Smithsonian Institution.

Owings, Nathaniel. 1973. *The Spaces in Between: An Architect's Journey.* Boston: Houghton Mifflin.

Pacheco, Joaquín S., and Francisco de Cárdenas. 1864–84. *Colección de documentos inéditos relativos al descubrimiento, conquista, y organización de las antiguas posesiones españoles en America, y Oceania.* Vol. 4 of 42 vols. Reprinted with permission of Academia de la Historia, Madrid, by Vaduz, Kraus Reprint.

Padua, Antonio María de. 1950. *La madre de Dios en México.* Vol. 2. Mexico City: J. Ballesca y Cía.

Paredes Gudiño, Blanca. 1999. "The Transformation of the Cult: The Feathered Serpent to the Tlahuizcalpantecuhtli in Tula, Hidalgo, Mexico." Paper presented at the Sixty-fourth Annual Meeting of the Society for American Archaeology, Chicago.

Paris. 1989. *Les magiciens de la terre.* Paris: Centre Georges Pompidou.

Parsons, Elsie Clews. 1923. "The Origin Myth of Zuni." *Journal of American Folklore* 36: 135–62.

———. 1932. "Isleta." Pp. 193–466 in *Forty-seventh Annual Report of the Bureau of American Ethnology, 1929–1930.* Washington, D.C.: Smithsonian Institution.

———. 1933. "Some Aztec and Pueblo Parallels." *American Anthropologist,* n.s., 35: 611–31.

———. 1939. *Pueblo Indian Religion.* 2 vols. Chicago: University of Chicago Press.

———, ed. 1936. *Hopi Journal of Alexander M. Stephen.* 2 vols. Contributions to Anthropology, no. 23. New York: Columbia University Press.

Pasztory, Esther. 1974. *The Iconography of the Teotihuacan Tlaloc.* Studies in Pre-Columbian Art and Archaeology, no. 15. Washington, D.C.: Dumbarton Oaks.

———. 1983. *Aztec Art.* New York: Harry N. Abrams.

———. 1997. *Teotihuacan: An Experiment in Living.* Norman: University of Oklahoma Press.

Patterson, Alex. 1992. *A Field Guide to Rock Art Symbols of the Greater Southwest.* Boulder, Colo.: Johnson Books.

Pendergast, D. M. 1962. "Metal Artifacts in Prehispanic Mesoamerica." *American Antiquity* 27, no. 4: 520–45.

Perry, Gill. 1993. "Primitivism and the 'Modern.'" Pp. 3–85 in *Primitivism, Cubism, Abstraction: The Early Twentieth Century,* ed. Charles Harrison, Francis Frascina, and Gill Perry. London and New Haven: Open University and Yale University Press.

Piña Chan, Roman. 1977. *Quetzalcóatl: Serpiente emplumada.* Mexico City: Fondo de Cultura Económica.

Pino, Pedro. 1812. *Exposición sucinta y sencilla de la provincia del Nuevo México.* Cádiz: Impr. del Estado-mayor-general.

Plog, Fred, Steadman Upham, and Phil C. Weigand. 1982. "A Perspective on Mogollon-Mesoamerican Interaction." Pp. 239–50 in *Mogollon Archaeology: Proceedings of the 1980 Mogollon Conference,* ed. P. H. Beckett. Ramona, Calif.: Acoma Books.

Plog, Stephen. 1997. *Ancient Peoples of the American Southwest.* London: Thames and Hudson.

Pogue, Joseph E. 1915. "The Turquoise: A Study of Its History, Mineralogy, Geology, Ethnology, Archaeology, Mythology, Folklore, and Technology." *Memoirs of the National Academy of Science* 12, no. 2, memoir no. 3.

———. 1974. *Turquois.* Originally published in 1915 in *Memoirs of the National Academy of Science* 12, no. 2. Reprint, Glorieta, N.M.: Rio Grande Press.

Pohl, John M. D. 1994a. "Mexican Codices, Maps, and Lienzos as Social Contracts." Pp. 137–60 in Boone and Mignolo 1994.

———. 1994b. "Weaving and Gift Exchange in the Mixtec Codices." In *Cloth and Curing: Continuity and Change in Oaxaca,* ed. Grace Johnson and Douglas Sharon. Museum Papers, no. 22. San Diego: San Diego Museum of Man.

———. 1994c. *The Politics of Symbolism in the Mixtec Codices.* Publications in Anthropology, no. 46. Nashville, Tenn.: Vanderbilt University.

———. 1998. "Themes of Drunkenness, Violence, and Factionalism in Tlaxcalan Altar Paintings." *RES* 33: 184–208.

———. [Forthcoming] "Middle Postclassic Confederacies of Southern Mexico." In *The Middle Postclassic,* ed. Michael E. Smith and Frances Berdan.

Pohl, John M. D., John Monaghan, and Laura R. Stiver. 1997. "Religion, Economy, and Factionalism in Mixtec Boundary Zones." Pp. 205–32 in *Codices y Documentos sobre México.* 2d symposium. Vol. 1. Mexico City: Instituto Nacional de Antropología e Historia.

Pohorilenko, Anatole. 1996. "Portable Carvings in the Olmec Style." Pp. 118–31 in Benson and de la Fuente 1996.

Pollard, Helen Perlstein. 1987. "The Political Economy of Prehispanic Tarascan Metallurgy." *American Antiquity* 52, no. 4: 741–52.

———. 1991. "The Construction of Ideology in the Emergence of the Prehispanic Tarascan State." *Ancient Mesoamerica* 2: 167–79.

———. 1993. *Tariacuri's Legacy.* Norman: University of Oklahoma Press.

Pollock, H. E. D. 1936. *Round Structures of Aboriginal Middle America.* Washington, D.C.: Carnegie Institution.

Quiñones-Keber, Eloise. 1995. *Codex Telleriano-Remensis: Ritual, Divination, and History in a Pictorial Aztec Manuscript.* Austin: University of Texas Press.

Ramírez, Mari Carmen, ed. 1992. *El Taller Torres-García: The School of the South and Its Legacy.* Austin: University of Texas Press for the Archer M. Huntington Art Gallery, College of Fine Arts, University of Texas.

Reents-Budet, Dorie. 1994. *Painting the Maya Universe: Royal Ceramics of the Classic Period*. Durham, N.C.: Duke University Press in association with Duke University Museum of Art.

Reichard, Gladys A. 1963. *Navajo Indian Religion: A Study of Symbolism*. 2d ed. New York: Bollingen Foundation.

Reyes García, Luis. 1977. *Cuauhtinchan del siglo XII al XVI: Formación y desarrollo histórico de un señorío prehispánico*. Wiesbaden, Germany: Franz Steiner.

Reyman, Jonathan E. 1971. "Mexican Influence on Southwestern Ceremonialism." Ph.D. diss., Southern Illinois University.

———. 1978. "Pochteca Burials at Anasazi Sites?" Pp. 242–59 in Riley and Hedrick 1978.

———, ed. 1995. *The Gran Chichimeca: Essays on the Archaeology and Ethnohistory of Northern Mesoamerica*. Avebury, England: Aldershot.

Rhodes, Colin. 1993. *Primitivism and Modern Art*. London: Thames and Hudson.

Ricard, Robert. 1995. *La conquista espiritual de México*, trans. Angel María Garibay K. Mexico City: Fondo de Cultura Económica.

Riley, Carroll L. 1963 "Color-Direction Symbolism: An Example of Mexican-Southwestern Contacts." *América Indígena* 23: 49–60.

———. 1987. *The Frontier People*. Albuquerque: University of New Mexico Press.

———. 1995. *Rio del Norte: People of the Upper Rio Grande from Earliest Times to the Pueblo Revolt*. Salt Lake City: University of Utah Press.

———. 1999. *The Kachina and the Cross*. Salt Lake City: University of Utah Press.

Riley, Carroll L., and Basil C. Hedrick, eds. 1978. *Across the Chichimec Sea: Papers in Honor of J. Charles Kelley*. Carbondale: Southern Illinois University.

Ringle, William M., Tomas Gallareta Negrón, and George J. Bey III. 1998. "The Return of Quetzalcoatl: Evidence for the Spread of a World Religion during the Epiclassic Period." *Ancient Mesoamerica* 9: 183–232.

Rivera, Diego. 1925. "Los retablos: Verdadera, actual y única expresión pictorica del pueblo mexicano." *Mexican Folkways* 1.

Rizo, Michael. 1998. "Scarlet Macaw Production and Trade at Paquime, Chihuahua." Master's thesis, Arizona State University.

Rodríguez, Sylvia. 1996. *The Matachines Dance: Ritual Symbolism and Interethnic Relations in the Upper Rio Grande Valley*. Albuquerque: University of New Mexico Press.

Rubin, William. 1994. *Les Demoiselles d'Avignon*. Studies in Modern Art, no. 3 New York: Museum of Modern Art.

———, ed. 1984. *"Primitivism" in Twentieth-Century Art: Affinity of the Tribal and the Modern*. New York: Museum of Modern Art.

Sagrada Mitra de Querétaro. 1895. *Edicto Diocesano*. Querétaro, Mexico: Imprenta de la Escuela de Artes; Guanajuato, Mexico: Archivo Parroquial de San José Iturbide.

Sahagún, Fray Bernardino de. 1950–82. *The Florentine Codex: General History of the Things of New Spain*, trans. Arthur J. O. Anderson and Charles E. Dibble. 12 vols. Santa Fe, N.M.: School of American Research; Salt Lake City: University of Utah.

———. 1997. *Primeros memoriales*, trans. Thelma Sullivan. Norman: University of Oklahoma Press.

Sánchez, Joseph P. 1997. *Explorers, Traders, and Slaves: Forging the Old Spanish Trail, 1678–1850*. Salt Lake City: University of Utah Press.

Sayles, Edwin B. 1936. *An Archaeological Survey of Chihuahua, Mexico*. Medallion Papers, no. 22. Globe, Ariz.: Gila Pueblo.

Schaaf, Gregory. 1996. *Honoring the Weavers*. Santa Fe, N.M.: Kiva Publishing.

Schaafsma, Curtis F., and Carroll L. Riley, eds. 1999. *The Casas Grandes World*. Salt Lake City: University of Utah Press.

———. 1980. *Indian Rock Art of the Southwest*. Santa Fe: School of American Research; Albuquerque: University of New Mexico Press.

———. 1997. *Rock Art Sites in Chihuahua, Mexico*. Office of Archaeological Studies, Archaeology Notes, no. 171. Santa Fe: Museum of New Mexico.

———. 1999. "Tlalocs, Kachinas, Sacred Bundles, and Related Symbolism in the Southwest and Mesoamerica." Pp. 164–92 in Schaafsma and Riley 1999.

———, ed. 1994. *Kachinas in the Pueblo World*. Albuquerque: University of New Mexico Press.

Schaafsma, Polly, and Curtis F. Schaafsma. 1974. "Evidence for the Origins of the Pueblo Kachina Cult as Suggested by Southwestern Rock Art." *American Antiquity* 39: 535–45.

Schaafsma, Polly, and Regge N. Wiseman. 1992. "Serpents in the Prehistoric Pecos Valley of Southeastern New Mexico." Pp. 175–84 in *Archaeology, Art, and Anthropology: Papers in Honor of J. J. Brody*, ed. Meliha S. Duran and David T. Kirkpatrick. Albuquerque: Archaeological Society of New Mexico.

Schaefer, Stacy B., and Peter T. Furst. 1996. *People of the Peyote: Huichol Indian History, Religion, and Survival*. Albuquerque: University of New Mexico Press.

Schavelson, Daniel. 1985. "El Caracol de Cozumel: Una pequeña maravilla de la arquitectura Maya." *Cuadernos de Arquitectura Mesoamericana* 5: 74–81.

Schele, Linda, and David A. Freidel. 1991. "The Courts of Creation: Ballcourts, Ballgames, and Portals to the Maya Otherworld." Pp. 289–316 in *The Mesoamerican Ballgame*, ed. Vernon L. Scarborough and David R. Wilcox. Tucson: University of Arizona Press.

Scholes, France V. 1930. "The Mission Supply Service of the New Mexico Missions in the Seventeenth Century." *New Mexico Historical Review* 5, nos. 1–2, 4: 186–210, 386–404.

———. 1935. "Civil Government and Society in New Mexico in the Seventeenth Century." *New Mexico Historical Review* 10, no. 2: 71–111.

———. 1937. *Church and State in New Mexico, 1610–1650*. Historical Society of New Mexico Publications in History, no. 7. Albuquerque: University of New Mexico Press.

———. 1942. *Troublous Times in New Mexico, 1659–1670*. Historical Society of New Mexico Publications in History, no. 11. Albuquerque: University of New Mexico Press.

Schroeder, Albert H. 1979. "Pueblos Abandoned in Historic Times." Pp. 236–54 in Ortiz 1979.

———. 1981. "How Far Can a Pochteca Leap without Leaving Footprints?" Pp. 43–64 in *Collected Papers in Honor of Erik Kellerman Reed*, ed. Albert H. Schroeder. Albuquerque: Archaeological Society of New Mexico.

Scully, Vincent. 1975. *Pueblo: Mountain, Village, Dance.* New York: Viking.

Sedgwick, Mrs. William T. 1926. *Acoma, the Sky City.* Cambridge: Harvard University Press.

Seler, Eduard E. 1990–98. *Collected Works in Mesoamerican Linguistics and Archaeology,* ed. Frank E. Comparato. 6 vols. Culver City, Calif.: Labyrinthos.

Serrano, Teresa. 1996. *Teresa Serrano.* Monterrey: Ramis Barquet Gallery.

Simpson, James H. 1852. *Journal of a Military Reconnaissance from Santa Fe, New Mexico, to the Navaho Country.* Philadelphia: Lippincott, Grambo.

Smith, Michael. 1997. "Life in the Provinces of the Empire." *Scientific American* 227, no. 3: 76–83.

Smith, Watson. 1952. *Kiva Mural Decorations at Awatovi and Kawaika-a.* Papers of the Peabody Museum of American Archaeology and Ethnology, no. 37. Cambridge: Harvard University.

Smith, Watson, Richard B. Woodbury, and Nathalie F. S. Woodbury. 1966. *The Excavation of Hawikuh by Frederick Webb Hodge: Report of the Hendricks-Hodge Expedition.* Contributions from the Museum of the American Indian, Heye Foundation, no. 20. New York: Museum of the American Indian.

Sofaer, Anna. 1997. "The Primary Architecture of the Chacoan Culture: A Cosmological Expression." Pp. 88–132 in *Anasazi Architecture and American Design,* ed. Baker H. Morrow and V. B. Price. Albuquerque: University of New Mexico Press.

Soja, Edward W. 1989. *Postmodern Geographies: The Reassertion of Space in Critical Social Theory.* London: Verso.

Sorrell, Victor. 1998. "Telling Images Bracket the 'Broken-Promise(d) Land': The Culture of Immigration and the Immigration of Culture across Borders." In *Culture across Borders: Mexican Immigration of Popular Culture,* ed. David R. Maciel and Maria Herrera-Sobek. Tucson: University of Arizona Press.

Spielmann, Katherine. 1989. "Colonists, Hunters, and Farmers: Plains-Pueblo Interaction in the Seventeenth Century." Pp. 101–13 in *Columbian Consequences,* ed. David H. Thomas. Vol. 1. Washington, D.C.: Smithsonian Institution.

———. ed. 1991. *Farmers, Hunters, and Colonists: Interaction between the Southwest and the Southern Plains.* Tucson: University of Arizona Press.

Spielmann, Katherine, and James F. Eder. 1994. "Hunters and Farmers: Then and Now." *Annual Review of Anthropology* 23: 303–23.

Sprague, Roderick. 1964. "Inventory of Prehistoric Southwestern Copper Bells: Additions and Corrections." *Kiva* 30, no. 1: 18–24.

Sprague, Roderick, and Aldo Signori. 1963. "Inventory of Prehistoric Southwestern Copper Bells." *Kiva* 28, no. 4: 1–20.

Steele, Thomas. 1986. *Santos and Saints: The Religious Folk Art of Hispanic New Mexico.* Santa Fe, N.M.: Ancient City Press.

Stephen, Alexander M. 1929. "Hopi Tales." *Journal of American Folk-Lore* 42: 1–72.

———. 1930. "Navajo Origin Legend." *Journal of American Folk-Lore* 43: 88–104.

———. 1936. *Hopi Journal of Alexander M. Stephen,* ed. E. C. Parsons. New York: Columbia University Press.

Stevenson, Matilda Coxe. 1887. "The Religious Life of the Zuñi Child." Pp. 533–55 in *Fifth Annual Report of the Bureau of American Ethnology for the Years 1883–1884.* Washington, D.C.: Bureau of American Ethnology.

———. 1894. "The Sia." In *Eleventh Annual Report of the Bureau of American Ethnology for the Years 1889–1890.* Washington, D.C.: Bureau of American Ethnology.

———. 1904. "The Zuni Indians: Their Mythology, Esoteric Fraternities, and Ceremonies." In *Twenty-third Annual Report of the Bureau of American Ethnology for the Years 1902–1903.* Washington, D.C.: Bureau of American Ethnology.

———. 1915. "Ethnobotany of the Zuni Indians." Pp. 35–102 in *Thirtieth Annual Report of the Bureau of American Ethnology for the Years 1908–1909.* Washington, D.C.: Bureau of American Ethnology.

———. 1987. "Dress and Adornment of the Pueblo Indians [1911 MS]," ed. Richard Ahlstrom and Nancy Parezo. *Kiva* 52, no. 4: 275–312.

Stirling, Matthew W. 1942. *Origin Myth of Acoma, and Other Records.* Smithsonian Institution, Bureau of American Ethnology, Bulletin no. 135. Washington, D.C.: Government Printing Office.

Sucec, David. 1992. "Seeing Spirits: Initial Identification of Representation of Shamans in Barrier Canyon Rock Art." *Canyon Legacy: A Journal of the Dan O'Laurie Museum,* no. 16: 2–11.

Swentzell, Rina. 1997. "An Understated Sacredness." Pp. 186–89 in *Anasazi Architecture and American Design,* ed. Baker H. Morrow and V. B. Price. Albuquerque: University of New Mexico Press.

Taube, Karl A. 1986. "The Teotihuacan Cave of Origin: The Iconography and Architecture of the Emergence in Mesoamerica and the American Southwest." *RES: Anthropology and Aesthetics* 29–30: 31–82.

———. 1995. "The Rainmakers: The Olmec and Their Contribution to Mesoamerican Belief and Ritual." Pp. 83–103 in Coe et al. 1995.

Teague, Lynn S. 1998. *Textiles in Southwestern Prehistory.* Albuquerque: University of New Mexico Press.

Tedlock, Dennis. 1979. "Zuni Religion and World View." Pp. 499–508 in Ortiz 1979.

Thompson, J. Eric S. 1970. *Maya History and Religion.* Norman: University of Oklahoma Press.

Thompson, Marc. 1994. "The Evolution and Dissemination of Mimbres Iconography." Pp. 93–105 in Schaafsma 1994.

Tipps, Betsy L. 1994. "Cultural Resource Inventory and Testing near Squaw Butte, Needles District, Canyonlands National Park, Utah." *Holocene Archeology near Squaw Butte, Canyonlands National Park, Utah.* Cultural Resources Report no. 411-04-9102. Denver: National Park Service.

Titiev, Mischa. 1937. "A Hopi Salt Expedition." *American Anthropologist* 39, no. 2: 244–58.

———. 1944. *Old Oraibi: A Study of the Hopi Indians of Third Mesa*. Papers of the Peabody Museum of American Archaeology and Ethnology, vol. 22, no. 1. Cambridge: Harvard University.

———. 1992. *Old Oraibi: A Study of the Hopi Indians of Third Mesa*. Foreword by Richard Ford. Albuquerque: University of New Mexico Press.

Tovar de Teresa, Guillermo. 1982. *México barroco*. Mexico City: SAHOP.

Townsend, Richard Fraser. 1979. *State and Cosmos in the Art of Tenochtitlan*. Studies in Pre-Columbian Art and Archaeology, no. 20. Washington, D.C.: Dumbarton Oaks.

———, ed. 1992. *The Ancient Americas: Art from Sacred Landscapes*. Chicago: Art Institute of Chicago.

Turner, Christy G., II, and Jacqueline A. Turner. 1999. *Man Corn: Cannibalism and Violence in the Prehistoric American Southwest*. Salt Lake City: University of Utah Press.

Tyler, Hamilton. 1979. *Pueblo Birds and Myths*. Norman: University of Oklahoma Press.

Underhill, Ruth M. 1948. *Ceremonial Patterns in the Greater Southwest*. Monographs of the American Ethnological Society, no. 13. New York: J. J. Augustin.

Upham, Steadman. 1982. *Polities and Power: An Economic and Political History of the Western Pueblo*. New York: Academic Press.

Vaillant, George. 1930. *Excavations at Zacatenco*. Anthropological Papers, vol. 32, no. 1. New York: American Museum of Natural History.

Valdez, Luis, and Saul Steiner, eds. 1972. *Aztlán: An Anthology of Mexican-American Literature*. New York: Alfred A. Knopf.

Van Well, Sister Mary Stanislaus. 1942. *The Educational Aspects of the Missions in the Southwest*. Milwaukee: Marquette University Press.

Van West, Carla R. 1994. *Modeling Prehistoric Agricultural Productivity in Southwestern Colorado: A GIS Approach*. Department of Anthropology, Reports of Investigations, no. 67. Pullman: Washington State University.

———. 1996. "Agricultural Potential and Carrying Capacity in Southwestern Colorado, A.D. 901 to 1300." Pp. 214–27 in *The Prehistoric Pueblo World, A.D. 1150–1300*, ed. Michael A. Adler. Tucson: University of Arizona Press.

Vargas, Victoria D. 1994. "Copper Bell Trade Patterns in the Prehistoric Greater American Southwest." Master's thesis, University of Oklahoma.

———. 1995. *Copper Bell Trade Patterns in the Prehispanic U.S. Southwest and Northwest Mexico*. Arizona State Museum Archaeological Series, no. 187. Tucson: University of Arizona.

———. 1996a. "Ideological Superordinance and Subordinance: The Ritual Primacy of Copper Artifacts at Paquimé in the Casas Grandes Region." Unpublished manuscript.

———. 1996b. "Copper, Ritual, and Esoteric Knowledge: Competition for Power at Paquimé, Casas Grandes." Unpublished manuscript.

———. 1999. "Copper, Ritual, and Power at Paquimé: An Alternative Interpretation for the Significance and Role of Copper Items." Paper presented at the Sixty-fourth Annual Meeting of the Society for American Archaeology, Chicago.

Vasconcelos, José. 1979. *La raza cósmica = The Cosmic Race*. Introduction and notes by Didier T. Jaén. Los Angeles: Centro de Publicaciones, Department of Chicano Studies, California State University.

Villagrá, Gaspar de. 1989. *Historia de Nuevo México*, ed. Mercedes Junquera. Crónicas de América, no. 51. Madrid: Historia 16.

Vivian, R. Gwinn. 1970. "Aspects of Prehistoric Society in Chaco Canyon, New Mexico." Ph.D. diss., University of Arizona.

Voth, H. R. 1905. *The Traditions of the Hopi*. Field Columbian Museum Anthropological Series, no. 8. Chicago: Field Columbian Museum.

Washburn, Dorothy K. 1978. "A Reanalysis of the Grave Goods from Pueblo Bonito: Some Mexican Affiliations." Paper presented at the Annual Meeting of the Society for American Archaeology.

———. 1980. "The Mexican Connection: Cylinder Jars from the Valley of Oaxaca." *Transactions of the Illinois Academy of Science* 72, no. 4: 70–82.

Waters, Frank. 1977. *Book of the Hopi*. Drawings and source material recorded by Oswald White Bear Fredericks. New York: Penguin.

Webb, Edith B. 1952. *Indian Life at the Old Missions*. Los Angeles: Warren F. Lewis.

Weber, David J. 1985. "Reflections on Coronado and the Myth of Quivira." Pp. 59–69 in *Coronado and the Myth of Quivira*, ed. Diana Everett. Canyon, Tex.: Panhandle-Plains Historical Society Publications.

Webster, Laurie D. 1997. "Effects of European Contact on Textile Production and Exchange in the North American Southwest: A Pueblo Case Study." Ph.D. diss., University of Arizona, Tucson.

Weigand, Phil C. 1966. "The Mines and Mining Techniques of the Chalchihuites Culture." *American Antiquity* 33, no. 1: 45–61.

———. 1975. "Possible References to La Quemada in Huichol Mythology." *Ethnohistory* 22: 15–20.

———. 1982. "Mining and Mineral Trade in Prehispanic Zacatecas." *Mining and Mining Techniques in Ancient Mesoamerica*. Special issue of *Anthropology* 6, nos. 1–2: 87–134.

———. 1992. "The Macroeconomic Role of Turquoise within the Chaco Canyon System." Pp. 169–73 in *Anasazi Regional Organization and the Chaco System*, ed. David E. Doyel. Maxwell Museum of Anthropology, Anthropological Papers, no. 5. Albuquerque: University of New Mexico.

———. 1993. *Evolución de una civilización prehispánica: Arqueología de Jalisco, Nayarit, y Zacatecas*. Zamora, Mex.: El Colegio de Michoacán.

———. 1994. "Observations in Ancient Mining within the Northwestern Regions of the Mesoamerican Civilization, with Emphasis on Turquoise." Pp. 21–35 in *In Quest of Mineral Wealth: Aboriginal and Colonial Mining and Metallurgy in Spanish America*, ed. A. K. Craig and R. C. West. Baton Rouge: Louisiana State University.

Weigand, Phil C., and Garman Harbottle. 1992. "The Role of Turquoises in the Ancient Mesoamerican Trade Structure." Pp. 159–77 in *The American Southwest and Mesoamerica: Systems of Prehistoric Exchange*, ed. J. E. Ericson and T. G. Baugh. New York: Plenum Press.

Weigand, Phil C., Garman Harbottle, and Edward V. Sayer. 1977. "Turquoise Sources and Source Analysis: Mesoamerica and the Southwestern U.S.A." Pp. 15–34 in *Exchange Systems in Prehistory*, ed. T. K. Earle and J. E. Ericson. New York: Academic Press.

411

424